WHY WE SERVE

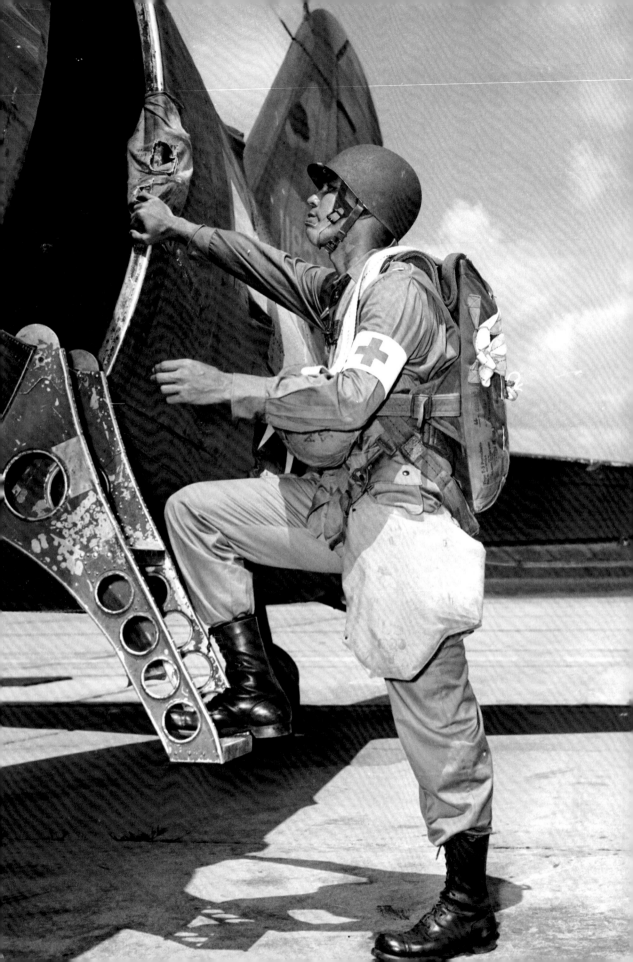

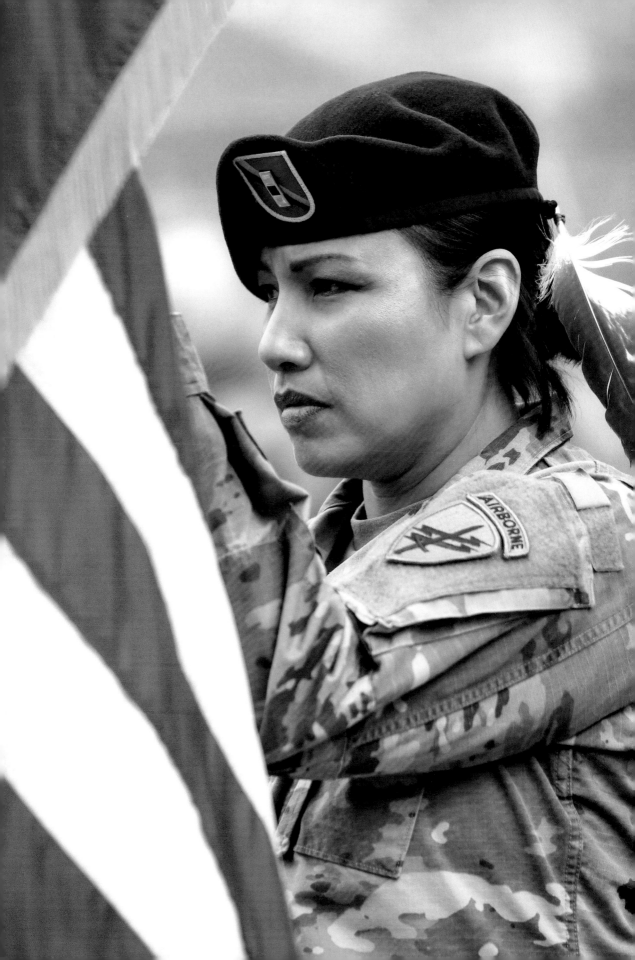

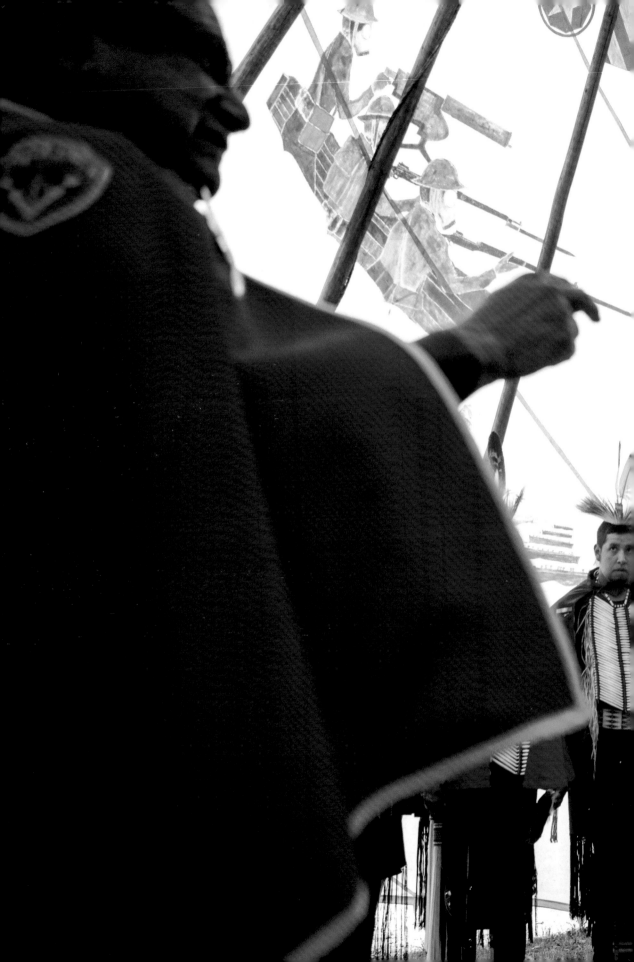

WHY WE SERVE

Native Americans in the United States Armed Forces

Alexandra N. Harris

Mark G. Hirsch

Published by the National Museum of the American Indian
Smithsonian Institution

The Smithsonian's National Museum of the American Indian

Vision: Equity and social justice for the Native peoples of the Western Hemisphere through education, inspiration, and empowerment.

Mission: In partnership with Native peoples and their allies, the National Museum of the American Indian fosters a richer shared human experience through a more informed understanding of Native peoples.

For more information about the Smithsonian's National Museum of the American Indian, visit www.AmericanIndian.si.edu.

Director: Kevin Gover (Pawnee)

Associate Director for Museum Research and Scholarship: David W. Penney

Publications Manager: Tanya Thrasher (Cherokee Nation)

Assistant Publications Manager: Ann Kawasaki

Project Editor: Alexandra Harris

Copy Editor: Joanne Reams

Design: Julie Allred/BW&A Books; Steve Bell, Senior Designer

Editorial and Research Assistance: Christine T. Gordon, Julie B. Macander, Bethany Montagano, Arwen Nuttall

Rights and Permissions: Wendy Hurlock Baker, Julie B. Macander

Index: Kate Mertes

Published to commemorate the dedication of the National Native American Veterans Memorial at the National Museum of the American Indian in Washington, DC, on November 11, 2020.

First Edition

10 9 8 7 6 5 4 3 2 1

Printed in Canada

Library of Congress Cataloging-in-Publication Data

Names: Harris, Alexandra N., 1976- author. | Hirsch, Mark G., author.

Title: Why we serve : Native Americans in the United States Armed Forces / Alexandra N. Harris, Mark G. Hirsch.

Other titles: Native Americans in the United States Armed Forces

Description: Washington : National Museum of the American Indian, [2020]. | Summary: "American Indians have served in our nation's military since colonial times. Throughout Indian Country, servicemen and women are some of the most honored members of their communities. Charged by Congress with creating a memorial on its grounds, the National Museum of the American Indian (NMAI) will dedicate the National Native American Veterans Memorial in fall 2020 to give all Americans the opportunity "to learn of the proud and courageous tradition of service of Native Americans." Why We Serve commemorates the opening of the memorial through the history of Native military service in all its complexity, from colonial Native nations who forged alliances, attempting to preserve their sovereignty, to contemporary individuals celebrating their Indigenous culture while fighting in foreign conflicts."—Provided by publisher.

Identifiers: LCCN 2019015758 | ISBN 9781588346971 (hardcover) | ISBN 9781588346995 (deluxe hardcover)

Subjects: LCSH: United States—Armed Forces—Indians—History.

Classification: LCC E98.M5 H37 2020 | DDC 355.0089/97073—dc23

LC record available at https://lccn.loc.gov/2019015758

Cover: Gus Palmer Sr. (Kiowa, at left) and Horace Poolaw (Kiowa) in front of a B-17 Flying Fortress. Mac-Dill Field, Tampa, Florida, ca. 1944. Photo by Horace Poolaw, 45UFL14, © Estate of Horace Poolaw

ii: Lieutenant Thomas S. Whitecloud II (Chippewa, 1914–1972), a twenty-nine-year-old parachute medical officer from Lac Du Flambeau reservation. Fort Benning, Georgia, July 4, 1944. According to a military press release, Lieutenant Whitecloud attended Tulane University Medical School and transferred to the parachute school from Kennedy General Hospital in Memphis, where he was training with the Army Medical Field Service. Parachute medical officers jumped, unarmed, into combat with paratroopers in order to care for the wounded. Whitecloud served in the 515th Parachute Infantry in the European Theater of the war. National Archives photo no. 75-N-PER-1

iii: Flag bearer Misty "Iglág Thokáhe Wiŋ" Lakota (Oglala Lakota) leads Grand Entry at the 2018 Georgetown University Powwow in Washington, DC. Photo by Tomas Alejo

iv–v: Members of the Ton-Kon-Gah, or Kiowa Black Leggings Society. Near Anadarko, Oklahoma, 2014. © 2014 Nicole Tung

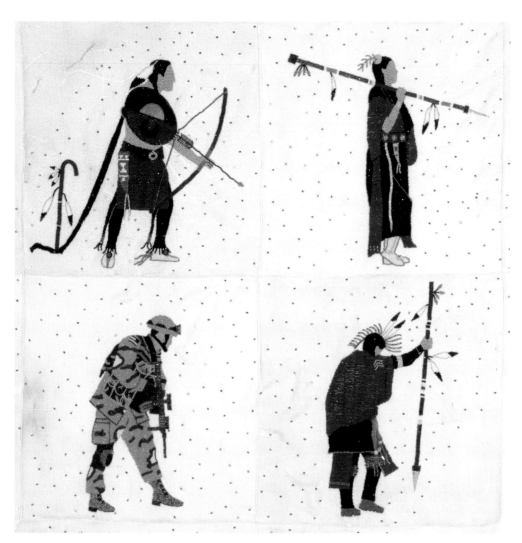

Teri Greeves (Kiowa, b. 1970), *Prayer Blanket*, detail, 2006. Metal, silver, and glass beads; hawk bells; brain-tanned deer hide; cotton cloth; wool cloth; silk ribbon, 132 × 132 cm. NMAI 26/3325 Photo by James Hart

CONTENTS

FOREWORD

Senator Ben Nighthorse Campbell
and Lieutenant Governor Emeritus Jefferson Keel

N ATIVE AMERICAN VETERANS of the U.S. Armed Forces have traveled a long road to reach this moment of national recognition. Before now, no monument in the nation's capital honored their sacrifices and service. Today, that changes.

The National Native American Veterans Memorial represents years of planning, decades of advocacy, and more than two centuries of American Indian, Alaska Native, and Native Hawaiian service in the military of the United States. With the dedication of this memorial, Native veterans are honored and recognized for service to this country since colonial times.

Acknowledging this legacy is no small task. When Congress authorized the creation of a memorial, the National Museum of the American Indian (NMAI) took up the charge to recognize and raise awareness of Native Americans' extraordinary tradition of service. To that end, the NMAI spent eighteen months meeting with and learning from Indigenous veterans, from Alaska to the Carolinas and Connecticut to Hawai'i. From 2015 to 2017 the museum held thirty-five community consultations, attended by more than a thousand veterans, that directly guided the memorial's development and design. The museum has committed itself to this historic cause.

As co-chairs of the memorial's advisory committee and veterans of the conflicts in Korea and Vietnam, we know how personal this memorial is for all Native veterans. The community consultations were an education in American history through the stories of brave servicemen and women. Veterans, families, and community members: we heard you. This memorial stands not only to honor your bravery but also to acknowledge your suffering and sacrifice and enable you to heal—physically and spiritually. After all you have endured, we recognize you with respect and welcome you home.

To commemorate the memorial's dedication, this book recounts the history of Native military service from before the Revolutionary War to the present day. Hundreds of thousands of Native Americans served throughout this time; enclosed in these pages are stories of bravery, struggle, devastation, and endurance. These pages not only honor their legacy but also serve as inspiration for Native peoples' future achievements.

Senator Ben Nighthorse Campbell

Northern Cheyenne, Colorado
Advisory Committee Co-chair

Courtesy of Senator Ben Nighthorse Campbell

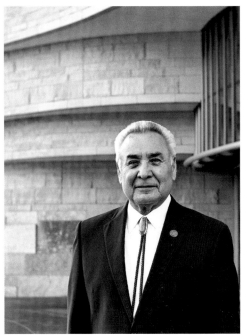

Lieutenant Governor Emeritus Jefferson Keel

Chickasaw Nation, Oklahoma
Advisory Committee Co-chair

NMAI

INTRODUCTION

Alexandra Harris and Mark Hirsch

I found out I am not only fighting for the little bitty piece of land I talk about, my immediate family. I found out I was fighting for all the Indian people, all the people in the United States....
—Samuel Tso (Navajo), United States Marine Corps[1]

W HY WE SERVE pays tribute to the generations of American Indians, Alaska Natives, and Native Hawaiians who have served in the armed forces of the United States.[2] Its stories shed light on a distinguished but largely unheralded tradition of military service rendered on and off the battlefield and in all branches of the armed forces for more than 250 years—a legacy that finally received official recognition in 2020 with the dedication of the National Native American Veterans Memorial, located on the grounds of the National Museum of the American Indian in Washington, DC.

Like the veterans memorial, this book honors the commitment, bravery, and sacrifices of tens of thousands of Native Americans who served in the United States Armed Forces, often paying with their lives, in every war since the founding of the American republic. Additionally, the book recognizes the Native people who served in capacities beyond war, including humanitarian and peacekeeping operations throughout the world.

The title of the book, *Why We Serve*, implies a question: Why have American Indians served so steadfastly and in such great numbers—at times at a higher rate in proportion to their population than any other group in American society?[3] Delving further, why have Native people fought for a country that broke nearly every promise it ever made to tribal nations? Why would they wear the uniform of a country that stole their homelands, suppressed their cultures, and consolidated their people on reservations? Put simply: Why have Native Americans consistently chosen to serve in the armed forces of a nation that has oppressed them for so long?

Of the veterans interviewed for *Why We Serve*, few had previously considered the implications of Native American service or questioned why they served. Yet, when we asked them, their thoughtful reflections helped us better understand the complexities of service.[4] Combined with Native commentary in published sources, Native veterans' perspectives came into clearer focus. Native motivations for military service have varied over time and space, and from individual to individual.[5] There is no doubt that Native people serve

Jesse T. Hummingbird (Cherokee, b. 1952), *Veterans*, detail, 2016. Acrylic on canvas, 101.4 × 76 × 3.5 cm. NMAI 26/9780

for the same reasons as anyone else: to learn a trade, get an education, experience the thrill of piloting a jet, explore new life horizons, strike a blow for gender equality, or uphold family traditions of military service that stretch back for generations. In some cases, joining the military was not a choice; coming from poor communities, many lacked the resources to avoid the draft. And, as again for many in America, serving in the military sometimes meant a job, meals, and stability that could not be found at home. Layered on top of these conventional reasons for service are others drawn from a uniquely Indigenous experience: adherence to family or tribal traditions and treaty alliances, as well as a commitment to defend tribal homelands.[7]

Though the immediate motivations to serve in the military may be the same for Native people as for others, it is true that some are influenced by tribal customs relating to war. A so-called warrior tradition remains a source of pride throughout many contemporary Native nations. The warrior spirit is in "your bones," a Korean War veteran explained during a consultation for the memorial in 2016. "It comes from you, from your ancestors, be it Sitting Bull [or] Geronimo."[8] Yet this tradition is not shared by all tribes, so does not directly explain why Native people participate in the military at such high rates. Additionally, this tradition is often co-opted by non-Indians, then used to stereotype American Indian service members—a stereotype that many, Indian and not, buy into. *Why We Serve* examines this push and pull of tradition, expectations, and service.

American Indian military participation has also been influenced by a feeling of responsibility to keep treaty promises with the United States. In the eighteenth and nineteenth centuries, Native nations signed approximately 370 treaties with the United States—nation-to-nation agreements that often stipulated peace and friendship between both parties. These treaty obligations have never been forgotten in Indian Country. And throughout the twentieth century, whenever the United States has issued a call to arms, Native people have answered, honoring their tribe's treaty alliance with the United States. "I know that the U.S. has broken its part of the bargain with us," a Native American Special Forces veteran of the war in Vietnam confessed, "but we are more honorable than that. [W]e honor our commitments, always have and always will."[9]

Few bonds are so strong for Indigenous peoples as the one to their homelands. Native peoples have fought for the United States because this land has been their home for millennia, and there has been no option but to defend it as they always have. Native American servicemen and women have fought to preserve their homelands—to be members of tribal nations as well as citizens of the United States. "This is still OUR home," explained a Native veteran of World War II:

When the war started, we thought, if someone else was to take over this land, they might treat us worse than the Americans did, if that is possible. So we were willing to fight to protect Our land and Our people first and foremost. I am a member of my tribe and the United States.[10]

Sergeant First Class Mitchelene BigMan (Apsáalooke [Crow] / Hidatsa), founder of the Native American Women Warriors organization, which provides support to Native women veterans, echoed the sentiment. "In our heart, this is still our land, so we're fighting still for our land."[11]

For some Kanaka ʻŌiwi, or Native Hawaiians, service in the U.S. military has been a tradition since the attack on Pearl Harbor. Staff Sergeant Thomas Kaulukukui's father and all of his eleven siblings (including three sisters) served the nation during World War II, earning his paternal grandmother the title of Hawaiʻi Territory's War Mother of the Year. Drafted to Vietnam, Kaulukukui served in the 173rd Airborne Brigade, the first major ground combat unit to serve in the war. "Because of the isolation of the islands, Hawaiian culture prizes close family relationships, mutual support, and mutual cooperation. This is part of the cultural concept of *aloha*, the heart and spirit of Hawaiian society. We must serve when needed." And that includes the military. "As a traditional culture, we're competitive people.... Hawaiians have an affinity for military service, they excel in battle, they are leaders in their units, and have a remarkable mixture of the temperament of aloha and the ferocity of a wild animal, like a wild boar or man-eating shark."[12] For others, serving to protect their homelands can be part of remedying Hawaiʻi's colonial history. Kawika McKeague, a Kanaka ʻŌiwi environmental and land use planner, hula practitioner, and ethnohistorian, reflects that "protect[ing] one's homeland is the path to reconciling the politics and strife" that results from a Hawaiian identity complicated by colonialism and acculturation. "We as a community can and should make a distinction [between] our political status as an occupied nation and the individual contributions made by Kanaka ʻŌiwi soldiers past and present."[13] Honoring loved ones who have served with honor can be compatible with ongoing Indigenous struggles for sovereignty.

WHY WE SERVE is thus a history of American wars told through the eyes of Native American servicemen and women, as well as a history of American Indian patriotism, both to tribal nations and the United States. Whenever possible, the authors have drawn on the veterans' own words to describe the face of battle and chronicle the sources of their dedication to military service. The volume is largely chronological, beginning with the colonial era and American Revolution and continuing with Native participation in each of the United States' conflicts through today's deployments to Iraq, Afghanistan, and other war-torn regions. Short essays and photographs probe thematic issues and shed light on the lives and perspectives of Native Americans whose names

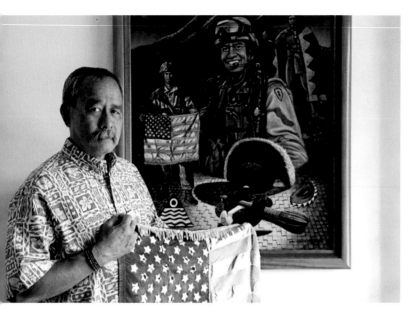

Allen Hoe (Native Hawaiian), in front of a painting that honors his son, First Lieutenant Nainoa Hoe. An army ranger, Lieutenant Hoe was killed while leading a foot patrol urging Iraqi citizens to vote in Iraq's first national elections. A scholarship in his name is awarded annually to a Hawaiian high school senior who is enrolled in a Junior Reserve Officers' Training Corps (JROTC) program and who will enter Army ROTC at the University of Hawai'i. Courtesy of Allen Hoe

rarely appear in the pages of conventional histories of the United States Armed Forces. Taking advantage of the collections and expertise of the National Museum of the American Indian, the narrative is interspersed with art and objects to make the history tangible.

The authors have attempted to include the stories of women throughout Native military history, yet the research evidences how little is recorded or written about women's experiences and roles. Before European contact, women were leaders of many Indigenous nations. Some Native women were known to accompany their men into battle; a few were even warriors themselves.

Although this book focuses on those who have served, it also acknowledges the determination of those who have supported Native American men and women in uniform. What is only hinted at within these pages is the mostly invisible labor and sacrifices made by women and families while their warriors are absent, when they don't return, or when they come home haunted, wounded, and changed. *Why We Serve* recognizes the struggles of these families. A soldier's work is only half the effort; those left at home must fight battles on a different front.

To offer balance, this book also recognizes tribal traditions of peace, for this reason: stereotypes of bloodthirsty Indian warriors abound in American popular culture—a caricature that needs to be challenged by historical fact. And the fact is, many Native traditions have considered war a state of imbalance—once the warrior returns, cleansing and ceremony must occur for the health of the individual and community, restoring balance to both. Additionally, traditions of negotiations, diplomacy, and peacemaking run deep in Indigenous cultures, providing civil equilibrium to the customs of war.

Why We Serve challenges the stereotype that all Native Americans were or are "super warriors," innately inclined and culturally conditioned to combat. Likewise, the book avoids any suggestion that America's wars would never have been won were it not for the military contributions of American Indians; this is not a book of tall tales or hero worship, but rather a chronicle of ordinary men and women doing extraordinary things under often unforgiving circumstances. Finally, *Why We Serve* does not pretend to be a comprehensive history. Though the book strives to represent the experiences of Indigenous peoples within the United States, it was not possible to include every tribal nation, or to tell the complete history of any one tribe or culture.

Their stories must be told. The histories presented in this volume only scratch the surface. Along with commemorating the National Native American Veterans Memorial, *Why We Serve* is meant to inspire further research into and reflection on the experiences of Native veterans. In the words of the founding legislation of the memorial, the purpose of these pages is to raise awareness of the "long, proud, and distinguished tradition of service in the Armed Forces of the United States," as well as to remind Americans of our national obligation to honor their legacy.[14]

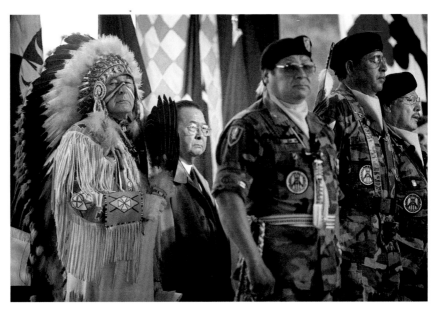

Senators Ben Nighthorse Campbell (Northern Cheyenne), at left in regalia, and Daniel K. Inouye stand with members of the Vietnam Era Veterans Inter-Tribal Association during the groundbreaking ceremonies for the National Museum of the American Indian, Washington, DC, September 28, 1999. Campbell, a Korean War veteran, is one of the few American Indians to serve in Congress. For his actions during World War II, Inouye (1924–2012) received more than fifteen medals and citations, most notably the Medal of Honor and the Presidential Medal of Freedom. MARIO TAMA/AFP/Getty Images

HOW MANY SERVED?

American Indians and Alaska Natives have served in the U.S. military at the highest rate per capita of any ethnicity. This oft-repeated phrase has come to embody the idea of Native service in the military since it was first uttered during World War I. But is it accurate?

Demographic data about the ethnicity of American servicemen and women has historically been imprecise, and the numbers of Native Americans who served in the military are, for the most part, estimates. Establishing accurate numbers has always been complicated by the question of how to classify Native American service members, particularly in racial terms. During the Civil War, for example, some Native people fought in "colored" units with African Americans. Some were integrated within white units or served in mostly Indian units, such as the Confederate Thomas Legion.

While research differs on the final numbers, it is estimated that around six thousand Native Americans enlisted in service during World War I, in addition to 6,509 draftees, or somewhere between 20 to 30 percent of the adult male Indian population—which doesn't include the hundreds of Native people from the United States who enlisted in the Canadian Army in the early years of the war.[1] Commissioner of Indian Affairs Cato Sells declared Native Americans "as furnishing a ratio to population unsurpassed, if equaled, by any other race or nation."[2] However, these numbers were complicated by often-subjective definitions of citizenship and race. The passing of the Selective Service Act on May 18, 1917, led to questions about whether and how to enlist Indians who were not citizens—at the time, this included more than one-third of American Indians.[3] Local draft boards were charged with

determining citizenship and therefore eligibility for the draft. Regardless of their social definitions, non-citizen Indians wanted to enlist; formal guidelines were distributed by the army provost marshal general's office in May 1918 for their entrance to military service.[4]

The problem of subjective racial classification by draft boards makes participation numbers for World War I even more elusive. Initially, draft boards recorded a description of the registrant, but not the race—except in the case of African Americans, where boards were instructed to tear the lower left corner of the registration card to maintain segregation. In this context, most Indians were considered "white." Later in 1917, registration cards included four categories of identification ("white," "Negro," "Oriental," "Indian"), though Native people continued to be considered "white" for quota purposes. Though the Office of Indian Affairs furnished numbers to inquirers, they admitted that the "Indians… were listed with white soldiers and it is practically impossible to determine which are white and which Indians."[5] Lacking inclusive or specific procedures on race, the military was having its own identity crisis; as a result, exact numbers are impossible to calculate.

More than twenty-four thousand reservation and twenty thousand off-reservation American Indian men served in the military during World War II.[6] Native women also joined in substantial numbers: eight hundred served in the armed forces during the war. John Collier, then commissioner of Indian Affairs, attempted to assemble comprehensive lists of Indian men who were drafted or enlisted, but he was not as intent on recording women.[7] Writing in 1942, not yet a year after

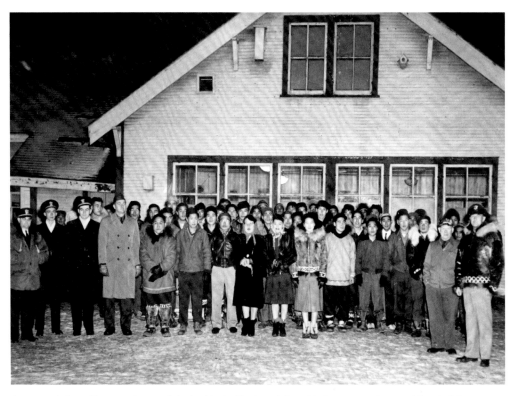

A group of about fifty people, possibly the Alaska Territorial Guard in Barrow, posing outside a building for a winter photograph. The military men appear to be from the United States Navy. Ernest H. Gruening Papers, 1914-[1959-1969] 1974, Alaska & Polar Regions Collections, Archives, University of Alaska Fairbanks

the attack on Pearl Harbor, Collier observed, "Prior to the Japanese assault at Pearl Harbor, Indians in the Army alone numbered 4,481, of whom approximately 60 per cent [*sic*] had enlisted either in the Regular Army or in the National Guard. The rate of enlistment has increased very substantially since we entered the war, until on June 1, 1942, more than 7,500 Indians were in the armed forces. While this seems a relatively small number, it represents a larger proportion than any other element of our population."[8] Still, the numbers are not precise and are at the mercy of classification; Southern states, for example, discriminated against Native Americans based on their shade of skin. In Mississippi, dark-skinned Choctaws were drafted into African American units, while those with lighter skin were routed to white units. Similar treatments occurred throughout the South, particularly to Virginia Indians and North Carolina Cherokees.[9] According to the Congressional Research Service, race was often untracked before the Korean War. When it was, service members "were given a choice between some variation of 'white' or 'black'; categories such as... 'Native American' were not used."[10]

Around ten thousand Native Americans served in the Korean War and, soon after, more than forty-two thousand are believed to have served in Vietnam between 1960 and 1973.[11] These numbers are estimates, as no category for "American Indian" existed at the time in military documentation. Furthermore, according

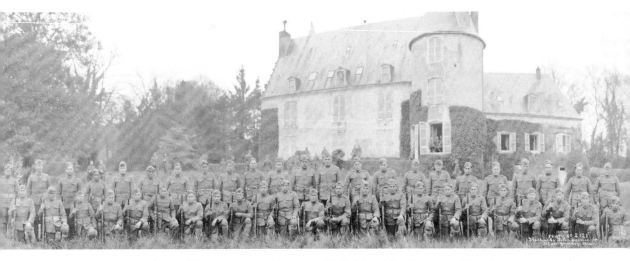

American Indian soldiers of Company E, 142nd Infantry, 36th Division at the Chateau de Vaus, France, during World War I. Choctaw members of this unit became the first code talkers, using their Native language to subvert enemy communications. Oklahoma Historical Society

to historian Tom Holm (Cherokee / Creek), who worked with the U.S. Veterans Administration's Readjustment and Counseling Services (RCS) in the 1980s, the 42,000-figure may have been an aggregate of numbers reported by tribal governments. Other factors complicated the assessment of American Indian participation in the war in Vietnam.[12] In the RCS study, only 40 percent of Native veterans reported that they had been enlisted as American Indians. Recruiters seemed to categorize people on the basis of appearance. Those surveyed were assigned to a range of descriptions, including "other," "Mongolian," "Negro," "Latin," or "Spanish," with many assigned as "Caucasian." Nevertheless, the total estimate of Native American participation in Vietnam is extraordinary and represents 1.4 percent of all troops sent to the conflict, at a time when American Indians made up only 0.6 percent of the larger U.S. population.[13]

As of 2017, a total of 21,526 American Indians and Alaska Natives were on active duty and in the reserves (making up 1 percent of the total military), though the Veterans

> **They were always at the front. If a battle was on, and you wanted to find the Indians, you would always find them at the front.**
>
> —Unidentified United States Army field officer, 1920.[14]

Administration and military sources admit that they record "American Indian / Alaska Native" only as a sole choice—if service members choose more than one ethnicity, they are counted as "other" or "multi-racial" (and the United States Army does not recognize "multi-racial" as a category, as other services do). In contrast, the "other" and "multi-racial" categories total 73,691 and 52,158, respectively; ostensibly these include some Indigenous people. Additionally, Native Hawaiians and other Pacific Islanders total around the same number (19,990) of active duty service members, though it is difficult to separate Native Hawaiian participation numbers from the rest of this category.[15]

At the request of the authors in 2019, the United States Coast Guard reported that their data for American Indian and Alaska Native participation goes back only to 1990. At that time, members were permitted to self-select only one "race code." They further indicated that in 2005 members were allowed to select multiple ethnicities, which "makes it difficult to compare diversity populations before...and after 2005."[16] In response to the same request, the Department of Defense indicated that they do not have demographic data for American Indians and Alaska Natives prior to 1980, and that American Indians and Alaska Natives do not appear as a separate race category until 2000. When compared to U.S. Census Bureau population estimates, the 2019 Department of Defense data reveals that both African Americans and Pacific Islanders currently serve at a higher rate than sole-choice American Indian and Alaska Native peoples.[17]

Contemporary criteria for Indian self-identification also complicate the accurate measurement of Native American military participation. As Holm asserts, "Does one use membership in a federally recognized tribe to prove an Indian identity? Self-identification? Cultural identification? Blood quantum? Or some combination of all four? If federal recognition is a criteria, then a tribal people like the Lumbees of North Carolina cannot be sampled, despite the fact that they entered the service in large numbers during the Vietnam conflict. There were a number of Yaquis from southern Arizona who served in Vietnam prior to their being recognized as a tribe by the federal government. Should they be excluded?"[18] Each of Holm's possible conditions raises similar issues. Definitions of Indigenous identity have always differed depending upon politics, traditions, and circumstance.

Accounting for Native American participation in the United States Armed Forces has been and remains a complicated endeavor. Yet a preoccupation with quantitative precision should not obscure the bigger picture: that Native Americans have demonstrated—and continue to demonstrate—an abiding devotion to military service.

ALEXANDRA HARRIS

Navajo code talkers, members of a Marine Corps Signal Unit, on Bougainville Island, December 1943. Official Marine Corps photograph, provided by Command Museum, MCRD, San Diego

THE STEREOTYPE OF THE INDIAN WARRIOR

Very early on, colonizers blended fact and legend to assign Native peoples a martial stereotype: warrior, savage, uncivilized—an identity assigned to Indigenous people all over the world to justify colonization. Creating this identity for Native peoples of the Americas accomplished two things: first, it excused colonial armies' losses to Native forces by claiming that the latter demonstrated extraordinary savagery or ruthless martial skills; second, it justified treating Native peoples as less than human and unworthy of their lands—or lives. "The enemy has to be crafty, vigorous, determined, tenacious, cruel, barbarous, bloody-minded, and brave," writes historian Tom Holm. "If the opponent were otherwise, the victor's courageous actions, brutal wounds, and battle deaths would have no significant meaning." Further, because Europeans' orientation to war was as a means to conquer massive territories and decisively destroy (i.e., kill) the enemy, the colonizers had no frame of reference for alternative methods, motivations, and outcomes of fighting, such as those employed by American Indians. Thus, they concluded that Native peoples' reason for war must be for "simple blood lust or utter savagery."[1]

The prominence of early Indian battle successes cemented not only the colonists' impression of their savagery but also of their tactical superiority. Colonel James Smith, in his account of his "captivity" with Delaware, Mohican, and Caughnewago Indians[2] between 1755 and 1759 during the French and Indian War, asserted that Native peoples' wartime successes lay in their learned proficiency. "I have often heard the British officers call the Indians the undisciplined savages, which is a capital mistake—as they have all the essentials

of discipline."[3] Smith recalls British officers during Colonel Henry Bouquet's campaign inflating numbers of Indian combatants in reports to Britain to thirty thousand, when his own observations estimated no more than one thousand. "The British officer hooted at me, and said they could not make England sensible of the difficulties they labored under in fighting them, as England expect that their troops could fight the undisciplined savages in America, five to one...they could not give an honorable account of the war, but by augmenting their number."[4] The Native warriors' success and comparative lack of casualties in war, claims Smith, are due to their discipline. "As they are a sharp, active kind of people, and war is their principal study, in this they have arrived at considerable perfection....Why have we not made greater proficiency in the Indian art of war?...No important acquisition is to be obtained but by attention and diligence; and as it is easier to learn to move and act in concert, in close order, in the open plain, than to act in concert in scattered order in the woods, so it is easier to learn our discipline than the Indian manœuvres."[5] Soon, colonists and their leaders realized the benefits of learning Indigenous fighting styles while also taking advantage of traditional enmities to ally with Indians to defeat other Indians. The formation of alliances and adoption of Native styles of combat turned the tide toward American successes in battle and the resultant expansionism.

Though Smith pointed out their dedication and learned skill, he also noted Native peoples' willpower. This characterization grew into the erroneous idea that Native peoples' militaristic talent must be inborn. The image of the warrior in the colonial mind clung to a stereotype

Dan Waupoose (Menominee), posing with a rifle and headdress in this United States Navy photograph taken during training exercises at Algiers, Louisiana, on August 24, 1943. In addition to serving in the armed forces during World War II, Native Americans figured in the U.S. government's media campaign to promote the war effort on the home front.[6] National Archives photo no. 520636

that has endured through the centuries to the present day: that American Indians have an innate talent as warriors, not learned but instead granted by genetic inheritance. Through time, the caricature of bravery is married to one of savagery, creating an enduring trope that Holm calls "Indian scout syndrome." This martial trope not only informed how Native people have been assigned to and deployed by the United States Armed Forces, but also how many Indigenous service members have understood their own identities. The legacy remains to the present day and has resulted in Native service members being sent to the forefront of battle and placed in the riskiest units, while assigning to them idealized—and often mystical—abilities for warfare, tracking, and strategy.

Representative of this belief were the experiences of the all-Indian Company K of the First Michigan Sharpshooters during the Civil War. The mainly Ottawa and Ojibwe sharpshooters were at the forefront of some of the bloodiest pushes made by the Union armies, taking heavy casualties at the Battle of the

Wilderness and Spotsylvania. They endured through to the horrendous Battle of the Crater, Petersburg, and the Appomattox campaign, losing a third of their original number.[7]

Scouts, by definition, preceded the regular army and therefore faced the greatest risk of discovery and engagement. So much so (and with such skill) that the army consciously had to ensure that Indian scouts did not overtake the enemy before the regular troops could arrive, in case it affected the morale of the white soldiers.[8] Memoirs and reports created by white members of the military about Native American scouts amplified the image of the ideal Indian warrior. This idea originated during the nineteenth-century Indian Wars, making famous those scouts who fought with the army against legendary foes such as Geronimo and Sitting Bull, and it has never truly left the American military psyche.

Native American service members' experiences during World War I were especially influenced by the warrior stereotype. Popular magazines portrayed Native people with inherent martial instincts. "Indians are far

keener soldiers than most white men. They can see danger quickly and take by instinct the best means out of it."[9] Generalized Indian stereotypes translated to the battlefield: stoic, bloodthirsty, animalistic. Did American Indian soldiers possess innate military talent? No more than any other soldier. What skills they brought to the battlefield were those learned at home; those who had hunted might have knowledge and experience as a tracker, but no mystical ability to sneak behind enemy lines. Yet non-Indian soldiers perceived Native peoples to be as proficient as the stereotype—and Indian soldiers strove to live up to their expectations (whether their tribe had an ancestral warrior tradition or not), as they came with a measure of respect Indians had not heretofore received from their white counterparts. In the process of meeting the criteria of this trope, Native soldiers frequently shouldered an undue burden of wartime casualties.[10]

Native American servicemen and women in subsequent conflicts have noted similar treatment: positioning in risky roles, units, and circumstances; earning the universal Indian nickname of "Chief"; and—perhaps most egregious of all—suffering the military's labeling of enemy territory "Indian Country." A few local newspapers during World War II singled out Indian women who supported the war effort, but only as they related to male "warrior" relatives, such as Carolyn White Bear, whose grandfather was "Chief Red Bear, a Custer scout."[11] "In Korea," recalled Jack Miles (Sac and Fox / Creek), an infantry veteran of the Korean War, "my platoon commander always sent me out with our patrols. He called me 'Chief' like every other Indian, and probably thought that I could see and hear better than the white guys. Maybe he thought I could track down the enemy. I don't know for sure, but I guess he figured that Indians were warriors and hunters by nature."[12]

This singling out of Native servicemen was a common complaint of Native Vietnam veterans. Interviewed by Holm in his broad

study of Native Americans who served in Vietnam, the men often discussed how they were given more dangerous assignments than non-Natives, particularly as a point man.[13] Similar to a scout, walking point had the greatest chance of tripping mines or happening upon the enemy. A lone scout or man on reconnaissance patrol felt pressured to live up to the exacting expectations of the Indian warrior stereotype in order to survive.

On the surface, the stereotype of the American Indian warrior—the belief in a race of people endowed with extraordinary abilities in warfare—seems like a compliment. And some Native people have chosen to embrace the romantic warrior identity themselves. But the consequences of such a stereotype—increased rates of casualty, reaffirmation of racist notions of Indian people—are anything but romantic.

ALEXANDRA HARRIS

An Mk 16 Zuni Folding-Fin Aircraft Rocket is launched by a United States Marine Corps Douglas A-4M Skyhawk, 1957. China Lake, California.
Robert Lawson Photograph Collection, National Naval Aviation Museum

By 1957, when the Zuni missile was named, the U.S. military had long been valorizing American Indians for their "warrior spirit." More consequential, the military by then associated American Indians' defense of their homelands and ways of life with its own defense of U.S. national borders and interests; it identified with American Indians on a level that defined who and what it was at its core.

Throughout the second half of the twentieth century, the U.S. military named other advanced weapons systems after American Indians, including the 1976 Tomahawk subsonic cruise missile. Yet, although the U.S. military asserts its desire to honor American Indians, the naming tradition, now more than a century old, remains controversial, certainly for many American Indian scholars and activists. For them, it perpetuates a reductionist view of American Indians while masking a painful history.—Cécile Ganteaume[14]

White Mountain Apache tribal chairman Ronnie Lupe (middle) gives the traditional Apache sacred blessing to the first Apache Block III aircraft, 2011. With him are Ramon Riley (left) and Jerry Gloshay Jr. (right). Photograph by Sofia Bledsoe, courtesy Defense Video Imagery Distribution System

On September 9, 1983, almost a century after the Apache Campaign in Arizona Territory was concluded, the world's most powerful attack helicopter was unveiled at its Mesa, Arizona, production site. At that dedication ceremony and those of subsequent generations of Apache helicopters, White Mountain Apache tribal officials have been present. It is a puzzle to many that the army would seek a symbolic association with American Indians, and perhaps more so that many American Indian tribes accommodate them. They lend their name, or image, on terms that they themselves find meaningful. According to one White Mountain official, in the case of the Apache helicopter, doing so is a reminder to the world of Apache history and the Apaches' ongoing place in it.—Cécile Ganteaume[15]

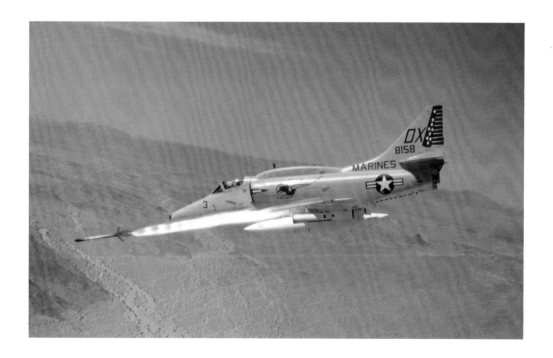

CULTURES OF WAR

Alexandra Harris

THE "WARRIOR TRADITION." Few concepts have had such an overarching impact on the experiences and identity of Native peoples in the United States. In many ways, and for many Indigenous cultures, traditions concerning war have been intrinsic to daily life for many generations. Beyond fighting, warriors cared for their community and helped in times of difficulty. They did what was necessary to ensure their people's survival, including laying down their lives. These traditions are not a simplified, monolithic warrior trope, however, but complex and diverse systems integrated with the rest of the Indigenous worldviews and values of their times.[1] Tribal traditions—for war or otherwise—are not static but have evolved over time, adapting to changing lifeways and circumstances. Likewise, Indigenous practices—social, spiritual, and tactical—surrounding war have both changed and endured over the course of history.

The experiences of Native Americans in the U.S. military have been as diverse as their many nations, and so every tribe's customary relationship with warfare is similarly specific. Many Great Plains Indian nations were organized around warrior societies, which served critical political and spiritual roles and determined one's status. But not every tribe had a so-called warrior tradition; many have had distinctly pacific practices, and most balanced warfare with traditions of diplomacy and peace. Hopi people of the Southwest continue to promote a worldview centered around respect, ethics, and peace, based on a pacifist worldview that has endured for centuries.[2]

On the other side of the continent, in the Northeast, the Haudenosaunee (Iroquois) balanced their warrior tradition with an equally stout tradition of peacemaking and diplomacy. The Great Law, the original teachings of the Haudenosaunee, promoted peace among the hitherto warring tribes, fostering the consolidation of the powerful Haudenosaunee Five Nations Confederacy.[3] After contact with Europeans, Haudenosaunee warrior culture was also mediated by the Guswenta, a treaty represented by a two-row wampum belt, which

Carl Gorman (Navajo, 1907–1998), *The Black Pot Drum of the Enemy Way*, 1971.
Zonnie Gorman, courtesy of the Heard Museum, Phoenix, Arizona

envisioned two different societies existing side by side, in peace and equality, each on its own terms.

Social and political structures based on the division between war and peace often maintained spiritual balance within a tribe. In the Southeast, before European contact and into the early American era, the Muscogee (Creek) recognized war and peace as separate functions of government, so towns identified with either white (peace) or red (war). Yet the colors represent ideas more complex than the duality of peace and war: "Red is the color of active life, while white is the color of reflective life."[4] Those colors and other decorations were painted on buildings to identify a town's allegiance. White and red towns each held jurisdiction over activities associated with their respective functions: white towns hosted councils of peace and acted as places of refuge, while red towns issued declarations of war and conducted diplomacy.[5] Similarly, governing bodies were divided between peaceful civil bodies led by a *micco* (town chief) and his council (many of whom nevertheless had risen to prominence through acts of bravery in war), and the war officials, who enforced community rules and represented the tribe in war.[6]

Though geographically and culturally autonomous from the continental U.S. Indigenous cultures, Kanaka 'Ōiwi (Native Hawaiians) also established strong social structures around war and warrior customs. Hawaiian culture is imbued with environmental metaphors that represent valued qualities and skills. *Koa*, the elite warriors who protected and defended their *ali'i* (rulers), took their name from the koa tree, an important native hardwood.[7] Trained from childhood in a hand-to-hand fighting style called *lua*, koa were also proficient in

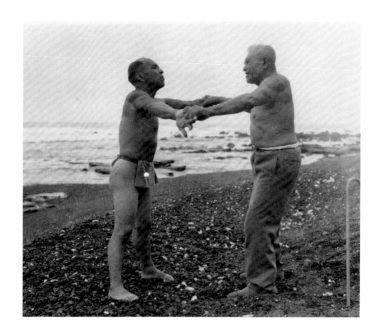

Naluahine Kaukaopua (on right), age 89, and James Kekahuna (both Native Hawaiian) demonstrate lua 'ai, or holds. Present but not pictured are Henry Kekahuna and Charles Kenn, who would become a father of modern lua. During this occasion, Naluahine demonstrated and shared his technique, which involved 'ai specific to the Kona area, with his cousins, the Kekahunas. Kona, Big Island of Hawai'i, July 1950. Courtesy of Jerry Walker

military strategy and weaponry. Lua masters in the ali'i armies were greatly respected, an equivalent to the U.S. Special Forces. A koa was given an 'ailolo ceremony to mark the end of lua training, in which the student would eat different parts of an animal such as a fish to represent the attributes they wished to attain.[9] Women were koa as well; King Kamehameha I reportedly had as many as three divisions of women warriors during his campaign to unify the Hawaiian Islands.[10]

Like koa, the word "lua" has *kaona*, or a hidden meaning. In this case, lua earns its name from the number two, signifying duality. Duality and polarity, force and counterforce, life and death, along with association with the gods Kū (representing the male) and Hina (representing female)—all emphasize the importance of maintaining balance.[11]

Native nations traditionally considered war a negative force that would throw nature and communities out of balance, requiring ceremony to restore equilibrium. Ceremonies traditionally prepared warriors for battle, provided protective medicine for endurance and survival, and honored and spiritually cleansed them upon their return. James Adair, a trader who traveled with Southeastern nations—particularly the Chickasaw—in the mid-1700s, observed the role of restoring balance after a warrior's return home.

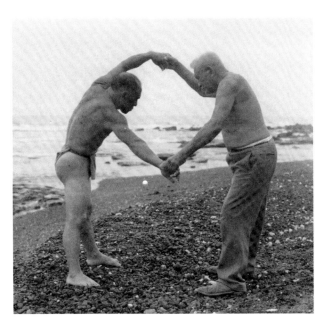
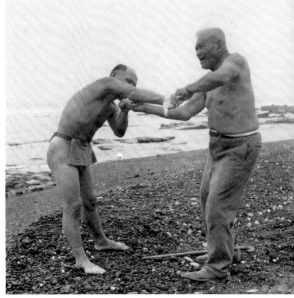

Tradition, or the native divine impression on human nature, dictates to them that man was not born in a state of war; and as they reckon they are become impure by shedding human blood, they hasten to observe the fast of three days…and be sanctified by the war-chieftain, as a priest of war, according to law. While they are thus impure, though they had a fair opportunity of annoying the common enemy again, yet on this account they commonly decline it, and are applauded for their religious conduct, by all their countrymen.[12]

On a deeper level, ceremonies have served a supportive function, affirming a kind of contract between the larger Native community and the warrior. Family and community participation in ceremonies expresses support for the warrior heading to battle, recognizes his sacrifice, and reassures the warrior of his continued role in the community upon his return.[13] In Indigenous cultures,

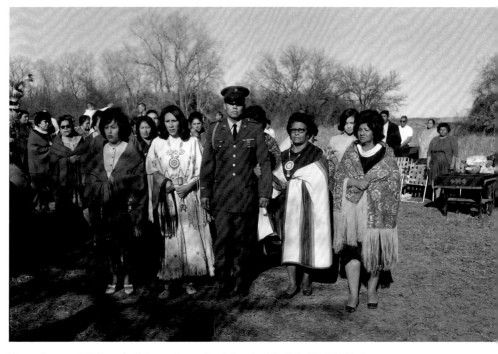

Honor dance at Bill Campbell Dance Ground, celebrating Virgil Swift's (Wichita) return from service. The women in the dark shawls at left belong to the Wichita Service Club, an organization of women devoted to serving the Wichita people, often through veterans' honorings and events. Left to right: Cecil Campbell, unidentified, Patricia "Potato" Ware; (in front row) Sandra Paddlety (Kiowa), Rose Sharon Archilta (Kiowa Apache), Virgil Hume Swift (in uniform), Nettie Laura Standing (Kiowa), LaVera Mae Swift Reeder (serviceman's mother, Wichita); (background) Sylvester "Sy" Luther (Wichita), Eva Guy Luther (Caddo), Corrinne Williams Stevenson (Caddo), Eunice Swift (serviceman's grandmother, Wichita). North of Anadarko, Oklahoma, ca. 1969. Photo by Horace Poolaw, 45POW80 © Estate of Horace Poolaw

> Mount Suribachi was on our left side just looming up. Before we hit the beach, the officer on that ship he tell us to pray in your own belief. Me I just took out my corn powder as I was told by our medicine man and then pray. So, I think some of the kids join me to pray.
>
> —Sam Tso, Navajo code talker, WWII[14]

where religion, politics, trade, social identity, and even homeland are interrelated, ceremonies managing the spiritual cost of war serve to maintain the stability of the community as a whole.[15]

In his work with Native American Vietnam veterans, historian Tom Holm (Cherokee / Creek) surveyed twenty Native nations' relationship with and motivations for warfare prior to European arrival. While practices surrounding warfare varied widely, Holm identified some commonalities. Almost all had arms and regalia specialized for warfare, military societies, ceremonial preparation for war, honors for heroism, cleansing of warriors upon their return, and victory or honoring ceremonies after the battle.[16]

Peoples across North America also shared what might be called a Native "way of war." Unlike the colonial and European style of combat, which endeavored to eliminate the opponent, Native peoples generally had different objectives in mind: defense of territory, revenge, resources, and challenge to traditional enemies. With some exceptions involving full-scale massacre, these motivations for war rarely had as their result wiping out the other party.[17] The added layer of what Holm calls "ritual warfare"—war as a ritualistic act rather than an opportunity to destroy the enemy—is perhaps what most defines and differentiates Native American combat from European warfare.[18] Upon European arrival, many tribes fiercely defended and attempted to retain their style of warfare. In this new method of warfare, however, the threat (largely colonial powers and their armies) was no longer a known, traditional enemy. Rather than ritual, war's purpose came to be about surviving against a conquering force. Though ritual warfare in the eastern United States largely ceased after European contact, Native warriors-turned-scouts or -soldiers retained elements of traditional practice, including ceremonies and medicine for preparation, protection, and homecoming, to the present day. Some customs were evident during the Civil War. Ethnographer James Mooney learned that, prior to going to the front, Cherokee warriors serving in William Holland Thomas's Confederate Legion of Cherokee Indians and Highlanders

> consulted an oracle stone to learn whether or not he might hope to return in safety. The start was celebrated with a grand old-time war dance at the townhouse on Soco, and the same dance was repeated at frequent intervals thereafter, the Indians being 'painted and feathered in good old style,' Thomas himself frequently assisting as master of ceremonies. The ballplay, too, was not forgotten, and on one occasion a detachment of Cherokee, left to guard a bridge, became so engrossed in the excitement of the game as to narrowly escape capture by a sudden dash of the Federals.[19]

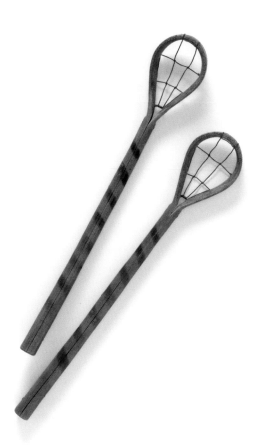

Pair of ball game sticks, 1900–20. Eastern Band of Cherokee, North Carolina. Wood, hide, 58.2 × 9.5 cm. NMAI 20/9389

Stick ball (called lacrosse by the French) was—and for many, still is—one of the most prominent games played among Native nations of the Great Lakes, Northeast, and Southeast. Considered by many tribes to be a gift from the Creator, the game combines sport, healing, and the resolution of disagreements, acting as a stand-in for battle between enemies. The Muscogee (Creek) people often called the game *hótti icósi*, or "younger brother of war," and Cherokees often used the term *da-na-wah' uwsdi'*, meaning "little war."[20] The symbolism of warfare was infused in the language and tools of the game. Historian and anthropologist Thomas Vennum has observed the similarities between ball sticks and war clubs in Cayuga, Ojibwe, and other Native tribes.[21] Red, the color of war, was featured on Cherokee players' adornments. For Cherokee people, red was also a condition, a state of war associated with blood and anger that required purification; the same purification rituals using fire and water were performed before and after a ball game just as they would be for war.[22]

Combined with their use of sacred formulas (verbal recitations that accompany rituals) to combat the enemy, the Thomas Legion sustained notably few losses through the Civil War, the bloodiest conflict in U.S. history.[23]

Native peoples continued to uphold tribal warrior traditions as their service in the U.S. military increased into the twentieth century. During World War I, many tribes revived and strengthened traditional war dances, ceremonies, and songs that the United States had outlawed in the late nineteenth century along with the rest of Native peoples' cultural practices. Departing soldiers were honored with giveaways, songs, parades, and feasts. In December 1917, a ceremony held by Standing Rock Sioux for new recruits celebrated them with a parade, songs, and patriotic speeches. Upon their return in November 1918, Sioux soldiers at Fort Yates, North Dakota, held a victory dance combining traditional symbols of the sacred tree and wolf as well as the American flag.[24] Symbols of American patriotism were also absorbed into Native ceremonial practices as the natural evolution of tradition created new, contemporary cultural forms.

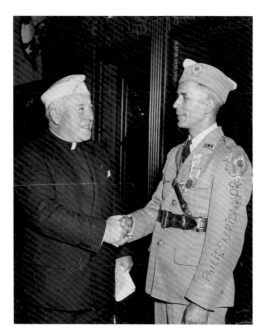

Turkey Tayac (Philip Proctor, Piscataway, 1895–1978), on right, attending a Catholic War Veterans convention in New Jersey, June 1946. Courtesy of Julie Tayac Yates

Less known are the traditional knowledge and skills that some Native people brought with them to the war, such as medicine for protection and healing. Turkey Tayac (also called Philip Proctor) brought his Piscataway medicinal skills from the Chesapeake Bay to France during World War I. Tayac gathered plants he found in France and, using his traditional knowledge, healed fellow soldiers who had been badly burned by mustard gas. Family members recall that he always had medicine with him—for his own protection and the healing of others.[25]

The massive commitment of Native Americans to World War II, combined with movement of Native peoples to cities for war-related work (in total around 150,000 people, about half the Native population), caused both a disruption in and a resurgence of tribal ceremonies.[26] Traditional ceremonial cycles dependent on the time of year clashed with urban settings, wage work, and military service. Yet many endured. According to the Office of Indian Affairs publication *Indians at Work*, the Pueblo of Santa Ana in New Mexico responded to the Japanese attack on Pearl Harbor with prayer. Immediately after the attack, the people "went secretly to their ancient shrine. There, . . . the entire Pueblo remained for one unbroken month in secret prayer. Their prayers were for the people of all the world."[27]

The revival of war dances and the creation of war and flag songs were other ways that people adapted old customs for the new needs of their people. *Indians at Work* reported in 1943 the prevalence of ceremonies for protection, at home and abroad. Men of the Forty-Fifth Infantry Division, hailing from many different tribes, came together in the evenings to share songs; Lakota from the Standing Rock Reservation held the first Sun Dance in fifty-two years "to pray for the destruction of the German and Japanese armies and the victorious return of 2,000 young soldiers from their tribe."[28] Many service members carried personal medicine with them for protection. Others blended their Christian and Indigenous faiths, or converted to Christianity while in the service. Under the pressure of war, Native beliefs adapted to the universal human need for protection and survival.[29] For Comanche code talkers and other soldiers, the Native American Church, a combination of Native and Christian traditions, helped them to recover after the war.[30]

Native American Vietnam veterans interviewed by Holm recalled their personal medicine, which might include medicinal herbs or sacred items that they

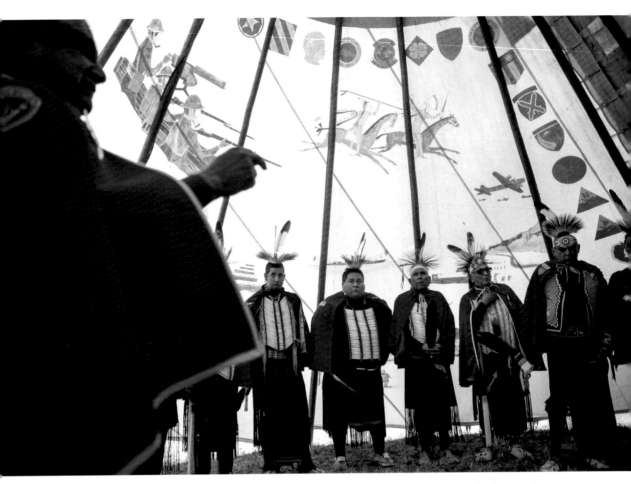

Members of the Ton-Kon-Gah, or Kiowa Black Leggings Society, discuss what it means to be a veteran before the start of a ceremony in memory of those who fought. The tipi depicts battles in which Kiowas participated and lists the names of all Kiowas killed in combat since World War II. Near Anadarko, Oklahoma, 2014. © 2014 Nicole Tung

took with them for protection. "An Ojibwa veteran said: 'My grandfather gave me some sacred tobacco. When you smoke it the prayers in it go straight to the Creator. The smoke disappears in to all things and raises the spirit. That's what my people say. I knew that I'd come back alive.'"[31]

Native service members experienced the same post-traumatic stress, depression, anger, and other combat conditions that plagued other Vietnam veterans. Yet Holm's research suggests a correlation between resolving these problems and the participation in "tribal rituals connected with warfare and/or ceremonies of healing."[32] One Navajo veteran received a Blessing Way ceremony before he left for Vietnam and an Enemy Way ceremony upon his return home. He reflected, "When I got back I had a lot of trouble. My mother even

called in one of our medicine men. It cost them but my folks had an Enemy Way done for me. It's a pretty big thing... It snapped me out of it."[33] The ceremony heals and restores balance, or *hózhó*, and counters the negative effects of sustained proximity to death.[34] Of those surveyed by Holm and a national working group on Native Vietnam veterans, 43 percent reported their involvement in tribal ceremonies to prepare, honor, and purify them through their service. A vast majority of those believed that ceremonies, though not a panacea, could greatly aid soldiers' return home.[35]

While not much is yet written about Native veterans of the Gulf War and present conflicts in the Middle East, existing evidence suggests that ceremonial and healing practices continue for many individuals and within communities. Local newspapers often list honoring ceremonies and victory dances for returning veterans.[36] When members of the Tohono O'odham Nation were called up for duty in 2003, their community held a ceremony in their honor.[37] And when his son, a marine, came home with post-traumatic stress from his second combat tour, Gulf War veteran Stan Rodriguez (Santa Ysabel Band of the Iipay Nation) organized a Hwaa Onyaao, or "Opening Up" ceremony, for him. "I'd been to war, and I'd seen what was happening to my son," Rodriguez recalled. "I told him we'd do [a] ceremony, when you leave, and when you come back.... We prayed for him to put it away until it's time to go again. That's how our people were, ready to be warriors all the time. But we had to reintegrate into society." Through the ceremony, not only is the service member prayed for, but also the enemy. "We wish to honor the people we fight. That's what makes us different."[38] Since then, his son has served eight tours in Afghanistan and Iraq.

In a few circumstances both at home and overseas, Native service members have shared social and healing practices such as dances, sweats, and other blessings with their non-Native military brothers and sisters. To provide strength during their year-long deployment and to celebrate Native cultures, the army's 120th Engineer Combat Battalion from Oklahoma held an intertribal powwow in September 2004 at Al Taqaddum Air Base. "I was brought up in a home where the Native culture, the Native spirit is very, very alive," said Specialist George D. Macdonald (Chickasaw). "So being away from it for a long time brings you down when you think about the powwows back home." "We all joined together, it was just like being at home," reflected powwow organizer Sergeant Debra K. Mooney (Choctaw). "It was just as important for them (other soldiers in the battalion), for the pride of 120th, and the state of Oklahoma as it was for us."[39]

Not all Native peoples have had the benefit of access to their ceremonies or gatherings; Native people who were removed to boarding schools or who relocated to urban centers may have been bereft of communal healing practices. They may experience what psychologist Stephen Silver terms "sanctuary trauma," in which the care a soldier receives from family, community, and even health care professionals upon returning from war fails to match expectations;

this was especially the case for those who returned from Vietnam to non-Native communities that rejected their war service.[40]

For many Native American veterans, powwow celebrations, social dances that occur year-round throughout Indian Country, have greatly broadened access and enabled the formation of a pan-tribal support system. The first pow-wow to honor Vietnam veterans specifically occurred on February 22, 1981, in Anadarko, Oklahoma, and became an annual event held by the Vietnam Era Veterans Inter-Tribal Association.[41] Powwows can create for veterans a powerful sense of community belonging, providing a collective affirmation of the individual warrior's experience as well as an opportunity to mitigate their trauma by privately sharing stories with other Native veterans—people who know the costs of war.[42]

In Hawai'i, opportunities for Kanaka 'Ōiwi service members to heal from their wartime experiences come in many forms, including physical practices such as lua or hula, and even surfing and canoe racing; visual art and music also create a healing counterpoint to the stress of war.[43] *Oli* (chants) and *mele* (songs) about warriors and battle endure from old times, yet new traditions have been created to respond to new wars. Contemporary songs commemorate events that took place on the Hawaiian island of Ni'ihau during the attack on Pearl Harbor or recount stories about the war in Vietnam. "As a musician we

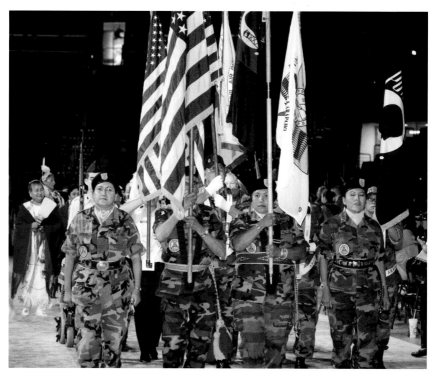

Vietnam Era Veterans Inter-Tribal Association Color Guard (VEVITA) leads the grand entry at the National Powwow. Washington, DC, 2007. NMAI

use the idea of melody to create a counterbalance, to be able to talk about these hard things," says Kawika McKeague, an environmental and land use planner, hula practitioner, and ethnohistorian. "So we can have a conversation about them in song and dance so we never forget. And that's the point, right? To never forget.... The role of music as a healing piece is key."[44]

Vietnam veteran and lua practitioner Thomas Kaulukukui is part of a group of Native Hawaiian veterans working to recall or reconstruct Hawaiian warrior cleansing ceremonies. With a scant historical record and guided by Hawaiian and other Polynesian cultural concepts, Kaulukukui's group is

West Coast wounded warriors hold handmade tribal drums during Operation One Drum's closing ceremony at Camp Pendleton, California, 2010. Photo by Lance Cpl. Daniel Boothe

In February 2010, Native American cultural practitioners worked with veterans from the Wounded Warrior Battalion West at Marine Corps Base Camp Pendleton, California, to relieve combat stress. Called Operation One Drum, the four-day workshop was the first program on a military installation to integrate Native practices into the rehabilitation of combat veterans. "It was time for Native Americans and soldiers to embrace one another in an act of healing," said Deborah Bear Barbour (Lakota), creator of Operation One Drum. Central to the workshop was the making of hand drums out of buffalo hide and cottonwood. Marines and sailors were taught the meaning behind the drum, led by specialists such as Larry "Grizz" Brown, whose drum group was nominated for a Native American Music Award later in 2010.[45] Nearly thirty combat veterans participated in the program. Lieutenant Colonel Greg Martin, commanding officer of the battalion, commented, "We have millions of dollars and several staff, all meant to help take care of these guys. What we can't do with these resources is necessarily touch their hearts and minds the way a program like this might."[46]

recreating a ceremony that cleanses warriors, restores balance to their personalities and lives, and helps them transition from war to peace so that they may successfully rejoin their communities. "A Māori elder once told me that as you go back and study your culture, you'll find gaps in the knowledge," says Kaulukukui. "It's like coming to a river with no bridge. Either you stand there and complain there's no bridge. Or you build a bridge.... This ceremony is being reconstituted through everything we know about our culture. Since we know of no established post-war cleansing or healing ceremony that has been consistently practiced from old times, we must rebuild this ritual to help modern warriors." In the process, the veterans will test and tweak the rituals until the ceremony meets their needs. "The first three of us to go through will be Vietnam veterans. Not because at our stage of enlightenment (fifty years after we left our war) we *need* it, but we're good ones to evaluate it."[47]

Researchers today acknowledge what Native peoples have always known: ceremonies and traditions surrounding war have enduring benefits for individual service members, their families, and their communities.[48] Ceremonies manage the psychological, physical, and social damage endured by combat veterans and help to reframe their experiences so they can heal from trauma. While the reasons Native people serve have changed over the long history of their participation in the U.S. military, cultural traditions—sacred or secular, for individuals or communities, specific to Native nation or shared across tribes—remain an enduring warrior tradition. "In my case, I studied lua after I returned from war," Kaulukukui reflects. "But this helped [me] to realize that I was a warrior by DNA before I went to war, that I have always been a warrior, and that my people were warriors. This helped to settle the troublesome issue of self-identity that combat calls into question. Am I the peaceful man or the hunter-killer? The answer is: I am, and always have been, both."[49]

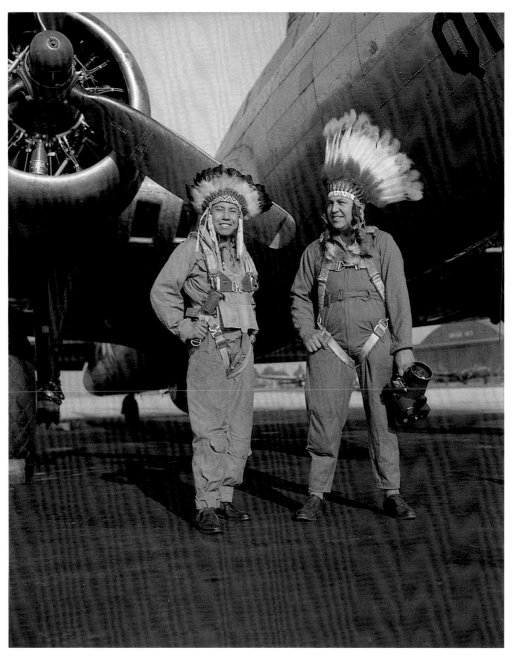

Gus Palmer Sr. (Kiowa, at left), side gunner, and Horace Poolaw (Kiowa), aerial photographer, in front of a B-17 Flying Fortress. MacDill Field, Tampa, Florida, ca. 1944. Photo by Horace Poolaw, 45UFL14 © Estate of Horace Poolaw

Horace Poolaw (Kiowa, 1906–1984) was an aerial photography instructor in the Army Air Forces during World War II. To his Kiowa community in Anadarko, Oklahoma, he is best known for documenting daily life, including the transitions and adaptations that the Kiowa people made to continue their culture after the damage caused by U.S. government cultural assimilation policies. Within that documentation are his photographs of service members and veterans—homecomings, leave-takings, funerals, parades, Gourd Dances, and honorings. He photographed veterans of three wars—World War II, Korea, and Vietnam.

KIOWA WARRIOR SOCIETIES

The respect and reverence Native Americans give to their veterans today is often an extension of older cultural traditions related to war. For the Kiowa of the southern plains, warfare has historically been infused throughout all aspects of society, from songs, dance, art, and religion to the tribe's entire social organization. Today, events honoring veterans recall and maintain traditional ways of defining Kiowa status, respect, and nationhood.

Before reservations, Kiowa men belonged to a variety of societies.[1] Called Yàpfàhêgàu, referring to their service as police and guards, the societies were structured by and progressed with the age, accomplishment, and social status of their members. Among them were several different military societies such as the Taipegau, Ton-Kon-Gah or Black Legs (or Leggings), and Ohomah, with membership based on a family's rank and the warrior's

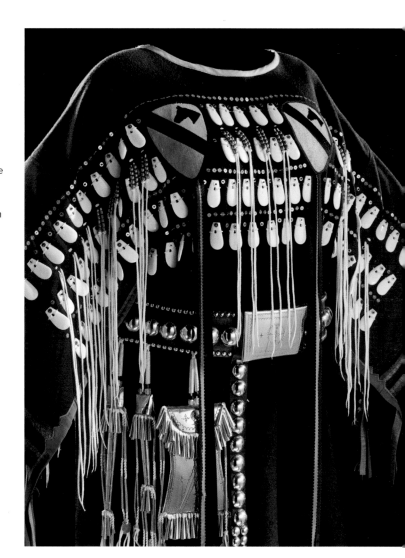

Vanessa Jennings (Kiowa/Pima, b. 1952), Kiowa Battle Dress, ca. 2000. Rainbow selvage red and blue wool; hide thong; imitation elk teeth (bone); glass beads; brass beads, sequins, and bells; military patches; ribbons. NMAI 26/5646[2]

This battle dress is similar to those worn by female relatives of warrior members of the Ton-Kon-Gah, or the Kiowa Black Leggings Society. The yellow patches with horse heads indicate a Vietnam War veteran from the army's First Cavalry.

status earned in battle. Prominent nineteenth-century leaders such as Big Bow, Dohausan, White Bear, Lone Wolf, and Sitting Bear were born to and lived the often combative Kiowa way of life, as honor was gained through showing valor, defending territory, and raiding neighboring tribes. Their achievements were made public through ceremonies within their military societies. After four war deeds, a Kiowa warrior earned the right to wear a feathered war bonnet.[3]

The period during which Kiowa people were moved to reservations (1875–1901) greatly altered their ways of life. The U.S. government, in an effort to eradicate American Indian culture, outlawed dances, ceremonies, and any activity associated with traditional religions. Many longstanding Kiowa traditions involving raiding and warfare were suppressed, including most of the military societies, as well as their dances and medicinal knowledge. These restrictions in turn affected the social structure and economy of the tribe, status having been based on the ability to acquire honors during raids and warfare, followed by exchanges of goods through giveaways.[4] By 1890 regular practices of the societies, as with the Sun Dance, had ceased.

Some societies resurfaced in the twentieth century, but not consistently. The Black Legs and Taipegau society dances reemerged in 1912 and continued into the late 1920s and '30s, respectively, before going dormant again. Though there were postwar celebrations for the fourteen Kiowas who served in World War I, the warrior societies were more enthusiastically reinvigorated mid-century with the outbreak of two more wars in relatively quick succession.[5] With the large-scale conflicts of World War II and Korea, the Kiowas' opportunity to achieve valor in combat and the need to celebrate military accomplishments through song and dance renewed the somewhat inactive Taipegau and Ton-Kon-Gah military societies.

> In our culture it is not proper for a man to brag about his war deeds. It is the woman's responsibility to dress and dance to honor him.
>
> —Vanessa Jennings

Taipegau revived in 1957 as the Kiowa Gourd Clan. Kiowa World War II veteran Gus Palmer Sr. was a key figure in renewing the Black Legs Society in 1958, and he served as commander from that time until his death in 2006.[6] Current Black Legs Society members are enrolled Kiowa citizens who are on active duty or who are honorably discharged veterans, including the National Guard and reserves—a change from the former requirement of combat experience to be more inclusive of service and to retain traditions by having ample society members.[7]

Prior to the reservation period, two main women's societies existed: the Calf Old Women and the Bear Women. The women's societies, which functioned until 1905, generally served to support Kiowa warriors in offering power, protection, and success in battle.[8] Kiowa women's societies reemerged along with those of men after World War II in a somewhat different form from pre-reservation times into four different service organizations: the Kiowa War Mothers (a chapter, and a distinctly Kiowa version, of the American War Mothers), the Carnegie Victory Club, the Stecker Purple Heart Club, and the Kiowa Veterans Auxiliary. The original women's societies were not revived, but the new ones incorporated their core values of honoring and supporting Kiowa warriors.[9]

Attended by a new generation of veterans, Kiowa military societies continue today, evolved from their pre-reservation traditions but nonetheless necessary to the spiritual health of both veterans and community.

ALEXANDRA HARRIS

GEORGE WASHINGTON
PRESIDENT
1792

THE PROMISE AND PERIL OF ALLIANCE FROM CONTACT TO 1814

Mark Hirsch

FROM THE EARLY YEARS of European contact in the 1600s to the War of 1812, the Indigenous peoples of eastern North America wrestled recurrently with a vexing question: whether to fight alongside of or against European soldiers, American militiamen, and their Indian allies. There was no easy answer. Tribal leaders knew their decision would affect the lives of their warriors, the wealth and well-being of their people, and their own power and prestige. The leaders struggled to make strategic alliances and decisions that ensured communal survival—an increasingly elusive goal in an age of European colonization, imperial rivalry, and revolution, all of which culminated in the consolidation of U.S. hegemony over the American continent.

In the seventeenth century, Native nations found it advantageous to ally with European colonial forces, whom tribal leaders perceived as powerful tools for establishing their people's dominance over rival Indian nations. European colonists, for their part, were eager to enlist Indigenous peoples as allies against

George Washington peace medal, 1792. Made by Joseph Richardson Jr. (1752–1831). Silver; 14.8 × 9.9 cm. NMAI 22/8915

The United States often gave medals to tribal leaders to commemorate peace and friendship. In 1792, President George Washington gifted a large silver medal similar to this to Red Jacket (Seneca [Haudenosaunee], ca. 1750–1830), a noted orator and political leader who struggled to maintain his people's culture and homelands in New York State after the American Revolution. One side of the medal was engraved with an image of Washington offering a pipe to a Native leader, who has dropped his tomahawk as a gesture of peace. In the background, a farmer plows his fields with yoked oxen, symbolizing U.S. aspirations for Indian assimilation into American culture.[1]

powerful Indian nations as well as rival European powers keen to assert exclusive control of the continent.[2] During the Pequot War (1636–38), for example, Narragansett, Mohegan, Mohawk, and other tribal warriors assisted English forces in destroying the powerful Pequot people of southern New England.[3] Similarly, during King Philip's War of 1675–76 (also known as Metacom's War), Mohegan and Mohawk allies helped New Englanders quash a Wampanoag, Nipmuc, and Narragansett resistance sparked by aggressive colonial encroachment on tribal territories. In return for Indigenous support, European colonists distributed guns, ammunition, and other manufactured goods—items that bolstered the power of tribal leaders, who wore officers' uniforms, medals, and other European military symbols of honor and bravery.[4]

Competition for Native allies increased as European powers vied for control of land and resources in North America. Between 1689 and 1748, Indigenous peoples were enmeshed in three wars between France and Britain: King William's War (1689–97), Queen Anne's War (1701–13), and King George's War (1744–48). Although these conflicts began in and extended over large areas of Europe, hostilities spread to North America, where French and British forces and their respective Indigenous allies engaged in fierce border warfare and extended struggles that razed towns, villages, and military fortresses in southern Canada, northern New England, and New York.[5]

England typically employed Mohawks, Mohegans, and Mohican warriors in its conflicts in the northeast and Canada. One historian estimates that Indians sometimes constituted "as much as one seventh or even a quarter" of New England's colonial armies.[6] The French recruited allies in Indian villages from the Saint Lawrence Valley, the Great Lakes, the Ohio, and the Mississippi. By the 1750s, French forces included warriors from Abenaki, Penobscot, Ottawa, Ojibwe (Chippewa), Menominee, Potawatomi, Lenape (Delaware), Sac and Fox, Haudenosaunee (Iroquois) and other tribal groups.[7] No matter what side they were on, Native people paid a high price for these alliances. Native villages were burned. Crops were destroyed. And death stalked the land. In 1749, a year after King George's War, a census of the Christian Indian town of Natick, Massachusetts, revealed that one-fifth of the women were widows.[8]

Indigenous people were indispensable to European colonial aspirations in North America, and they knew it. They resented being treated as subservient auxiliaries and demanded respect. "It is necessary to inform them of all the plans, to consult with them, and often to follow what they propose," a French officer admitted of his army's Indian allies. "In the midst of the woods of America one can no more do without them than without cavalry in open country."[9] Likewise, tribal allies might pay allegiance to either the British or the French, but they embraced their sovereignty as Native nations and had no compunctions about reminding Europeans that they marched to the beat of their own drummer. In 1684, a Haudenosaunee leader assured the English that his people had pledged themselves to supporting the Crown, but he added, "We are a free people uniting ourselves to what sachem [leader] we please."

Polly Cooper (Oneida) accompanied Oneida troops, food, and supplies that relieved the starving American soldiers during the winter of 1777–78 at Valley Forge, Pennsylvania. She gave the army white corn and taught them how to prepare it. Cooper remained at Valley Forge through the winter as General Washington's cook.[10] For her efforts, she was gifted a shawl by the officers' wives, which still resides in the hands of her descendants today.[11] Oneidas participated in battles prior to and after Valley Forge as scouts, spies, and soldiers, giving significant aid to the revolutionary cause.

Oneida Indian Nation

John McNevin, *Washington and Gist visit Queen Aliquippa*, 1856. Engraving, 16 × 23 cm.
The Miriam and Ira D. Wallach Division of Art, Prints and Photographs: Picture Collection,
The New York Public Library.

"Queen" Aliquippa (d. 1754) led the Mingo Seneca, who lived near what is now Pittsburgh,
Pennsylvania. She was a key ally of the British leading up to the French and Indian War.
Aliquippa commanded great respect among colonial leaders (including a young Major
George Washington), who honored her requests to pay tribute when in her territory.

More than seventy-five years later, an Abenaki chief declared that his peo-
ple were "allies of the king of France. . . . We love that monarch, and we are
strongly attached to his interests." At the same time, he added, the Abenakis
were "entirely free."[12]

The Native American commitment to promoting strategic self-interest
is perhaps best reflected in the diplomacy of the powerful Haudenosaunee
Confederacy, which managed to remain neutral in the new world of early
eighteenth-century European imperial rivalry. Negotiating treaties with the
French and the English, the Haudenosaunee played each European power
against the other, maintaining open trade policies with both, while refraining
from taking up arms for either one. The strategy was not lost on one British
observer who noted, in 1750, that "the great ruling principle of the Mod-
ern Indian Politics" was "to preserve the Ballance [*sic*] between us and the
French."[13]

The French and Indian War (1755–63), the last imperial war between Brit-
ain and France over colonial domination of North America, began at the

Forks of the Ohio River as an extension of the Seven Years' War. Both names are misnomers; Indians served on both sides of the British-named French and Indian War, while the Seven Years' War lasted far longer than seven years.[14] Most Algonquian tribes from the Saint Lawrence Valley to the Great Lakes supported the French, an allegiance bolstered through trade, intermarriage, and a common desire to prevent British territorial expansion. In New York, Sir William Johnson, an Irish emigrant to the Mohawk Valley who became the British Crown's superintendent of Indian affairs, used gifts and deft diplomacy to pressure the Mohawk and other Haudenosaunee nations into fighting for Britain. Mohegans and Mohicans also fought for the King's cause, often serving as scouts to the English.[15]

British victory in 1763 transformed the world and reshaped the dynamics of Native American power in North America. According to the historian Gordon S. Wood, Great Britain emerged from the war as "the most powerful empire the world had ever seen." Under the Treaty of Paris, Britain gained control over the northeastern half of North America, all of Canada, East and West Florida, and millions of acres that stretched from the Appalachians to the Mississippi River.[16] French people and culture continued to pervade large stretches of the continent after 1763, but France's colonial empire in North America had been obliterated.

The outcome of the French and Indian War had broad implications for Native Americans. Tribal nations that had exploited the European colonial rivalry, by playing one imperial power against the other, discovered that that delicate diplomatic game could not be played without France at the North American "table." France's Indian allies were particularly hard hit. Long accustomed to receiving goods and gifts from the French, Indian nations around the Great Lakes and the Ohio Valley were now obliged to seek them from the British, who discouraged the costly and time-consuming protocols of diplomacy that had sustained France's strong relationship with Indigenous peoples. In part, English stinginess reflected a growing realization that victory in the French and Indian War had saddled Great Britain with the enormous financial burden of administering a vastly expanded "New World" empire.[17] The dual challenge of paying for Britain's enlarged North American territories and preventing Europeans and Americans from invading sovereign tribal homelands within it promoted tensions in Indian Country as well as discord between American colonists and the Mother Country. These tensions helped to fuel the War for Independence, which would end America's colonial era.

When the American colonies revolted against the British Empire in 1775, most Indian tribes tried to remain neutral, viewing the revolution as a quarrel that did not concern them. Yet neutrality proved difficult to sustain. As the war intensified, so, too, did British and American competition for Indian allies, which enmeshed Indian nations into the conflict. Ultimately, most tribes sided with the Crown, reasoning that the British represented their best hope

of protecting their tribal homelands. If the colonists prevailed, many tribal leaders feared, Indian territories would be overrun by land-hungry Americans. Mohawk leader Joseph Brant reflected that concern when he urged Indians to "defend their Lands and Liberty against the Rebels, who in a great measure begin this Rebellion to be sole Masters of this Continent."[18]

Not all Indians agreed. The Oneida and Tuscarora, two of the Haudenosaunee Six Nations Confederacy, supported the Americans as did Native communities influenced by Christian missionaries, such as the Stockbridge-Munsees of western Massachusetts. Residents of Native villages surrounded by colonial neighbors, such as the Catawbas of South Carolina, also supported the Americans. In southern and central New England, pro-American Indians turned out for military service even though they—along with African Americans, schoolteachers, and Harvard and Yale students—were exempt from the draft. The small Indian town of Mashpee, Massachusetts, on Cape Cod, furnished some twenty-six men for the Continental Army; all but one were killed.[19]

A host of individual Native men enlisted, although their motives are lost to history. Take Joseph Burd Jaquoi: a Mohegan from Connecticut, Jaquoi was serving in England on a lieutenant's half pay when the War of Independence began. Although he was offered a captain's commission in the British Army, Jaquoi refused, gave up his lieutenancy, and returned to the colonies, where he joined the Continental Army.[20] Yet, few Indians followed suit. With the war going badly, Americans went to great lengths to coax Indian nations out of neutrality and into a military alliance in support of independence. In 1778, the Continental Congress dispatched representatives to Fort Pitt (modern-day Pittsburgh) to negotiate a treaty of peace, friendship, and alliance with the Lenape—the first treaty between the United States and a Native nation. In exchange for recognizing Lenape territorial sovereignty and an option to join other pro-American Indian nations in forming a fourteenth state with representation in Congress, Lenape leaders, such as George White Eyes, agreed to escort American troops across Lenape lands to attack the English at Detroit. After escorting American troops to the west, as his nation had promised in the treaty, White Eyes was murdered, likely by Indian-hating American militiamen.[21] Ultimately, the Americans' lofty treaty promises came to naught, inclining most Lenape people toward embracing the British cause.

Native people who supported the American cause often found themselves at odds with their friends and neighbors. In New York, the War of Independence split the Haudenosaunee Confederacy, with the Oneida and Tuscarora supporting the Americans, and the Mohawk, Onondaga, Cayuga, and Seneca supporting the Crown. The resulting civil war pitted brother against brother, upending Haudenosaunee unity. At the 1777 Battle of Oriskany, pro-British Haudenosaunee soldiers under Joseph Brant fought pro-American Oneida and Tuscarora warriors under Honyery Doxtader (Oneida).

British-aligned Haudenosaunee warriors fought furious battles with the Americans, for which the Americans exacted revenge. In April 1779, American

Military service record of John Montour, ca. 1781.
National Archives photo no. 31138408

John Montour (Lenape [Delaware]/Métis, 1744–1788) was a cultural mediator between his people and Euro-Americans during the Revolutionary War. He also served the Americans as captain of a company of Lenape soldiers.

troops obliterated the Onondaga towns. In May, General George Washington ordered John Sullivan's troops to lay waste to the Haudenosaunee homelands. Some forty Cayuga and Seneca towns, as well as all apple and peach orchards and cornfields, were burned, causing more than five thousand Haudenosaunee to flee to Canada. Washington's scorched-earth policy earned him the Haudenosaunee name Hanadahguyus—Town Destroyer.[22]

American victory in the Revolutionary War proved disastrous for pro-British Indian nations. Abandoned by their British allies, Indian nations were left to face the Americans, who considered them conquered peoples. "We are now Masters of this island," an American general told the Haudenosaunee after the war, "and we can dispose of the Lands as we think proper or most convenient to ourselves."[23]

Even Indians who had fought for the Americans came to regret their decision. The Oneida's hopes of retaining their homelands and autonomy were undermined by settlers and land speculators after the war. By 1790, they had lost millions of acres, mostly by sale in treaties with New York State.[24] The big picture was not lost on a Miami tribal leader who told a former British ally, "In endeavoring to assist you, it seems we have wrought our own ruin."[25]

When the War of 1812 began, Native nations were once again faced with difficult choices. Should they remain neutral in this new war between the

Americans and Great Britain? Should they support their old allies, the British? Or should they cast their lot with the Americans? Ultimately Native nations became enmeshed in the War of 1812 no matter what, and for one simple reason: for the United States, the war was more than a contest over British efforts to dictate American commercial and diplomatic policy. It was also a war of conquest—a mission to secure control of eastern North America from tribal nations that resisted American westward expansion. For Americans, victory over British troops and Indigenous warriors was part of the same goal: to

Aunt Dinah John, 1876. Photo by Phillip S. Ryder, charcoal on photograph. Onondaga Historical Association

During the American Revolution and War of 1812, many Native women followed their men to war. Perhaps related to the power women held in their society, Haudenosaunee women stand out as participants in colonial conflicts. Though classified as "cooks" in pension records, Haudenosaunee women had fought in combat and supported supply lines in the American Revolution—it is plausible that they did much more than cook in the 1812 war as well.[26]

"Aunt" Dinah A. John (Onondaga, ca. 1774–1883), born Ta-wah-ta-whejah-quan ("the earth that upholds itself"), accompanied her husband Thomas John for some of his enlistment in the War of 1812. The Onondagas had been allies of the United States since the Treaty of Canandaigua in 1794. Thomas John served for two years in two different regiments: Tall John's company of New York Indians and Captain Cold's (Ut-ha-wah's) company of New York militia. Dinah served as a cook in these all-Indian regiments.[27] At least fourteen other Native women from New York served in this war, and four received pensions as military cooks.[28]

Unable to prove her service (and therefore receive her own pension), Dinah attempted to acquire a "widow's pension" after her husband's death in 1857. Rejected for the inability to prove her marriage, which was traditional until the two were formally married after the war, and refusal to swear allegiance to the U.S. Constitution, John survived on sales of her basketry and pottery to non-Indians in Syracuse and tribal treaty annuities.[29] It wasn't until 1882 when, at more than 105 years old, she was awarded by the government a pension of eight dollars a month and a one-time back payment of four hundred dollars.[30] Dinah John passed away in May 1883 and was recognized by both her Onondaga and Syracuse communities.

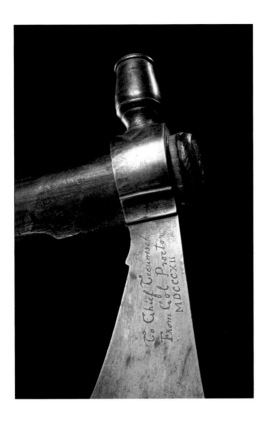

Pipe tomahawk presented to Chief Tecumseh, ca. 1812. Wood, iron, lead; 66 × 22.5 cm. Gift of Sarah Russell Imhof and Joseph A. Imhof. NMAI 17/6249

This ceremonial pipe tomahawk was a gift from British Colonel Henry Proctor (1763–1822) to Tecumseh (Shawnee, 1768–1813), who, with his brother Tenskwatawa (also called the Shawnee Prophet, 1775–1837), created a pan-tribal coalition that sided with the British in the War of 1812. On October 5, 1813, a year after Tecumseh accepted the gift, Proctor and the British fled an American attack at the Battle of the Thames, in Ontario, Canada, leaving Tecumseh and his warriors to their fate.[31]

preserve their "Empire of Liberty" and consolidate America's claim to territories that stretched from the Great Lakes to the Gulf of Mexico.[32]

U.S. territorial aspirations were clear to Native nations long before the War of 1812 began. Since 1794, Indian nations in Ohio, Michigan, Indiana, and Illinois had seen their territories overrun by whites, who now outnumbered them by a margin of seven to one.[33] Here, in the heart of the Old Northwest, tribal nations had relinquished thousands of acres of territory in treaties with the United States, and they were intent on protecting their remaining homelands. Into this cauldron of unrest came Shawnee Chief Tecumseh and his brother, Tenskwatawa, known as the Prophet, who attempted to unite tribes in a powerful pan-Indian confederacy to quash American expansion. Advocating a revival of traditional tribal values, Tecumseh also railed against making land cession treaties with the United States. The brothers' message resonated loudly among discontented Shawnee, Potawatomi, Kickapoo, Ho-Chunk, Wyandot, Ottawa, Ojibwe, and Sac and Fox Indians, many of whom came to view the War of 1812 as an opportunity to halt the juggernaut of U.S. expansion.[34]

When the United States declared war on Britain in June 1812, many tribal nations once again allied with the redcoats, yet Native support for the Crown was hardly universal. Memories of the redcoats' defeat during the War of Independence, coupled with Britain's abandonment of its Indigenous allies in the aftermath, ran deep in tribal communities, fueling skepticism that Britain

William Apess, from the frontispiece to *A Son of the Forest*, 1831. Rare Book Division, The New York Public Library

Long before he achieved notoriety as a writer, lecturer, preacher, and champion of Native American rights, William Apess (Pequot, 1798–1839) joined the New York militia to fight the British in the War of 1812. He was fifteen years old. Beginning as a drummer, Apess soon exchanged his drumsticks for a rifle and saw action in battles around Lake Champlain, in Vermont, and in expeditions into Canada.[35] "Their balls whistled around us, and hurried a good many of the soldiers into the eternal world, while others were horribly mangled," Apess recalled in his 1829 autobiography, *A Son of the Forest*—the first published autobiography by a Native American writer. "The horribly disfigured bodies of the dead—the piercing groans of the wounded and the dying—the cries of help and succor from those [who] could not help themselves—were most appalling. I can never forget it."[36]

could prevail in a new war with the Americans. Native reluctance to resume an alliance with Britain also sprang from a desire among tribal leaders to adhere to treaty commitments guaranteeing that their people would live in peace and friendship with the United States.[37] These factors generated Native support for the American cause during the War of 1812. According to one source, more than one thousand American Indians, including members of the Choctaw, Creek (who today call themselves the Muscogee [Creek] Nation), Cherokee, Chickasaw, and Stockbridge tribes, served in at least one hundred U.S. military companies, detachments, or parties.[38] Among the American forces who pursued and killed Tecumseh and his followers near Moraviantown, in Canada, in 1813, were 260 Delaware, Shawnee, Wyandot, and Haudenosaunee warriors.[39] In 1814, a civil war between pro- and anti-American factions within the Muscogee Nation gave the United States an excuse to mount a military campaign against the Red Sticks, Tecumseh-influenced rebels hostile to the American invasion of their Muscogee homelands. On March 27, an army of 1,500 Americans under General Andrew Jackson, along with hundreds of Choctaw, Muscogee, Chickasaw, and Cherokee allies, decimated the Red Sticks at the Battle of Horseshoe Bend, on the Tallapoosa River in Alabama.[40]

Muscogee people who fought for the United States during the War of 1812 reaped little for their service. In the Treaty of Fort Jackson, signed after the battle, the Muscogee Nation surrendered twenty million acres of land to the United States. The Lower Muscogees, most of whom had opposed the Red Sticks, lost approximately a third of their lands. After signing the treaty, they petitioned the federal government, complaining that the agreement unfairly

John William Gear, *Push-ma-ta-ha*, 1838. Copy after Henry Inman and Charles Bird King, hand-colored lithograph on paper. National Portrait Gallery, Smithsonian Institution; gift of Betty A. and Lloyd G. Schermer

Conceding that Indians had been "unjustly treated and shamefully wronged" by the United States, Choctaw Chief Pushmataha (ca. 1760–1824) acknowledged that tribal nations could never prevail against the more powerful and populous Americans. During the War of 1812, he and his warriors engaged and routed anti-American Muscogees, known as the Red Sticks, and joined U.S. forces under the command of General Andrew Jackson to defeat the British at the Battle of New Orleans. In recognition of his service, the United States presented Pushmataha with a full-dress military uniform, such as the one shown here. When he died in 1824 during a diplomatic visit to Washington, more than two thousand people followed the cortege to his funeral at Congressional Cemetery.[41]

penalized allies who had "adhered faithfully in peace and war to our treaty stipulations with the United States."[42] The appeal fell on deaf ears.

Native American military alliances were always built on shifting ground on what became, in the 1700s, an increasingly uneven playing field. With the American victory over Britain in the War of Independence and the War of 1812, Indigenous people lost any powerful European ally that could help arrest the tide of American western expansion. Henceforth, Native people would have to deal on their own with the United States—a nation that evinced increasing hostility to tribal survival, autonomy, and land rights.

Yet the challenge of making strategic military alliances did not end with the War of 1812. In 1861, tribal leaders would be faced with the problem of choosing sides or remaining neutral in yet another war—this time the great Civil War that would determine the fate of African American slavery in the United States.

NATIVE WOMEN LEADERS AND WAR

An ideal history of Native people's military involvement in colonial times would represent the experiences of both men and women. The historical record, written by colonists with a male-centered European worldview, rarely mentions women's powerful contributions as leaders, negotiators, and warriors. Women in positions of power did not exist in the colonist's reality. Rather, colonists sought to circumvent and undermine female authority by negotiating agreements with their brothers, sons, or other men with perceived status.

Women held positions of leadership in many eastern Native nations. Depending on the tribal social structure, female leadership manifested in different forms, in some cultures a complement to men's and in others as sole heads of state. As Native American worldviews then did not separate military service from other aspects of daily life, like our society does today, tribal citizens were raised as protectors of their sovereignty and territory as a matter of course. Leaders, whether women or men, acted as diplomat and commander.

During the centuries before the United States and its armies held dominance within its borders, Native nations allied with different colonial powers—or against them—in the interest of their own sovereignty and political strategy. Begun in 1675, King Philip's War was one of the earliest major conflicts on the East Coast between settlers and Indigenous people. Tensions between Plymouth colonists and the Native peoples in the region ran high in the years leading up to the war, in large part from the colonists' insatiable appetite for Native land. Much has been written about Metacom, who, as chief sachem, or leader, of the Wampanoags, organized a coalition of Wampanoag,

Narragansett, Nipmuc, and Pocumtuck Nations that waged war against colonists throughout Massachussetts, Connecticut, Rhode Island, and north into Maine.

At least three female leaders, called *saunksqwa*,[1] led neighboring bands of Wampanoag and Narragansett during the time of the war, providing supplies and warriors to allies, negotiating diplomatic agreements, and protecting and defending their people. Through kinship—marriage and sisterhood—the women were closely tied. Arguably the most notable, Weetamoo (also known as Namumpum) was saunksqwa of the Pocasset band of Wampanoag. Colonist Nathaniel Saltonstall alludes to her prominence as he describes how Metacom began his campaign against the English. "[Philip's] first errand is to a *Squaw Sachem* (i.e., a Woman Prince, or Queen)...he promising her great rewards if she would joyn with him in this Conspiracy, (for she is as Potent a Prince as any round about her, and hath as much Corn, Land, and Men, at her Command) she willingly consented, and was much more forward in the Design, and had greater Success than King *Philip* himself."[2] Weetamoo earned her leadership through not only family inheritance but also skill. In her analysis of the history, Abenaki scholar Lisa Brooks describes Native alliances through the lens of traditional definitions of kinship, in particular how in 1651 neighboring sachems recognized Weetamoo on paper as a kinswoman with sovereignty over her territory, who could permit or disallow settlement at Pocasset.[3] She dealt with unwelcome settlers, played the settlers' own game of land deeds, and, with evidence that war was brewing, strategized how best to protect her families from harm.[4] Through the late summer of 1675,

Metacom and Weetamoo withdrew their people to safety through the swamps they knew well, successfully evading the colonial forces. Weetamoo sought respite with neighboring Narragansett saunksqua Quaiapin before sheltering further north with the Narragansett.[5]

Awashonks, saunksqwa of the Saconet (Sakonnet) band of Wampanoag, sought peace for her territory under threat of colonial military violence and relentless pressure to relinquish her land. Though she hosted Metacom's ambassadors and considered his position on the eve of the war, she was ultimately persuaded by Captain Benjamin Church, a settler on her land who would later lead the English against her kin, to ally with his countrymen—with the understanding that the lives of her men, women, and children would be spared and that they would not be sold into slavery.[6] Regardless, by July 1675 Awashonks and her families retreated into the swamps, pursued by English soldiers who burned their homes, seeking refuge with the English-allied Narragansetts.[7] Though Awashonks and many of her defenders aligned with the English campaign, some did not—as did all individuals, they made the choice to hide or fight with one side or another.[8]

Referred to by colonists as the "old queen," Narragansett saunksqwa and negotiator Quaiapin sheltered her people near her village at the so-called Queen's Fort, a network of stone walls and hidden subterranean chambers. As her warriors skirmished with colonial forces, who then burned her village in mid-December 1675, a reported four thousand people were hidden below in a multilevel structure, camouflaged from above.[9] In July of the following year, Quaiapin's encampment at Nipsachuck was exposed and attacked. Still believing that peace was possible, Quaiapin was killed along with thirty-four men and ninety-two women and children.[10]

The tide of war shifted during the summer of 1676 when Pocasset families returned to their homelands to plant. A combination of thinner vegetation, caused by drought, and colonial troops who had allied with the Pequot and Mohegan and adapted their strategies meant that previously successful tactics employed by Weetamoo and her families began to erode.[11] Though there seems to be no firsthand account, colonial narratives tell of an ambush of Native people by soldiers from Taunton at Lockety Neck, after which Weetamoo's drowned body was discovered. According to Reverend Increase Mather: "August 6. An Indian that deserted his Fellows, informed the inhabitants of Taunton that a party of Indians who might be easily surprised, were not very far off, … whereupon about twenty Souldiers marched out of Taunton, and they took all those Indians, being in number thirty and six, only the Squaw-Sachem of Pocasset, who was next unto Philip in respect of the mischief that hath been done, and the blood that hath been shed in this Warr, escaped alone." Discovering a Native woman deceased, he writes, the men recognized her as Weetamoo and cut off her head. "When it was set upon a pole in Taunton, the Indians who were prisoners there, knew it presently, and made a most horrid and diabolical Lamentation, crying out that it was their Queens head. Now here it is to be observed, that God himself by his own hand, brought this enemy to destruction. For in that place, where the last year, she furnished Philip with Canooes for his men, she her self could not meet with a Canoo, but venturing over the River upon a Raft, that brake under her, so that she was drowned, just before the English found her."[12] Yet Brooks and others have questioned the accuracy of this tale based on geographical knowledge and the suspicious lack of any mention of her death in reports from the field; it may be that she was captured and killed with her people during the fight, which would undermine the divine irony inherent in Mather's watery ending.[13] Metacom was killed in mid-August, and colonial troops relentlessly pursued his remaining kin and their people, killing or selling those they found into slavery in the Caribbean.

ALEXANDRA HARRIS

DANIEL NIMHAM: FIGHTING FOR TWO NATIONS

In the 1760s, Daniel Nimham (1724?–1778) fought for the British cause during the French and Indian War. But during the American Revolution, Nimham, the son of an influential Wappinger Indian leader, served as an officer in the Stockbridge Indian Company, attached to George Washington's Continental army.[1] What accounted for Nimham's change of heart?

The answer lies in his people's unsuccessful effort to save their New York homelands on the east side of the lower Hudson River. That story begins in 1756, when the Wappinger were preparing to fight in the French and Indian War. After finding shelter for their women, children, and elderly among the Mohican in the Christian "praying town" of Stockbridge, Massachusetts, the Wappinger men, according

to one source, "cheerfully entered his majesty's service" and marched off to fight Britain's colonial rival, France.[2]

When they returned from the war, the Wappinger war veterans discovered that aristocratic landlords in the Hudson Valley had taken their lands, claiming rights granted under a forged deed allegedly signed in 1702.[3] Outraged by the manor lords' temerity, Nimham lodged a formal legal complaint with New York authorities to regain his people's lands. Though he was granted a hearing, Nimham could find no lawyer to represent his case, and it was dismissed.

Bankrolled by Yankee farmers who lived as tenants on Wappinger lands, the undaunted Nimham sailed for Britain to appeal directly

"An Indian of the Stockbridge Tribe," Kingsbridge, New York, 1778. Sketch by Lieutenant General Johann von Ewald, Schleswig Jäger Corps (1744–1813). Pen and ink. Johann Ewald Diary, Volume II, Joseph P. Tustin Papers, Special Collections, Harvey A. Andruss Library, Bloomsburg University of Pennsylvania

The Stockbridge Indians of western Massachusetts, a refugee community of Mohican, Housatonic, and Wappinger peoples, fought bravely for the cause of independence during the American Revolution. This sketch, by Captain Johann Von Ewald, a Hessian officer who fought for Britain, depicts what a Stockbridge warrior would have worn and carried into battle. According to Von Ewald, the Stockbridge soldier-warriors wore "a shirt of course linen down to the knees, long trousers also of linen down to the feet, on which they wore shoes of deerskin, and the head was covered with a hat made of *bast* [matting made from basswood bark]. Their weapons were a rifle or musket, a quiver with some twenty arrows, and a short battle-axe which they know how to throw very skillfully. Through the nose and in the ears they wore rings, and on their heads only the hair of the crown remained standing in a circle the size of a dollar-piece, the remainder being shaved off bare."[4]

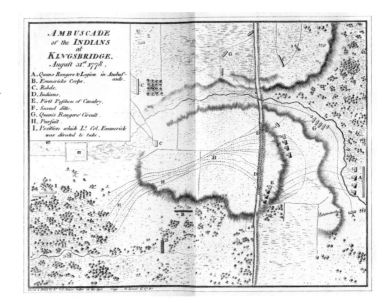

Map of the Battle of Kingsbridge, by John Graves Simcoe, commander of the Queen's Rangers, 1778. Map reproduction courtesy of the Richard H. Brown Revolutionary War Map Collection in the Norman B. Leventhal Map & Education Center at the Boston Public Library

This map was drawn by John Graves Simcoe, commander of the Queen's Rangers, who engaged the Stockbridge Indian unit at the Battle of Kingsbridge, in the Bronx, in August 1778. The map shows how British, Hessian, and Loyalist forces ambushed the Stockbridge Indian unit at Cortlandt's Ridge on the northern end of what is today Van Cortlandt Park.[5]

to royal authorities, who ordered New York to reconsider the case. At a hearing in March 1767, an English attorney argued in defense of the Wappinger case, but the New York tribunal, dominated by landed aristocrats, dismissed the petition.[6]

Having exhausted all legal remedies, the Wappingers resolved to stay in Stockbridge, Massachusetts. Feeling abandoned and betrayed by the New York grandees and their British allies, the Wappingers' resentment festered until the American Revolution offered them a chance for payback. Nimham was given a military commission as a captain in the Continental army. His son Abraham was given command of the Stockbridge Indian Company.[7]

The Stockbridge Indian contingent fought gallantly for the American cause. But on August 31, 1778, the sixty-man unit was ambushed by five hundred British regulars, Hessian (German) mercenaries, and Loyalist troops at Kingsbridge, on the north end of what is now Van Cortlandt Park, in the north Bronx.[8] The elder Nimham enjoined his comrades to flee, "that he himself was old, and would die there," recalled the commander of the Queen's Rangers. But most of the Indians held their positions. "No Indians...received quarter," a Hessian officer wrote in his diary. "The chief, his son, and the common warriors were killed on the spot."[9]

A plaque honoring Daniel Nimham's service to the revolutionary cause was erected by the Bronx chapter of the Daughters of the American Revolution in 1906 near Van Cortlandt Park East and Oneida Avenue. In 1937, New York State established a monument to Nimham in the town of Fishkill.[10]

MARK HIRSCH

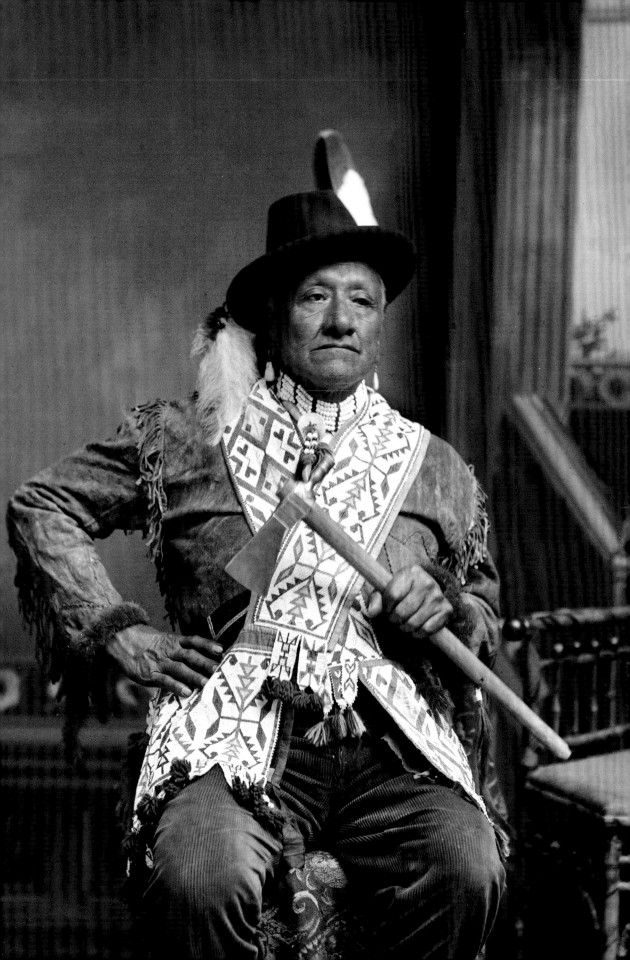

THE INDIANS' CIVIL WAR
CHOOSING SIDES

Alexandra Harris

THOUSANDS OF NATIVE AMERICANS served in the Union and Confederate armies during the Civil War.[1] Thousands more participated less directly in the War between the States, aiding or sabotaging one side or another while remaining outside the military. Still others suffered as the war exacerbated internal tribal enmities or brought violence to their homelands. Native Americans' experiences in the Civil War were as diverse as the tribes themselves. From the Confederate rangers of the Great Smoky Mountains to Ulysses S. Grant's right-hand man, Native Americans significantly influenced the outcome of the war from both sides.

What motivated Native peoples to participate in the Civil War? They were not U.S. citizens and had been progressively dispossessed of their rights, lands, and lives in the decades leading up to—and during—the Civil War. Yet most Indians viewed participation in the war as an attempt to retain or even regain tribal autonomy. Native nations that allied with the federal cause did so with the hope that their treaties would be upheld or the alliance would enable them to forge better treaties and negotiate the return of some of their lost homelands. Many tribes that aligned with the Confederacy—and the majority of Native people who fought sided with the South—negotiated new treaties with the rebel government, resentful of the federal government's treatment in the preceding years. The government-run, forced removals of the 1830s were fresh in the minds of Southeastern peoples now living west of the Mississippi. Some of those removed had enslaved people and supported the Confederacy in order to defend slavery. Generally, patriotism toward the North or South was not a primary motivating factor; Native peoples were far more loyal to their own nations than to any occupying their homelands.

Approximately 3,530 Native Americans enlisted in the Union army.[2] A few Native nations and individuals gained a reputation for skill as guides and trackers. The Lenape (Delaware) served as the most notable intermediaries,

Henry Rice Hill (or SanJanMonEKah, Ho-Chunk), ca. 1900. A private in Company A of the Omaha Scouts during the Civil War, Hill wears a tail feather of a golden eagle in his hat to signify his warrior or veteran status. He holds a pipe tomahawk and wears a beaded choker and two bandolier bags. Wisconsin Historical Society, WHS-60910

Black Beaver (or Suck-tum-mah-kway, Lenape [Delaware], 1806–1880), photographed by Alexander Gardner during an 1872 Lenape delegation to Washington, DC. A guide, interpreter, and one of the most accomplished Indian scouts on the continent, Black Beaver offered his experience to the Union early in the Civil War, though well into his fifties.[3] NMAI P03344

interpreters, and guides. Ejected from their mid-Atlantic homelands, some Lenapes who settled in Kansas hoped to establish a new home by siding with the Union. Around 170 served, some raiding Confederate-allied tribes in Indian Territory, others acting as scouts and cavalrymen. Black Beaver was the most well known. In the 1840s, he had guided wagon trains west and had been the most accomplished Indian scout, commanding the only Native company—Black Beaver's Spy Company, a Texas mounted volunteer company of Shawnee and Lenape men—to serve during the Mexican War (1846–48).[4] During the Civil War, he warned federal troops of Confederate advances and led troops hundreds of miles through enemy territory without losing men or supplies.[5]

Some individuals, such as Private Austin George, a Mashantucket Pequot from Connecticut, were assigned to "colored" regiments and fought almost entirely with African American troops. George, previously a sailor who may have joined for economic reasons, was a member of the Thirty-First United States Colored Infantry of the Army of the Potomac.[6] Unsurprisingly, the "colored" regiments suffered from racism; they received less pay than their white counterparts and were assigned to rear-area duties such as guarding supply lines.

Long afflicted by social and economic discrimination in Virginia, Pamunkey people took on critical roles for the Union. After the war invaded their homelands in spring 1862, many Virginia tribes were forced to flee or became refugees. Union General George B. McClellan recognized that the nations of the Powhatan Confederacy would be able to navigate the complex terrain and rivers; he hired them as guides, river pilots, and spies. Most famous of the fourteen Powhatans to serve as guides was William Terrill Bradby (Pamunkey/Chickahominy). Bradby guided over land and sea, and he served as a spy for Pinkerton's Secret Service, which led espionage efforts on behalf of the Union army. Respected by his community after the war, Bradby became an entertainer, advocate, and adviser on Pamunkey culture to prominent anthropologists.[7]

Despite pressure and coercion to serve the Confederacy, many of the Lumbee people in North Carolina operated as citizen-guerrillas—not officially Union, but certainly anti-South. They rejected the South as racist and resented the subservient status imposed upon them by white southerners. In 1864, a teenager named Henry Berry Lowry and his Lowry Band (including family, other Indians, African Americans, whites, and escaped Union soldiers) became folk

heroes. For ten years, the Lowry Band resisted, raided, killed, and otherwise undermined white supremacy, the North Carolina Home Guard, and the emerging Ku Klux Klan. They faced violence and retribution, yet they continued until 1874, when their last member died. Henry Berry Lowry's "outlaw" legacy is still honored by the Lumbee today.[8]

The most prominent Native American to serve in the Civil War was Ely Samuel Parker, a Seneca man from the Tonawanda Reservation in New York. Educated by his Native grandfather in the old ways and by Baptists in mainstream white ways, Parker read law, learned engineering, and was selected by his people as a tribal leader. He was active in Tonawanda tribal matters and cared for family and farm before receiving a commission in 1863 as a captain in the

ABOVE: Henry Berry Lowry (Lumbee, ca. 1845–?) Courtesy of the State Archives of North Carolina

RIGHT: William Terrill Bradby, dressed traditionally and holding a club, October 1899. Photo by De Lancey W. Gill. National Anthropological Archives, Smithsonian Institution [NAA INV 06197600]

William Terrill Bradby (Pamunkey, 1833–?) and other men from Virginia's Pamunkey and Mattaponi Nations served as river pilots, land guides, and spies for the Union army during the 1862 Peninsular Campaign. They piloted steamers, tugboats, gunboats, and torpedo boats during the remainder of the Civil War.

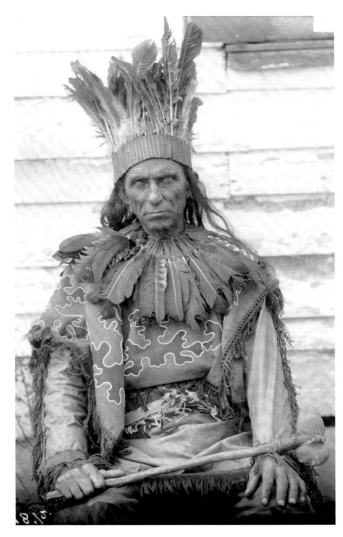

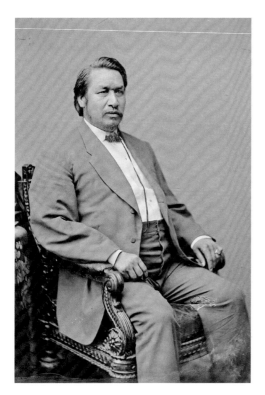

Ely S. Parker, 1860–65. Photo by Mathew Brady, National Archives photo no. 529376

At the surrender at Appomattox in 1865, Ely S. Parker (Seneca, 1828–1895) was the highest ranking American Indian in the Union army, a lieutenant colonel. As General Ulysses S. Grant's secretary, he drafted the terms of surrender. A popular story states that Confederate General Robert E. Lee, noticing that Parker was an American Indian, remarked, "I am glad to see one real American here." Parker later recalled, "I shook his hand and said, 'We are all Americans.'"[9]

Union army. He served as assistant adjutant general, division engineer, and, after General Ulysses S. Grant assumed command of the Union army, acted as Grant's military secretary. By the end of the war, Parker had earned the rank of brevet brigadier general and, at Lee's surrender at Appomattox, drew up the documents of surrender while standing at Grant's side. Grant praised and valued Parker's talents; afterward, Grant acted as the best man at Parker's wedding and appointed him as the first Native American commissioner of Indian Affairs.

While the main battles between the North and South raged in the East, the United States waged a bitter military campaign to defeat American Indians in the West. Union-aligned forces, including units awaiting assignment and those diverted from Civil War battlefields, found themselves deployed against Native nations. The most infamous encounter occurred in 1864 at Sand Creek, where Colorado volunteer cavalrymen under the command of Colonel John Chivington massacred two hundred Cheyennes and Arapahos, mostly women, children, and elderly. A lesser-known but brutal attack was perpetrated in 1863 by California Volunteers, who killed an estimated 250 to 400 Northwestern Shoshone men, women, and children in Idaho.[10]

THE VAST MAJORITY of Native people who served in the Civil War fought for the Confederacy. After surviving removals, broken treaties, and other depredations enacted by the federal government, southern Indian nations sought to renegotiate their political situations with the new government, hoping to gain a stable land base. In some cases, such as the Catawba of North Carolina, entire tribes allied with the Confederacy.[11] In western North Carolina, William Holland Thomas's Confederate Legion of Cherokee Indians and Highlanders included four hundred Cherokees who had avoided removal beyond the Mississippi and followed a leader they knew and trusted. Active between 1862 and 1865, the legion played a critical role in defense of the Great Smoky Mountains. Led by Thomas, a white man who had been adopted by the Cherokee chief

General Ulysses S. Grant (fourth from left) and his staff, including Lieutenant Colonel Ely S. Parker (second from the right), late spring, 1864. Photo by Mathew Brady, National Archives photo no. 524444

Yonaguska as a child, the legion gained a reputation for ferocity and was the last Confederate unit east of the Mississippi River to surrender.[12] Ostensibly in return for their support of the South, North Carolina affirmed the Cherokee right to residency on the lands that Thomas had accumulated in their interest before the Civil War. Without the legacy of the Thomas Legion or the support of its commander, the Cherokee might not have retained any of their home-lands east of the Mississippi; today these lands are called the Qualla Boundary Reservation, home to the Eastern Band of Cherokee Indians.

The Civil War left many Native communities destitute, perhaps none so much as those in Indian Territory, where the war exacerbated fissures existing prior to the tribes' removal from the east. The Confederate government took advantage, negotiating new treaties with leaders from the Cherokee, Muscogee (Creek), Choctaw, Chickasaw, and Seminole nations. Many Native people had adopted Southern culture and attitudes, including the ownership of enslaved people. The Cherokee and Muscogee split along lines similar to those they had over Removal—resulting in infighting that decimated the world they had rebuilt. Some Native nations agreed to assist the Confederacy versus raising regiments; the Comanche, among others, signed a treaty with the Confederacy, raiding Union supply lines and otherwise supporting Southern efforts. In the end, the Civil War damaged some Native nations as deeply as had their removal, with consequences still felt today.

THE "SECOND RUINATION OF THE CHEROKEE NATION"

John Ross and his wife, Mary Brian Stapler, n.d. Courtesy of the Oklahoma Historical Society

Historian Laurence M. Hauptman describes the Civil War period as the "second ruination of the Cherokee Nation." During this time, the population of the Cherokee Nation in Indian Territory declined from 21,000 to 15,000 people. Thousands became refugees, and by 1863 one-third of married women were widowed and one-fourth of children orphaned.[1]

Cherokee Principal Chief John Ross, who had seen his people through their forced removal to Indian Territory in 1838, had advocated neutrality in the war. Under mounting pressure from Confederate-aligned Cherokees, Ross was forced to abandon his neutral position and reluctantly signed a treaty with the Confederacy on October 7, 1861.[2] Cherokee forces were organized under two mounted regiments: one under Stand Watie, the other under John Drew, Ross's nephew.[3]

In 1862, Ross-aligned Cherokees asserted their Unionist allegiances; many Cherokee soldiers under Drew defected after their defeat at Pea Ridge and joined Muscogee (Creek) Unionists in Kansas under their leader Opothleyahola. In the summer of 1862, Union forces entered the Cherokee capital of Tahlequah, arrested Ross, and led him to Washington, DC, to meet with President Lincoln, effectively exiling him for the rest of the war. In 1863, Ross's supporters abolished slavery, abrogating their treaty with the Confederacy. With Ross in exile, the Cherokee Nation split into two governments—one pro-North and the other pro-South—for the duration of the war. Though there were many Unionist Cherokee, 3,000 served in the Confederate army and between 8,500 and 13,500 supported the South.[4]

Confederate-aligned Cherokee were led by Stand Watie, a signer of the Treaty of New Echota of 1835, which ceded all tribal lands in the east and initiated the people's forced removal to Indian Territory. By 1861, Watie had asserted himself as pro-slavery and a colonel in the Confederate army. In Ross's absence, Watie claimed the title of Cherokee principal chief of the Southern faction. Through his military prowess he would eventually gain the rank of brigadier general, but not without enabling and inflicting violence upon Unionist Cherokee—tactics that included killing his Cherokee opponents, burning the Cherokee Council House and Ross's family home, and raiding and destroying many others.

The experiences of Native women have largely been left out of the historical Civil War record, yet undoubtedly those left behind fought on a different front, particularly when hostilities overtook their homes. Cherokee women had many different experiences depending on their class and affiliation, North or South. Most only wanted the war to end and lamented the destruction of life, property, and

Stand Watie, 1860–65. Photo by Mathew Brady, National Archives photo no. 529026

Stand Watie (or Degataga, Cherokee, 1806–1871) was elected principal chief of the Confederate-aligned Cherokee and awarded the rank of brigadier general—the only American Indian to achieve that rank in the Civil War—as commander of the Indian Cavalry Brigade, which included the First and Second Cherokee Cavalry, the Creek Squadron, the Osage Battalion, and the Seminole Battalion.

Upper Creek Chief Opothleyahola (ca. 1780–1863), leader of a large group of Muscogees and members of other tribes loyal to the Union during the Civil War from Indian Territory to Kansas. They sought refuge in Kansas, where Confederate forces confronted them in December 1861 in a series of battles later called the Trail of Blood on Ice. Opothleyahola died of illness at a refugee camp in Kansas.[5] Joseph Thoburn Collection, Oklahoma Historical Society, 21773

Sarah C. Watie, wife of Stand Watie. Western History Collections, University of Oklahoma Libraries, Phillips Collection, 1453

their nation. Sarah, wife of Stand Watie, wrote to her husband to encourage him to leave the war, "I would like to live a short time in peace just to see how it would be. I would like to feel free once in life again and feel no dread of war or any other trouble."[6] A few Cherokee women acted as spies and resisters, and many more attempted to defend their homes against raids from opposing factions—whether soldiers, pillaging guerrillas, or other Cherokees.[7]

In the end, the federal government treated both Unionist and pro-slavery Cherokee the same. According to federal officials, signing a treaty with the Confederacy had nullified those made previously with the United States. The Cherokee, along with the Muscogee, Seminole, Choctaw, and Chickasaw, signed new treaties in which they lost additional territory and sovereignty. Under their new treaty, signed in 1866, the Cherokee Nation agreed to peace, abolition of slavery, and additional cessions of territory.

ALEXANDRA HARRIS

COMPANY K OF THE FIRST MICHIGAN SHARPSHOOTERS

The largest contingent of American Indian troops in the Union army east of the Mississippi was raised in the summer of 1863. Company K of the First Michigan Sharpshooters was composed of 146 Indians, mostly Ottawa and Ojibwe but also Lenape, Oneida, Huron, and Potawatomi soldiers. While some may have joined for adventure or pay, Michigan's Native men primarily fought for their country—not the United States or the Union, but for the homelands that were under constant threat from settler encroachment and the federal government's insatiable demand for land. By supporting the Union, they hoped to leverage the trust gained from military service toward negotiating new and more favorable treaties with the federal government.

Initially, some Union soldiers regarded the presence of the Indian sharpshooters with derision. After taking a heavy toll in the battles of the Wilderness and Spotsylvania in the spring of 1864, however, the sharpshooters gained a reputation for "conspicuous coolness, courage, and gallantry" in battle, according to Union Colonel Charles De Land.[1] They carried an unusual standard, a live eagle, perched on a platform atop a long pole.[2] The first to encounter the enemy, and mostly stationed in front of the main army, the sharpshooters suffered heavy losses. Of the original 146, 43 died in the war. One member of Company K, Antoine Scott, was recommended twice for the Medal of Honor after the Battle of the Crater for risking his own life to provide covering gunfire so that others could escape. And although they were included in the group of Michigan sharpshooters who raised the U.S. flag when Petersburg, Virginia, fell at the end of the war, their rights and territories deteriorated along with those of all other Indian nations.

ALEXANDRA HARRIS

Wounded American Indian Union sharpshooters resting beneath a tree at Brompton, the home of John L. Marye, in Fredericksburg, Virginia, May 14, 1864. Five days earlier, the First Michigan Sharpshooters, including Company K, had been heavily engaged at the Ni River during the Battle of the Spotsylvania Courthouse; the casualties were evacuated to Fredericksburg. Captain Edwin V. Andress is sitting under the tree facing forward; though non-Native, Andress spoke a number of Michigan Indian language dialects and recruited many of the Native sharpshooters.[3] Sergeant Thomas "Ne-o-de-geshik" Ke Chittigo (Chippewa, 1836–1916), wounded on May 12, is seen standing to the right of the tree. Civil war photographs, 1861–1865, Library of Congress, Prints and Photographs Division

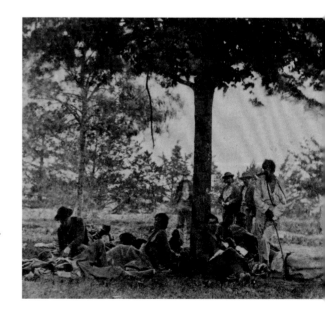

NATIVE HAWAIIANS IN THE CIVIL WAR

Portrait of Henry Hoʻolulu Pitman (Native Hawaiian, 1845–1863), about 1860. Oil on canvas, 33.66 × 26.04 cm. Peabody Essex Museum, Gift of Mr. Charles D. Childs, 1966. M12775 Courtesy of Peabody Essex Museum. Photo by Mark Sexton

Native Hawaiians have participated in the United States Navy and Army since the War of 1812.[1] At the time of the Civil War, the Kingdom of Hawaiʻi was an independent, sovereign nation with deep economic and diplomatic ties to the United States. In 1861, King Kamehameha IV declared the Kingdom of Hawaiʻi neutral in the conflict. Yet Native Hawaiians served on both sides. Most Hawaiians—Native, missionaries, and expatriate Americans who mostly hailed from New England—supported the Union and abolitionist causes. As a result, 114 Hawaiians are documented to have served in the war, the majority of whom were Native Hawaiian sailors who joined the United States Navy. When the United States purchased sailing vessels to build its navy swiftly, the Hawaiian sailors who had manned the former merchant ships enlisted.[2]

The stories of Native Hawaiians' participation in the Civil War were largely forgotten until interest was renewed in recent years. How many actually served is difficult to know; their names were often either Anglicized or invented for easier pronunciation. Often they were registered with the name Kanaka (e.g.,

Joseph Kanaka), the Hawaiian word for "person," used in the nineteenth century to refer to Native Hawaiians.[3]

Native Hawaiians also served as infantry. Generally the United States Army placed them in "colored units." J. R. Kealoha enlisted as a private and was assigned to the Forty-First Regiment United States Colored Troops formed in Pennsylvania.[4] He is one of the few Native Hawaiians known by name to fight in the war.

Another, Henry Hoʻolulu (Timothy) Pitman, mustered into a white regiment during the Civil War. The son of businessman Benjamin Pitman, originally of Salem, Massachusetts, and Kinoʻoleoliliha, an *aliʻi* (chief) of Hilo, Hawaiʻi, Henry left school to fight in the Civil War. Ostensibly because of his mixed ancestry, he was able to enlist in the Twenty-Second Regiment Massachusetts Volunteer Infantry, a white Union regiment. He fought at Antietam and during the Maryland Campaign and was captured by Confederates during the march to Fredericksburg. He contracted "lung disease" in Libby Prison and died February 27, 1863, in Camp Parole, not yet eighteen years old.[5]

In early 1865, the Confederate armed cruiser CSS *Shenandoah* began raiding ships in the Pacific in an attempt to disrupt the lucrative whale oil trade to the North.[6] Eleven of the Native Hawaiians who served the South were sailors from whaling ships captured in one of the *Shenandoah*'s raids. Given the dire choice to become prisoners, be marooned on an island, or serve on the *Shenandoah*, they chose to join the crew.[7] The *Shenandoah* ultimately captured thirty-eight ships, and their mostly Hawaiian and Polynesian crews, in 1864 and '65.[8]

ALEXANDRA HARRIS

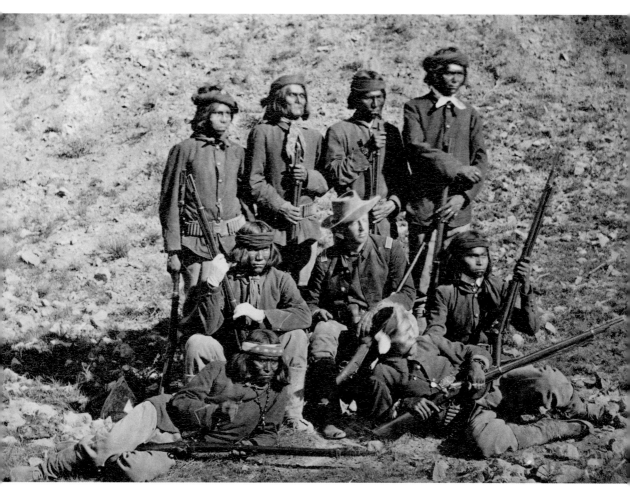

Unidentified Apache scouts in uniform, ca. 1890. To distinguish them from "hostile" Apaches, "friendly" Apache scouts were given red cloth to use as headbands.[1] NMAI P08584

INDIAN WARS, INDIAN SCOUTS

Alexandra Harris and Mark Hirsch

> "I cannot too strongly assert, that there has never been any success in operations against these Indians, unless Indian scouts were used."
> —United States Army Brigadier General George Crook, commander of U.S. troops in Arizona Territory, ca. 1886[2]

AMERICAN INDIAN PEOPLES' REASONS for serving colonial and then American interests as scouts, interpreters, and intermediaries may be the least intuitive of Native American military history. Why would Native peoples participate in the colonization and destruction of their Indigenous brethren? Like everything else in this story, it's complicated. Native people, as individuals and as nations, made choices, taking into consideration what actions and partnerships might be most advantageous to their tribe, band, family, and themselves. From the earliest encounters, Native peoples and European settlers negotiated alliances that pitted tribes against each other. Often, these tribal enmities had existed long before the arrival of Europeans, so American Indians viewed such alliances as opportunities to strengthen their hands in the ongoing competition for continued retribution. Intertribal rivalries were exacerbated after European contact, as tribes competed for horses, guns, and other imported material goods.[3] The slightly better-known history of nineteenth-century Indian scouts is only one part of a longer-standing legacy of Indian–white cooperation that extended coast to coast upon contact, from New Spain to Plymouth Colony.

Any advantages tribes had previously gained through alliances with colonial powers dissolved after the War of 1812 established American hegemony. As U.S. populations and power grew, American Indian people increasingly shared knowledge of their enemies and environments with the U.S. military. As the nineteenth century progressed, U.S. territory expanded westward, necessitating expeditions into lands unknown to Euro-Americans—but thoroughly understood by those who had lived there for centuries.

Initially, Native people served as guides and interpreters to Americans exploring and documenting the West. The Lenape (Delaware), Shawnee, Potawatomi, and Kickapoo peoples were viewed by the United States Army as "partially assimilated" because they had been removed from their homelands and were thereby considered "friendly" (as opposed to so-called "hostile" tribes who remained in their home territories outside reservations). As a

result, the army regarded men from these tribes as especially desirable guides and scouts.[4] Before his support of Union efforts in the Civil War, Black Beaver and other Lenape were employed to find raiding Native groups on the southern plains; the army used Black Beaver to convince tribes such as the Caddo and Wichita to sign treaties and give up their resistance.[5] By the mid-1800s, federal government strategies had changed from exploration to settlement and were particularly focused on curtailing the conflicts between settlers and Indigenous peoples. Gold rushes in California and other territories only exacerbated conflicts.[6]

Federal policy from the 1820s to 1850s focused on removing Indian people farther west and to Indian Territory, yet settlers craved land and mineral rights wherever they traveled. Believing that the United States was granting the "great gift" of white civilization, the federal government mandated that Native peoples give up their lands, move to reservations, and assimilate into mainstream American society.[7] Wrote the Secretary of the Interior in 1866, "It is no doubt the best, if not the only policy that can be pursued to preserve them from extinction."[8] Enlisting American Indians as scouts not only supported the government's assimilationist goals but also helped to quash Native unrest. According to army strategists, sourcing scouts from a tribe related to or the same as the "hostiles" would destroy the latter's morale and facilitate surrender.[9] Undoubtedly the army also played intertribal animosities or factionalism to their advantage.

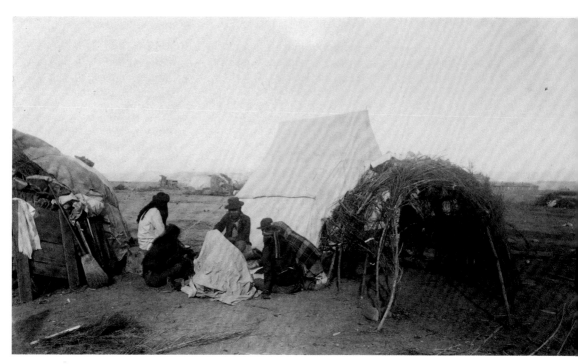

Quechan scout camp, possibly Arizona, n.d. NMAI P06764

A group of officials seated on a rock at Great Falls, on the Potomac River, near Washington, DC, 1861–65. Library of Congress Prints and Photographs Division

The five men in front are identified as (left to right) A. Harper Caldwell, chief telegraph operator, army headquarters; Albert Linde, Pamunkey Indian scout from Whitehouse, Virginia; Jessie Brunell, Secret Service telegraph operator at army headquarters; Harry Thomas, Secret Service operator; and G. H. Thiel, Secret Service operative.

Aroosataka (or As-Sau-Taw-Ka, Pawnee), or White Horse, photographed ca. 1870 by William Henry Jackson. Aroosataka served as a scout for the United States Army during engagements with the Lakota, Cheyenne, and Arapaho during the 1870s. His hairstyle and multiple earrings were common among Pawnee men.[10] NMAI P20548

After the Civil War, Native nations took up arms to protect their lands and lifeways from the advance of American settlers and soldiers. In these years, "Indian fighting" became a primary mission of the United States Army, but the military was ill prepared for the task. Faced with a rapidly diminishing post–Civil War army as Congress economized spending, commanders and soldiers struggled to subdue armed and mounted Native warriors and consolidate tribal peoples on reservations over territories that spread across nearly half the continental United States.[11]

To address the Western conflicts, Congress passed in 1866 the "Act to increase and fix the Military Peace Establishment of the United States" (also called the Army Reorganization Act), which authorized the army to "enlist and employ in the Territories and Indian country a force of Indians, not to exceed one thousand, to act as scouts," with the same pay and allowances as cavalry

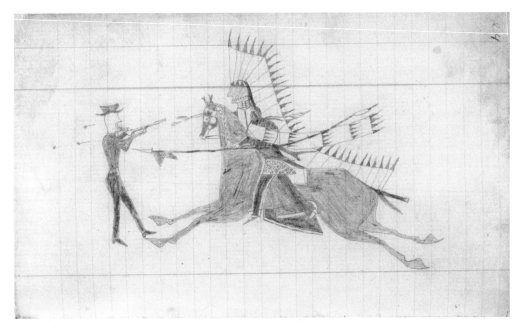

High Bull (Northern Cheyenne, ca. 1848–1876), page from the Double Trophy Roster Book, 1876. Montana. Paper, graphite; 12.5 × 19 cm. Presented by Grace Hoffman White. NMAI 10/8725

This sketch was made by High Bull, a decorated Northern Cheyenne warrior, who recorded his courtship, marriage, and war exploits in a United States Army roster book taken by the victors from the site of the Battle of the Little Bighorn, in June 1876. Five months later, the army, assisted by Pawnee, Shoshone, and Bannock allies, recovered the book following an attack on a Cheyenne village, which took the lives of forty warriors, including High Bull. The volume is referred to as the "Double Trophy Roster Book," as it was captured by and then regained from its previous owners.

soldiers.[12] The limit of scouts was reduced to three hundred for a brief time between 1874 and 1876, only to be raised back to one thousand after the army's loss at the Battle of the Little Big Horn, and then reduced again; in other words, government funding for enlisted scouts fluctuated as Congress deemed it necessary.[13]

Familiar with the western terrain and holding intimate knowledge of rival tribes, Indian scouts became invaluable allies in U.S. military operations throughout the West. Scouts served in two ways: the army enlisted some for brief periods of time, while others were hired akin to modern-day contractors.[14] They served as guides, trackers, couriers, and soldiers in many far-flung locations. For example, Colonel Frank North's Pawnee Battalion guarded construction crews building the transcontinental railroad across the Great Plains in the 1860s, and Black Seminole scouts participated in military expeditions in the 1870s against the Comanche, Kickapoo, and Apache along the Mexican border.[15]

Though the 1866 act regularized the practice of scouting, arrangements between the army and Indians remained informal when it served military (and

Curley (Apsáalooke [Crow], 1856–1923), also known as Curly, Shi-Shia. NMAI P06650

Curley was one of six Crow scouts assigned to Lieutenant Colonel George A. Custer's command when the men of the U.S. Seventh Cavalry rode to their deaths at the Little Bighorn, in Montana, on June 25, 1876. Although Curley did not participate in the battle, journalists frequently later hounded him for details about "Custer's Last Stand." In later years, Curley worked as an Indian policeman and tribal judge at the Crow Agency, and eventually took up ranching along the Little Bighorn, about a mile from Last Stand Hill. He is buried at the Little Bighorn Battlefield Monument.[16]

also tribal) purposes. Often, the army allied with particular tribes who were eager to wage war against a common enemy, bypassing the need to enlist or hire them. The Crows, for example, worked with garrisons between 1866 and '68 on the Bozeman Trail but were not formally enlisted. In 1876, 250 Crows and Shoshones accompanied General George Crook against the Sioux as "volunteers" who were nevertheless armed by the U.S. military.[17] Because many commanders, including General Philip Sheridan, ignored official limits and used both enlisted and "volunteer" scouts, there is no reliable data for the number of Native American people who served as Indian scouts.[18]

Scouting provided a source of income for Native men on poverty-stricken reservations and may have offered a relief from the boredom and restrictions of reservation life. Army service also offered an opportunity to continue and honor warrior traditions, which conferred status in many tribes, and to protect Native communities from raids by tribal adversaries. Pawnee, Arikara, Crow, and Shoshone people served as scouts to fight against their rivals, the Sioux and Cheyenne, the most famous service being that of the Arikara and Crow scouts in Custer's 1876 campaign. Osage scouts led expeditions against the Comanche and Kiowa on the southern plains. In 1877, Bannock men joined General O. O. Howard's 1,400-mile pursuit of the Nez Perce across Oregon, Washington, Idaho, and Montana.[19]

As of March 9, 1891, Native Americans were authorized to enlist in the regular army to serve in Indian companies within some infantry and cavalry regiments.[20] In total, 1,071 Native Americans served in the army's Indian Scout Program between March 1891 and June 1897.[21] Perhaps the most notable

Apparently the last photograph taken of Troop L, Seventh Cavalry, on the day the unit was disbanded in 1897. At that time, the scout unit was composed mainly of Apache prisoners of war, alongside Comanche and Kiowa men. National Anthropological Archives, Smithsonian Institution, NAA INV 02023900

contingent, Troop L of the Seventh Cavalry, which ironically was decimated at the Battle of the Little Big Horn only to be resurrected as an all-Indian unit, was the only unit of scouts to serve out their enlistments.[22] Based at Fort Sill, Oklahoma, the troop was composed mainly of Kiowa, Comanche, Apache, and a few Cheyenne and Arapaho men, who served until 1897.[23] The Indian Scout Program of the 1890s was deemed a failure overall—not because of the Native soldiers' performance, but rather because of negative attitudes within the officers' corps and lack of support.[24]

Given the benefit of hindsight, we might assume that Indian–white conflict dominated Native consciousness in the western territories in the last half of the nineteenth century. Yet that perspective neglects the enduring power of intertribal enmity. Whites were a useful ally against powerful enemies, and Native people did not necessarily see that collaboration as betrayal.[25] Devotion to bands, clans, or local groups frequently overrode broader allegiances to common-language speakers, tribe, or Indians in general.

Clan and family connections flowed across tribal bands, complicating the positions of scouts. In his account, White Mountain Apache scout John Rope (Tlodiłhił or "Black Rope," ca. 1855–1944) told of an incident that exemplifies not only the violence of the time but the complicated interrelations between Apache bands. He describes the reaction of a Chiricahua Apache man, Pine Pitch House, to a proposed retaliation against White Mountain Apache scouts during General Crook's 1883 campaign to bring the Chiricahua Apache back from Mexico.

The Chiricahuas were camped apart from us and [held a council].... They said that this night they were going to put on a social dance for the White Mountain scouts and all the other scouts and let the Chiricahua girls dance with them. Then all the Chiricahua men would get behind and while the scouts were dancing, they would kill them all. It didn't matter if they themselves, the Chiricahuas, got killed, but they would get us scouts anyway.... 'Pine Pitch House' said, "I won't join in this because the White Mountain people are like relatives of mine."[26]

Some scouts may have viewed cooperation with the army as a way to force militant fellow tribesmen to lay down their arms and prevent the extermination of their people—a concern that may have motivated the two Chiricahua Apache scouts, Martine and Kayitah, who convinced Geronimo to surrender in 1886.[27] Martine, who as a boy was kidnapped by Mexicans but was eventually able to rejoin his people, reportedly grew into a man with no interest

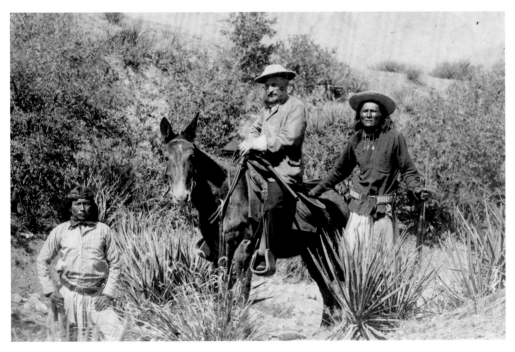

General George Crook, wearing his campaign outfit and riding his mule, Arizona Territory, 1885. With him is Chiricahua Apache scout Ba-Keitz-Ogie (Yellow Coyote, ca. 1855–1893), called Dutchy, at left, and Alchesay (1853–1928), a White Mountain Apache scout who earned the Medal of Honor during Crook's campaign from 1872 to 1873 in the Tonto Basin area against Chiricahua Apaches. Alchesay, who served more than fourteen years as a scout and later became chief of the White Mountain Apaches, was also present during the tense negotiations between General Crook and Geronimo over the Chiricahua Apache leader's surrender, at Canyon de los Embudos, in northeastern Sonora, Mexico, in March 1886.[28]
Photo Lot 24 SPC Sw Apache NAA 4877 Baker & Johnston 02028600, National Anthropological Archives, Smithsonian Institution

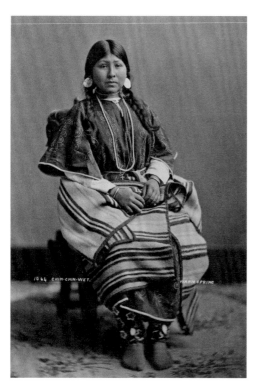

Chin-Chin-Wet, or Alone (Warm Springs), accompanied her husband Wey-A-Tat-Han, or Owl, an Indian scout during the Modoc War. NMAI P02151

in warfare. Martine's son George recalled, "He did not want to go on the warpath, nor did he want his wife and children to have to do so. He wished to live in peace. On a trip to Arizona he enlisted as a scout at Fort Apache. He knew well how the scouts were disliked by their people, who regarded them as traitors; but he knew, too, that his wife and children could live at the fort and be protected."[29] His account also exemplifies the difficult choices scouts made in risking ostracism or retaliation as a traitor and seeking safety for their families.

The man most skilled at organizing scouts and taking advantage of their tribal connections was General George Crook. A Civil War veteran, Crook commanded two companies of scouts from the Warm Springs Reservation (Wasco, Warm Springs, and Paiute tribes) in Oregon and allied with friendly "Snake" Indians (the settlers' term for Northern Paiutes, Bannocks, and Shoshones who lived along the Snake River) to defeat their Snake River brethren from 1866 to '67. After the scouts' successes in this conflict, which spanned throughout Oregon, Idaho, Nevada, and California, Crook became a strong advocate for Indian scouts, especially the use of those most closely related by language and culture to their enemies.

Crook continued to recruit scouts during his campaigns on the Plains and Arizona Territory, even enlisting newly surrendered Indians at the end of peace talks.[30] Between 1882 and 1886, in Arizona Territory and into Mexico, he most notably used Apache scouts to track the Apache bands, secure their surrender, and bring them into the reservations. During this time, Apaches dubbed him Nantan Lupan, or "Tan Wolf."[31] As a staunch advocate for Indian scouts, their talents, and their loyalty, Crook was often unpopular with his fellow army officers. General Sheridan, commanding general of the army, disagreed strongly with Crook about the scouts' loyalty after Geronimo and his band escaped into Mexico in 1886; Crook was transferred to the Platte and replaced by General Nelson Miles.[32] Ultimately, Lieutenant Charles Gatewood and the two aforementioned Chiricahua scouts negotiated Geronimo's surrender.

Many tribes paid a heavy price for their service as scouts. In 1884, the Tonkawa were removed from Texas to Indian Territory, where their population dwindled and nearly disappeared. After Geronimo's surrender, the United States removed the Chiricahua Apache, including the army scouts,

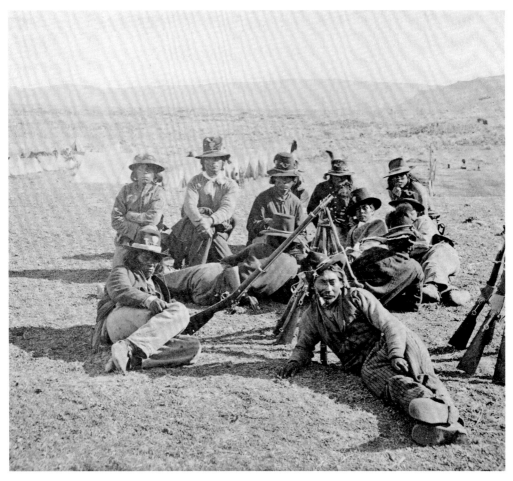

Scouts from the Warm Springs Reservation in north-central Oregon at ease during the "Modoc War" (1872–73). The men were recruited by the United States Army to pursue a group of Modoc people who had left their reservation in Oregon and returned to their homelands in northern California. When the army tried to force the Modocs back to the reservation, violence ensued. Led by Kintpuash, known as Captain Jack, approximately sixty Modocs retreated to a stronghold in the lava beds near Tule Lake, California, where, for five months, they resisted removal efforts by a force of approximately one thousand U.S. soldiers and Indian scouts. Outmanned and outgunned, the Modocs gradually surrendered. Captain Jack and three of his followers were hanged for killing two U.S. peace commissioners sent to end the standoff. About 153 Modocs were exiled to Indian Territory. Survivors were not permitted to return to their homelands until after 1900.[33] BAE GN 02899A 06465400, National Anthropological Archives, Smithsonian Institution

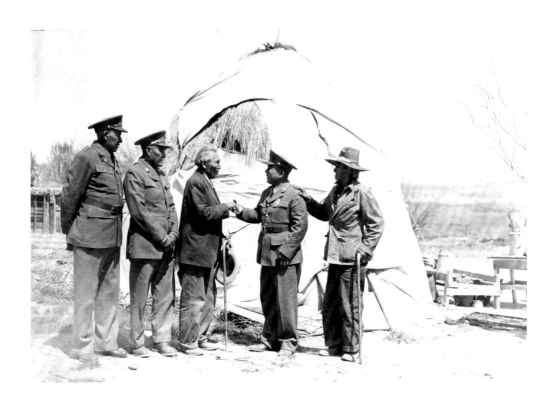

Sergeant Sinew Riley and other Apache scouts listen to John Rope, retired United States Army scout, relate the many battles he fought. Fort Huachuca, Arizona, April 1, 1942. National Archives photo no. SC131151

Staff Sergeant Sinew Riley (White Mountain Apache, 1891–1958). NMAI P15880

Sergeant Riley was a third-generation Indian scout, son of John Riley and grandson of Dead Shot, one of three Apache scouts hanged after the so-called Battle of Cibecue in August 1881, during which the Apache scouts turned against the non-Indian soldiers—the only recorded mutiny by Indian scouts.[34] Riley joined the scouts in 1922 and served until his unit was deactivated in 1947.[35]

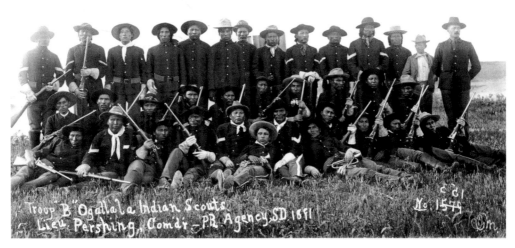

Oglala Lakota scouts of Company B, United States Cavalry, pose with Lieutenant John J. Pershing in front of a tipi at Pine Ridge Agency, South Dakota, 1891. Library of Congress, Prints and Photographs Division

to internment camps in Florida and Alabama. Despite their long association with the army, the Pawnee lost their Nebraska homelands and accepted a reservation in Indian Territory, only to face allotment and the sale of their lands in the 1890s.

The army's Indian scouts remained active into the twentieth century. A contingent of Apache scouts accompanied General Pershing in his pursuit of Pancho Villa during the Mexican Revolution.[36] Pershing, who had commanded Sioux scouts at the Pine Ridge Reservation in 1891, also utilized Indigenous Moro and Filipino scouts during the Philippine–American War and Apache and Sioux scouts during World War I.[37]

The scouts were officially disbanded in 1943, after seventy-seven years of service. In the previous year, the Army Special Forces adopted the scouts' crossed-arrow insignia. In 1922, the last unit of scouts resided at Fort Huachuca, Arizona. Those who remained in 1941, all Apache, included Sergeant Sinew Riley, 49; Corporal Ivan Antonio, 52; Corporal Alejo J. Quintero, 51; Private Jess Billy, 47; Private Kessay, 43; Private Jim Lane, 51; Private William Major, 39; and Private Andrew Paxton, 53.[38] The final four scouts were ordered by the War Department into retirement in 1947.[39]

"SEMINOLE NEGRO INDIAN SCOUTS"

African enslavement, American Indian resistance, and U.S. government removal policies intersect in the history of the Black Seminoles. Sharing more than a century of intertwined history with the Seminole Nation, the Black Seminoles struggled for decades to win their own freedom and autonomy before joining the United States Army in a unit called the Seminole Negro Indian Scouts.

The story of the Black Seminoles begins in the 1700s, when members of Muscogee (Creek), Mikosuki, Apalachicola, and other Florida tribes came together under a central Seminole identity. Meanwhile, free people of African descent and those who escaped enslavement sought refuge in Spanish Florida and established "maroon"[1] communities with close trade and military relationships with Seminole people.[2] Over time the neighboring communities shared languages, trade, styles of dress, and other ways of life, and occasionally intermarried, though the Black Seminoles maintained their own communities, blended culture, and leadership. In some cases maroons were integrated into Seminole communities, and in others, the two communities lived separately but in close proximity.[3] In the late eighteenth or early nineteenth century, the Seminoles adopted a form of enslavement, perhaps taking their cue from Native practices and the comparatively lax Spanish attitudes. The relationship was casual, such as with a tenant farmer, requiring an annual tribute to the tribe similar to the payment that Seminole citizens made to their *micco*, or leader—beyond this, the maroons were allowed to live independently, and armed.[4] Maroons often acted as translators, being conversant in the local languages including the Seminoles' Muscogee and Hitchiti. The

Seminoles and maroons established a military alliance against encroaching Americans that supported their respective goals: the Seminoles' desire to remain in their territory and the Africans' desire to remain free.

The allies became a formidable foe to the United States Army during the First and Second Seminole Wars, but ultimately the Black Seminoles chose removal to Indian Territory along with the Seminole people over re-enslavement. The Seminoles' removal treaties of 1832 and '33 stipulated that they would resettle with the Muscogees. Muscogees, in turn, and white Americans, who operated institutional bondage, attempted to lay claim to the Black Seminoles. Traditionalist Seminoles under their leader Coacoochee (Wild Cat) allied with Black Seminole leader John Horse, son of an enslaved mother and Seminole father, to reject settling with the Muscogees. Upon arriving in Indian Territory, though, their homeless position was desperate. Horse and Coacoochee led many of their people further south into Mexico—where slavery was illegal—in 1850, striking an agreement with the Mexican government to settle in Coahuila along with other refugees, including Kickapoos, and maroons from the Seminole, Muscogee, and Cherokee nations.[5]

In 1856 the Seminoles in Indian Territory secured by treaty their own territory, and all had returned to the United States by 1861. The Black Seminoles endured in Mexico, but not well. Their leader, John Kibbetts, negotiated an agreement whereby the United States Army would enroll the men as scouts in Texas and otherwise support them until they returned to Indian Territory.[6] On August 16, 1870, Sergeant John Kibbetts and ten privates were

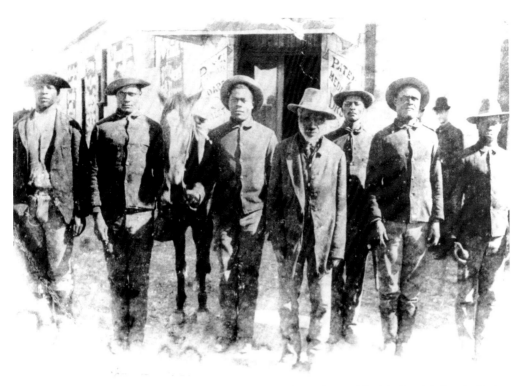

A group of Black Seminole scouts, July 15, 1889. Left to right: Plenty Payne, Billy July, Ben July, Dembo Factor, Ben Wilson, John July, and William Shields. National Archives photo no. 64-M-228

mustered as a new army unit that would be known as the Seminole Negro Indian Scouts.

For the next few years, the scouts patrolled west Texas against raiding Indian tribes. Their first major expedition, in May 1873, engaged Kickapoos who were raiding into Texas from Mexico. In 1874 the scouts played prominent roles in the Red River War against the Comanche, Kiowa, and Southern Cheyenne, ultimately returning them to reservations in Indian Territory. Three scouts—Sergeant John Ward, Trumpeter Isaac Payne, and Private Pompey Factor—earned the Medal of Honor in 1875 through their actions to save their commander, Lieutenant Bullis, from Comanche raiders; another, Adam Paine, also received the

Medal of Honor in 1875 for actions against the Comanche the previous year. The Seminole Negro Indian Scouts continued to serve the army notably throughout the 1870s, pushing free Native peoples such as the Lipan Apache and Kickapoo onto reservations. Meanwhile, the U.S. government neglected their promises to the Black Seminoles, neither returning them to Indian Territory nor giving them supplies for their Texas settlement. Eventually the Black Seminoles decided for themselves, some returning to Mexico, others to Indian Territory, and still others staying in Brackettsville, Texas, where their descendants still live today. The Seminole Negro Indian Scouts were officially disbanded in 1914.

ALEXANDRA HARRIS

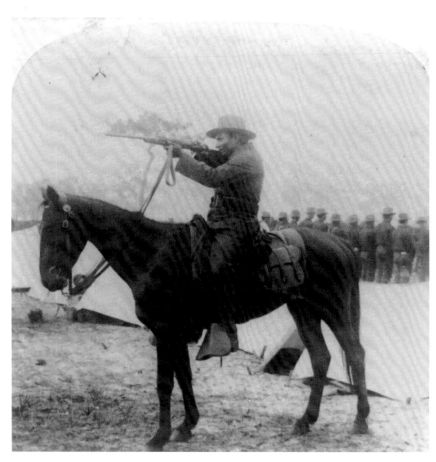

Bankston Johnson, 1898. Stereograph by Strohmeyer & Wyman, Library of Congress Prints and Photographs Division

Bankston Johnson (Choctaw, 1862?–?) was a trooper in Theodore Roosevelt's First Volunteer Cavalry Regiment, popularly known as the Rough Riders.

THE SPANISH–AMERICAN WAR

Alexandra Harris

URING THE SHORT-LIVED Spanish–American War (1898), Native Americans served in the United States Volunteers, particularly the First Territorial Volunteer Infantry and, most famously, the First Volunteer Cavalry, also called the Rough Riders.[1] The war with Spain eventually spread to other Spanish-controlled territories in the Caribbean and Pacific, including Puerto Rico and the Philippines (ushering in the Philippine–American War [1899–1902], during which Native soldiers also served). Richard Henry Pratt, an advocate for Indian cultural assimilation and architect of the Native American boarding school system, observed that young Native men at the Carlisle Indian Industrial School greeted early rumors of war with Spain with "eager[ness] to prove their loyalty to the Government, and expressed their wish to enlist should there be a call for volunteer troops. The military government and drill used at the school," Pratt remarked, "especially qualified them for such service."[2] Native women took part in the war as well; most notable were four Lakota nuns who made a strong impression as nurses, earning accolades for their skill and care.

When Congress declared war on April 25, 1898, then Assistant Secretary of the Navy Theodore Roosevelt mustered one thousand Rough Riders from New Mexico, Arizona, and Oklahoma and Indian Territories, although men also joined from farther afield. They were an eclectic bunch: Ivy Leaguers from Harvard, Yale, and Princeton; Roosevelt's own ranching and hunting friends; and a smattering of men from the Washington, DC, area joined recruits from the western territories. These latter "wild rough riders of the plains," as Roosevelt wrote in his memoir *The Rough Riders*, gave the regiment "its peculiar character."[3] Many of these men had participated in killing the great bison herds and had fought Indians during westward expansion; they were gamblers, criminals...and a few clergymen.

Roosevelt took particular pride in the inclusion of American Indians in the Rough Riders. "From the Indian Territory," wrote Roosevelt, "there came... Cherokees, Chickasaws, Choctaws, and Creeks." Most, Roosevelt only remembered by their last names: a Cherokee named Adair, another Cherokee named Holderman ("an excellent soldier and for a long time acted as cook for the headquarters mess"), a Chickasaw named Colbert, and a Pawnee man named

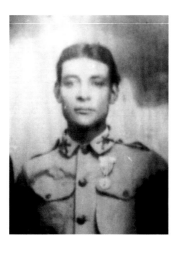

Frank C. Brito (Yaqui, 1877–1973). City of Las Vegas Museum

Born in the mining town of Pinos Altos, New Mexico, twenty-one-year-old Frank C. Brito and his brother Joe (Jose), both Yaqui, enlisted and were assigned to Troop H. Roosevelt nicknamed Frank "Monte," short for Montezuma. The brothers, along with one third of the cavalry and all horses—excluding the officers' mounts—were ordered to remain in Tampa because of the lack of transportation to Cuba.[4] Brito reflected, "It was no honor to stay behind. Tampa was a hell-hole. We were there, waiting, thinking we would get over to Cuba, or maybe Puerto Rico, and nothing happened. A lot of us got sick and a lot got in trouble in Tampa. No wonder. We were there over two months with nothing to do but get sick and get mad."[5] Joe Brito went on to fight in the Philippines, where he went missing in action and was presumed dead. The second-longest-living Rough Rider, Frank died on April 22, 1973, in El Paso, Texas, at age ninety-six.[6]

Pollock who earned Roosevelt's regard: "one of the gamest fighters and best soldiers in the regiment."[7] Two young Cherokee recruits, a football player and a glee-club member, were recommended by their teacher. Both were deemed "fine young fellows." Other Native people, whom Roosevelt described as "of a wilder type," joined the regiment. Roosevelt characterized them as needing "rough discipline," yet remarked on their exceptional horsemanship. "The life histories of some of the men who joined our regiment would make many volumes of thrilling adventure."[8]

While some of the Native Rough Riders were stalled in Florida on their way to Cuba, many did see action. Thomas Isbell (Cherokee), first to shoot and to be shot, was wounded at least seven times, including two bullets to the neck, one each to the thumb, hip, and hand, and more, over half an hour of fighting.[9] Even so, Isbell declined to leave the battle. Having lost too much blood to continue, he was moved to the rear instead. "The man's wiry toughness was as notable as his courage," reflected Roosevelt.

It is difficult to know what motivated the Native men to volunteer to fight. Perhaps, like Holderman, they fought because "his people had always fought when there was a war, and he could not feel happy to stay at home when the flag was going into battle."[10] After 115 days, the Spanish surrendered and the Treaty of Paris was signed, handing temporary control of Cuba and dominion over Puerto Rico, Guam, and the Philippines to the United States.

WILLIAM POLLOCK

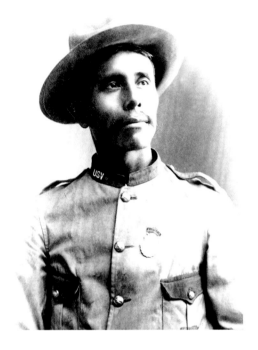

William Pollock (Pawnee, 1870–1899), one of Roosevelt's most respected Rough Riders, ca. 1898. Courtesy of Western History Collections, University of Oklahoma Libraries, Wenner 110

I am somewhat a conspicuous character. Some folks at home thought I was very foolish to put myself into such a situation where dangers of all kinds are inevitable. If my mother was yet living, I would not take any such step; my brothers, they are all men and will not worry about me, but will rather be somewhat proud of me even should I fail at my duty as a soldier under the service of the U.S. Government.[1]

William Pollock was one of eight Pawnee men to enlist in Roosevelt's Rough Riders. Born in Nebraska and educated at Haskell Indian Industrial School in Lawrence, Kansas, Pollock studied drawing and art. After war was declared, Pollock enlisted—not to be a scout, spy, or tracker as his people had been before, but as a full member of the army. He mustered into Company D of the First Volunteer Cavalry. From Camp Wood, Texas, he wrote to fellow Pawnee Samuel Townshend:

> I am not going to predict any or do any boasting, but I'll only say that in the memory of our brave fathers I will try and be like one of them, who used to stand single-handed against the foes. Being the only full-blooded Indian in this troop,

Throughout training, he continued to sketch. Roosevelt observed Pollock to be "a silent, solitary fellow—an excellent penman, much given to drawing pictures."[2]

In Cuba, Pollock and a handful of other men led the charges and fought nearest the enemy.[3] In a biography of his friend Roosevelt, social reformer and journalist Jacob Riis took note of the impression Pollock had made: "'You should see him in a fight,'" commented Pollock's superior officer. "'I shall never forget the ungodly war-whoop he let out when we went up San Juan hill [sic]. I mistrust that it scared the Spaniards almost as much as our charge did. I know that it almost took my breath away.'"[4]

Pollock's community celebrated his courage upon his return. Receiving and honoring him

William Pollock, *Buffalo Bill (William F. Cody)*, n.d., oil on canvas. This damaged painting appears to be the only work by Pollock in public hands. Smithsonian American Art Museum, Bequest of Victor Justice Evans, 1985.66.362,139

traditionally as a warrior, they gave speeches and gifted Pollock with horses during community gatherings. Yet Pollock recognized that service in the United States Army complicated at least one of the honors tribes traditionally bestowed on returning warriors, that of a new name. As no other Pawnee had witnessed his bravery in battle, Pollock's name would remain unchanged.[5]

Along with other Rough Riders, Private Pollock signed a contract to join Buffalo Bill's Wild West show, which would have involved touring and a performance at Madison Square Garden in New York City.[6] Yet his declining health prevented his participation. Barely six months after his return to Pawnee, Oklahoma, at age twenty-eight, Pollock succumbed to pneumonia, complicated by malaria contracted in Cuba. He was buried with full military honors, combining U.S. and Pawnee customs.[7] Roosevelt, then governor of New York, sent his regrets in care of the reverend who performed the service: "I would...have you extend my sympathy to his relatives and his fellow tribesmen and say that he conferred honor by his conduct not only upon the Pawnee tribe, but upon the American army and nation."[8]

ALEXANDRA HARRIS

NATIVE NURSES IN CUBA

Congress authorized the recruitment of a thousand civilian nurses to tend to the sick and wounded in Cuba. Of these were four Lakota nuns from a small sisterhood on the Fort Berthold Indian Reservation in North Dakota. That these four women became the first documented Native women veterans in a distant Caribbean war is a testament to their skill and courage, yet arguably as much or more to the ambition of their priest, Father Francis M. Craft.

A complicated and eccentric man with Mohawk ancestry and a history as a Civil War messenger boy, medical professional, and armed mercenary for France, Craft entered the Jesuit priesthood with the primary intent of becoming "an Indian to save the Indian."[1] At the Rosebud Reservation in South Dakota, Craft learned the Lakota language and in 1883 was adopted by the family of Chief Spotted Tail. Craft's ambition in general, and his aspiration to create an Indian Catholic sisterhood in particular, was unpopular with both his church superiors and Indian agents, whose racial prejudices against the sisterhood aimed to undermine its existence. As a result, over the course of his career Craft was reassigned to different Lakota reservations and ultimately to Fort Berthold, North Dakota, with the Mandan, Hidatsa, and Arikara peoples. While at the Standing Rock Reservation, Craft was persuaded to aid the army's attempt to disarm Chief Big Foot's band at Wounded Knee Creek; in the historic 1890 massacre that followed, Craft was severely injured. After he accused the Indian Department of corruption, agents began rumors that he was mentally unhinged, a stigma that would follow him for the rest of his career. Craft established his

sisterhood—the Congregation of American Sisters—at Fort Berthold and advocated for their religious and medical education. By 1896, Sacred Heart Convent housed both the sisterhood and a hospital.

Yet agents and church leaders continued to undermine the convent's tentative success. Former Fort Berthold Indian agent John S. Murphy, resentful of having been fired, sought to sabotage his own replacement and destroy Craft's sisterhood at the same time. Murphy spread rumors of sexual liaisons between the sisters and agency staff, resulting in suspension of the staff accused and investigation of the sisterhood. Craft believed that the church stood by and allowed the corrosion of his efforts because the sisters were Indian. He mistrusted the "men of the Church, wherever there is a question of race—especially the Indian race."[2] In the end, many sisters returned to their homes, but four remained: Susie Bordeaux, who took the name Mother Mary Anthony; Ellen Clark (Sister Mary Gertrude); Annie Pleets (Sister Mary Bridget); and Josephine Two Bears (Sister Mary Joseph). Ejected from Fort Berthold, Craft and the four sisters sought refuge at the Cheyenne River Reservation, yet the agent there increased the severity of the rumors, accusing Craft of having his own relations with the sisters.

To escape the scandal and avoid exile from the reservations, Craft offered the nuns' services as nurses after the United States Navy battleship *Maine* sank in Havana's harbor on February 15, 1898. Contracted for thirty dollars a month, the sisters were first stationed at Camp Cuba Libre in Jacksonville, Florida, for training in the care of infectious diseases. Among the thousand nurses chosen by the

Father Craft and four members of the Congregation of American Sisters at Pinar del Rio, Cuba, about 1899. Left to right: Annie Pleets (Sister Mary Bridget), Ellen Clark (Sister Mary Gertrude), Father Francis M. Craft, Josephine Two Bears (Sister Mary Joseph), and Susie Bordeaux (Mother Mary Anthony). Marquette University Archives, Bureau of Catholic Indian Missions Records, ID 09-1 60-07

federal government were people of color who had already had yellow fever or were otherwise considered immune.[3] After transferring to Camp Onward in Savannah, Georgia, Craft and the sisters sailed for Cuba and arrived at Camp Columbia, Havana, on December 22, 1898.

Craft's reputation followed him to Havana, and while the church barred him from preaching or hearing confessions, the sisters received awards and accolades from the Surgeon General and soldiers. Wrote Craft, "The Surgeon General wrote to them to praise and thank them, and the 'Order of Spanish–American War Nurses' adopt them as members, and will soon send them their badges. They are the only Sisters who came with the Army to Cuba, and remained."[4] In February 1899 the sisters

transferred to the Havana military hospital, but by the end of the month their contracts were annulled as their services in the short war had been fulfilled.[5]

Their homecoming delayed, Craft and the sisters founded an orphanage at Pinar del Rio in May 1899. Sadly, in October of that year Susie Bordeaux (Mother Mary Anthony) died of tuberculosis, complicated by pneumonia. She was buried in grave 22, City Cemetery, Pinar del Rio, with full military honors, attended by soldiers, sisters, orphans, and veterans. "This is the first time in the history of our Army," wrote Craft, "that a Sister was buried by the Army with the honors of war, and it will be of interest to the Army that the first Sister so buried, was a granddaughter of Chief Spotted Tail, and a grandniece of Chief Red

Cloud. She was much beloved by the soldiers whom she had nursed back to health at the sacrifice of her own life, and American soldiers mingled their tears and prayers with those of Cubans and Spaniards who loved her for her care of their orphans and sick."[6] Craft later requested her reburial at Arlington National Cemetery along with the rest of the war dead, but was refused because she was a civilian.

In December, Annie Pleets and Ellen Clark broke with Father Craft. Desperate to return home, the women appealed to the missionary at Cheyenne River Reservation in South Dakota for travel funds. Letters indicate that they desired to remain in the church, but felt they had to leave the sisterhood to distance themselves from Craft. In the meantime, Craft had arranged for the sisters to return home via New York City in January of 1900. They never returned to religious life.

Annie Pleets and Joe Dubray married and had three children. With her training, she practiced midwifery at Standing Rock and died in 1948.[7] Ellen Clark returned to Cheyenne River, married, and had three children with Joe Hodgkiss; during her long life she was a widow twice and spent her later years at the Old Soldiers Home in Hot Springs, South Dakota.[8] Josephine Two Bears (now Mother Joseph) remained in Cuba with Craft to run the orphanage until sailing to the United States in 1901. She returned home, married Joachim Hairychin in 1903, and died in 1909 giving birth to twins. Father Craft, who had been exiled from Indian Country, settled in comparative obscurity in Pennsylvania as a parish priest.

ALEXANDRA HARRIS

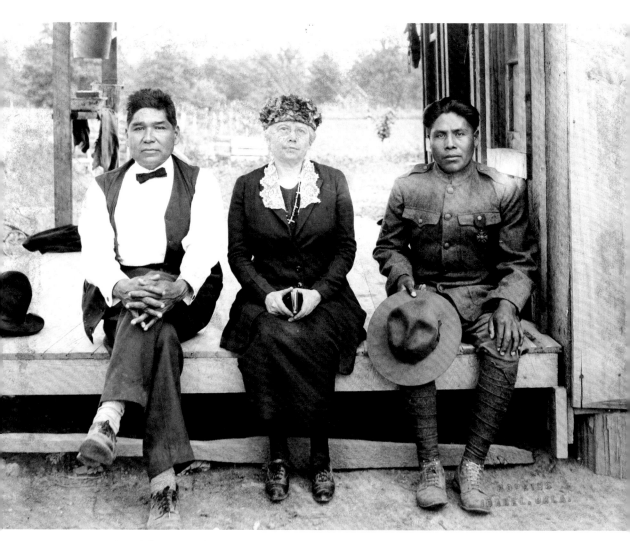

Joseph Oklahombi (Choctaw, 1895–1960), right, with John Golombie (Chickasaw) and Czarina Colbert Conlan (Choctaw/Chickasaw) at Oklahombi's home. Near Wright City, Oklahoma, May 12, 1921. Photo by Hopkins. Courtesy Oklahoma Historical Society

The most highly decorated Native American serviceman during World War I, Joseph Oklahombi received the Croix de Guerre, France's highest military honor for gallantry, and a Silver Citation Star, after he and twenty-three other men rushed a German stronghold near Saint-Etienne in October 1918, capturing 171 prisoners and killing about 79.[1]

WORLD WAR I

Alexandra Harris and Mark Hirsch

MORE THAN TWELVE THOUSAND Native Americans are estimated to have served in the United States Armed Forces during World War I, approximately 25 percent of all eligible adult Indian men—a remarkable number considering that a third of the American Indian population was not recognized as U.S. citizens.[2] Hundreds of Native people from the United States also enlisted in the Canadian Army before April 1917 when America joined its allies—Britain, France, and Russia—in the war to end all wars.[3]

Native American responses to the war effort varied widely, as did motivations for military service.[4] Some Native people, such as the physician and activist Carlos Montezuma (Yavapai), opposed the wartime draft, arguing that a nation that denied citizenship to Indians had no right to require them to sacrifice their lives for it.[5] Yet few Native men requested deferments from the draft, and thousands enthusiastically embraced the opportunity of serving in uniform by enlisting in the armed forces.[6]

Some Native people joined up for the same reasons as did many non-Indians: to secure employment, explore new horizons, and prove themselves in combat. Others, chafing under the U.S. Indian Office's autocratic control of tribal communities, were inspired by President Woodrow Wilson's articulation of America's wartime mission: "to fight...for the ultimate peace of the world and for the liberation of its peoples," and "for the rights of nations great and small and the privilege of men everywhere to choose their way of life."[7] Still others—both Native and non-Native—hoped military service would prove that Indians could be patriotic Americans as well as members of tribal nations, allegiances that seemed incompatible in a country that equated nationalism with cultural assimilation. Native American men who registered for service numbered 17,313, according to the U.S. Office of Indian Affairs; of the 12,000 who ultimately served, some 6,509 were drafted.[8] Another 3,000 to 6,000 men enlisted.[9] Students at federal Indian boarding schools volunteered in huge numbers, so significantly that the Bureau of Indian Affairs recorded registrants' boarding school affiliation in their reference files, in which each service member's participation was recorded after the war.[10] The Carlisle Indian Industrial School in Pennsylvania alone contributed 205 servicemen.[11]

American Indian students from Carlisle Indian Industrial School. Hog Island Shipyard, Pennsylvania, September 4, 1918. National Archives photo no. 533744

Native people served the war effort in many different ways, including working in defense industries. These students from the Carlisle, Pennsylvania, boarding school built ships during World War I.

Native Americans participated in every branch of the service. The ten thousand Native Americans in the army were assigned to the cavalry, medical corps, signals units, military police, balloon squadrons, and the aviation corps. Of the one thousand Native people in the navy, most served on transport and escort vessels, though some were stationed on battleships.[12] Fourteen Native women reportedly served in the Army Nurse Corps, though the Office of Indian Affairs recorded a total of eighteen Native nurses in the war.[13]

Unlike African American soldiers, who were assigned to racially segregated army units, Native soldiers served in regular infantry companies, and they were often tasked with particularly hazardous duties, for which they won praise and commendation for battlefield bravery and achievement. Yet valor had its costs. About 5 percent of Native combat soldiers were killed, compared with 1 percent of American forces overall.[14]

Native enthusiasm for wartime service was not universal. Some Native people residing in Pueblo and Navajo communities, parts of Oklahoma, and in the Haudenosaunee (Iroquois) Nations of New York objected to military service and resisted conscription. Many refused to die fighting for freedom

> [T]his world war in which I took part is something that will be in my memory for ever, I kn[e]w I might get killed yet I kn[e]w that I ought to do something for my country as we Indian's are the real American's so I enlisted, and seen some hard times yet I am glad I have done my duty and I got back safely home.
>
> —Owen Hates Him (Cheyenne River Sioux), who served at the Battle of Chateau Thierry in July 1918[15]

abroad when freedom was denied to Indians at home. Government plans to increase wartime food production by accelerating the allotment, or privatization, of tribally held reservation lands also eroded Native support for the American war effort in general and military service in particular. The Haudenosaunee, asserting tribal sovereignty, argued that the United States had no right to induct non-citizens, yet two Haudenosaunee nations, the Oneida and Onondaga, found a work-around by declaring war against Germany on their own terms.[16]

In addition to providing soldiers for the war effort, tribal communities purchased some $25 million in war bonds—about $75 for every Native man, woman, and child.[17] As an incentive to purchase even more bonds, Native people were offered a bonus: a captured German military helmet. About ten thousand American Indians joined the Red Cross, supporting the war effort by purchasing Red Cross memberships, fundraising, and donating supplies.[18]

World War I offered Native people an opportunity to participate in what most Americans considered a great crusade to defend democracy in Europe. In recognition of their wartime service, Congress passed the Citizenship Act of

Charlotte Edith Anderson Monture (Six Nations of the Grand River, 1890–1996), 1919. Courtesy of John Moses

Edith Monture was the first Native Canadian registered nurse. After Indian Act restrictions of her era prevented her from pursuing professional training in Canada, she sought nurse's training in the United States. In 1917, at the age of twenty-seven, she volunteered for the U.S. Medical Corps and served in a hospital in France, treating soldiers who had been shot or gassed. She was the only Native woman among the fourteen Canadian nurses who served in the U.S. Army Nurse Corps during World War I.

Elson M. James, ca. 1918. Mathers Museum of World Culture, Indiana University

A private in the infantry, Elson M. James (Snohomish, 1885–1918) lived at the Tulalip Reservation, in northwestern Washington, before being drafted into the army. Recognized for his bravery, James was made a scout. He led patrols in and out of enemy territory in France while gathering information and securing prisoners.[19] James died of pneumonia in December 1918, possibly a victim of the diseases that swept the battlefields after war's end.[20]

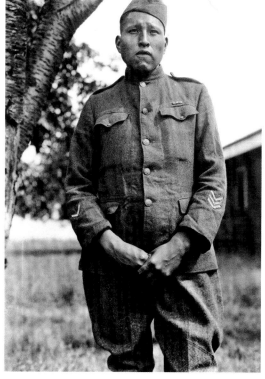

Alphonse Bear Ghost (Sioux), after his return from France, Camp Merritt, New Jersey, 1919. Mathers Museum of World Culture, Indiana University

A private first-class in Company M, Twenty-Sixth Infantry, First Division ("Pershing's Own"), Bear Ghost was wounded in the left arm during the Saint-Mihiel Offensive in France on September 12 and 13, 1918, and was decorated with a Silver Star for "displaying great gallantry and devotion to duty." Recalled his sergeant, "I wished many times that all boys in the American Army were like Bear Ghost."

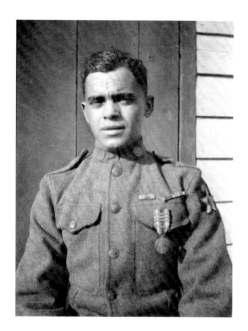

Ferdinand Clark (Nanticoke, 1891–1932), 1922. NMAI N12440

Ferdinand Clark, who served with the Second Engineers in World War I, fought in the battles of Chateau Thierry, Soissons, Saint-Mihiel, Mont Blanc, Attigny, Argonne, and the Rhine. He was chief of the Nanticoke from 1928 to 1932.

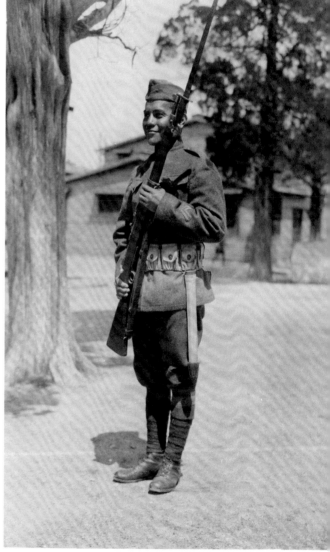

Amado Garcia (Acoma Pueblo), Camp Dix, New Jersey, May 17, 1919. Mathers Museum of World Cultures, Indiana University

A resident of Acoma Pueblo, New Mexico, Amado Garcia enlisted in the United States Army on June 3, 1918, in Lamar, Colorado. With two other men from his unit, Garcia advanced three hundred yards through barbed wire under heavy fire, capturing the guns and returning unwounded to Allied lines. He was decorated with the French Croix de Guerre with Gilt Star.

1919, granting citizenship rights to American Indian veterans of World War I who endured the arduous, bureaucratic process of applying.[21] Indian contributions to the war effort also promoted enthusiasm for extending citizenship to all Native Americans. "[T]he Indian threw himself into the struggle to help throttle the unthinkable tyranny of the Hun," declared Dr. Joseph K. Dixon, an advocate for assimilating Native people into American culture and society. "The Indian helped to free Belgium, helped to free all the small nations, helped to give victory to the Stars and Stripes. The Indian went to France to help avenge the ravages of autocracy. Now, shall we not redeem ourselves by redeeming all the tribes?"[22] Pro-citizenship advocates such as Dixon ultimately won the day. Persuaded that Native people "deserved the rewards" of citizenship, Congress in 1924 passed the Indian Citizenship Act, which conferred

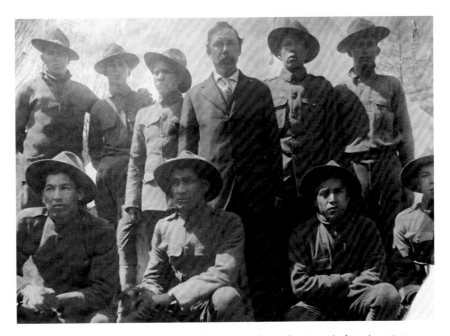

Passamaquoddy soldiers in Company I of the 103rd Infantry Regiment before departure for France in 1917. Standing, from left: Sam Dana, David Sopiel, Peter Lewey, Chief William Neptune, George Stevens Sr., and Charles Lola. Kneeling: Peter Stanley, John Newell, Henry Sockbeson, and Moses Neptune. Passamaquoddy Cultural Heritage Museum, Donald Soctomah

The Passamaquoddy of Maine sent twenty-five men to fight in World War I.[23] Among those were Passamaquoddy tribal governor William Neptune and his son Moses, one of the last U.S. servicemen killed in the war. Moses, who enlisted in 1917 at age nineteen, died in the Argonne Forest along with ten other men of the 103rd Infantry Regiment on November 10, 1918.[24] The armistice was signed the following morning. The Passamaquoddy left a unique legacy: in an underground French quarry where the American troops lived, the nine Passamaquoddy who fought with Company I of the 103rd Infantry carved images of their canoes, warriors wearing headdresses, and symbols of their culture.[25] Not only were they present, but they left a piece of their artistic expression as well.

> I am an Indian and never had any Experience in a war before, but I realize that I was doing my duty as a patriot and was fighting to save Democracy and do hope that in the future we Indian's may Enjoy freedom which we Indian's are always denied.
>
> —Joe High Elk (Cheyenne River Sioux), World War I veteran, ca. 1919. High Elk enlisted in 1916 [?] in Rapid City, South Dakota, and served as a gunner at the Battle of the Argonne Forest and Saint-Mihiel in September 1918.[26]

citizenship on all Native Americans born in the United States.

American citizenship fell far short of the recognition Native people had hoped to receive in return for supporting the war effort. Indian demands for citizenship did not feature on the reform agenda of tribal communities during and after World War I. Indeed, many believed that citizenship would undermine tribal nationhood and embolden the federal government to disregard its treaty obligations. Instead, after fighting for democracy abroad, many Native veterans expected the United States to extend the blessings of democracy to Indian Country. They wanted liberation from the iron hand of the Office of Indian Affairs, which controlled life on Indian reservations. They wanted the Indian Office to respect tribal cultures and traditions as well as preserve traditional homelands. After the war, American Indian leaders, inspired by the democratic wartime rhetoric of President Woodrow Wilson, increasingly demanded far-reaching changes in the relationship between the United States and Native peoples. Echoing Wilson's call for a lasting peace based on the self-determination of all subjected peoples, American Indians linked their people's aspirations to the president's lofty vision of a new democratic world order. "How can our nation pose as the champion of the 'little peoples' until it has been fair to its own?" asked Charles Eastman (Santee Sioux), a physician, writer, and member of the Society of American Indians.[27] Robert Yellowtail (Crow), a young boarding school graduate, also leveraged Wilson's rhetoric to advance tribal self-determination. In his testimony to Congress, in 1919, Yellowtail expressed the hope that the president would "not forget that within the boundaries of his own nation are the American Indians who have no rights whatsoever—not even the right to think for themselves."[28] Yellowtail was ahead of his time. American Indians would have to fight in other wars before the United States would recognize the sovereignty of their tribal nations.

CODE TALKERS

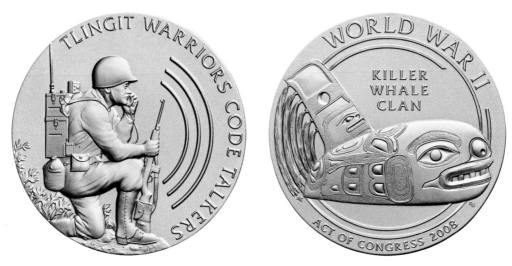

Medal awarded by the Code Talkers Recognition Act of 2008 to the Tlingit tribe of southeast Alaska for its service in World War II. Designed by Susan Gamble, engraved by Renata Gordon and Joseph Menna, 2013; gold; diameter 7.5 cm. United States Mint Tlingit Tribe Code Talkers Recognition Act of 2008 Congressional Gold Medal designs (exclusive of Native American Tribal Insignia) © 2008 United States Mint. All Rights Reserved. Images courtesy of United States Mint. Used with permission.

During World Wars I and II, hundreds of Native American servicemen from more than twenty tribes used their Indigenous languages to send secret messages in a code that enemies never broke.[1] Known today as "code talkers," these men used their knowledge of tribal languages to help U.S. forces achieve military victory on the battlefields of Europe and in the Pacific. At times planned, and other times by chance, code talking was one of the most singular and significant contributions made by Native peoples to U.S. military history.

Code talking fell into two categories: type one, in which special vocabularies were developed within Native languages for military terms (a code within a code), and type two, the use of Native languages without coded terminology. The latter type could be intentional or completely circumstantial, such as two or more language speakers finding each other in war and using their talents for military advantage.[2]

For Native American soldiers, using Indigenous languages for communication emerged seemingly naturally between speakers during their shared wartime experiences. Though U.S. military policy discouraged all-Indian units, some primarily Native companies were drawn from areas with high Indian populations, such as the Thirty-Sixth and Ninetieth Divisions in World War I, which encompassed large numbers of Native people from Oklahoma, and the Forty-Fifth Division in World War II, which included many Indian people from Oklahoma and New Mexico. Many of the men had attended government boarding schools and so knew some English; translating their

languages for use in battle took advantage of their bilingual abilities.[3]

The first acts of code talking during World War I reflected a serendipitous response to a dire situation, in which American communications were often intercepted by Germans who had broken the Allies' codes. The earliest documented use of Native languages as code involved Ho-Chunk speakers in June 1918, followed by Eastern Band of Cherokee Indians during the Somme Offensive in World War I. First Lieutenant John W. Stanley, a non-Indian telegraph operator, noted that the 119th and 120th Infantry Regiments contained many Cherokees and suggested to a division signal officer that their language might solve the problem of intercepted communications. "The matter was taken up with the division commander," wrote Stanley, "and the next day found every command post from brigade forward, including some company command posts, [with] a telephone with a Cherokee Indian beside it. Needless to say, there were no further messages intercepted by the enemy that we heard of.... From then on until October 12, 1918, at which date I was ordered back to the United States as an instructor, the Cherokees were kept on the job with continued

We…were very fortunate to contribute our language as a code for our country's victory. For this I strongly recommend we teach our children the language that our ancestors were blessed with at the beginnings of time. It is very sacred and represents the power of life.

—Kee Etsicitty, Navajo code talker[4]

success, and I understand were used until the end of the war."[5]

Happenstance also played a part in positioning Choctaws for service as code talkers. Near the end of the war in 1918, the 142nd Infantry Regiment, Thirty-Sixth Division, went to France for training, then to the front near Saint-Etienne, France. According to Solomon Louis (Choctaw), a "Captain Lawrence" (possibly E. W. Horner)[6] was walking through camp and overheard Louis and Private First Class Mitchell Bobb speaking in Choctaw. After listening a few minutes, Lawrence realized the possibilities and engaged Louis, asking how many Choctaw speakers there were and whether any were at headquarters. The first

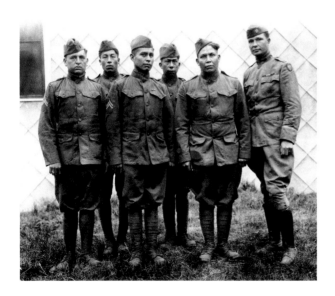

Choctaw telephone squad, returned from fighting in World War I. Camp Merritt, New Jersey, June 7, 1919. From left: Corporal Solomon Bond Louis, Private Mitchell Bobb, Corporal James Edwards, Corporal Calvin Wilson, Private George (James) Davenport, Captain Elijah W. Horner. Mathers Museum of World Cultures, Indiana University

message was spoken over the field telephone by Mitchell Bobb to fellow Choctaw Ben Carterby, who translated it to English for his battalion commander. Louis, appointed chief of the detail, chose eight initial Choctaws, who were arranged throughout the field headquarters to cover communications. On October 26 and 27, 1918, the 142nd Regiment attacked the Germans' front lines by surprise at Forest Ferme. Because Choctaws James Edwards and Solomon Louis had communicated German locations and plans in their unbreakable "code," the Allies were able to advance and the Germans sustained heavy losses.[7] Words like "patrol" and "grenade" did not exist in Choctaw, so terms were developed during a brief training period after Forest Ferme—creating the first documented type-one code, though because the war ended on November 11 they were not used.[8] "Stone" stood for grenade, "tribe" for regiment, and "two grains of corn" referred to the Second Regiment.[9] "There was hardly one chance in a million that 'Fritz' would be able to translate these [Native] dialects," recalled Colonel A. W. Bloor, commanding officer of the 142nd Infantry Regiment.[10]

In addition to Choctaw, Ho-Chunk, and Eastern Cherokee language speakers, Comanches, Cheyennes, Yankton Sioux, and Osages were among the Native men who served as code talkers during World War I.[11] Their service to the Allied cause would not be forgotten.

Even before the United States entered World War II, military leaders remembered the success of the Native language code talkers who served in 1918. In 1940 and 1941, the army recruited Comanche, Meskwaki, Chippewa, and Oneida language speakers to train as code talkers. In April 1942, the Marine Corps trained twenty-nine Navajo men in combat and radio communications, who served as the foundation of the largest code-talking program in the military. Later, in mid-1943, the army engaged eight Hopis—who were already in service—in the Eighty-First Division.[12]

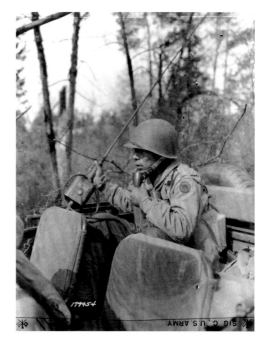

Radio operator Private First Class Floyd Dann Sr. (Hopi) of Moenkopi Village, Arizona. Second Army Tennessee maneuvers, Nashville, Tennessee, July 1943. Army records note, "There are eight Hopi Indians in the company and they are able to maintain virtually uninterceptable communication between the battalions and regimental headquarters."
National Archives photo no. 111-SC-179954

The Navajo code talkers made their wartime debut in 1942 at Guadalcanal, on the Solomon Islands in the South Pacific. Required to memorize a list of 211 military terms translated into their Native language (which increased to more than 700 by the end of the war), each Navajo code talker was expected to encode, send, receive, and decode messages quickly, while at the same time defending their positions, often under heavy enemy fire.[13] They soon won praise for their ability to send secret messages that flummoxed Japanese eavesdroppers. "All the services, like the army, and divisions and companies and battalions, regiments...we just gave them clan names," recalled William McCabe (Navajo). "Airplanes, we named them after birds...like the buzzard

Meskwaki code talkers, February 1941. Top, left to right: Judie Wayne Wabaunasee, Melvin Twin, Dewey Roberts Sr., Mike Wayne Wabaunasee; Bottom: Edward Benson, Frank Jonas Sanache Sr., Willard Sanache, Dewey Youngbear. The men were assigned to the 168th Infantry, 34th Red Bull Division and were sent to North Africa, where they participated in the attacks on Italy under heavy shelling. Dewey Youngbear and Frank Sanache were captured by German soldiers in Tunisia, while Judie Wayne Wabaunasee was captured by Italians. They spent time in Italian and German prison camps; Youngbear and Wabaunasee both escaped their

respective camps, only to be recaptured. At one point, they arrived at the same prison camp in Germany and guards noticed that they knew each other. Youngbear suffered abuse from his captors for refusing to give information about his fellow code talker.[14] State Historical Society of Iowa, Iowa City, Iowa

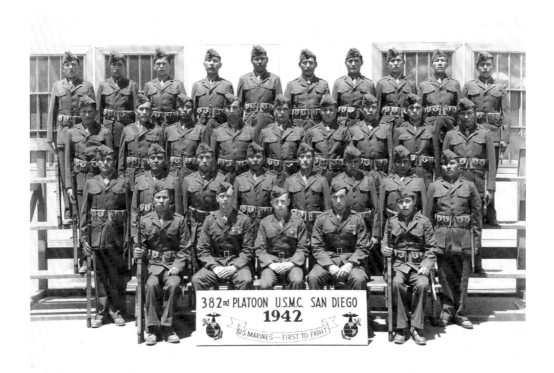

United States Marine Corps 382nd Platoon, the first platoon of Navajo code talkers to graduate boot camp. Camp Pendleton, San Diego, California, 1942. Official Marine Corps Photograph, provided by Command Museum, MCRD, San Diego

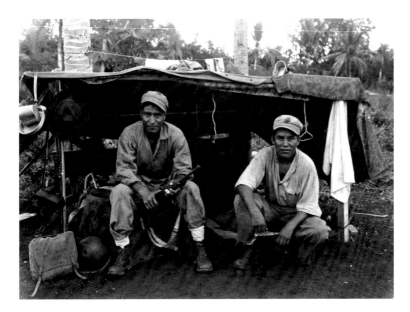

Navajo code talkers Private First Class George H. Kirk and John Goodluck, Guam, 1944. Official Marine Corps Photograph, provided by Command Museum, MCRD, San Diego

is the bomber, and the hawk is a dive bomber, and the patrol plane is a crow, and the hummingbird is the fighter."[15] Try as they might, enemy forces would never figure out that the Navajo word for potatoes meant hand grenades, and that "Our Mother" meant America.[16] Dispersed across six marine divisions fighting in the Pacific, the Navajo radiomen saw action in many pivotal battles, including Guadalcanal, Bougainville, Tarawa, Makin, Kwajalein, Eniwetok, Saipan, Guam, Tinian, Peleliu, Iwo Jima, and Okinawa.[17] By war's end, an estimated 420 Navajo code talkers had helped win the war in the Pacific.[18]

In Europe, as members of the Fourth Signal Company of the Fourth Motorized Infantry Division, the Comanche code talkers participated in D-Day (formally called Operation Neptune, the 1944 Allied invasion of Nazi-occupied Normandy, France), as well as many of the major campaigns that brought an end to the war in Europe, including the battles of the Hedgerows, Saint-Lô, the Hürtgen Forest, the Battle of the Bulge, and the liberation of Paris.[19] The first coded message on D-Day was communicated by Private First Class Larry Saupitty (Comanche), driver, radio operator, and general orderly for Brigadier General

Theodore Roosevelt Jr., the assistant division commander, to report that he had arrived safely: "*Tsaaku nunnuwee. Atahtu nunnuwee*," or "We made a good landing. We landed at the wrong place."[20]

After conversations from 1943 to 1944 between army, navy, and marine corps representatives had revealed distrust in the military's inability to monitor messages transmitted in Native languages, the army decided to limit their program's expansion, while the marine corps continued the Navajo code talker program. However, the military's insecurity regarding the Native code talkers resulted in the potential underutilization of hundreds of speakers.[21]

Ultimately, an estimated 534 American Indian men served as code talkers during World War II. Other than the handful of languages recruited and trained for type-one code talking, many smaller groups of language speakers from more than a dozen tribes were informally organized for communications, including the Crow, Chippewa, Oneida, Muscogee Creek, Pawnee, four dialects of Lakota / Dakota, and even the Canadian Cree, who were recruited as code talkers for the American Eighth Air Force, Ninth Bomber Command in London.[22]

Wayne Cooper, *Indian Code Talkers*, 2000. Oil on canvas. The painting depicts Charles Chibitty (Comanche) after landing at Utah Beach. Courtesy of the Oklahoma State Senate

After 1945, the classified status[23] of the Navajo code-talker program, the code talkers' reluctance to speak of their wartime experiences, as well as the passage of time combined to diminish American memory of and appreciation for the Native American code talkers' unique contribution to U.S. military victories. The Navajo code talkers received some recognition after their code was declassified in 1968, and they received recognition from Congress in 2001, when President George W. Bush presented Congressional Gold Medals to the four surviving members of the original twenty-nine Navajo code talkers. (Family members received medals on behalf of the non-surviving Navajo radiomen.) Then, in 2008, Congress authorized gold medals recognizing the additional Native nations whose language speakers served in World Wars I and II. Their "service…

deserves immediate recognition for dedication and valor," lawmakers declared. "[H]onoring Native American code talkers is long overdue."[24] Created with tribal involvement, the Congressional Gold Medals were presented to twenty-five of the tribes on November 20, 2013, at the U.S. Capitol.

ALEXANDRA HARRIS AND MARK HIRSCH

We're just a walking coding machine, that's all. Whatever we say comes out coded. Whatever the other guy [hears], it goes through his ears, it comes out un-coded.…In Navajo everything is in memory. From the songs, prayers, everything. It's all in memory. So we didn't have no trouble. That's the way we were raised up.

—William McCabe, Navajo code talker[25]

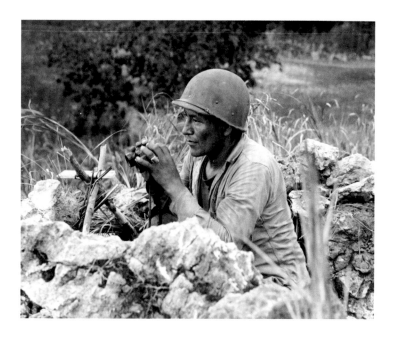

Code talker Private First Class Carl Gorman (Navajo) mans an observation post overlooking the city of Garapan, Northern Mariana Islands, June 27, 1944. Official Marine Corps Photograph, provided by Command Museum, MCRD, San Diego

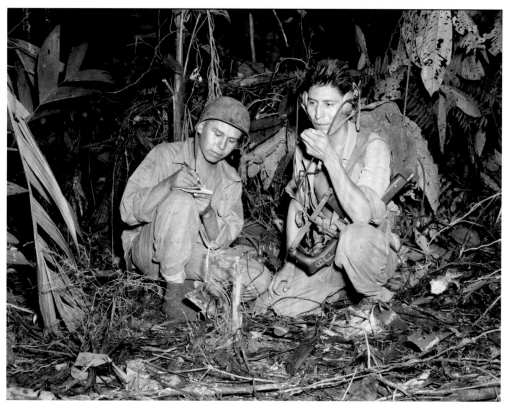

Navajo code talkers Corporal Henry Bahe Jr. and Private First Class George H. Kirk. Bougainville, South Pacific, December 1943. National Archives photo no. 127-MN-69889-B

J. T. Willie (Diné [Navajo], b. ?), *Diné Bizaad yee Nidaazbaa'ígíí (A Tribute to Our Navajo Code Talkers)*, 2015. Deer hide and tail; glass, turquoise, and gold beads; metal conchas, wool yarn, and dyes, 38.0 × 33.0 × 5.5 cm; 102.5 cm w/strap. NMAI 26/9693

Navajo members of the 158th U.S. Infantry pose in jungle grass, wearing regalia they made for a dance ceremony on an island in the South Pacific, January 20, 1944. Left to right: Private First Class Dale Winney and Private Joe Tapaha, of Gallup, New Mexico; Private First Class Joe Gishi and Private Perry Toney, of Holbrook, Arizona. National Archives photo no. 208-AA-Box 70-Folder X

WORLD WAR II

Alexandra Harris

AMERICAN INDIANS ENLISTED in overwhelming numbers after the attack on Pearl Harbor in 1941. Forty-four thousand (more than 24,000 reservation and 20,000 off-reservation) Native Americans from an estimated population of under 400,000 saw active duty, including nearly 800 women—between 5 and 10 percent of the entire Native population.[1] Commenting on the high rate of enlistment in Indian Country, the Commissioner of Indian Affairs John Collier noted that their participation "represents a larger proportion than any other element of our population."[2] Native servicemen earned at least 71 Air Medals, 34 Distinguished Flying Crosses, 51 Silver Stars, 47 Bronze Stars, and 5 Medals of Honor. Roughly 20 percent of all American Indians, men and women, were involved in the war effort, either in the service or working in war-related industries on the home front.[3]

Reasons for service in World War II were as subjective as in any other conflict, though, arguably, previous wars had not provided the same level of opportunity for American Indians. The military attracted tens of thousands of Native people for reasons including defense of democracy, anger at German and Japanese military aggression in Europe and Asia, and a vested interest in retaining treaty rights (i.e., not losing them should another country invade). The need for skilled labor in wartime industries also provided opportunities to learn trades and acquire a stable income for those at home.[4] Lewis Naranjo (Santa Clara Pueblo) reflected, "We are fighting with Uncle Sam's army to defend the right of our people to live our own life in our own way."[5]

Indian boarding schools provided recruits for military service as well as labor in defense-related industries. Established in the nineteenth century to assimilate young Native men and women into mainstream American culture, boarding schools were run in a military style, with organized companies, uniforms, and strict discipline. As part of their acculturation, students at Indian boarding schools were taught agricultural and industrial skills to prepare them for life and labor in a market economy. The boarding schools' military and industrial value was not lost on the Bureau of Indian Affairs. In 1941 and '42, John Collier designated six Indian Service boarding schools as defense training centers.[6]

Founded in 1884, the Chilocco Indian Agricultural School near Newkirk, Oklahoma, educated boys and girls from tribes across the United States. Chilocco was one of the first boarding schools to adapt an aircraft sheetmetal

Company I of the 180th Infantry Regiment, Forty-Fifth Infantry Division. Camp Barkeley, Texas, April 5, 1941.
Courtesy of the 45th Infantry Division Museum

Many students from Chilocco Indian Agricultural School, an Indian boarding school, were members of Companies C and I of the 180th Infantry Regiment. Lieutenant Jack Montgomery (Cherokee) is seated in the front row, far right. Montgomery earned the Medal of Honor for his bravery during the Battle of Anzio, Italy.

Chilocco Company C, 279th Infantry Regiment, in front of the Chilocco Indian Agricultural School entrance. Near Newkirk, Oklahoma, ca. 1950. Courtesy of the 45th Infantry Division Museum

The Thunderbirds got their name from their shoulder patch. Each side of the square represents one of the four states—Oklahoma, Colorado, Arizona, and New Mexico—that originally populated the division. The colors reflect the Hispanic heritage of those states.

Originally a traditional American Indian design similar to the Nazi swastika, the emblem had to change once Hitler rose to power and the symbol took on a different meaning. After holding an art competition, the division adopted in 1939 the thunderbird motif, designed by Kiowa artist Woody Big Bow (1914–1998). United States Holocaust Memorial Museum Collection

course for defense, educating about three hundred women and men for work in wartime industries.[7] The 180th Infantry Regiment, Forty-Fifth Infantry Division, of the Oklahoma National Guard included many current and former Chilocco students. After the attack on Pearl Harbor, many of Chilocco's staff and students enlisted in all military branches.

The Forty-Fifth Infantry Division, known as the Thunderbirds for their distinctive insignia, became one of America's most acclaimed World War II combat units. Many American Indians served in the Forty-Fifth, including three who received the Medal of Honor: Jack Montgomery (Cherokee, 1917–2002), Van T. Barfoot (Choctaw, 1919–2012), and Ernest Childers (Muscogee [Creek], 1918–2005).

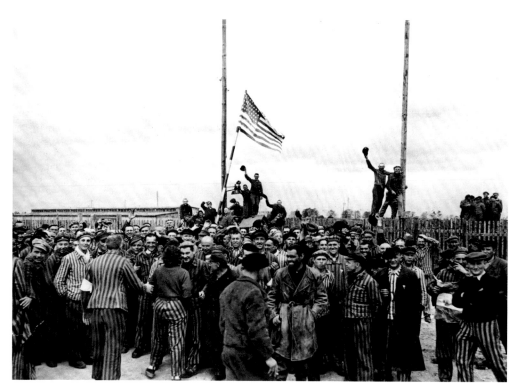

As soldiers of the Forty-Second and Forty-Fifth Infantry Divisions of the Seventh United States Army arrived, prisoners at the Dachau concentration camp rejoiced in their freedom by raising a homemade American flag. Dachau, Germany, April 30, 1945. National Archives photo no. 111-SC207745 (Album 1469)

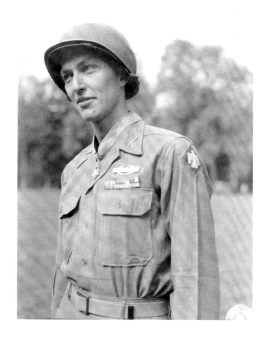

Second Lieutenant Van T. Barfoot was awarded the Congressional Medal of Honor by General Alexander M. Patch. Seventh Army, France, September 28, 1944. National Archives photo no. 111-SC-195392

Among the many actions of valor that Barfoot exhibited to earn the honor was his single-handed destruction of machine guns with grenades and his own submachine gun. He also captured seventeen prisoners and, later the same day, used a bazooka to disable a tank while leading his men through newly captured ground.

Formed as a National Guard unit in 1923, the Thunderbirds deployed to North Africa in June 1943. After invading Sicily and participating in the bombardment of Salerno and Anzio in Italy, the division invaded southern France and engaged in fierce combat in the Vosges Mountains before crossing the border into Germany. There, the Forty-Fifth liberated Dachau concentration camp, freeing more than thirty thousand prisoners. General George Patton said to the Thunderbirds, "You are one of the best, if not the best, divisions in the history of American arms."[8] American Indians made up about one-fifth of the Forty-Fifth Infantry Division, and as the Forty-Fifth endured some of the heaviest combat of the war, Indians suffered heavy losses in turn.[9]

In battles pivotal to the war's success, Native people not only were present but also played important roles. An estimated five hundred American Indians participated in Operation Neptune, commonly called D-Day, on June 6, 1944. On the Normandy coast at Omaha Beach was Private Charles Shay, a nineteen-year-old Penobscot army medic from Indian Island, Maine. Shay pulled supply-laden, drowning infantrymen out of the sea, tended the wounded, and comforted the dying. For his bravery he was awarded the Silver

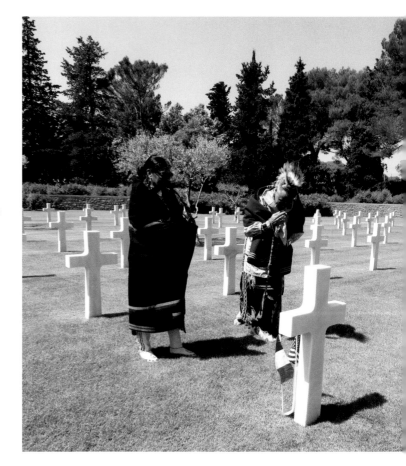

Private Andrew Perry (Choctaw, 1920–1944), who served in the 180th Infantry Regiment, Forty-Fifth Infantry Division, was a type-two code talker. In 2017, Perry's niece, Debbie Cheshewalla (Choctaw), along with her cousin Chad Renfro (Osage), attended the Memorial Day Ceremony at Rhone American Cemetery, in Draguignan, France, resting place for 858 U.S. war dead, most of whom lost their lives during the liberation of southern France in August 1944. At least 92,958 U.S. service members who fought in and died during World War II are buried abroad.[10]
American Battle Monuments

Star; much later, in 2007, French President Nicolas Sarkozy honored him with the Légion d'Honneur.[11]

Upon landing at Utah Beach the following day (D-Day Plus One), twenty-three-year-old Corporal Charles Chibitty—one of fourteen Comanche code talkers to serve in World War II—relayed a message to another Comanche.[12] Translated to English, it said: "Five miles to the right of the designated area and five miles inland, the fighting is fierce, and we need help."[13] In an interview with the National Museum of the American Indian in 2004, Chibitty recalled, "Utah Beach in Normandy was something else. Everybody asked me if I would go through it again, and I said, no, but I could train the younger ones how we used our language and let them go ahead and do it because it was hell."[14]

Serving in a different theater of the war, Corporal Ira Hamilton Hayes (Pima, 1923–55) remains one of the best-known American Indians to serve in World War II. In 1945, Hayes was one of the six servicemen who raised an American flag on top of Mount Suribachi on February 23, 1945, during the Battle of Iwo Jima in the South Pacific—memorialized in a Pulitzer Prize–winning photograph by Joe Rosenthal and then immortalized by the Marine Corps War Memorial, located just outside Arlington National Cemetery. The

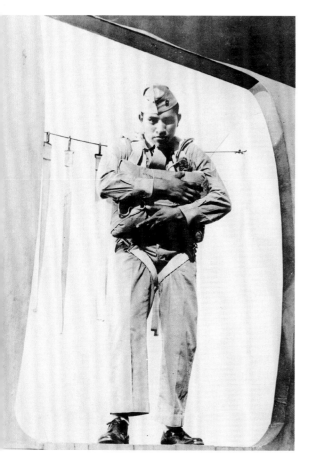

men became national heroes. "Sometimes I wish that guy had never made that picture," confessed Hayes, who afterward attempted without success to lead a private life. Uncomfortable with fame, Hayes succumbed to alcoholism and died at age thirty-three. He was buried with full honors at Arlington.

Infrequently told is the story of the first flag raising on Mount Suribachi—the famous photograph was of the second raising of a larger flag, later on the same day. Another Native marine, Louis Charlo (Bitterroot Salish), was nearby when the American flag was first raised on the mountaintop. Seeing their national colors, the surrounding marines, sailors, and coastguardsmen erupted in cheers. Charlo was killed several days later while rescuing a wounded comrade.[15]

Ira Hayes, age nineteen, at the United States Marine Corps Parachute Training School, where he was dubbed Chief Falling Cloud. San Diego, California, 1943. National Archives photo no. 519164

General Douglas MacArthur, commander-in-chief of the Allied forces in the South Pacific, on an inspection trip of American battle fronts, late 1943. From left: Staff Sergeant Virgil Brown (Pima), First Sergeant Virgil F. Howell (Pawnee), Staff Sergeant Alvin J. Vilcan (Chitimacha), General MacArthur, Sergeant Byron L. Tsingine (Navajo), Sergeant Larry Dekin (Navajo).
National Archives photo no. 111-SC-352188

The historic photograph by Joe Rosenthal, taken on February 23, 1945, depicts five marines and a navy corpsman raising a U.S. flag atop Mount Suribachi during the battle for the island of Iwo Jima in World War II. Ira Hayes is on the far left. National Archives photo no. 520748

Seagoing Indian

JOSEPH R. TOAHTY

THE FIRST American Indian to participate in an offensive operation with United States naval forces in World War II has returned to the United States after almost two years' service in the Southwest Pacific as a Coast Guard Invader.

Motor Machinist's Mate Le-tuts-sta-ka-ha, 23, of Pawnee, Okla., whom official service records list as Joseph R. Toahty, has been granted a 30-day furlough to recuperate from five attacks of maleria contracted during four months' consecutive duty on Guadalcanal.

Emulating his paternal namesake, powerful Civil War Pawnee Chief White Eagle, who gave invaluable service to the nation as a Federal Army scout, Toahty has been serving in the Southwest Pacific aboard troop landing barges; and when Marines first landed at Guadalcanal last August some were put ashore by the young graduate of famous Haskell Institute for Indians, Lawrence, Kans.

Toahty, who is the first Pawnee ever to go to sea, will be tendered a high ceremonial when he returns to his tribe. He has a younger brother, Benjamin, who enlisted in the Navy last Christmas; while older Brother Benjamin serves in the Army.

He recalled that "while it gave me a big thrill to be in on the Guadalcanal offensive, by far the most exciting thing which happened to me in the Southwest Pacific was when Polynesian natives of New Zealand gave an all-day ceremonial in my honor."

"I was the first American Indian they had ever seen," Toahty explained, "and they went all out to honor my presence. They treated me as if I were a king; and in fact one of the dances they performed was reserved strictly for royalty. I hated to leave that village."

Motor Machinist Mate Joseph R. Toahty Sr. (Le-Tuts-Taka, or "White Eagle," Pawnee/Kiowa, 1919–1997) was reportedly the first Pawnee citizen to go to sea, as well as the first American Indian to participate in the U.S. naval offensive operations in World War II and to step foot in Japanese-held territory. Toahty suffered injuries from an explosion during a Japanese air attack but was not recognized with a Purple Heart until 1984. After the war, he continued to support veterans, serving in war bond drives with military members and celebrities. At home in Oklahoma, Toahty was a member of several American Indian warrior societies. In retirement, he volunteered to help Vietnam veterans claim benefits for exposure to Agent Orange and process discharge papers.[16] *Coast Guard Magazine*, courtesy United States Coast Guard

Private Simeon Pletnikoff (Aleut, 1919–1997) on board a transport ship bound for Attu, a Japanese-held island in the Aleutians. Pletnikoff was reportedly the most decorated army soldier in the Aleutian Campaign.[17] Though Aleut men mainly entered the services after the U.S. government's evacuation of the Aleut villages in 1942, some, like Pletnikoff, enlisted early. He recalled of his time on Attu: "I had a heck of a time. Out on the front line the Americans would get a hold of me and want to kill me and all that. They tried to take me to the Provost Marshal for impersonating a U.S. soldier. 'What's the matter with you guys? I'm an Aleut.'"[18] National Archives

Clarence L. Tinker, commander of the 20th Pursuit Group, in front of a Boeing P-12, Mather Field, California, about 1930. Tinker Air Force Base Historical Archives

Major General Clarence L. Tinker (1887–1942) was the first Native American in United States Army history to attain the rank of major general and the first U.S. general to die in World War II. An Osage citizen from Pawhuska, Oklahoma, Tinker was educated at the Osage Indian Boarding School; the Haskell Institute, a Native American boarding school in Lawrence, Kansas; and the Wentworth Military Academy, in Lexington, Missouri. In 1920, he joined the United States Army Air Service—a precursor to the Army Air Forces of World War II and its successor, the Air Force—becoming an accomplished flier with extensive knowledge of aerial pursuit and bombardment.

After the Japanese attack on Pearl Harbor in December 1941, General Tinker was given command of the Army Air Corps stationed in Hawai'i. It was a difficult challenge. Approximately 75 percent of the planes on the airfields surrounding Pearl Harbor were damaged or destroyed, and more than two hundred Army Air Corps personnel were killed. Undaunted, Tinker set out to train combat crews and repair and modify damaged aircraft, getting airmen and their planes into battle readiness.

When the Japanese began their massive June 1942 attack on Midway—a small but strategically significant Pacific island halfway between Asia and North America—Tinker elected to lead one of several high-level bomber attacks on the Japanese fleet. Refusing to delegate leadership of the dangerous mission to a subordinate, Tinker and his ten-man crew boarded their LB 30 bomber (a British version of the American B-24D bomber) in the predawn hours of June 7, 1942. The aircraft was last seen falling out of formation, disappearing into the clouds below, and crashing into the sea, killing Tinker and the entire crew. "He died knowing that he had an important part in winning a great victory," Lieutenant General Delos C. Emmons, military governor of Hawai'i, remarked of Tinker's role in the Battle of Midway, regarded as perhaps the most important air and sea engagement in the Pacific theater during World War II. Cited for "exceptionally meritorious and distinguished service," Tinker was posthumously awarded the Distinguished Service Medal.[19]

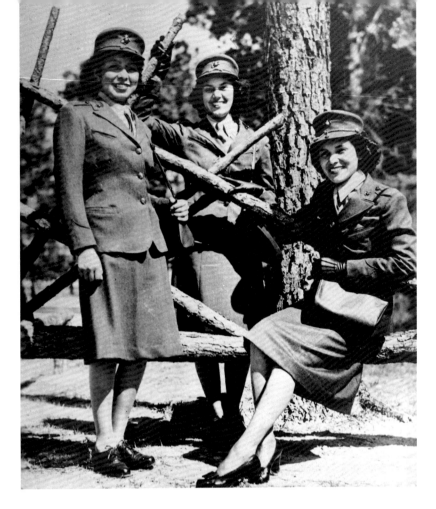

Marine Corps Women Reservists, Camp
Lejeune, North Carolina, October 16, 1943.
From left: Minnie Spotted Wolf (Blackfoot),
Celia Mix (Potawatomi), and Viola Eastman
(Chippewa). National Archives photo no.
535876

World War II veteran Ruby Whiterabbit
(Ho-Chunk), 1940s. The war bonnet, worn
by chiefs and warriors, was not traditional
among the Ho-Chunk until it came to them
through the Lakota, with whom they par-
ticipated in Wild West shows.[20] Wisconsin
Historical Society, WHS-64315

On November 25, 1942, the army and navy awarded Solar Aircraft Company in San Diego, California, the Army–Navy Production Award—the "E" Award—"for high achievement in the production of war material." During the official presentation of the award, each of the men and women employed at the plant was presented with "E" lapel pins. Accepting for the women of Solar was Louise Ortega (third from right), a welder and Sherman Indian School graduate from the Los Coyotes Reservation near Warner Springs, California.[21] National Archives at Riverside

In 1944 alone, forty-four thousand American Indians left their reservations to seek jobs.[22] By the same year, the Sisseton Sioux, Potawatomi, Navajo, and Pueblo Indian agencies reported that 25 percent of the tribal population had left for urban areas. In 1940, fewer than 5 percent of Native American people lived in cities; by 1950, that number had risen to around 20 percent.[23] Such a diaspora often caused scarcity in labor at home, but it offered many opportunities for those who left.

About eight hundred Native American women were accepted into the WAC (Women's Army Corps) and Waves (Women Accepted for Volunteer Emergency Service, a naval reserve), some serving for the duration of the war, others for their career. Hundreds more trained in Indian service schools for aircraft industries on the West Coast. Estimates of Native women in war industries in 1943 topped 12,000, around 25 percent of the total population that had moved from the reservation for work.[24]

Not all women worked in industries that directly supported the war effort. As in other parts of the country, with male labor largely absent, women left on the reservation took over jobs previously occupied by men, in addition to assuming household, farming, and livestock care. Pueblo women took auto-mechanic training classes and drove trucks, hauling freight throughout the

Cherokee mother on the Qualla Boundary (Eastern Band of Cherokee Indians) in western North Carolina's Great Smoky Mountains buys a war bond from Postmaster Amelia Walkingstick, 1944.
Bettmann/Getty Images

Southwest.[25] Even though they remained at home, their horizons expanded, economically, culturally, and literally.

Native American soldiers, sailors, marines, coastguardsmen, and airmen, supported by Native women and relatives on the home front, played influential roles in all theaters of World War II. The war had significant lasting effects for Native people as a whole. An estimated 150,000 American Indians had worked directly to support the war in military, agricultural, and industrial capacities. White Americans expected Native people to relinquish their tribal associations, but many of the Indian people who stayed living in cities retained the connection to home, family, and culture—albeit forever changed by distance and wartime experience. Newly gained social awareness and education overcame the previous physical and cultural isolation from mainstream America. In the post-war era, advocates for American Indian rights fought for self-determination and political action.[26] In her 1944 book, *Speaking of Indians*, Standing Rock Sioux scholar Ella Deloria wrote that the war "wrought an overnight change in outlook, horizon, and even habits of the Indian people—a change that might not have come about for many years yet."[27]

Teri Greeves (Kiowa, b. 1970), *Sovereign Citizen*, 2008. Bamboo, glass beads, waxed linen; 35.5 × 28 cm.

Sovereign Citizen features figures in uniforms from World Wars I and II to connect Native American citizenship, voting, and veterans' rights. Courtesy of the artist

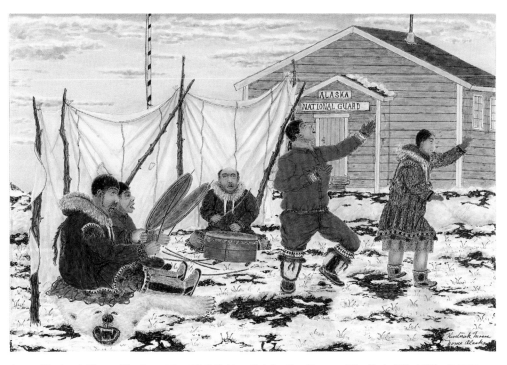

James Kivetoruk Moses (Iñupiaq, 1901–1982), *Eskimo Celebration Dance at the End of World War II*, 1962. Paperboard, colored pencil, ink, watercolor. NMAI 26/2288

THE NATIVE HAWAIIAN RESPONSE
TO THE ATTACK ON PUʻULOA

The Japanese attack on Puʻuloa (the Hawaiian name for Pearl Harbor) on Oʻahu on December 7, 1941, came as a shock to most people on the island, including high school students attending the Kamehameha Schools (KS). Established in 1884 by the will of Princess Bernice Pauahi Bishop (great-granddaughter of King Kamehameha I) upon her death, the boarding schools—one for boys and one for girls—were exclusively for Native Hawaiians. The two campuses sat high on the Kapālama hillside with a clear view of Pearl Harbor below; thus the students and staff bore witness to what they initially thought was a military training exercise on the morning of December 7. Over the next twenty-four hours, anti-aircraft shells fired from Pearl Harbor hit the campus, one

destroying a section of a rock wall and another remaining embedded in a field for days until its removal by the United States Army.[1] Evacuees from the Japanese attacks (which took place on multiple military bases on Oʻahu) began filing on to Kapālama. The campus was later declared a wartime hospital for women and children, in which KS girls, trained in nursing, assisted patients.[2]

Kamehameha students were perhaps more prepared for the outbreak of war than other high school students in the Territory of Hawaiʻi. The boys' school, which had been officially recognized as a military institution since 1908, had a Junior Unit of the Reserve Officer Training Corps (ROTC). Senior boys were issued old World War I rifles and assigned to

Bill Puniwai, left, and Curtis Kamai were among those who guarded Kamehameha's water reservoir above the Kamehameha School for Girls. Used with permission from Kamehameha Schools

Student and faculty guards shared continuous day and night shifts in the hills of Kuahiwi ʻAlapaki above the Kapālama campuses following the December 7, 1941, attacks. Used with permission from Kamehameha Schools

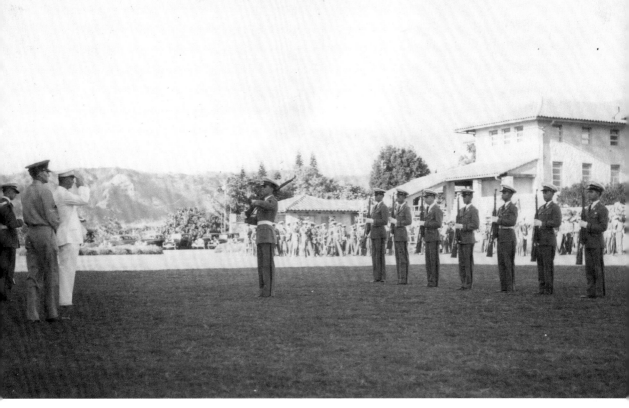

ROTC cadets from the Kamehameha School for Boys in battalion formation on Konia Field prior to the outbreak of war, 1941. Used with permission from Kamehameha Schools

guard the campus's water supply from any Japanese paratroopers who were (falsely) reported to be landing in the forested uplands. The late Senator Daniel Akaka, who was among this group, recalled in his memoir that the only eyes he encountered in those chilly nights were those of a two-hundred-pound wild sow and her piglets.[3]

The memories of other former KS students paint vivid pictures of Hawaiian experiences and interpretations of Pearl Harbor.[4] Kauaʻi native Louis "Buzzy" Agard, a member of the class of 1942, recalled that on the morning of December 8, their ROTC director, Lieutenant Ainsley Mahikoa, had a bus ready for any seniors who wanted to go downtown to volunteer for the Hawaiʻi Territorial Guard. Agard did so, and in the first twenty-four hours he performed guard duty at the various public utilities (e.g., water, electricity, and telephone) buildings in Honolulu. En route to an army

base on the other side of the island the following day, Agard and his companions were detoured to Pearl Harbor, where he witnessed the sight of charred bodies being dragged out of the water, the stench of which "stayed with you for at least a couple of days later."[5] Although Agard was discharged a few days later for being underage, the experience left an indelible mark. In 1966, he self-published a small pamphlet titled *Pacific Pearl Epic* and gave tours at Pearl Harbor while he was a commercial fisherman.

The meanings Hawaiians attribute to December 7 are complex, contradictory, and open-ended. The KS students who picked up arms during World War II also came from families suffering the cultural suppression and economic marginalization that accompanied America's forced annexation of the Hawaiian Kingdom in 1898—an event motivated by the United States' interest in developing a naval station at Puʻuloa that would propel

the expansion of its empire into the Pacific. Despite this colonial history, the KS students all maintained an abiding loyalty to the land under any flag that led to lifelong service to their people. Senator Daniel Akaka (who served in the Army Corps of Engineers in Saipan and Tinian at the end of the war) pursued the path of federal recognition through a bill he sponsored between 2000 and 2012 that unsuccessfully attempted to create a nation-to-nation relationship between the Hawaiian people and the United States. Buzzy Agard (who was stationed at Schofield Barracks from 1945 to '46) honored the sacrifices of those who died at Pearl Harbor while also recalling the ways that the United States Navy forced Kamehameha Schools to sell their lands at Puʻuloa for construction of their base. He spent much of his life educating the broader community on the need for restorative justice for the Hawaiian people as well as for conservation measures for the islands' marine resources. Their classmate, Kekuni Blaisdell, a renowned activist and physician, was a vocal leader of the Hawaiian independence and demilitarization movement after the war. His political convictions were shaped by his experiences living under martial law in Hawaiʻi during World War II, serving as a battalion surgeon in the Korean War, and later researching hematological disorders in Japan with the Atomic Bomb Casualty Commission. The labors and service of these individuals (like those of many other men and women of their generation) have set the foundation for young Indigenous Hawaiians today to return to their histories as well as imagine a new sovereign future for their lands and their peoples.

DR. TY P. KĀWIKA TENGAN

THE ALASKA TERRITORIAL GUARD

In June 1942 the Japanese invaded the U.S. Territory of Alaska, bombing Dutch Harbor and occupying the Aleutian Islands of Attu and Kiska. The Japanese occupation shocked the American public and fueled U.S. military concerns about defending Alaska's vast 6,640-mile coastline (as a measure, California has 840). Although the U.S. military had been sending troops, constructing airplane runways, and developing railroads in the region before World War II, deploying regular soldiers was impossible in road-shy Alaska. In addition, the terrain and weather of Alaska are some of the most challenging on earth, especially in winter. This was a problem, as the army had never developed good winter fighting clothes or equipment. To meet these unique circumstances, Territorial Governor Ernest Gruening and Major Marvin Marston created the Alaska Territorial Guard (ATG), or "Eskimo Scouts,"[1] who would serve as the eyes and ears of the military along the expanse of the Alaska coast."[2] Traveling by dogsled with Native guide Sammy Mogg, Major Marston visited and organized Alaska Natives. More than 6,300 people from 107 communities volunteered for the ATG.[3]

Recruiting and training Alaska Natives for the military raised concerns. Racial discrimination was widespread: bars, restaurants, movie houses, and other social places were normally segregated. Some areas in Nome, Juneau, Fairbanks, Anchorage, and other communities were restricted for whites only.

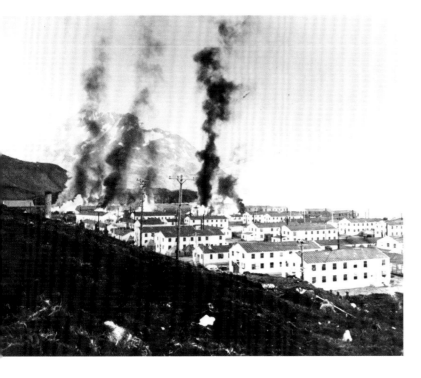

Fort Mears on fire after Japanese aircraft struck U.S. Army and Navy installations at Dutch Harbor, Unalaska Island, Alaska, on June 3, 1942. The raid, which came six months after the Japanese attack on Pearl Harbor, claimed 43 U.S. lives, including 33 soldiers. Courtesy of the U.S. Naval Institute Photo Collection. Naval History and Heritage Command website. Catalog # 80-G-12031

The Bureau of Indian Affairs operated a separate Native school system. My father, Tommy Ongtooguk, attended the Alaska Native elementary school in Nome. Native Alaskans were routinely paid half as much as whites for the same work. Given this treatment, the prospect of arming and training them aroused fears of a violent backlash against non-Native Alaskans.

As it turned out, there was nothing to worry about; Alaska Natives were eager to serve. Recruits were required to bring good winter clothing, be able to march along terrain that allowed little room for weakness or mistakes, and be able to shoot a rifle well. Some joined as young as twelve years old and as old as eighty—but they were all fit.[4] More than twenty-seven Alaska Native women were ATG members, including Laura Beltz Wright, who outshot everyone in her village.[5] She was not the only woman to do so.

The ATG were taught military drill and communication systems and how to identify Japanese aircraft and ships. They were trained

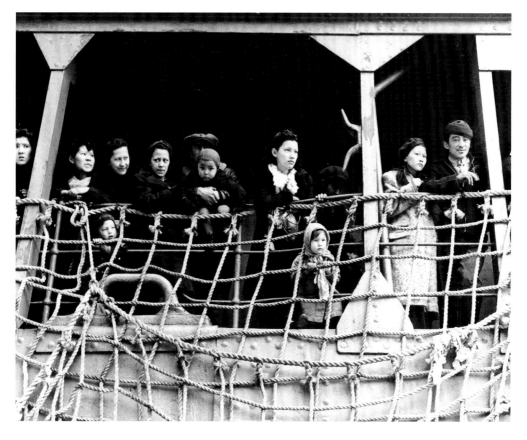

Residents of Alaska's Pribilof Islands, located in the Bering Sea between the United States and Russia, gaze at their homes as the USS *Delarof* pulls away from the dock at Saint Paul Island in 1942. In response to Japanese aggression against the Aleutian Islands—as well as anticipated enemy attacks on the Pribilof Islands—U.S. authorities scrambled to evacuate the islands' Aleut people, allegedly for the residents' own well-being. Ushered aboard cramped transport ships, the displaced families were transported to southeastern Alaska, where they were resettled for the next three years in fish canneries, abandoned mine buildings, and other substandard and unsanitary quarters. Approximately 100 of the 881 interned evacuees died by war's end. National Archives photo no. DHBR-9041

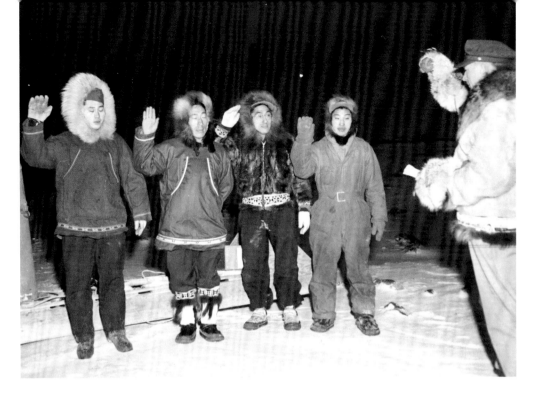

ABOVE: A military officer swearing in four Alaska Territorial Guardsmen for an assignment at noon in Barrow, Alaska, on the shore of the Arctic Ocean. Ernest H. Gruening Papers, 1914-[1959–1969] 1974, Alaska & Polar Regions Collections, Archives, University of Alaska Fairbanks

LEFT: Magnus Colcord "Rusty" Heurlin (1895–1986), Alaska Territorial Guard poster, ca. 1942. This artwork was used nationwide as a war-bond-drive poster. University of Alaska Museum of the North, UA1969-007-001. Photographer Karinna Gomez.

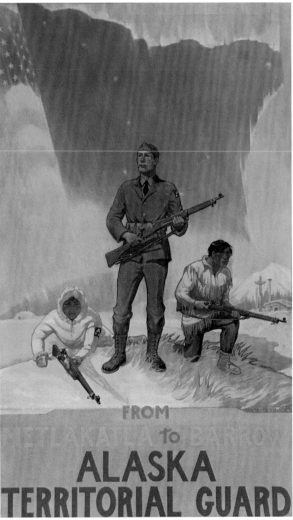

FROM
to BARROW
ALASKA
TERRITORIAL GUARD

The USS *Pruitt* leads landing craft from the USS *Heywood* on the first day of the U.S. campaign to retake Attu, westernmost of the remote Aleutian Islands, which was occupied by Japanese forces in June 1942. Although American forces regained Attu in June 1943, the victory came too late for forty-two of the island's Indigenous Aleut residents, who had been taken to Japan as prisoners of war. When the war ended, the twenty-four surviving Aleut returned to the United States, but were not allowed to return to their homes on Attu Island. Courtesy of the U.S. Naval Institute Photo Collection. Naval History and Heritage Command website. Catalog # NH 78232

to patrol, scout, and ambush the enemy— skills that many Alaska Natives already knew well; our long history of protecting traditional boundaries of tribal resources, lands, and waters from other tribes endured well after the 1900s. ATG members brought to their service thousands of years of learning and living on the lands and waters they were called on to protect. The skills, knowledge, and connections to these homelands were crucial aspects of their effective service.

The ATG watched the borders, spotting and shooting down Japanese incendiary balloon bombs that traveled the jet stream and ignited forest fires on impact.[6] In order to prevent public panic, the existence and effectiveness of these weapons were classified information. The ATG's role in finding and reporting these weapons was revealed many years after the force was disbanded.

The social impact of serving in the ATG was significant. Many ATG volunteers learned more about neighboring villages and cultural groups, some of whom had been traditional rivals. The ATG also laid the groundwork for social and political collaboration. After the war, ATG Alaska Natives rightly felt they had earned their place as equals with other Alaskans and advocated further for racial equality.[7]

Many participated in the regular military after the ATG was disbanded in 1947. My father was among them. He served in the Army Air Forces, and later the Air Force when it became a separate branch. The war was an education in western political systems and leadership, and upon their return home veterans organized and advocated for Alaska Native peoples and communities.

ATG members were finally recognized as veterans in 2000. My grandfather, Charley Ongtooguk, and my dad both served in the ATG. Being a member of the ATG was and still remains a symbol of honor and respect in many Alaska Native communities and circles.

This medal, issued to honor the members of the Alaska Territorial Guard who served in Alaska's remote rural villages in World War II, was presented to Tommy M. Ongtooguk ca. 1980. Photo by Tim Remick, courtesy of Paul Ongtooguk

Tommy M. Ongtooguk (Iñupiaq, 1922–2002), 1953. Courtesy of Paul Ongtooguk

The only medal my dad wanted buried with him was his medal of service as a member of the ATG, given to him late in his life by a commanding officer of the Alaska National Guard. In this, he was not much different from his fellow ATG service members. Their story is a small but important chapter in the history of Native American warriors who have served the United States of America.

PAUL ONGTOOGUK

GRACE THORPE'S LIFE AND LEGACY

Grace Thorpe (Sac and Fox, 1921–2008), was a World War II veteran and Native rights activist. The daughter of famed athlete Jim Thorpe, Grace served in the Women's Army Corps (WAC) from 1943 to 1945. She served as a recruiter for the WAC before being sent overseas to New Guinea, the Philippines, and Japan in 1944. Corporal Thorpe was later awarded the Bronze Star for her service in the Battle of New Guinea.[1] Following the end of the war, Thorpe remained in Japan with her husband, Lieutenant Fred W. Seely, and worked at General MacArthur's headquarters as chief of the Recruitment Section, Department of Army Civilians.[2]

In the 1960s Thorpe moved to Arizona, where she became involved with American Indian issues and activism. She was appointed Economic Development Conference coordinator for the National Congress of American Indians' 1968 and 1969 conferences.[3] Between 1969 and 1970, Thorpe joined Native American activists at the occupation of Alcatraz Island for three months and managed their publicity.[4] She then served as a congressional intern from 1974 to 1975 for Senator James Abourezk of South Dakota. Thorpe was later appointed as a legislative assistant with the Senate Subcommittee for Indian Affairs and as a task force program and planning analyst for the American Indian Policy Review Commission, which made sweeping policy recommendations for improving the relationship between the federal government and Indian nations.[5] During this time she also began working on the restoration of her father's 1912 Olympic titles (stripped from him when it was discovered he had played professionally) as well as other projects to recognize and honor her father.[6]

Grace Thorpe, posed in Women's Army Corps uniform, 1943. Grace Thorpe collection (NMAI.AC.085), photo folder 7, NMAI

After returning to her tribal homeland in Oklahoma, she became active in tribal affairs and in 1982 successfully restored her father's Olympic record.[7] In later years, Thorpe served her tribe as a tribal district court judge and health commissioner, and in 1999 she earned a Nuclear-Free Future Award for her opposition to storing nuclear waste on tribal lands.[8] She remained active in Native American issues, a matriarch and genealogist of the Thorpe family, and involved with her grandchildren and great-grandchildren. Thorpe's daughter, Dr. Dagmar Seely, and granddaughter, Tena Malotte, donated Grace Thorpe's collection of personal papers, photographs, and medals to the Smithsonian's National Museum of the American Indian in 2015.

RACHEL MENYUK

Grace Thorpe at work in General MacArthur's headquarters in Tokyo, Japan, in December
1945. Grace Thorpe collection (NMAI.AC.085), negative box 8, item 19, NMAI

Grace Thorpe at the Sac and Fox Courthouse in Stroud, Oklahoma, 1997. Grace Thorpe
collection (NMAI.AC.085), photo folder 124, NMAI

JOE MEDICINE CROW:
THE ART OF CAPTURING HORSES

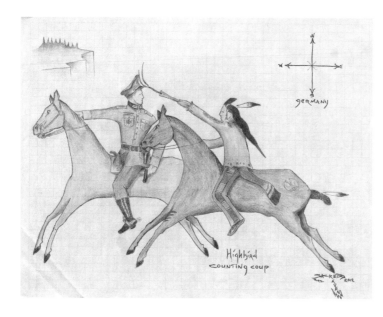

Chester Medicine Crow
(Apsáalooke [Crow],
b. 1973), *Highbird Count-
ing Coup*, 2012. Graph
paper, graphite, colored
pencil, ink, 21.6 × 27.8 cm.
NMAI 26/8974

Joe Medicine Crow rides
close to an enemy and
hits him on the head with
a riding quirt. Getting
close to an enemy was
considered a coup, or
achievement.

Capturing a prize horse from an enemy was
the dream of every aspiring Plains Indian war-
rior. The successful horse thief had every right
to boast about his exploit. He might depict it
in a pictograph drawing on his *tipi* cover, wear
a beaded vest or shirt featuring the horse he
had captured, or carve a wooden effigy that he
would hold during an honor ceremony dance
or other important community events. These
traditions have survived even into the twenty-
first century, particularly among the Crow of
southeastern Montana, who still cherish their
horses and warrior traditions.[1]

Joe Medicine Crow (1913–2016) grew up lis-
tening to the stories of his grandfather White
Man Runs Him and the other veterans of
the Indian wars. In World War II, he got the
chance to capture his own horse in the finest
tradition of a Plains Indian warrior. Near the
end of the war, his platoon followed a group

of S.S. officers retreating on horseback. Since
the Germans were riding on an asphalt road,
the U.S. soldiers could hear the clop, clop
of the hooves ahead of them. Near daybreak,
the horsemen went to a farm about three miles
down a dirt road where they planned to hide
during the day. "We followed their trail in the
moonlight and arrived at a villa," remembered
Medicine Crow. "We came there and found a
little pasture with a barn." The commanding
officer sat down with the platoon leaders to
discuss how best to handle the situation. "All I
could think about was those horses in the pad-
dock." As the commanding officer gave orders
to platoon leaders, Medicine Crow mentioned
the horses.

I said, "Maybe I should get those horses out
of the corral before you attack because some
of those S.S. guys might be able to escape

on them. It would only take me about five minutes." The C.O. looked at me funny for a second, but he probably had an idea of what I was up to. I was the only Indian in the outfit, and he always called me "Chief." He said, "O.K. Chief, you're on." That's all I needed. I took one of my buddies and we sneaked down towards the corral and the barn. Nothing was moving. The horses were tired, just standing around. I crawled through the paddock fence and came up to one of them. I told him, "Whoa. Whoa." He snorted a little bit, but settled down. I had this little rope with me that I used to tie my blanket. It was about six feet long. I tied a loop around his lower jaw like the old-time Crow warriors used to do, and then I tried to get on, but it was a tall horse, and my boots were so muddy and caked up, I couldn't do it. Finally, I led the horse to the watering trough and stood on that to get on its back. Meanwhile, I told my buddy that I was going to the other end of the paddock behind the horses. "As soon as I get there," I said, "I will give a little whistle, and when I do you open the gate and get out of the way." Well, I got back there, gave the whistle, then a war whoop, and started the horses moving. The kid took off and here they come. Just about that time our boys opened fire on the farmhouse. There was lots of commotion. I just took off. There was some timber about half mile away, so I just headed that way. By that time it was daylight, so as we galloped along I looked at the horses. I had about forty or fifty head. I was riding a sorrel with a blaze, a real nice horse. So I did something spontaneously. I sang a Crow praise song. I sang this song a little bit, and rode around the horses. The horses looked at me. Finally, I left them in the woods, but I stayed on my horse and headed back to the farmhouse. The firing had stopped by now. The Germans had surrendered real quick. So I came back. After we finished mopping up, the company

commander said, "Let's go," and we took off. . . . It was good, better to ride than walk, so I just stayed on the horse about a mile. Finally, the C.O. said, "Chief you better get off. You make too good a target." When I got back to the Crow Reservation after the war, the elders gave me credit for that coup just like it was done in the old days.

Such exploits continue to fire the imaginations of later generations of Crow soldiers. Carson Walks Over Ice, Medicine Crow's nephew, fought in Vietnam as a Green Beret. His goal, too, was to count coup on the enemy—a practice in which a Plains warrior demonstrated bravery by galloping up to an enemy and touching him with a special "coup stick," without killing or wounding him. Walks Over Ice counted coup many times in Vietnam, but he never got a horse. "I did get two elephants, and that should have counted for something," he says, "but the elders did not see it my way."

DR. HERMAN VIOLA

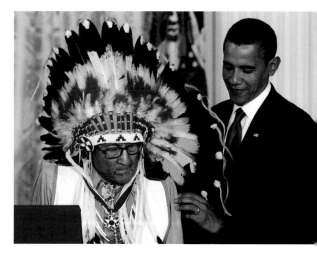

President Obama awards Joseph Medicine Crow (Apsáalooke [Crow], 1913–2016) the Presidential Medal of Freedom. Washington, DC, August 2009.
JEWEL SAMAD / AFP / Getty Images

The Apsáalooke [Crow] people named Medicine Crow a war chief for his military exploits in Europe during World War II.

CHARLES NORMAN SHAY: MEDIC ON D-DAY

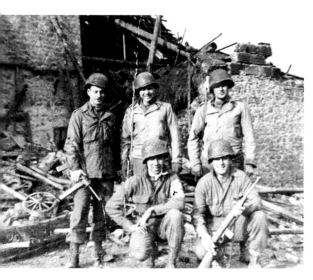

Medic Shay with his brothers-in-arms outside of Aachen, Germany, 1944. Left from the back row: the first sergeant, Lieutenant Otsby, and Lieutenant Jan Kowski. Kneeling: Medic Private Shay and the radioman. Courtesy of Charles Shay

Charles Norman Shay, a nineteen-year-old Penobscot from Indian Island, Maine, was an army medic in the Sixteenth Infantry Regiment, part of the unit known as the Big Red One. Shay had the distinction of being in one of the three combat regiments of the First Infantry Division that spearheaded the Operation Neptune (D-Day) assault in Normandy, France. The Big Red One sustained about two thousand casualties, most during the first hour of the landings under heavy German fire.

With his eyes stinging from the thick smoke that engulfed the battle, Shay looked seaward on Omaha Beach at injured men struggling to get ashore, loaded down with equipment. Some were drowning in the rising tide. Without hesitation he ran into danger.

Armed with only his two satchels of medical supplies, he maneuvered around the fallen to pull the living up on the beach. By noon, almost half of the soldiers and most of the officers in his company were wounded or dead. Up to three thousand Allied troops died, and some nine thousand were injured or classified as missing on the day of the largest seaborne invasion in recorded history.

Shay remembers cradling the critically wounded to give them some comfort. He stayed with Private Edward Morozewicz, easing his passing. In 2017 Shay visited Morozewicz's family, making sure they knew of Edward's bravery, and he participated in a special ceremony honoring his fellow medic. He still questions why he lived when Morozewicz perished. "I knew he was slowly dying. I bandaged his wounds and gave him morphine. But I knew there was no help for him," says a somber Shay. Seven medics from his regiment were killed on D-Day and twenty-four others wounded. "I am a great believer in a spiritual way of life. My mother's prayers must have guided me." For his gallantry that day, Private Shay was awarded the Silver Star. In 2007 French President Nicolas Sarkozy honored him with the Légion d'Honneur. He is one of two American Indian combat medics to survive the war, both without any injuries.

On the 2017 anniversary of D-Day, he listened intently to the waves lapping the shore, remembering his brothers-in-arms who had died there 73 years ago, as he performed a smudging ceremony at dawn. "The ceremonies are my way of trying to take up contact with the spirits of the brave men that remain there." Since 2007 Shay has made the pilgrimage to Normandy nearly every year. Wearing a

Charles Norman Shay (Penobscot, b. 1924) performs his smudging ceremony on Omaha Beach, where he landed during the D-Day invasion, 2017. Photo by Ian Patrick, courtesy of Charles Shay

deer-hide vest with the beaded design of a turtle on the back, he fanned the smoke, created from burning tobacco, sage, and sweetgrass, gently with an eagle feather, sanctifying the area. "I bathe myself in this smoke to cleanse my mind and my body of all evil, concentrating very earnestly on the spirits of my fellow comrades-in-arms who are still there. I let them know they're not forgotten."

His 2017 trip back to the war zone was different in a special way. His nephew, Timothy Shay, assisted him in the ceremony, and the people of France honored him by dedicating a park on a bluff that overlooks Omaha Beach to him and all American Indians who fought for the Allies during the war. The Charles Shay Memorial immortalizes the 175 Native Americans who landed on Omaha Beach on D-Day. Only fifty-five of them have been identified. "Now, there is a plaque commemorating Indian soldiers who left Turtle Island to help liberate our ancient French allies. An estimated five hundred tribesmen participated in Operation Neptune (D-Day), as paratroopers or as ground troops landing on the beaches…

these brave men have passed into the spirit world. We will not forget," said Shay at the park's commemorative ceremony. The turtle is a sacred animal representing wisdom and longevity. It also is the animal Shay chose as a little boy to be his personal Penobscot animal. Sculpted by his nephew Tim, the park's turtle looks out over the Atlantic, with its head turned west toward Indian Island, home of the Penobscot Nation, where Shay lives.

Charles Shay went on to see action during the Battles of Aachen, Hürtgen Forest, and the Bulge. After crossing the Rhine on the bridge at Remagen in 1945, he was captured. Shay and his three brothers served in World War II; two in the United States Navy and one in the Army Air Forces as a B-17 gunner. All survived. But for nearly two agonizing months, Shay's mother, Florence, thought Charles had perished, unaware he'd been taken prisoner. Shay said he would never forget her expression when she opened the door and saw him standing there. Tears of joy streamed down her face. "It was the only time I enjoyed making my mother cry."

Jobs at home were scarce, so Shay reenlisted and served in Austria. He returned to combat as a medic in Korea and was awarded the Bronze Star with two Oak Leaf clusters, again for valor in saving lives. After serving a short time in the southern Pacific, where atomic bombs were being tested, he joined the Air Force, before retiring in 1954 as a master sergeant. Then he worked in Vienna for the International Atomic Energy Commission and later for the United Nations High Commissioner for Refugees, before finally returning home to Indian Island.

In 2009, Governor John Baldacci of Maine honored Shay and other American Indians by proclaiming June 21 Native American Veterans Day in the state. The date was specifically chosen because it is the anniversary of the day the Wabanaki joined the American Revolution in 1775. The Penobscot Indian Nation is one of four tribes in Maine that make up the

Shay gives tribute to all Native Americans who fought on the shores of Normandy on D-Day during the opening of the park dedicated to them, June 5, 2017. The Charles Norman Shay Memorial Park is located on a bluff overlooking Omaha Beach. Tribal representatives from across the United States traveled to France for the occasion. Courtesy of Charles Shay.

Wabanaki Confederacy. Shay is a direct descendent of Penobscot Chief Joseph Orono, who fought with General Washington's troops in the Revolutionary War. "We were second-class citizens in our own country but served this country faithfully. In effect, we were fighting to protect our own land," says Shay. "I know that bullets and shrapnel do not distinguish between soldiers of different racial, national, ethnic, or religious heritage. But I know that not all those who served and sacrificed have been, or are, treated equally. This day will provide us with the opportunity to remind…and to honor those who have served or are now serving our country," said Shay at the bill signing. Looking out over the Penobscot River that runs adjacent to his home, Shay points in the direction of Normandy, France. "On June 21st, Native American Veterans Day, we will unveil a twin turtle statue to the one on Omaha Beach. The turtles will be looking at each other across the ocean, to bring our peoples together."

RAMONA DU HOUX

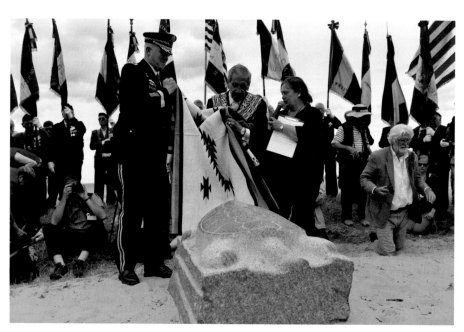

Unveiling the turtle monument at the Charles Shay Memorial Park in Saint-Laurent-sur-Mer, France, June 5, 2017. DOD photo by A1C Alexis C. Schultz / Released

Our nation would not be what it is today if it weren't for the strength and resilience of so many Native American heroes. The National Native American Veterans Memorial honors the Native men and women who have served our country proudly.

Native Americans have played an important role in the U.S. military; our armed services have relied heavily on Native American service for generations. Over 21,000 Native Americans are currently on active duty and there are more than 180,000 living Native veterans. Since World War I, Native Americans have served at one of the highest percentages of all ethnicities.

When I think of Native service and veterans who have set an example for me, I always think of my papa, Kenneth "Cowboy" Morris. My papa, who is a citizen of the Cherokee Nation, served in World War II and stormed the beaches of Normandy on D-Day. I remember his stories well—stories of the war, the friends he made, and what it was like to come back home. My papa's generation—the Greatest Generation—served their country with a sense of duty never seen before, paving the way for American ideas, views, and principles to spread around the globe. His service inspired my own public service.

It is important that we recognize the contributions made by Native American service members since before the United States was established. The National Native American Veterans Memorial will forever stand as a tribute to the Native men and women who fought and sacrificed for the freedoms we all enjoy.

—Congressman Markwayne Mullin (OK-02)

Kenneth Morris (Cherokee), grandfather of Congressman Mullin. Courtesy of Congressman Markwayne Mullin

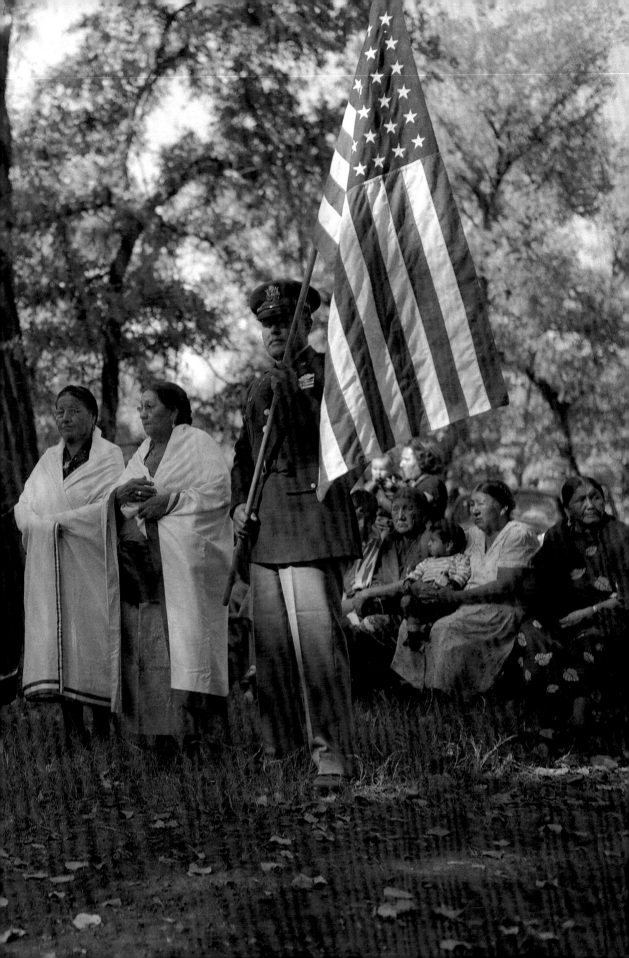

KOREA

Mark Hirsch

People ask me, "Why did you go? Look at all the mistreatment that has been done to your people." Somebody's got to go, somebody's got to defend this country. Somebody's got to defend the freedom. This is the reason why I went.

—Chester Nez (Navajo), United States Marine Corps, World War II
and Korean War[1]

APPROXIMATELY TEN THOUSAND Native Americans served in the armed forces during the Korean War (1950–53), a deadly, three-year-long conflict that has been dubbed America's "Forgotten War."[2] Overshadowed by World War II and the war in Vietnam, the Korean War remains an ambiguous chapter of U.S. history. Even historians are challenged to tell the story, particularly from a Native American perspective. Compared with World War II and Vietnam, first-person accounts of the Korean War seem fewer and farther between, making it difficult to identify American Indian motivations for military service. Fortunately, the Veterans History Project of the Library of Congress as well as other libraries and institutions are now compiling and disseminating video- and audio-taped interviews with armed forces veterans, sources that shine a light on the subjective experience of American Indian servicemen during the Korean War.[3]

The Korean War began in June 1950, when the armies of the communist North swept across the thirty-eighth parallel, invading the southern, pro-Western half of the Korean peninsula. Fearing a communist takeover, Washington committed ground forces to an allied army fighting under U.N. auspices. Their goal: to engage Chinese and North Korean forces intent upon reunifying Korea under communist rule, and, ultimately, to reunite the two Koreas under a democratic form of government. President Harry Truman considered American military intervention as a police action, as Congress issued no formal declaration of war.[4] Yet the Korean conflict was a war—one that claimed the lives of some 37,000 U.S. servicemen, including approximately 194 Native Americans.[5]

Honor dance welcoming home Pascal Cleatus Poolaw Sr. (right, holding the American flag) after his service in the Korean War. To his right are members of the Kiowa War Mothers. Carnegie, Oklahoma, ca. 1952. Poolaw (Kiowa, 1922–1967) remains the most decorated American Indian soldier in history, having earned forty-two medals and citations during three wars: World War II, Korea, and Vietnam. Detail of photo by Horace Poolaw, 45POW29 © Estate of Horace Poolaw

Many Native American servicemen in Korea had seen action in World War II. Some, especially those from chronically poor, job-shy tribal communities, enlisted because they needed money to support themselves and their families. Others hoped to secure vocational training—skills that would enable them to qualify for better jobs on the home front. Still others aspired to attend college through tuition benefits provided to veterans under the G.I. Bill. And many, particularly young men fresh out of high school, were drafted. Family traditions of military service, aspirations to protect tribal homelands, and responsibility to defend American freedom may also have played a part.

Whether veterans of combat or new recruits to the armed forces, U.S. servicemen—and most of the American public—were initially surprised by the fierce resolve of North Korean and Chinese forces. "Everybody thought it was going to be a lark—that we'd go in there and push the North Koreans back a little ways because they were a small country," recalled Richard J. Moon (Mohican/American), who served with the United States Army Tenth Corps Combat Engineers. "Well, they found out it was not fun at all."[6] Some servicemen found that out the hard way. Army Corporal Roy Orville Hawthorne (Navajo) was checking military phone lines when he was hit and grievously injured by a mortar shell explosion. After being evacuated by helicopter, the former World War II code talker was taken to a field hospital, where a nurse told him, "Chief, you're going to make it." He did. But his right leg had to be amputated.[7]

Native American servicemen participated in some of the toughest battles of the Korean War, including combat at Pork Chop Hill, Old Baldy, and Heartbreak Ridge. Vernon Tsoodle (Kiowa), a marine communications lineman who served two tours in Korea, was one of 16,000 U.S. servicemen trapped by more than 100,000 Chinese soldiers in sub-zero temperatures at the Chosin Reservoir. He was awarded the Bronze Star for heroism. Altogether, five American Indians and two Native Hawaiians were awarded the Medal of Honor for heroism in Korea.

During the Korean War, as in all wars, Native and non-Native servicemen had to acclimate to the specter of dead and disfigured men, the agony of wounded comrades, and the act of taking enemy lives. "Your enemies have to become monsters in your mind to be destroyed," recalled Staff Sergeant Andrew "Sonny" Campbell (Mojave), who served with the Army Second Infantry Division. "Psychologically you have to make them less than you, like a bug or a snail."[8]

Despite their service abroad, American Indian veterans continued to face discrimination on the home front. In 1951, the managers of a Sioux City, Iowa, cemetery refused to bury the body of Sergeant John Raymond Rice (Ho-Chunk), who had been killed in action in Korea. The stated reason: a cemetery rule that reserved burial for whites only. The only way the funeral could go forward, officials insisted, was if Rice's wife, Evelyn, signed a document stating that Rice was Caucasian. She refused, saying: "When these men are in the army, they are all equal and the same. I certainly thought they would be the same after

Ben Nighthorse Campbell (Northern Cheyenne, b. 1933) shares a laugh with a young South Korean man during his service in the United States Air Force in the Korean War. Photo courtesy of Senator Ben Nighthorse Campbell

John Emhoolah, ca. 1950

John Emhoolah (Kiowa/Arapaho, b. 1929) was one of five brothers who served in the military. Upon his return from the Korean War, he became active in the fight for Native nations' treaty rights. Courtesy Debbie Emhoolah

death." When word of the incident reached Washington, President Harry Truman offered Evelyn a space for her husband to be buried at Arlington National Cemetery. Sergeant Rice, who had earned a Bronze Star and Purple Heart for his service in Korea, was later buried at Arlington with full military honors.[9]

Ultimately, heroism on the battlefield failed to clinch victory. Like a deadly pendulum, the momentum of the Korean War swung back and forth between

Charles George (Eastern Band of Cherokee Indians, 1932–1952) was born on the Qualla Boundary of North Carolina and grew up in the mountain community of Birdtown, where his family lived along the Oconaluftee River. Enlisting in the United States Army during the Korean War, George began basic training in 1951 at Fort Benning, Georgia. On November 30, 1952, Private First Class George sacrificed his life to save his fellow soldiers near Songnae-dong, Korea. A member of Company C, 179th Infantry Regiment, 45th Infantry Division, George breached the crest of a hill and jumped into a trench occupied by enemy forces. When one of the soldiers tossed a hand grenade at the Americans, George threw himself upon the explosive, absorbing the full blast, saving the lives of his fellow soldiers. Although severely wounded, he kept silent so as not to reveal the position of the men with him. His companions evacuated him, but he died shortly thereafter. George received the Medal of Honor posthumously on March 18, 1954.

Charles George's legacy lives on today. In 2002, the Veterans Administration Medical Center in Asheville, North Carolina, was renamed the Charles George VA Medical Center, and his name is invoked each year at the Cherokee Indian Fair and Parade, in Cherokee, North Carolina. A statue of George stands proudly at the VA hospital, and a bronze bust of George, shown wearing an army helmet with the Medal of Honor around the neck, is displayed at Cherokee Veterans Park, in Cherokee, North Carolina. In 2014, a bridge across the Oconaluftee River was renamed for George, following legislation submitted by first-grade students from the New Kituwah Language Academy, and four years later, the Museum of the Cherokee Indian opened an exhibition honoring George's life and heroism. "We know from his record that he was inspired by the heroic military service of our Cherokee people," Army Colonel Bob Blankenship (Retired) remarked at the event. "He knew of the pride the Cherokee had for service in the military."[10] U.S. Department of Veterans Affairs

adversaries, then settled into a deadly stalemate. Negotiations between the opposing forces began in July 1951, but the talks—and the war—dragged on until 1953, when North Korea, China, and the United States reached an armistice. However, South Korea refused to agree to its terms, and no formal peace treaty was ever signed.[11] Despite the expenditure of American blood and treasure, the United States failed to achieve its ultimate objective: to reunify the divided Korean peninsula under democratic control. The two Koreas remain separate to this day.

Prayer service at the funeral of Marine Corps Sergeant Alfred Gene Unap (Kiowa, 1933–1953), killed while in Hawai'i during the Korean War. Left to right, seated: Alfred's father Arthur Unap Sr. (Kiowa), Arthur Unap Jr. (Kiowa). Unidentified honor guards, standing. Carnegie Funeral Home, Carnegie, Oklahoma, 1953. Photo by Horace Poolaw, 45UFN25 © Estate of Horace Poolaw

The Korean stalemate confused, frustrated, and angered Americans, who, eight years earlier, had celebrated victory in perhaps the greatest war in history. How could the United States, the world's most powerful nation, fail to win what many considered a border skirmish in a small Asian country? This troubling question has gone unanswered—a fact that may help explain the Korean War's relative obscurity in American memory.

Yet Native and non-Native veterans never forgot the Korean War. In oral history interviews, they generally speak with pride about their military service. Korea widened their world, they say. It brought them in contact with different cultures and peoples and enhanced their sense of personal as well as tribal pride. "The war let us know that we could do what [non-Native] people thought we couldn't do," said Roy Orville Hawthorne. "[W]e didn't realize that before the war."[12]

After the Korean War, many returning Native American servicemen became active in revitalizing tribal cultural traditions. Having fought bravely in the face of battle, they had acquired a keener understanding of what it meant to be a warrior, and they dedicated themselves to reviving ancestral warrior societies and ceremonies long suppressed by the U.S. government.[13] The resurgence of tribal warrior traditions spread in the 1950s and '60s, reflecting a growing conviction in Indian Country: that Native Americans would always uphold their responsibilities as citizens of the United States yet also remain faithful to their Indian way of life.[14]

THE MEDAL OF HONOR

Created during the American Civil War, the Medal of Honor is the highest military decoration presented by the U.S. government to a member of its armed forces. To earn this decoration, the recipients must distinguish themselves with a heroic act of bravery at the risk of their own life beyond the call of duty in action against an enemy of the United States. Because of the nature of this medal, it is often presented posthumously. Of the 3,400 Medal of Honor recipients, 34 are known to be Native American or Native Hawaiian.

The absence of hard data makes it difficult to quantify the full history of Native American participation in the United States Armed Forces, in general, and the number of Native Medal of Honor recipients, in particular. Yet by culling, crosschecking, and collating a variety of U.S. government—as well as Native-American veteran—sources, historians have compiled the following list of Native American Medal of Honor recipients who served from the so-called Indian Wars (1860s–80s) through the war in Vietnam.[1]

INDIAN WARS[2]

- Co-Rux-Te-Chod-Ish / Mad Bear (Pawnee), Army, sergeant, Republican River, Kansas. Date of issue: August 24, 1869.

- Chiquito (White Mountain Apache), Army, scout, Arizona Territory. Date of issue: April 12, 1875.

- Bow-os-loh / Jim "The Great" (White Mountain Apache), Army, sergeant, Arizona Territory. Date of issue: April 12, 1875.

- Machol (Apache), Army, private, Arizona Territory. Date of issue: April 12, 1875.

- Nannasaddie (White Mountain Apache), Army, scout, Arizona Territory. Date of issue: April 12, 1875.

- Nantaje / Nantahe (White Mountain Apache), Army, scout, Arizona Territory. Date of issue: April 12, 1875.

- William Alchesay (White Mountain Apache), Army, sergeant, Arizona Territory. Date of issue: April 12, 1875.

- Blanquet (Apache), Army, scout, Arizona Territory. Date of issue: April 12, 1875.

- Elsatsoosu (Apache), Army, corporal, Arizona Territory. Date of issue: April 12, 1875.

- Kelsay (White Mountain Apache), Army, scout, Arizona Territory. Date of issue: April 12, 1875.

- Kosoha (White Mountain Apache), Army, scout, Arizona Territory. Date of issue: April 12, 1875.

- Adam Paine (Black Seminole[3]), Army, private, Canyon Blanco tributary of the Red River, Texas. Date of issue: October 13, 1875.

- Pompey Factor (Black Seminole), Army, private, Pecos River, Texas. Date of issue: May 28, 1875.

- Isaac Payne (Black Seminole), Army, trumpeter, Pecos River, Texas. Date of issue: May 28, 1875.

- John Ward (Black Seminole), Army, sergeant, Pecos River, Texas. Date of issue: May 28, 1875.

- Y. B. Rowdy (Yavapai), Army, sergeant, Arizona Territory. Date of issue: May 15, 1890.

- Gregory Pappy Boyington (Sioux), Marine Corps, major, Central Solomons area, Pacific Ocean. Date of issue: March 1944.[4]
- Ernest Childers (Muscogee [Creek]), Army, second lieutenant, Oliveto, Italy. Date of issue: April 8, 1944.
- Jack C. Montgomery (Cherokee), Army, first lieutenant, Padiglione, Italy. Date of issue: January 15, 1945.
- Van T. Barfoot (Choctaw), Army, technical sergeant, Carano, Italy. Date of issue: September 28, 1944.
- Roy W. Harmon (Cherokee), Army, sergeant, Casaglia, Italy. Date of issue: October 2, 1945. Awarded posthumously.
- Ernest E. Evans (Cherokee/Creek), Navy, commander, off Samar Island, Philippines. Awarded posthumously.
- John N. Reese Jr. (Creek), Army, private first class, Paco Railroad Station, Manila, Philippines. Date of issue: October 19, 1945. Awarded posthumously.
- Francis Brown Wai (Native Hawaiian), Army, captain, Leyte, Philippines. Date of issue: June 21, 2000. Awarded posthumously.

KOREAN WAR

- Mitchell Red Cloud Jr. (Ho-Chunk), Army, corporal, Chonghyon, Korea. Date of issue: April 25, 1951. Awarded posthumously.

- Raymond Harvey (Chickasaw), Army, captain, Taemi-Dong, Korea. Date of issue: August 2, 1951.
- Tony Kenneth Burris (Choctaw), Army, sergeant first class, Mundung-ni, Korea. Date of issue: September 5, 1952. Awarded posthumously.
- Anthony T. Kahoʻohanohano (Native Hawaiian), Army, private first class, Chupa-ri, Korea. Date of issue: May 2, 2011. Awarded posthumously.
- Woodrow Wilson Keeble (Dakota Sioux), Army, master sergeant, Sangsan-ni, Korea. March 3, 2008. Awarded posthumously.
- Charles George (Cherokee), Army, private first class, Songnae-dong, Korea. Date of issue: March 18, 1954. Awarded posthumously.
- Herbert Kailieha Pililaʻau (Native Hawaiian), Army, private first class, Pia-ri, Korea. Date of issue: June 18, 1952. Awarded posthumously.

VIETNAM WAR

- Roy Perez Benavidez (Yaqui), Army, master sergeant, Loc Ninh, South Vietnam. Date of issue: February 24, 1981.
- James Elliott Williams (Cherokee), Navy, boatswain's mate, first class, Mekong River, South Vietnam. Date issued: May 14, 1968
- Michael E. Thornton (Cherokee), Navy, petty officer second class, South Vietnam. Date issued: October 15, 1973.

Ernest Childers receives the Congressional Medal of Honor from Lieutenant General Jacob L. Devers (left). Fifth Army headquarters, April 8, 1944.
Bettmann/Getty Images

Lieutenant Childers earned the honor for wiping out two German machine gun nests near Oliveto, Italy, while working under heavy enemy fire, as well as killing enemy snipers and capturing an artillery observer.

ERNEST CHILDERS

Guardsman Ernest Childers (Muscogee [Creek], 1918–2005) entered C Company, 180th Infantry Regiment, in the Forty-Fifth Division of the National Guard in 1940. The Forty-Fifth was one of four National Guard units activated in 1940 by President Roosevelt. During World War II, Acting Second Lieutenant Childers led campaigns through North Africa, Sicily, and southern Italy. On September 22, 1943, the Germans launched an assault on the 180th Infantry Regiment in Oliveto, Italy.[12] Under heavy fire, Childers fell into a shell crater and fractured his foot. In an effort to take out German machine gun nests within houses perched uphill, Childers and eight of his men began a steep trek up mountainous terrain.[13]

While his men provided cover fire, Childers crawled toward the German-occupied houses while firing on the first enemy machine gun nest. Having neutralized that threat, he crawled to the second house. To lure the German soldiers outside, Childers threw rocks through the windows. Believing the rocks were hand grenades, the Germans evacuated the home and were killed in the hail of bullets discharged by Childers and his men, who succeeded in destroying the second machine gun nest. On April 8, 1944, with an audience of nine army companies, General Jacob L. Devers awarded Childers the Medal of Honor during a ceremony in Naples, Italy.

Childers returned stateside to much fanfare. At the behest of President Franklin D. Roosevelt, Childers traveled to Washington, DC, to meet personally with the president at the White House. On April 26, 1944, the people of Childers's hometown of Broken Arrow, Oklahoma, honored him with the largest parade in its history; schools and businesses closed to express their pride and support of his military accomplishments.[14]

In 1965, he retired from the United States Army as a lieutenant colonel after his additional military service in the Korean and Vietnam wars. In 1994, the city of Broken Arrow erected a nine-foot statue of Childers in uniform in Veteran's Park. He passed away in 2005 at age 87.[15]

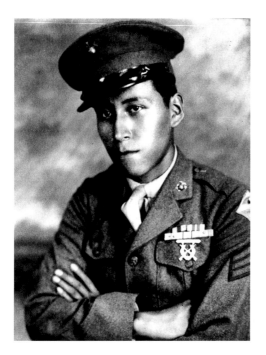

Corporal Mitchell Red Cloud Jr., ca. 1945.
United States Army

MITCHELL RED CLOUD JR.

A veteran of World War II, Mitchell Red Cloud Jr. (Ho-Chunk, 1925–1950) left the marines as a sergeant after the war. He voluntarily returned to active duty, enlisting in the army in 1948 and deploying shortly thereafter to a combat zone in North Korea. On November 5, 1950, Red Cloud was stationed at a listening post on a ridge, ahead of his company's main positions.[8] Armed with a Browning automatic rifle, Red Cloud was the first line of defense, protecting his Company E, Nineteenth Infantry Regiment, Twenty-Fourth Infantry Division, who were positioned on the ridge behind him on Hill 123 near Chonghyon, North Korea.[9]

When a Chinese assault force attacked Hill 123 and vicinity, Red Cloud alerted his company and began his sole assault on the oncoming Chinese soldiers. According to his Medal of Honor citation, Red Cloud directed intense and accurate fire at the enemy with "utter fearlessness." After sustaining multiple gunshot wounds, Red Cloud wrapped his arms around a small tree, picked himself up and continued firing at the enemy point-blank until he succumbed to his wounds. Later, American officers found more than twenty Chinese soldiers dead in front of Red Cloud's body. Red Cloud was awarded the Medal of Honor posthumously for displaying "dauntless courage and gallant self-sacrifice."

Red Cloud was initially buried at a U.N. cemetery in Korea. In April 1951, General Omar N. Bradley presented the Medal of Honor to Red Cloud's mother, Lillian "Nellie" Red Cloud, during a ceremony at the Pentagon. In 1955 Red Cloud's remains were reinterred at the Decorah Cemetery at Winnebago Mission in Wisconsin. A few years later, on Armed Forces Day, May 18, 1957, the army further memorialized Red Cloud's sacrifice by giving his name to a U.S. military installation on the Korean peninsula, where he had sacrificed his life.[10] Camp Red Cloud served as the headquarters for the army garrison in Uijeongbu, South Korea, until its closing in 2018.[11]

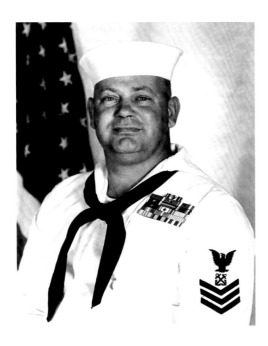

JAMES E. WILLIAMS

In June 1966, Boatswain's Mate First Class James E. Williams (Cherokee, 1930–1999) did the unthinkable. With only two years left to serve before his navy retirement, Williams volunteered to leave his routine military post and requested a personal transfer to the war zone in South Vietnam during the height of the Vietnam War. Within eight months of his arrival he earned every combat decoration available, including the congressional Medal of Honor, to become one of the most decorated servicemen of all time.[5]

One of the most highly decorated sailors in the history of the United States Navy, Boatswain's Mate First Class James E. Williams earned the Medal of Honor for demonstrating "conspicuous gallantry" on October 31, 1966, while serving as a patrol-boat commander in Vietnam.[6] Naval History & Heritage Command, Photo Section: NH 89561, L38-97.04.01

During a routine two-boat patrol of the Mekong River, Williams and his crew took on sudden enemy fire from two nearby sampans, twenty-four-foot-long flat-bottomed boats used by the Vietcong as makeshift naval vessels during the Vietnam War. As the Vietnamese used sampans extensively to carry their daily supplies and as fishing vessels, it was almost impossible to distinguish a civilian from an enemy.

Within minutes, Williams and his crew found themselves outgunned and outnumbered, taking fire from more than a dozen encroaching sampans that blocked their route. Returning fire, Williams and his crew engaged in a naval gunfight for more than eight hours. Williams personally directed the counterattack and took up arms himself to stave off approaching vessels, as he and his crew systematically took down one enemy vessel after another.[7] U.S. helicopter gunships finally answered Williams's radio calls for backup, and together they took out dozens of enemy sampans. For his display of courage, Williams received the Medal of Honor on May 14, 1968.

DR. BETHANY MONTAGANO

MASTER SERGEANT WOODROW WILSON KEEBLE

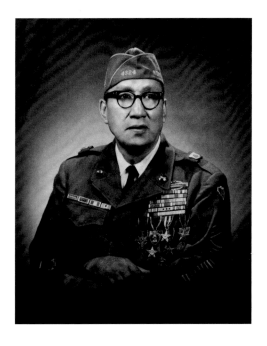

Master Sergeant Woodrow Wilson Keeble, ca. 1955.
Vets Incorporated, Wahpeton, ND

When asked to describe Woodrow Wilson Keeble (Dakota Sioux, 1917–82), family members invariably speak of a gentle giant, a humble and kind-hearted man who was highly regarded by everyone who knew him. "Woody was as big as a mountain, and he had unbelievable strength," his stepson Russell Hawkins recalled.[1] Keeble's nephew, Kurt Bluedog (Sisseton Wahpeton Oyate), agreed, adding: "He was very jovial, and he was fun to be around."[2] Yet on a battlefield, this gentle soul was a ferocious warrior, one who risked his life to save his fellow soldiers. For his actions, in 1951 Keeble was decorated with the Distinguished Service Cross, the Purple Heart, and the Bronze Star. In 2008, twenty-six years after his death, Keeble was awarded the Medal of Honor "for conspicuous gallantry...at the risk of his life, above and beyond the call of duty."

Keeble was born on the Sisseton-Wahpeton Sioux Reservation, in Waubay, South Dakota, on May 16, 1917. While still young, he and his family moved to Wahpeton, North Dakota, where his mother, Nancy (Shaker) Keeble, worked at the Wahpeton Indian School, known today as the Circle of Nations School.[3] As a young man, he excelled in athletics, particularly baseball. "He had a cannon for a right arm," Hawkins remembered.[4] Some say Keeble was being recruited by the Chicago White Sox when he was called to active duty in World War II.[5]

In 1942, Keeble and his unit, the 164th Infantry Regiment of the North Dakota National Guard, were deployed to Guadalcanal, in the South Pacific—site of some of the fiercest hand-to-hand combat of World War II. There he earned a reputation for bravery, for which he was decorated with the Purple Heart and Bronze Star.[6]

When the Korean War began, Keeble volunteered for duty on the front lines. Asked why, the thirty-four-year-old war veteran quipped, "Somebody has to teach these kids how to fight."[7] As a master sergeant and acting platoon leader in the U.S. attack on Hill 765, near Sangsan-ni, North Korea, in October 1951, Keeble and his men were pinned down by withering machine-gun fire on a steep and rocky incline held by Chinese forces

entrenched in three well-fortified hilltop bunkers. Thrice wounded over the previous four days yet reluctant to put his men in harm's way, Keeble chose to attempt a solo assault on the enemy positions. Armed with a Browning automatic rifle and a clutch of hand grenades, Keeble crawled to the ridgeline, lobbed grenades at the first bunker, and fired his rifle with great accuracy to eliminate survivors. Then, with Chinese shrapnel and bullets raining down on him, Keeble worked his way to the second bunker, and then the third, destroying each one. Only after he had eliminated the machine gunners would Keeble order his men to advance and then lead them to secure the hill.[8]

Keeble's one-man assault cost him dearly. Sustaining grievous injuries to his chest, arms, calf, knee, and thighs, Keeble had no fewer than 83 grenade fragments removed from his body—most, but not all, of the shrapnel that had torn into his flesh. Yet Keeble had won the respect and admiration of men who served with him. Later, every surviving member of Keeble's company signed a letter recommending him for the Medal of Honor. But the paperwork was lost.[9]

Life after Korea was not always kind to Keeble. Diagnosed with tuberculosis, he underwent surgery to remove one of his lungs—a procedure that triggered a series of strokes that left him partially paralyzed and speechless. Several years later, his wife, Nettie, passed away, leaving him to care for their young son. And once, when money was scarce, he was forced to pawn his medals. Yet, somehow, he never lapsed into bitterness. "Woody was a very upbeat person," said Hawkins. "He

enjoyed the small things in life, and concentrated on what he had, not what he didn't have."[10]

In 1967, Keeble married Blossom Iris Crawford-Hawkins, the first Sioux woman to complete a PhD program at the University of South Dakota. He also became a champion for veterans' causes, supporting fundraisers and wearing his army uniform at parades and other events that honored U.S. servicemen and women. For younger generations, Keeble was a living icon of the Native American warrior tradition.

By the early 1980s, multiple war wounds and successive strokes had severely diminished Keeble's body, though not his spirit. He passed on January 28, 1982. Yet memories of Keeble's remarkable valor lived on, fueling a robust initiative by his family to encourage Congress to posthumously award him the Medal of Honor. That effort bore fruit in December 2007, when Congress overwhelmingly passed a bill authorizing the president to award Keeble America's highest military honor. In March 2008, Russell Hawkins accepted the Medal of Honor on his stepfather's behalf in a ceremony at the White House.[11]

Why did Keeble risk his life so dramatically during the Korean War? "He never gave any rationale," Bluedog recalled. "Like a lot of Native people, he didn't relive the war."[12] About his actions on the field of battle, Keeble once said: "There were terrible moments that encompassed a lifetime, an endlessness, when terror was so strong in me, that I could feel idiocy replace reason. [Yet], I have never left my position, nor have I shirked hazardous duty. Fear did not make a coward out of me."[13]

MARK HIRSCH

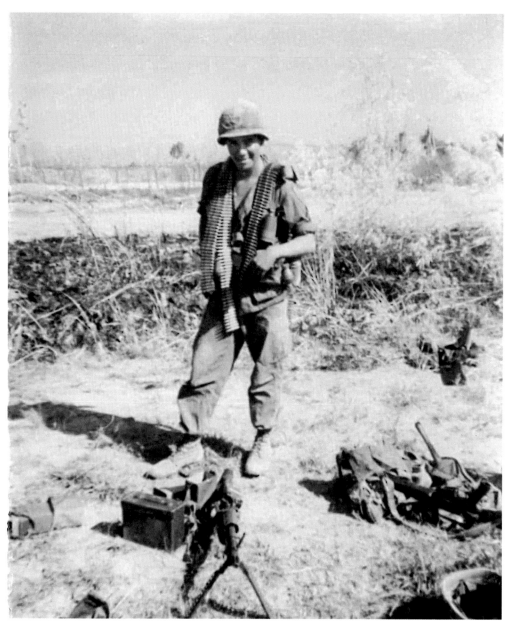

Ernie Wensaut (Forest County Potawatomi, b. ca. 1945) checking his gear before a patrol mission near the Cambodian border in the highlands of Vietnam, in March 1967. A member of Company C, 2nd Battalion, 10th Infantry, 1st Division (also known as the "Big Red One"), Wensaut was an M-60 machine gunner whose weapon, nicknamed "The Pig," fired 500 to 600 rounds per minute.[1] Potawatomi Traveling Times

VIETNAM

Mark Hirsch

I had an uncle who was killed in Normandy with the 82nd Airborne, and I remember a Purple Heart…on my grandparents' wall.…My brothers were in the Air Force. My cousins [were] in the Navy and the Army.…[G]rowing up it was understood that sooner or later males of the family [were] going to go in the military. It was just a matter of what branch.
—Steven L. Bobb (Umpqua/Confederated Tribes of Grand Ronde), United States Marine Corps, Vietnam[2]

IN THE EARLY 1960S, few Americans could locate Vietnam on a world map. By 1968, the growing deployment of U.S. combat forces, mounting American casualties, extensive media coverage, and the rise of the largest antiwar movement in U.S. history had seared Vietnam into the American consciousness.[3]

The United States deployed nearly three million troops to southeast Asia between 1964 and 1973. Their mission, presidents and policymakers insisted, was to defend the pro-American regime of South Vietnam from aggression by Communist North Vietnam.[4] More than forty-two thousand Native Americans served in Vietnam.[5] According to Tom Holm (Cherokee/Creek), a Vietnam Marine Corps veteran and professor of American Indian studies, one of every four eligible Native people served, compared with one of twelve in the general population.[6]

No single factor explains the disproportionate presence of Native Americans in the United States Armed Forces during the war in Vietnam. As in other U.S. wars, military service during the Vietnam era offered young Native men a paying job—a scarce commodity on tribal reservations plagued by poverty, unemployment, and limited educational opportunities. Aspirations to carry on family and tribal traditions of military service and win the respect of tribal community members also figure prominently in the memoirs written by American Indian Vietnam veterans, as well as their oral history interviews. Grandfathers, fathers, uncles, and older brothers who had fought in previous U.S. wars provided powerful examples of heroism and sacrifice, which young Native men of the Vietnam generation hoped to emulate.[7] "I knew I had to go to Vietnam because of the warrior traditions in my family and my tribe," explained Carson Walks Over Ice (Crow), whose grandfather was a veteran of World War I and whose father and uncle were veterans of World War II.[8] Protecting tribal homelands also appears as an incentive for military service. "The

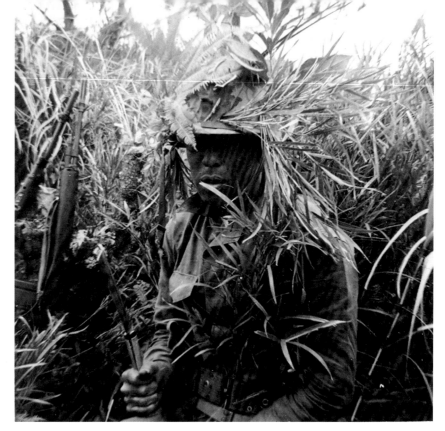

Harvey Pratt (Cheyenne and Arapaho) holds a naga knife—a Southeast Asian knife used for cutting through vegetation—during the camouflage and evasion portion of ambush training for his service in Vietnam, 1963. Courtesy of Harvey Pratt

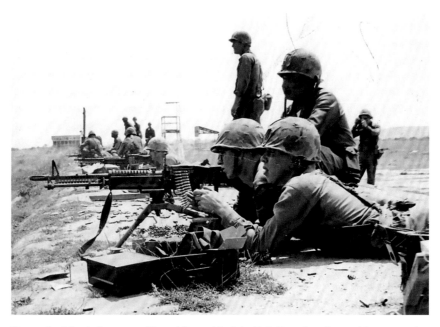

Harvey Pratt feeds the ammunition while, on his right, R. D. Pratt fires the machine gun at the Vietnamese Ranger range. Standing in the background is Lieutenant Hughes. Courtesy of Harvey Pratt

An elevated observation post sits atop a command bunker in the northern I-Corps tactical zone in South Vietnam, 1963. Courtesy of Harvey Pratt

land is still ours to fight for," writes Leroy TeCube (Jicarilla Apache), who saw action as an infantryman in Vietnam. "We still live on it."[9]

Inequities in the Vietnam-era draft may also have contributed to the Native American presence in the war effort. Coming from less privileged backgrounds, young Native men may have lacked the means, information, or qualifications to obtain educational, occupational, or health-related draft deferments that shielded other Americans from military service.[10] Lacking these and other advantages, young American Indian men joined disadvantaged African Americans, Latinos, and white working-class men to form the backbone of U.S. fighting forces in Vietnam. Their average age: nineteen.[11]

The combat experience of the Vietnam generation was unlike anything their fathers and grandfathers had encountered. During World Wars I and II, and in Korea, American forces fought conventional battles against conventional armies. In the villages, jungles, and rice paddies of South Vietnam, however, U.S. patrols searched endlessly, and usually unsuccessfully, for an elusive enemy committed to conducting a guerrilla war for national unification. Try as they might, U.S. forces could never get the enemy to fight on American terms: in the open.[12] "[M]ost of the time we did not know who the enemy was until they started shooting at us," recalled James Chastain (Lumbee), who served in the 173rd Airborne Brigade in Vietnam's central highlands.[13] Ironically, this harks back to a similar misalignment of tactics and strategy experienced between European and American Indian styles of warfare in the American colonies during the seventeenth and eighteenth centuries.

Donna Loring, 1966. Loring (Penobscot, b. 1948) served in 1967 and 1968 as a communications specialist at Long Binh Post in Vietnam, where she processed casualty reports from throughout Southeast Asia. She was the first woman police academy graduate to become a police chief in Maine and served as the Penobscots' police chief from 1984 to 1990. In 1999 Maine governor Angus King commissioned her to the rank of colonel and appointed her his advisor on women veterans' affairs. Courtesy Donna Loring

Strengthened by infiltration into South Vietnamese communities, Communist insurgents (the Vietcong) and soldiers from North Vietnam unleashed rifle, mortar, and rocket fire on American patrols, then quickly melted into nearby hamlets, tunnels, and jungle redoubts. With the assistance of sympathetic villagers, enemy forces planted mines and installed booby traps, which killed and maimed thousands of American soldiers.[14] Unable to distinguish between politically neutral civilians and Vietcong guerrillas, frontline troops existed in a world of insecurity, in which enemies, real or imagined, seemed to lurk everywhere, and in which safe spaces were few and far between. As one Native veteran put it, "[t]he only territory you held was where you stood."[15]

As the war dragged on, U.S. forces adopted increasingly heavy-handed tactics to flush out Vietcong insurgents and quash civilian support for them. Search-and-destroy operations, targeting peasant villages suspected of harboring or sympathizing with the enemy, were initiated throughout the countryside. Peasant villages were emptied and torched; those deemed enemy strongholds were designated "free-fire zones," in which U.S. troops were greenlighted to fire on anything that moved.[16] Some five million South Vietnamese civilians, out of a total population of seventeen million, were uprooted and relocated during the war.[17] Between 1961 and 1975, about 1.5 to 2 million Vietnamese were killed.[18]

For some, the plight of Vietnamese civilians seemed redolent of American Indian history. "We went into their country and killed them and took land

that wasn't ours," one Native veteran recalled. "Just like the whites did to us…when they moved us to the rez. We shouldn't have done that."[19] Encounters with the Vietnamese revealed other parallels. During one search-and-destroy mission, a Native infantryman was approached by an elderly Vietnamese man whose home had been torched by U.S. forces. The old man looked at the soldier, compared their skin and hair color, and said: "You…me, same-same."[20] A similar observation by a captured Vietcong insurgent deeply unsettled an American Indian combat soldier. "[O]ne day, out on patrol, I realized he was right, that I had been a red man killing yellow men for the white man. I put my gun down and I couldn't kill anymore. There was no honor in what I had done. I had shamed myself and the gifts of courage and strength that had been given me."[21] Despite such misgivings, Native soldiers fought bravely in Vietnam. Approximately 226 American Indians died in action. Three were awarded the Medal of Honor. For valor under fire, Carson Walks Over Ice earned the Silver Star, the Bronze Star, and the Purple Heart.[22] James Chastain (Lumbee) received the Bronze Star, an Army Commendation Medal, a Presidential Unit Citation, the Vietnamese Cross of Gallantry, a Purple Heart, a Vietnamese Service Medal, the Combat Infantryman Badge, and the Air Medal.[23]

After completing their tours of duty, Native American servicemen returned home and tried to move on with their lives. Their life trajectories varied widely. After earning the Bronze Star, two Purple Hearts, and other decorations for heroism in Vietnam, Jefferson Keel (Chickasaw) continued his army career, and later became lieutenant governor of the Chickasaw Nation and president of the National Congress of American Indians.[24]

Others became active in tribal government or joined political organizations to work for social justice.[25] Seriously wounded in a firefight near Chu Lai in 1967, Sid Mills (Yakama / Walla Walla) returned stateside and renounced his military service, proclaiming that he "refused to serve a country that didn't let Indians live." Released after six months in a military stockade, Mills began a lifelong career as a Native American treaty rights activist. In 2018, he belatedly collected the Purple Heart, which he had earned in combat fifty-one years earlier but never received.[26]

The tension between fighting for "freedom" in Vietnam and facing second-class status at home unsettled many veterans, propelling some toward the American Indian Movement (AIM), a broad coalition of Native people who combined savvy media skills with radical confrontational tactics to advocate for Native American rights. Several Native Vietnam veterans participated in the seventy-one-day occupation of the town of Wounded Knee, South Dakota—a violent standoff between Oglala Lakota tribal insurgents and AIM activists on the one hand, and heavily armed U.S. marshals, FBI agents, and National Guard troops on the other.[27]

Like many other Vietnam veterans, American Indians were often deeply traumatized by what they had experienced. The face of death, the screams of the grievously wounded, the sight of maimed children—these reminders of the

war, which came suddenly in terrifying flashbacks and heart-pounding night-mares, proved difficult to control, and, for some, too hard to bear. Wounded in mind, body, and soul, afflicted veterans fell victim to anger, rage, alcohol and drug abuse, and deep depression. According to the U.S. Department of Veterans Affairs, about 30 percent of Vietnam veterans have experienced post-traumatic stress, the highest rate among veterans of previous wars.[28]

Unlike non-Indians, who often felt ignored or shunned for having participated in an unpopular war, many returning Native American veterans found solace in community ceremonies that recognized and honored their wartime sacrifice. From tribal dances and sweat lodge ceremonies to honorary pow-wows, veterans participated in time-honored community practices designed to help warriors reintegrate into society. Through these ceremonies, Vietnam veterans were recognized for their bravery and honored for the hard-won wisdom that war grants to warriors. "[W]e honor our veterans for their bravery," a Ho-Chunk elder remarked at a Wisconsin powwow, "and because by seeing death on the battlefield, they truly know the greatness of life."[29]

Rick Bartow (Mad River Wiyot, 1946–2016),
PTSD I, II, III, 2008. Acrylic on canvas, 8 × 24 in.
Collection of Douglas Macy. Courtesy of the
Richard E. Bartow Trusts and Froelick Gallery,
Portland, OR; the Doug Macy Collection at North-
ern Arizona University, Flagstaff, AZ

The Haaland family at Naval Amphibious Base Little Creek, Norfolk, Virginia, about April 1968. Left to right: First Lieutenant John D. Haaland, with Mary E. Toya, Deb Haaland, Zoe Haaland, John D. Haaland Jr., and Denise Haaland, who are all enrolled members of Laguna Pueblo. This photo was taken to mark the occasion of Haaland's receiving the Silver Star for his actions during his two-year deployment to Vietnam. Haaland and Toya met while both were stationed at Naval Base Treasure Island in California. Official U.S. Navy photograph by J. Oliver, courtesy of Deb A. Haaland

My parents are part of a proud tradition of service to our country—it's a tradition that many Native American families embrace. My dad was a first-generation American in the Marines and my mom a Pueblo woman in the Navy—we moved almost every two years to a different base, traveling back and forth across the country. While my dad served in Vietnam, my mom would sit us down at the kitchen table almost every day to write him letters. Even at that early age, I knew that he couldn't be with us because he had a responsibility to be somewhere else in the world. It was how I learned what service to your country was.

As a member of the House Armed Services Committee and daughter of veterans, I have a strong understanding of, and deeply appreciate, the sacrifice our Native service members and their families give to our country. Our country owes a great deal of gratitude to the Native American community. It was the code talkers who ensured that strategic military plans remained classified and unbreakable to the enemy during World War II, and our communities continuously have one of the highest rates of service no matter what era.

We wear the badge of service proudly, and our veterans suffer the burdens of war with disproportionate rates of homelessness, behavioral health struggles, and lack of access to health services. It's a serious reality that our country must come to grips with and address. It's why I've made it a top priority to ensure that our Native American veterans, and all veterans, receive the benefits they have earned. Their stories and their experiences are important and contribute to the fabric of our country.

—Congresswoman Deb A. Haaland (NM-1)

ARTIST VETERANS

Following World War II, the G.I. Bill made funding available for veterans to further their education. For some, including the influential Yanktonai Dakota painter Oscar Howe, it provided an opportunity to attend art school. Howe, a graduate of Dorothy Dunn's Studio at the Santa Fe Indian School, had begun his career as an artist prior to being drafted into the army in 1942. Following his service, he earned a BA at Dakota Wesleyan University on the G.I. Bill and went on to receive an MFA at the University of Oklahoma.[1] Eva Mirabal of Taos Pueblo, also a student of Dunn's, served as an artist in the Women's Army Corps (WAC), where she worked on murals and created the comic strip "G.I. Gertie." After completing her service, Mirabal used her G.I. benefits to study at the Taos Valley Art School.[2] Hopi jeweler and artist Charles Loloma attended Alfred University's School for American Craftsmen after being stationed in the Aleutian Islands during World War II.[3]

Particularly since the Vietnam War, some Native American veterans have used art to express or come to terms with their experiences during their service. In 1966, after graduating from the Institute of American Indian Arts in Santa Fe and starting classes at the San Francisco Art Institute, T. C. Cannon (Caddo / Kiowa) surprised his family and friends by enlisting in the army, following in the strong Kiowa military tradition. Cannon's father, Walter, had served in World War II. In *On Drinkin' Beer in Vietnam in 1967*, Cannon and his friend from back home, Kirby Feathers (Ponca), have a beer and a smoke while a mushroom cloud is visible behind them. Some of Cannon's subsequent artwork, music, and

World War II war bonds poster featuring work by Native artists from the Santa Fe Indian School, 1942. Made by Eva Mirabal (Taos Pueblo, 1920–1968), Ben Quintana (Cochiti Pueblo, 1923–1944), and Charles Pushetonequa (Sauk and Fox, 1915–1987) for the Government Printing Office. Ink on paper, 95.7 × 60.9 cm. NMAI 26/9677

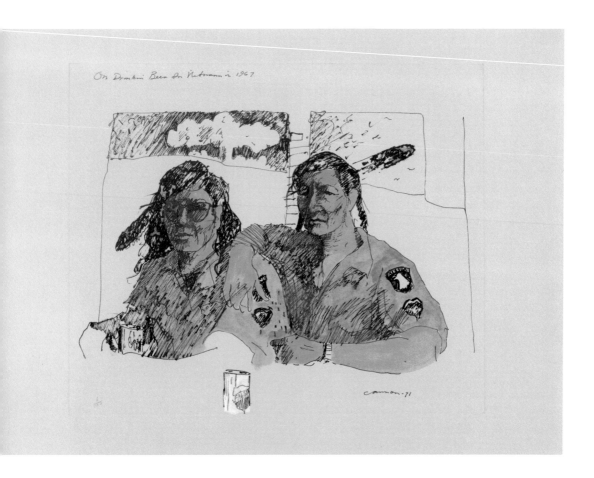

poetry reflects his conflicting feelings of pride and pain about his service in Vietnam.[4] In 1970, Cannon and his father were inducted together into the Kiowa Ton-Kon-Gah, or Black Leggings Warrior Society.

Rick Bartow (Mad River Band of Wiyot) also served in Vietnam and struggled with post-traumatic stress following his deployment. Trained as an artist prior to his service, Bartow eventually turned back to art as a way of coping. His expressive paintings, sculptures, and prints frequently include imagery of physical, emotional, and spiritual transformation. Painted the year before he died, *Buck (Indian Hero)* is a rare work in which Bartow directly references his service. The title refers to a nickname for Bartow's rank at the time he was drafted. The wheelchair suggests his deteriorating health near the end of his life.[5]

Michael Naranjo's (Santa Clara Pueblo, b. 1944) artistic career began following his service in Vietnam, where he lost his vision and the use of one hand to a grenade. Naranjo, who comes from a large family of potters and artists, began sculpting with clay while recovering in the hospital.[6] His bronze sculpture, *He's My Brother*, depicting a soldier carrying a fallen comrade, is included in the Heard Museum's American Indian Veterans National Memorial.

Non-veteran artists have also addressed traditions of service in their work (some of which are pictured elsewhere in this book) and honored veterans individually and collectively as an expression of the high regard Native communities have for those who have served.

REBECCA HEAD TRAUTMANN

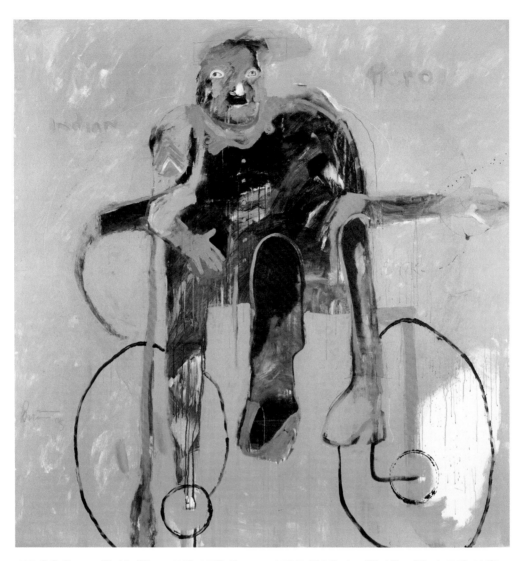

LEFT: T. C. Cannon (Caddo / Kiowa, 1946–1978), *On Drinkin' Beer in Vietnam*, 1971. Lithograph on paper, 48 × 76 cm. Collection of Museum of Contemporary Native Art. CD-33; Gift of Kenneth French Estate, 2000; Courtesy of the IAIA Museum of Contemporary Native Arts, Santa Fe, NM; Joyce Cannon Yi, Executor of the T. C. Cannon Estate.

ABOVE: Rick Bartow (Mad River Wiyot, 1946–2016), *Buck (Indian Hero)*, 2015. Acrylic on canvas, 72 × 72 in. Courtesy of the Richard E. Bartow Trusts and Froelick, Gallery, Portland, OR. Image courtesy of Jordan Schnitzer Museum of Art—University of Oregon 2018:5.1

PASCAL CLEATUS POOLAW SR.

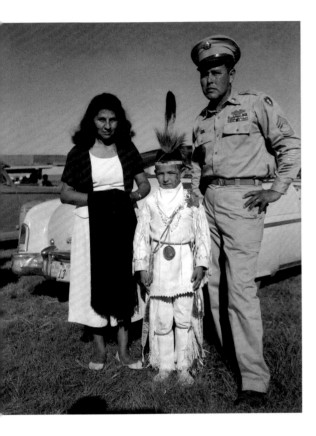

First Sergeant Pascal Cleatus Poolaw Sr. (Kiowa), known as "Cleatus" by friends and family, has been called the most decorated American Indian in the history of the U.S. military and was also a member of the Kiowa Black Legs (or Leggings) Warrior Society.[1] Sergeant Poolaw's service spanned three wars—World War II, Korea, and Vietnam—and earned him forty-two medals, badges, and citations, including four Silver Stars, five Bronze Stars, three Purple Hearts (one in each war), and the Distinguished Service Cross.[2]

Although Poolaw had retired from the military, he reentered in 1967 hoping to prevent his son Lindy from having to deploy. (Army regulations prevented two family members from serving in the same combat zone without their consent.) Another son, Pascal Cleatus Jr., had recently returned from Vietnam in 1967 after losing a leg to shrapnel from a mine. Sergeant Poolaw's strategy failed, and father and son went to combat together. This was not new for Cleatus, however, who had served in World War II with his father, Ralph, and two brothers. Four months later, Cleatus was killed while carrying a wounded soldier to safety. Afterward, Horace Poolaw (Kiowa)—Cleatus's uncle and photographer of their Kiowa community—committed his energy to seeing him inducted into the Hall of Fame of Famous American Indians in Anadarko, Oklahoma, where a bust of him now resides. Tragically, Lindy, the son Cleatus had intended to save, was struck by a car in Wildflecken, Germany, and died of his injuries at Landstuhl army hospital in 1968.

In December 2018, Cleatus was remembered at the hall bearing his name at Fort Sill, Oklahoma. His youngest brother,

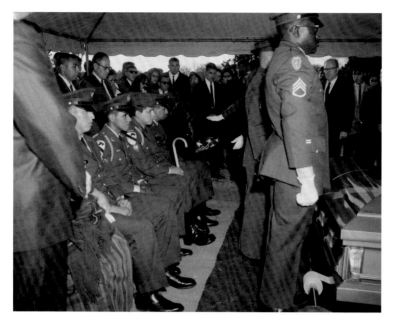

Irene Poolaw receives the flag at husband Pascal Cleatus Poolaw Sr.'s funeral. Left to right: Donald Poolaw (Kiowa), Lindy Poolaw (Kiowa), Pascal Poolaw Jr. (Kiowa), Lester Gene Poolaw (Kiowa), Irene Chalepah Poolaw (Kiowa Apache). Fort Sill, Lawton, Oklahoma, 1967. Photo by Horace Poolaw, 45UFN5 © Estate of Horace Poolaw

Ricky, recalled, "He had a booming voice. Some of his soldiers said he was a master psychologist because with little effort he could get things done in his unit because of the way he handled himself, and how he spoke to his soldiers. They respected him a great deal."[3] Horace Poolaw's daughter Linda remembers her cousin fondly. "I never knew him to be mad, or angry. I always remember him laughing all the time. It was like a celebration when he came home on leave. He had a lot of friends because he went to Riverside [Indian School]; he was everybody's hero. He still is."[4]

ALEXANDRA HARRIS

Irene Chalepah Poolaw (Kiowa Apache) at the funeral of her husband, Pascal Cleatus Poolaw Sr., showing his medals. Fort Sill, Oklahoma, 1967. Photo by Horace Poolaw, 45UFN1 © Estate of Horace Poolaw

WAR AND PEACE

Alexandra Harris and Mark Hirsch

NATIVE AMERICANS HAVE CONTRIBUTED to the United States Armed Forces off the battlefield as well as on. Whether deployed to combat zones, engaged in peacekeeping operations or humanitarian relief missions, or assigned to foreign or domestic military bases, Native servicemen and women have embraced the changing contours of military service. In so doing, they are redefining what it means and what it takes to be a warrior in the twenty-first century.

NO ONE would refute Johancharles "Chuck" Van Boers's status as a war veteran. The first Lipan Apache in a hundred years to be honored with the title of tribal war chief, Chuck Boers is a highly decorated, twenty-six-year veteran of the United States Army, who retired in 2009 as a master sergeant. His service record includes deployments to multiple conflicts, including Operation Urgent Fury (Grenada), Operation Desert Shield, Operation Desert Storm, Operation Southern Watch (Kuwait and other locations in the Middle East), Operation Restore Democracy (Haiti), and Operation Iraqi Freedom. Yet describing Boers as an archetypal combat soldier flattens his distinguished and diverse record of service. For instance, Boers frequently served as a combat photographer, providing commanders with real-time imagery with which to plan and assess the progress of missions. Additionally, Boers was deployed on numerous peace-keeping and humanitarian missions and what he calls OTW (other-than-war) operations, which have played an increasingly large role in U.S. military activity since the end of the Cold War.[1] Thus, Boers participated in Operation Joint Endeavor with the NATO Implementation Force in Sarajevo, Bosnia; Operation Joint Guard in Tuzla, Bosnia; Operation Joint Guardian in Kosovo; drug interdiction missions in Central America; and de-mining operations in Africa.[2]

The experience of war and peacekeeping, as well as his title as a Lipan Apache war chief, have given Boers a unique sensibility about what it means to

Sergeants Sam Stitt (Choctaw) and Chuck Boers (Lipan Apache), who discovered a shared Native heritage while serving in the army, pose next to their artwork in An Najaf, Iraq, in 2004. Courtesy of Chuck Boers

be a Native American warrior in the modern world. "Being a warrior isn't all about fighting and going off to wars," he insists. "It is sometimes about keeping the peace." Being a warrior, he says, requires a selfless commitment to serving others without regard to one's own well-being. It means having "the moral and physical courage to stand up to injustices," not just for one's self, "but for others as well." It means maintaining and displaying "a strong sense of duty and commitment" to one's family, community, and tribal nation, as well as to Native belief systems, values, and traditions. Ultimately, being a warrior means "not just leading by example, but by living it daily." Says Boers: "These are just a few of the many attributes of a warrior, and that [warrior] culture is still very strong throughout Indian Country."[3]

"WE'RE ALWAYS PREPARED for war, but there are other things we do," reflects retired Major Manuel Hernandez (Barona Band of Mission Indians).[4] Major Hernandez joined the army out of high school in 1988 as a "grunt." He trained as a paratrooper at Fort Bragg, like his uncle Anthony Pico, who enlisted in the army and served as a paratrooper in Vietnam before returning home to serve as chairman of the Viejas Band of Kumeyaay Indians for twenty-six years. At age nineteen, Hernandez patrolled the Egyptian–Israeli border with the Multinational Force and Observers—including soldiers from Fiji, Columbia, and the Netherlands—on a mission for the United Nations. After

three years as an enlisted soldier, he pursued his educational goals at the U.S. Military Academy, West Point, where he graduated as an army aviation officer. In 1998, Hurricane Mitch devastated Central America. With only a few days' notice, Hernandez and his unit were sent to stabilize Guatemala, delivering water and food by helicopter to isolated communities. In the military, "you're prepared to go at any time—it's not a combat mission but a humanitarian mission, but we're prepared to go regardless." In December 2001, Hernandez was chosen specifically to deploy for Operation Enduring

Manuel "Chief" Hernandez, left, patrolling the island of OP-311 in the Gulf of Aqaba in the Red Sea, December 1989. Hernandez stayed on the island for twenty-one days at a time before rotating out.
Courtesy of Manuel Hernandez

Freedom to Uzbekistan, where the army required logistical experts to establish resources before the main army arrived. As a budget officer, Hernandez was in demand. He hired local people to assist with operations and worked to fortify the army's base by constructing tents, working in mess halls, and providing other infrastructure requirements. "That was my critical role, financing all these operations. You have to be considerate and cautious. You have to pay him a wage consistent with wages in the host country. In many cases this is significantly less than what we pay in America. If you pay him too much, you could have doctors standing in line to fill sand bags." The delicate nature of military logistics often can be overlooked by civilians yet is critical to keeping the military engine running smoothly and negotiating space within a host country.

OVER THE COURSE of twenty-two years in the United States Army, Mitchelene BigMan (Apsáalooke [Crow] / Hidatsa) was deployed to Operation Iraqi Freedom (2003–4), completed two deployments near Baghdad, and was stationed at military bases in Germany, Korea, and the United States. Beginning as a diesel mechanic supporting an all-male combat battalion, she became a squad leader, section sergeant, and platoon sergeant, before retiring as sergeant first class in 2009.[5]

"I'm from a family that served," BigMan says, citing a bevy of kin who wore a U.S. military uniform before her. Both of her grandfathers served in the army during World War II, as did one of her grandmothers, who was a drill sergeant in the Women's Army Corps. Other family members served in Korea, Vietnam, Iraq, Afghanistan, and Somalia. Yet adhering to her family's tradition of military service was not her main reason for enlisting in 1986. Rather, she was running for her life, desperately seeking to escape an abusive former boyfriend. "I might have enlisted to get out of a bad situation," she explains, "but once I raised my right hand and pledged to defend the country, once I put on that uniform, it was like coming home."[6] Ultimately, the army enabled BigMan to recalibrate her life and claim a place in her family's legacy. "The military was a great experience," she says. "It made me see the world and…grow as a person, and not be scared."[7]

Yet the army was no cakewalk. "I caught a lot of flak because I was a female, because I was a minority, and because I was Native American," BigMan recalls. "It was three strikes against me."[8] As a woman, BigMan faced the distrust of male peers who doubted her physical strength and mental toughness and resented her presence in "a man's army." As a Native American, she interacted with peers who had never encountered an Indian or who embraced a litany of Native stereotypes. "No, we don't live in tipis, we live in houses, like everybody else," she'd tell them. "And we shop at Walmart, too."[9]

Adhering to her own punishing exercise regimen, volunteering for dangerous assignments, and watching the backs of people around her, BigMan

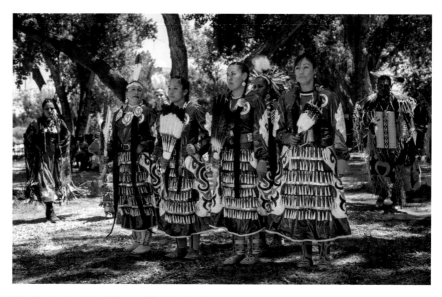

The Native American Women Warriors leading the grand entry during a powwow in Pueblo, Colorado, June 14, 2014. From left: Sergeant First Class Mitchelene BigMan (Apsáalooke [Crow]/Hidatsa), Sergeant Lisa Marshall (Cheyenne River Sioux), Specialist Krissy Quinones (Apsáalooke), and Captain Calley Cloud (Apsáalooke), with Tia Cyrus (Apsáalooke) behind them. © 2014 Nicole Tung

eventually won the respect of her peers…except for one: a male colleague who sexually assaulted her one night in Aberdeen, Maryland. BigMan never reported it; she kept it secret for ten years.

In Iraq, BigMan's unit faced danger from mortar attacks and from inter-actions with some Iraqi civilians who were hostile to the U.S. presence in their nation. "You never knew who the enemy was," BigMan recalls—a problem that manifested itself in bold relief when her unit was deployed on humani-tarian aid missions to local schools and communities. As a mother who had to leave her two little ones in the United States in the care of their grandmother, BigMan wanted to reach out to the kids she met in this war-torn place, maybe give them snacks or even just a smile. But in Iraq, U.S. soldiers had to sti-fle such instincts. A forlorn-looking child could be carrying a knife or worse. And for BigMan, quashing those emotions was hard. "I'm a big sap," BigMan admits. "I'd see a child and think, 'What if that kid just needed a hug?'" But "you always had to be alert and vigilant," she recalls. No smiles. No hugs. Stay focused on the mission.[10]

BigMan describes herself as a Native American first, and a retired ser-vice member second. But she is also a mother, a wife whose husband is also a veteran, a survivor of sexual assault, a soldier who has served in combat and during peacetime, and a warrior who is trying to heal herself as well as other Native American women.[11] In 2010, BigMan founded Native American

Women Warriors, an organization that raises awareness about Native American women veterans and provides support services in health, employment, and education.[12] "As a woman veteran, I felt like during my time we were not really given recognition for our hard work. Amongst our own people, it seemed like we weren't really accepted or even noted," BigMan said. "I took that step out of my comfort zone and really pursued it."[13] It's what modern Native American women warriors do.

THERE ARE THOUSANDS of Native American military veterans, such as Big-Man, Hernandez, and Boers, men and women who have served during times of peace and war and in every kind of mission in between. By adapting to the ever-changing needs of the armed forces, they have demonstrated an enduring commitment to military service in all its forms and helped to broaden the criteria that traditionally define tribal warriors. The National Native American Veterans Memorial honors all American Indian veterans for their service, no matter how, when, or where it was rendered—a point made forcefully by a Native Vietnam veteran at a 2016 planning meeting for the National Native American Veterans Memorial in Tulsa, Oklahoma. We should acknowledge "the veteran whether he was combat or if he wasn't. If it wasn't for those support people, a lot of us wouldn't be here. So whether they were stateside or whether they were in a country that was not combat, we need to recognize those people also. They were just as important to us and our well-being and our service time as anybody else."[14]

Senior Airman Christine Fink (Comanche) takes photos during her deployment to Africa in 2010. U.S. Air Force

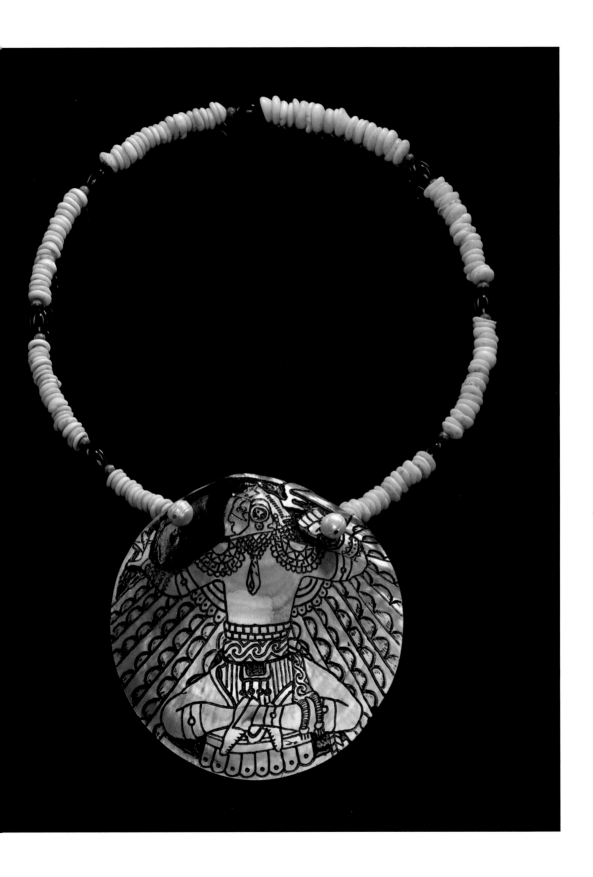

LEFT: Dustin Illetewahke Mater (Chickasaw, b. 1979), *Herrington: 21st-century Birdman*, 2014. Shell, wood, and glass beads. NMAI 26/9323

On November 23, 2002, former United States Navy pilot John Bennett Herrington (Chickasaw) became the first citizen of an American Indian nation to be sent into space. Herrington, an aeronautical engineer who had qualified as a NASA astronaut in 1996, carried eagle feathers, wooden Indian flutes, and the flag of the Chickasaw Nation with him on his thirteen-day mission to and from the International Space Station. Johnson Space Center, NASA

COAST GUARD

American Indians, Alaska Natives, and Native Hawaiians have been recognized by the military for centuries not only for their expertise in their own lands but also for their knowledge of their home waterways. Indigenous peoples have served in the Coast Guard and two of its predecessor services, the United States Life-Saving Service and the Lighthouse Service, since the early nineteenth century. Coastal tribes such as the Makah and Quileute in the Pacific Northwest and the Wampanoag in Massachusetts, as well as the Ojibwe in the Great Lakes, lent their experience as watermen to the task of saving lives at sea. In 1882, a non-Native keeper with an entirely Native volunteer crew manned the Life-Saving Service station at Neah Bay, Washington Territory. The local crew included As-chik-abik, Quedessa, Byron, Tsos-et-oos, Tsul-ab-oos, Kaloe, Chilee, and others.[1] Other than the American Indian army scouts serving farther east, the Neah Bay station was the earliest Indigenous unit in federal service.[2]

In a letter in 1882, Albert T. Stream, keeper of the United States Life-Saving Service at Shoalwater Bay, Washington Territory, discussed sourcing volunteers from the local Indian village.[3] One of Stream's volunteers was "Lighthouse" Charley Matote (so called because he had given the land upon which the lighthouse was built), chief of the Lower Chehalis, Shoalwater Bay, and Chinookan people on the Shoalwater Bay Reservation.[4] In late October 1881, the British iron bark *Lammerlaw* had run aground on the Middle Sands of Shoalwater while transporting coal from Australia to Portland, Oregon.[5] Stream and his mixed crew of local Native Americans and non-Natives worked for two days to save the *Lammerlaw*'s men. They worked through the night in the turbulent conditions, until a couple of the Native men balked at the danger posed by the stormy waters and wind.[6] Matote's son, seventeen-year-old George Charley (who would succeed Matote as chief) joined the effort on the second day, concerned that the older men with families were risking their lives.[7] Queen Victoria recognized Stream and George Charley with medals for their heroism and sacrifice in rescuing the *Lammerlaw*'s entire crew.[8]

Other Native people participated in the United States Lighthouse Service, which became part of the Coast Guard in 1939. The earliest were the Wampanoag people of Massachusetts. In 1815, the lighthouse keeper at Gay Head Light on Martha's Vineyard reported that he preferred to hire Wampanoag tribal members as the most effective lighthouse operational support. Gay Head keepers reportedly found the Wampanoags more reliable employees than non-Native locals. In the early morning of January 19, 1884, the passenger steamer *City of Columbus* ran aground near the Gay Head cliffs. Within twenty minutes, an estimated one hundred people drowned. Keeper Horatio Pease, a non-Native, and his Wampanoag crew attempted to reach the survivors, as did the Revenue Cutter *Dexter*.[9] Though their boat capsized twice in the attempts to reach the ship, both crew and survivors reached the shore. The Wampanoag volunteers were recognized by the local community and press for having saved nearly thirty passengers and crew, and they received medals and awards from the Massachusetts Humane Society, which founded the Life-Saving Service. Many continued to serve the Gay Head Lighthouse and

Locally famous lighthouse keeper Charles Vander-hoop Sr. (Aquinnah Wampanoag), who oversaw lights on Nantucket and Martha's Vineyard. His son, Charles Vanderhoop Jr., also loved Gay Head and the sea. Vanderhoop Jr. traveled the world as a Merchant Marine officer and served in World War II in the Coast Guard–Merchant Marine Branch.[10]
US Coast Guard

went on to serve in the Life-Saving Service station after it was established in 1895.[11] Then in 1920, the Coast Guard appointed Charles Vanderhoop (Aquinnah Wampanoag) as the tenth principal keeper at the Gay Head Light-house. Over his twenty-year career, he maintained the lighthouse, light, and lens through all weather and gave tours for around three-hundred thousand people, including President Calvin Coolidge.[12]

Men and women from the Pacific Islands have participated in the Coast Guard for nearly 170 years, beginning with the Revenue Cutter Service. Their seafaring expertise was highly valued throughout the Pacific, and Native Hawaiians, along with the Indigenous people of other U.S. territories such as Guam and American Samoa, lent their skills to the cutter and lighthouse service. Notable Coast Guardsmen to serve during wartime were Melvin Kealoha Bell, who manned the Diamond Head radio station on December 7, 1941, and warned commercial vessels of the attack on Pearl Harbor, and temporary reservists such as Duke Paoa Kahinu Mokoe Hulikohola Kahanamoku, Olympic gold-medal swimmer and surfing icon.[13]

More recently, Native American Coast Guardsmen have served with distinction during the World Wars, such as Carlton West (Wampanoag), who enlisted during both wars; have earned recognition for service in Vietnam; and graduated from the Coast Guard Academy. No longer exclusively from coastal tribes, the more than eight hundred Native Coast Guard members serving today come from many different Native nations and work in a variety of roles.[14]

Machinery technician Michelle Roberts (Tlingit) recently earned the rank of chief petty officer, and she is believed to be the first Native American woman to achieve the rank.[15] Born in Juneau, Alaska, Roberts's Tlingit name is Khaaw. aat, and she is of the Ch'aak (Eagle) moiety, Dak̲l'aweidí (Killer-whale) Clan.[16] When Roberts joined at age nineteen, her family—many of whom served in the Coast Guard—was ecstatic. "My family loved it. They knew everything that was going to happen to me at boot camp, and the adventures I would have after." In her seventeen years in the United States Coast Guard, she has served from Key West, Florida, to

Manama, Bahrain, in support of Operation Iraqi Freedom, earning many awards and commendations. Her enthusiasm about her Coast Guard family and work is infectious. Roberts explained what it means for her to achieve the rank of chief: "I was surprised how much I loved helping people move through life. People don't know their options and they don't want to ask. You just change people's lives by throwing a little knowledge at them." Reflecting on the service of Native people in the military, she remarked, "There's a lot of pride in who we are, and who we are is still about taking care of our family. . . . Maybe it's just to show that we are still here, we can still fight, we can still fight for what's good, and we'll fight for our pride. I'm thinking of [code] talkers or trackers—they'll do it to prove to you they're amazing people. . . . They'll do it and show you how great they are."[17]

ALEXANDRA HARRIS

Master Chief Melvin Kealoha Bell (1920–2018), per-
forming a final inspection at his retirement ceremony
following twenty years of active service (1938–
1958), Boston, Massachusetts, December 31, 1958.
Bob Bell/USCG

Born in Hilo, Hawai'i, Bell learned his mechanical
and electrical skills from his father. After joining the
Coast Guard in Honolulu, his talents led him to the
position of radioman. As radioman, Petty Officer
Bell learned communications and naval intelligence
work while serving at Diamond Head Lighthouse
on O'ahu. When the attack on Pearl Harbor by the
Japanese Imperial Navy occurred on December 7,
1941, Bell was on duty. He was the first to radio
warnings to commercial vessels and military

installations. After the attack, Bell focused on the
war effort as a specialist in naval communications
intelligence with the Navy's Fleet Radio Unit Pacific
(FRUPAC) as they broke the Japanese Imperial
Navy's codes, thereby contributing to victories in
the Pacific theater.

While in the Coast Guard, Bell became the first
Pacific Islander to become a chief petty officer, and
notably he was the first non-white coastguardsman
to achieve the rank of master chief. After twenty
years of active duty, he continued another forty-five
as a civilian Coast Guard employee, finally retiring
at age eighty-four with sixty-five years of service,
one of the longest military careers in U.S. history.[18]

LEFT PAGE ABOVE: Born in Nantucket, Massachusetts,
Seaman Carlton H. West (Wampanoag, 1896–1969)
served in the Coast Guard in World Wars I and II.
Courtesy of the Nantucket Historical Association,
PH31-0v-4

LEFT PAGE BELOW: Michelle Roberts, standing watch
in the generator room aboard the Coast Guard Cutter
William Trump while patrolling in the Caribbean, 2015.
Courtesy of Michelle Roberts

REAR ADMIRAL MICHAEL HOLMES:
A LIFETIME OF SERVICE

Over the course of his thirty-two-year career in the United States Navy (1973–2005), Rear Admiral Michael Holmes (Lumbee) covered a spectrum of assignments, all of which focused on defending the nation during an age of increasing global tension. His service record included flying tours in patrol squadrons; duty at the Pentagon, where he served as congressional liaison and air anti-submarine warfare officer for the Secretary of the Navy; and numerous assignments as commander of United States Navy patrol, surveillance, and reconnaissance forces in the Pacific, Mediterranean, and Atlantic. For his service, Holmes received numerous honors, including the Navy Distinguished Service Medal, Legion of Merit (three awards), Meritorious Service Medal (three awards), Navy Commendation Medal (two awards), as well as several unit and service awards.[1]

Born in 1950 on his family's farm, near Lumberton, North Carolina, Holmes worked shoeless in the fields as a young man, cropping tobacco, picking cotton, and pulling corn. Gripping the handles of a plow, he spent countless hours after school and during the summer looking at what he calls "the south end of a northbound mule." It was "a good life, and an honest living," he says. But the work was hard and unforgiving. "What farming taught me, besides the value of hard work, was that I didn't want to be a farmer when I grew up."[2]

One day, when he was in eighth grade, Holmes looked up and saw something he never forgot. There, approximately five-hundred feet above his parents' farm, was a single-file formation of fifty-six Air Force cargo planes

engaged in low-level navigation exercises. "I don't know what those pilots are doing," he thought, "but I *bet* they're having more fun up there . . . than I am down here, plowing this mule."

Holmes's rendezvous with naval aviation would await other developments. After graduating high school in 1968, Holmes attended Pembroke State College (now the University of North Carolina at Pembroke), from which he graduated in 1972 with a degree in mathematics. Shortly thereafter, he was recruited by the R. J. Reynolds Tobacco Company—a smart career move for a young man who "knew everything there was to know about tobacco."

His career in business was short-lived. While driving past the Raleigh-Durham Airport one day, Holmes noticed a billboard: "Join the Navy. Learn to Fly." Making a quick U-turn, he headed to the nearest Navy Recruiting Office, where the recruiter asked Holmes if he would like to take an orientation flight. "Why not?" Holmes replied.

Soon Holmes and a Navy pilot boarded the aircraft, a P-3 Orion. It was the first plane Holmes had ever been in. Once aloft, Holmes's mind traveled back to the day, many years before, when he was following "behind that mule, counting the planes." And he couldn't help but realize that he had it right as a kid. "These pilots were having fun," he says. "They were flying in an air-conditioned plane, drinking coffee, and eating doughnuts. They had a kitchen in the back, and two bunks to rest in during long flights. All this and getting *paid*."

After landing, Holmes took and passed the test to be considered for training as a Navy

Rear Admiral Michael Holmes, proudly wearing his service dress blue uniform, naval flying wings, and multiple service ribbons, on the day of his promotion to rear admiral, April 2000. Throughout his career, Holmes served in several command positions, including Commander Patrol Squadron Twenty-Four in Jacksonville, Florida; Commander Patrol Squadron Thirty, the Navy's largest aviation squadron, also in Jacksonville, Florida; Commander Patrol and Reconnaissance Wings Pacific in Honolulu, Hawai'i; Commander Fleet Air Mediterranean in Naples, Italy; Commander Task Force Six Seven also in Naples, Italy; and Commander Patrol and Reconnaissance Group in Norfolk, Virginia. Rear Admiral Holmes retired from the Navy on October 1, 2005. U.S. Navy, courtesy of Michael Holmes

pilot. Three weeks later, on July 6, 1973, he joined the Navy through the Aviation Officer Candidate School, in which he finished first in his class. He was commissioned a naval officer on December 20, 1973, and went on to earn his pilot wings in November 1974.

When the Navy asked him what kind of aircraft he wanted to fly, Holmes said he wanted to pilot the first plane he had ever been on, the P-3. His affinity for that aircraft never waned. "I came into the Navy flying the P-3 as an Ensign," he quipped, "and departed 32 years later, flying the P-3 as the Admiral in charge of all P-3 squadrons in the Navy."

MARK HIRSCH

Drum, titled *Desert Thunder*, and drumsticks used in a two-day powwow at Al Taqaddum Air Base near Fallujah, Iraq, 2004. Made by 120th Engineer Combat Battalion. Metal, wood, hide, twine, nylon cord, adhesive tape, plastic, nails; 45 × 61 × 62 cm. (drum); length 49, 49, and 60 cm. (drumsticks). Gift of Sergeant Debra K. Mooney and 120th Engineer Combat Battalion. NMAI 26/5148

CONFLICTS IN THE MIDDLE EAST
1991–2018

Dr. Laurence M. Hauptman

D URING THE LATE TWENTIETH CENTURY, American Indians served in every corner of the world, including major hot spots such as Afghanistan and Iraq, for much the same reasons as in previous generations. American military intervention in the Middle East began in earnest in 1991, when a U.S.-led coalition of more than two dozen nations launched Operation Desert Storm in order to drive Iraqi president Saddam Hussein's occupying forces out of Kuwait after Hussein ignored a U.N. resolution calling for the withdrawal of his troops. Within four days, coalition forces drove the Iraqi army out and inflicted tens of thousands of casualties. Then, instead of marching to Baghdad and removing Hussein from power, the American-led coalition signed a cease-fire accord.

But there would be no peace in Iraq, nor elsewhere in the Middle East. After the attack on the United States on September 11, 2001, President George W. Bush launched the War on Terror, in which as many as one hundred thousand American soldiers were subsequently deployed to Afghanistan against the Taliban, an Islamic fundamentalist group hostile to the country's Western-backed regime. Native American people likewise reeled from the tragedy of 9/11, sensing that their territory, as well as the country as a whole, was threatened. Armed with questionable evidence that Saddam Hussein possessed weapons of mass destruction, American officials launched a new war to promote "regime change" in Iraq in 2003.[1] When a new scourge known as the Islamic State raised its head a decade later, the United States once again intervened.

From 2001 onward, Americans read about far-off and dangerous places such as Anbar and Helmand provinces, Fallujah, Kandahar, Mosul, Raqqa, and Tora Bora. Military campaigns have focused on toppling leaders and eliminating terrorist threats. News of never-ending conflicts resulting in refugee crises, death, and destruction have since filled newspaper columns and television reports.

The human and financial costs of perpetual war have been astronomical. According to the Congressional Research Service, 2,346 Americans were killed in action and more than twenty thousand wounded in Operation Enduring Freedom (Afghanistan, 2001–14).[2] This includes thirty American Indians and Alaska Natives killed and 188 wounded. The same report indicated that in

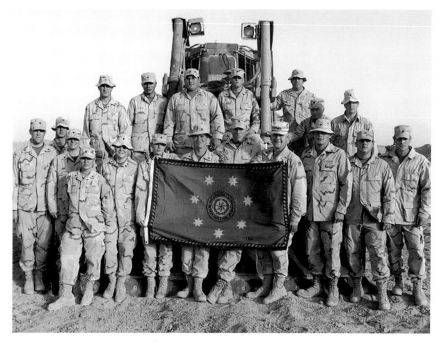

Soldiers from the United States Army's 120th Engineer Combat Battalion, posing with the Cherokee Nation flag. The photo was taken during the powwow events held at Camp Taqaddum, Iraq, September 17 and 18, 2004. Photo by Chuck Boers

Operation Iraqi Freedom, from March 2003 to September 2010, 4,411 Americans lost their lives and 31,954 were wounded. In this campaign, forty-three American Indians and Alaska Natives died, while 344 were wounded. In the first twelve years of American involvement in Iraq and Afghanistan, fourteen Diné (Navajo) were killed in combat, three in 2004 alone: Sergeant Lee Duane Todacheene, a medic in the First Infantry Division; and, in roadside bombings, nineteen-year-old Private First Class Harry N. Shondee Jr. and Lance Corporal Quinn A. Keith, just before he was scheduled to return stateside.

Many American Indians returned home with debilitating physical and psychological wounds from combat, such as Gulf War syndrome and post-traumatic stress. Bureaucratic inefficiency and limited staffing in hospitals and clinics administered by the Department of Veterans Affairs also seriously undermined efforts to handle the health needs of Indian and non-Indian veterans. The National Violent Death Reporting System for Oklahoma has indicated that the American Indian veteran deaths from suicide in the years 2005 to 2012 was 19 percent higher than for whites and three times higher than for African Americans.[3]

During the wars in Iraq and Afghanistan, the 120th Engineer Combat Battalion had the highest proportion of American Indians—20 percent—of any military unit in the combat zone.[4] Part of the Oklahoma National Guard (and successor to the highly decorated Forty-Fifth Regiment, the famous

Thunderbirds of World War II), this Oklahoma National Guard unit was ordered into federal service on December 7, 2003, to meet the increased need for troops. Later, in 2008, it was reorganized as the 2120th Engineer Construction Vertical (ECV), 120th Engineer Battalion. First based in Okmulgee and then Broken Arrow, Oklahoma, it was awarded a meritorious unit commendation for its participation in the War on Terror and its role in the fighting in Afghanistan.

On September 17 and 18, 2004, during the fighting in Operation Iraqi Freedom, the battalion held an intertribal powwow at Al Taqaddum Air Base to celebrate their diverse Native American heritage and to give the American Indian soldiers inner strength in the face of many dangers. Organized by Sergeant Debra K. Mooney, a Choctaw citizen from Idabel, Oklahoma, the powwow also aimed to educate their non-Indian comrades about American Indian cultural traditions.

In planning, Native participants sent home for their regalia and all the accoutrements they needed. "The drum...was the pivotal point," Mooney recalled. "If we couldn't get a drum, we couldn't have a powwow.... [T]he drum is the heartbeat, the spirit of the Native American."[5] They fashioned their drum from canvas from a cot and a discarded fifty-five-gallon oil barrel.[6]

Desert Thunder, an all-Cherokee drum group during the powwow in Iraq, September 17 and 18, 2004. Four soldiers from the 120th Engineer Combat Battalion wore ribbon shirts made from found materials at the base, and used a drum fashioned from a 55-gallon oil drum cut in half and covered with canvas from a sleeping cot. The powwow was the first documented to have taken place in a combat zone. Photo by Chuck Boers

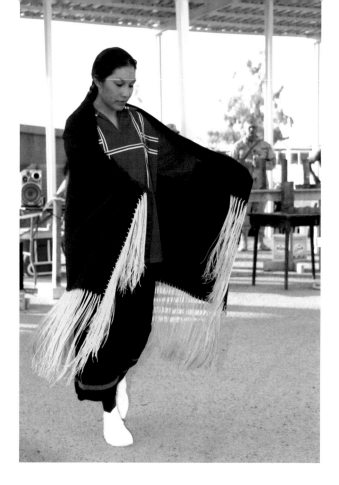

Specialist Leslie Montemayor (Muscogee [Creek]/Seminole) dances alone in memory of a fellow warrior, September 2004. During a powwow in Iraq, an honor ceremony was held for Private Raymond Bryan Estes III (Ponca, 1979–1998). Montemayor wears a dance shawl sent by Estes's family to be used in the powwow.
Photo by Chuck Boers

Soldiers from the 120th Engineer Combat Battalion playing a game of stickball in Camp Taqaddum, Iraq, September 17 and 18, 2004.
Photo by Chuck Boers

Master Sergeant Joshua Wheeler (Cherokee, 1975–2015) was a member of the army's elite Delta Force and the recipient of eleven Bronze Stars during his military career. Wheeler died on October 22, 2015, while rescuing prisoners from the Islamic State (ISIS) near Hawija in northern Iraq. He was the first known U.S. military casualty in the fight against ISIS. US Army DA Photo

"We got a drum maker—[Sergeant] Michael Morris. He was our major crafter. He made our tomahawks. He made our drum. He used the plasma cutter to cut the Thunderbirds around the bottom of it. We had armor plating off vehicles that were already blown. He used the plasma cutter and ground it down and made tomahawk heads out of it. The handles we used were broken tent mallets, and we used half for the tomahawks. Then the other half we used for the stickball sticks."[7] During lulls in war and military duties Native soldiers rehearsed their dances and songs, prepared traditional foods, and instructed their non-Indian comrades about powwow etiquette. After the powwow, Mooney later maintained that this first powwow held in a war zone had instilled pride among the Indian participants and that it helped bring the battalion together. "It gave us a little bit of comfort. We were doing something that we'd be doing if we were back home. We were also introducing something brand new to people that didn't have a clue, and we were representing the state of Oklahoma. We were representing the Oklahoma National Guard. We were representing Oklahoma Native American tribes and pride, and we were representing ourselves individually."[8]

LORI ANN PIESTEWA, 1979–2003

Lori Piestewa, a Hopi citizen, was one of the most reported casualties of war in the Middle East. Piestewa, a specialist in the Quartermaster Corps, was from Tuba City on the Navajo Reservation in Arizona. At birth she received her name, Köcha-hon-mana, or White Bear Girl, and was raised in the Hopi culture of non-violence.[1] She became the first woman killed in Operation Iraqi Freedom and the first known American Indian woman soldier to die in combat in a foreign war.[2] On March 23, 2003, while serving in the army's 507th Maintenance Company, Piestewa's unit was ambushed at Nasiriyah in southern Iraq while traveling in a convoy through the desert. While she was driving a Humvee, Piestewa's vehicle was hit in a rocket-propelled attack by Saddam Hussein's forces. The attack forced her vehicle to smash into a disabled tractor-trailer. Three soldiers in the Humvee died immediately; three additional American soldiers—including Piestewa and Jessica Lynch, both wounded—were taken prisoner. Piestewa, suffering from a head wound, died of her injury in an enemy hospital.[3]

Like many American Indians in military service, Piestewa had family members who had served in the United States Armed Forces. Her grandfather had fought in World War II and her father in Vietnam. Although originally buried in news reports about the freeing of her comrade Jessica Lynch, the story of Piestewa's brief life, once revealed, was commemorated throughout the nation. Lynch later credited her close friend and roommate Piestewa as the real heroine during the ambush. Arizona state officials soon changed the name of Phoenix-area Squaw Peak—a designation offensive to

Lori Piestewa (Hopi, 1979–2003), a specialist in the Quartermaster Corps of the 507th Maintenance Company of the United States Army, February 18, 2003. Piestewa was killed in the invasion of Iraq in Operation Enduring Freedom, becoming the first American Indian woman service member killed in combat in an American war. Piestewa Family/ Getty Images

contemporary American Indians—to Piestewa Peak. The United States Army also named its Directorate of Training Sustainment headquarters at Fort Benning, Georgia, Piestewa Hall in 2011. In the same year, the American Legion Post No. 80 on the Hopi Reservation was renamed the Lori Piestewa Post. "She will be remembered as a daughter, as a proud mother of two, as a good friend able to comfort others in distress," declared Hopi Tribal Chairman Wayne Taylor.[4]

DR. LAURENCE M. HAUPTMAN

DON'T CALL ME CHIEF

Unfortunately, ignorance about Native peoples continues in the military ranks. For over a century, American Indian servicemen have been referred to as "chief" rather than respectfully called by their last names. Most Native people have resented but nevertheless tolerated this stereotype. In the War on Terror, however, the cultural insensitivity went further. The U.S. military command in Iraq and Afghanistan labeled the enemy's territories as "Indian Country," as if they were still fighting late-nineteenth-century wars against Plains and Southwestern American Indian nations—and they have been referring to hostile territories and people using that and other American Indian metaphors since the Vietnam War.[1] In Operation Neptune Spear, the Navy SEALS' secret mission to kill Osama bin Laden, the al Qaeda terrorist's code-name was "Geronimo."[2] This and other incidents equating the War on Terror with "pacification" campaigns against American Indian nations fighting to preserve their lands and sovereignty was rightly condemned by numerous Native nations and later in a formal resolution by the National Congress of American Indians.[3]

DR. LAURENCE M. HAUPTMAN

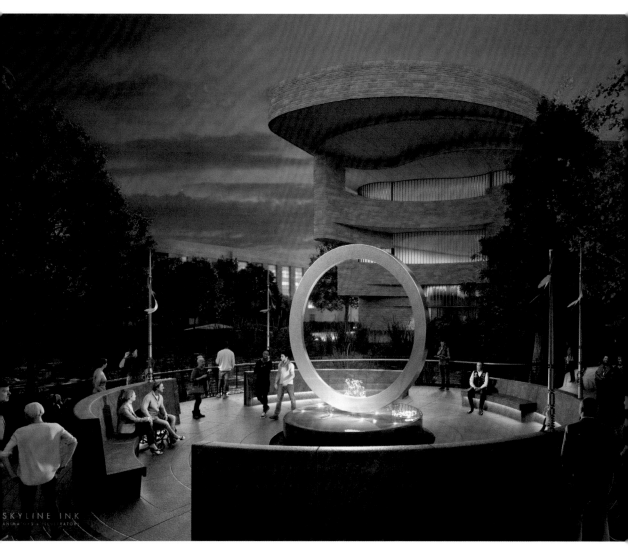

The design for the National Native American Veterans Memorial, by artist Harvey Pratt.
Design by Harvey Pratt/Butzer Architects and Urbanism, illustration by Skyline Ink, courtesy of the Smithsonian's National Museum of the American Indian.

HONORING THE LEGACY OF SERVICE
THE NATIONAL NATIVE AMERICAN VETERANS MEMORIAL

T HE NATIONAL NATIVE AMERICAN Veterans Memorial brings long-overdue recognition to American Indians, Alaska Natives, and Native Hawaiians who have served their country selflessly and with honor. The U.S. Congress passed legislation in 1994 (amended in 2013), authorizing the National Museum of the American Indian to create a memorial to give "all Americans the opportunity to learn of the proud and courageous tradition of service of Native Americans in the Armed Forces of the United States." Bringing this memorial to fruition is both a privilege and a great responsibility for the museum, on whose grounds the memorial resides.

The museum understood from the outset that it was essential to seek guidance from those whom the memorial would honor. With this in mind, the NMAI formed an advisory committee composed of distinguished Native American veterans and family members from across the country. Led by Senator Ben Nighthorse Campbell (Northern Cheyenne) and Chickasaw Nation Lieutenant Governor Jefferson Keel, the committee members represented all branches of the armed forces and several eras of service, from the Korean War to the present. The insights and guidance they contributed, based on their own experiences and their discussions with other veterans and service members, have been invaluable.

Working with the advisory committee, museum staff undertook an extensive consultation process, holding thirty-five consultations in sixteen states and

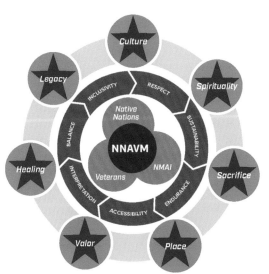

The National Native American Veterans Memorial vision and design principles, informed by the museum's consultations with Native veterans throughout the United States. NMAI

Planning, design, and architecture teams locating the memorial site in the museum's landscape during a memorial design workshop, December 19, 2018. NMAI

Design competition jury meeting, January 23, 2018. Left to right: Larry Ulaaq Ahvakana (Iñupiaq), Dr. Herman Viola, Mark Kawika McKeague (Kanaka ʻŌiwi [Native Hawaiian]), Stephanie Birdwell (Cherokee Nation), Brian McCormack (Nez Perce), Lillian Pitt (Wasco/Yakima/Warm Springs), Edwin Fountain, Design Competition Project/Communications Manager Jennifer Mannhard, NMAI Director Kevin Gover (Pawnee, alternate juror), and Design Competition Manager Donald Stastny. Not pictured: Dr. Johnnetta Betsch Cole. NMAI

the District of Columbia between late 2015 and mid-2017. Staff met with some twelve hundred people, sharing plans for the memorial and listening to their experiences, thoughts, and recommendations. These conversations were key to better understanding the perspectives and wishes of Native veterans, as well as the story the memorial needs to convey, the values it must embody, and what the experience of visiting the memorial should be.

The findings of the consultations shaped the vision and the design goals for the memorial. There was, first and foremost, a shared understanding that the memorial must be inclusive, honoring the courageous service of all Native

Verné Boerner (Iñupiaq), president and CEO of the Alaska Native Health Board, and Lester Secatero (Navajo), chairman of the Albuquerque Area Indian Health Board, attending consultations between the NMAI and the Veterans Affairs Office of Tribal Government Relations. Washington, DC, September 28, 2016. NMAI

Marine Corps veteran Debra Wilson (Oglala Lakota) addresses a panel from the NMAI about her vision for the National Native American Veterans Memorial during a public forum at the Hard Rock Hotel and Casino Tulsa in Catoosa, Oklahoma, 2016. STEPHEN PINGRY / Tulsa World

American veterans—including American Indian, Alaska Native, and Native Hawaiian men and women from all branches of the United States Armed Forces. The memorial should acknowledge a shared cultural commitment to serve and protect, and the sacrifice and support of the families of service members. It must be timeless, recognizing the legacy of service of past, present, and future generations.

Tribes and communities hosted the consultations, opening them with color guards, drum groups, and remarks from tribal leadership. Community members offered traditional songs and blessings, with prayers for healing for those impacted by service and for guidance in the creation of the memorial. Veterans and family members told stories of service, sharing both the pride and the pain these bring them.

Veterans also discussed their reasons for serving. Foremost among these was an inherited duty to protect their homeland, family, community, and way of life. At a consultation hosted by the Southern Ute Indian Tribe, tribal member and Vietnam veteran Rod Grove remarked, "Our great-great-grandparents'

Eric Birdinground (Apsáalooke [Crow]) speaks at the National Native American Veterans Memorial consultation at Crow Agency, Montana, July 29, 2016. NMAI

Left to right: Veterans Clarence J. Tougaw (Puyallup), Rodney A. Sisson (Puyallup), and Michael Sisson (Puyallup) at the fourth annual National Gathering of American Indian Veterans, Cantigny Park, Wheaton, Illinois, July 25, 2018. NMAI

Members of the National Native American Veterans Memorial Advisory Committee (left to right): Elaine Peters (Ak-Chin), Mitchelene BigMan (Apsáalooke [Crow]/Hidatsa), Debra Kay Mooney (Choctaw), Nancy Tsoodle Moser (Kiowa), Mark Azure (Assiniboine), Gary Hayes (Ute Mountain Ute Tribe), Debora Coxe (Mackinac Tribe of Odawa and Ojibwe Indians), Johancharles "Chuck" Boers (Lipan Apache), Colonel Wayne Don (Cup'ig/Yup'ik), Stephen D. Bowers (Seminole Tribe of Florida), Kevin P. Brown (Mohegan Tribe), Gerald L. Danforth Sr. (Oneida), Kurt V. BlueDog (Sisseton Wahpeton Oyate), Senior Advisor Dr. Herman Viola, Project Curator Rebecca Trautmann, Marshall Gover (Pawnee). National Museum of the American Indian, Washington, DC, January 19, 2017. NMAI

bones are in this land that we live on, so we still think of it as our own. We're willing to put forth our lives to keep enemies away."[1] And in Anchorage, Alaska, army veteran Nelson N. Angapak Sr. (Yup'ik) commented, "The memorial must reflect life.... We were taught to love life, even to the point of risking our lives to save the life of another person."[2]

Veterans and family members agreed that it was important for the experience of visiting the memorial to be a reflective and contemplative one, and many expressed a preference for a site in one of the quieter areas of the museum's grounds. There was also a desire for the memorial to reflect Native American spirituality, creating a welcoming space for gathering and ceremony and a place of healing for veterans, their families, and returning service members.

An open, international competition drew 120 design proposals. From these, a distinguished, eight-member jury representing artists, designers, cultural experts, and veterans unanimously selected the design concept submitted by Harvey Pratt, titled "Warriors' Circle of Honor." Pratt is a member of the Cheyenne and Arapaho Tribes of Oklahoma and a Southern Cheyenne peace chief, in addition to being a Marine Corps Vietnam veteran and artist.

Pratt's design for the memorial creates a semi-enclosed circular space, with a large, vertical stainless-steel circle sitting atop a low, cylindrical stone drum as its central element. Water flows continuously from the center of the drum, gently pulsing to send echoes or ripples outward. A flame will be lit at the base of the circle to mark ceremonial occasions. On a nearby stone wall, five circular seals echo the memorial's forms and pay tribute to the five branches of the armed forces.

Situated within the landscape surrounding the museum, the memorial is multisensory and interactive. It incorporates the elements of fire, suggesting strength, courage, endurance, and comfort; water, representing purity, prayer, cleansing, and reflection; and the earth itself. The circular gathering area has four points of entry at the cardinal directions. Visitors may attach prayer ties to four vertical spears in memory of loved ones who have served. Wind will carry these prayers and memories skyward, and will bring the sounds and scents of the surrounding vegetation and nearby water into the memorial.

The memorial's design is both simple and powerful, timeless and inclusive. It evokes the concept of a sacred circle, the cycles of time and life, and the movement of the stars and planets. The jury appreciated the circle's relevance to all Native American cultures, in the shape of a drum and of circles for dance, storytelling, and prayer. As they noted, the design's "concept of the circular nature of life makes individual veteran experiences and stories part of a collective unified experience."[3] The National Native American Veterans Memorial is a welcoming space for gathering, reflection, healing, and remembrance, a moving and lasting tribute to those who have given so much of themselves for their country.

HARVEY PRATT: CALLING PEOPLE TO GATHER

Harvey Pratt was born in 1941 in the small town of El Reno, Oklahoma. His mother, Anna Guerrier Pratt, had Cheyenne, Sioux, French, and English heritage. His father, Oscar Noble Pratt, was Arapaho. Theirs was a traditional family. "Growing up, we danced at powwows," Harvey Pratt says. "We were taught to respect the warriors and the veterans coming home." It was a creative family as well. Anna Guerrier Pratt was an accomplished storyteller, honored in 1987 as National Indian Woman of the Year. Pratt's brother Charles became a well-known sculptor. "He couldn't have been twelve years old, and he made a tandem bike out of scraps. Instead of handlebars he put a steering wheel on it," Pratt recalls. "I was younger than him, and schoolteachers would say, 'Are you Charlie Pratt's little brother?' and I'd say 'Yes, ma'am.' They'd say, 'Are you as talented as he is?' And my answer was, 'Well, I guess I am. I like to draw.'" He has been drawing for as long as he can remember. And it was a family with a history of military service. Pratt's great-great-great grandfather, the priest and arrow-keeper White Thunder, died at the Battle of Wolf Creek in 1838. Charles Guerrier, Anna Pratt's younger brother, was a much-decorated marine who fought in World War II and the Korean War.

Encouraged by his family and schoolteachers, Pratt intended to be an artist. When he was seventeen, he painted a crucifixion scene in which all of the figures were American Indians. An admirer bought it for $90, two weeks' wages for a laborer at the time. At college in Edmond, Oklahoma, however, an art teacher used one of Pratt's drawings as an example of what not to do. He changed his major from art to psychology, then left school altogether

to enlist in the Marine Corps, where his uncle was still on active duty. Assigned to the Marine Corps Military Police in Okinawa, Pratt volunteered for special duty. He spent an additional two months in training, then seven months in Vietnam guarding the air base at Da Nang and helping to support helicopter squadrons in recovering pilots who had been shot down.

In 1965, when his enlistment ended, Harvey joined the Midwest City, Oklahoma, Police Department. The first drawing of a suspect he made from a witness description led to an arrest and conviction in a homicide. In 1972, he joined the Oklahoma State Bureau of Investigation (OSBI) and retired as an assistant director in 1992, but he continued to serve until 2017 as a forensic artist. In addition, he has used his skill in portraiture to work on historic reconstructions.

Pratt has also had a distinguished career as an artist, working in oil, watercolor, metal, clay, and wood. His public art works include a sculptural relief for the entrance to the OSBI building and a thirty-seven-foot-long mural depicting the bureau's history. A sculpture by Pratt will be at the center of a memorial to the victims of the 1864 Sand Creek Massacre to be built on the grounds of the Colorado State Capitol. His paintings are held in the permanent collections of the Smithsonian and the National Park Service.

In thinking about concepts universal to American Indians for his memorial design, Pratt focused on the four directions, the elements—water, fire, earth, air—and especially the circle. "Everything that we have as tribal people honors the circle," he says. "Tipis and kivas are round. Earth lodges and igloos

Harvey Pratt stands on the airfield at Da Nang on his last day of service in Vietnam, in 1963. He carries the rappelling rope he used to descend from helicopters to clear landing fields, as well as an M-14 and grenades.
Photo by Ranny Pratt, courtesy of Harvey Pratt

are round. Indian people have always seen the circle in the sun and the moon. We've seen it in the weather, the seasons, and the cycle of life. It is continuous and timeless." Repeating circles form the foundation of Pratt's design for the memorial. A circular inner wall opens to the cardinal directions. An outer circle holds four lances, or eagle staffs.

In the center, an upright metal ring rests on a circular fountain that evokes a drum. In Native American cultures, Pratt notes, the drum is a heartbeat that calls people to gather. He sees the ring as an opening to the spiritual world. On special occasions, a flame at its base can be lit.

If the circle is the memorial's key design symbol, its meaning lies in the way visitors will use it. "I don't want people just to walk up to a statue and think it's pretty," Pratt says.

I want them to come inside the walls. There's a place to sit and do whatever someone has to do for medicine, to use the water, use the earth, use the wind. I hope it will be a place for war mothers. As non-Native visitors see Native veterans and their families blessing the water and tying prayer cloths, letting the wind carry their prayers, the memorial will be a place of learning and understanding as well. I hope it will be a place where veterans come and tell a war story, and where people come and say, "We're so proud of you."

That is what people did when Pratt returned from Vietnam—they did an honor dance and prayed for him. He reflects: "It becomes a place of power, a place of strength, a place of comfort."

HOLLY STEWART

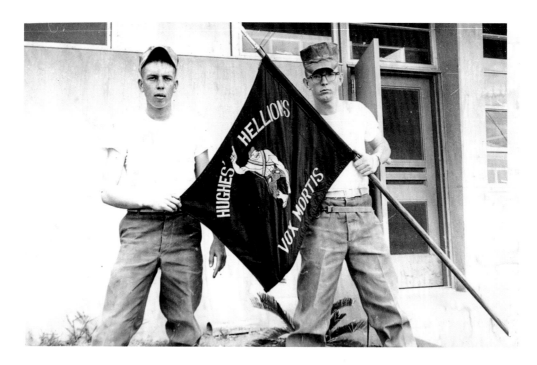

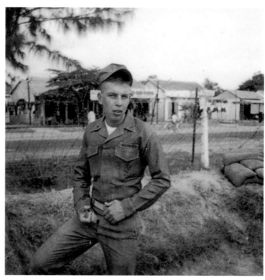

Harvey Pratt (left) and his friend, R. D. Pratt, hold the guidon flag Harvey designed for their platoon when stationed at Da Nang in 1963. The two took Harvey's drawing to a seamstress in town to have the flag made. The platoon was nicknamed "Hughes' Hellions" after its commander, Lieutenant Hughes. Courtesy of Harvey Pratt

Harvey Pratt, in his tailored Marine Corps Military Police uniform, at Da Nang Air Base in 1963. Behind him is Highway 1, which runs the length of Vietnam. Courtesy of Harvey Pratt

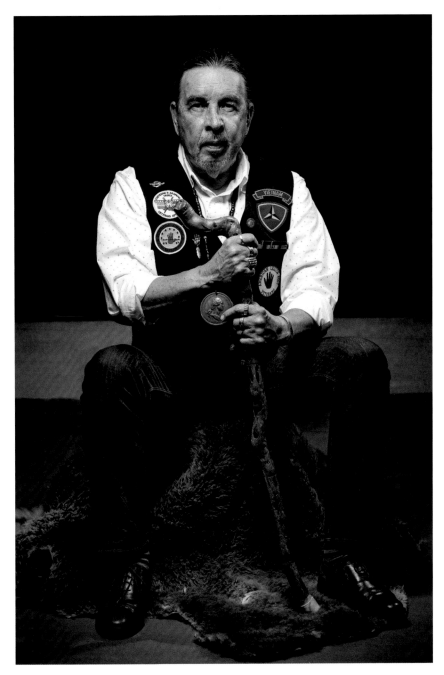

Harvey Pratt, 2019. © Abraham Farrar

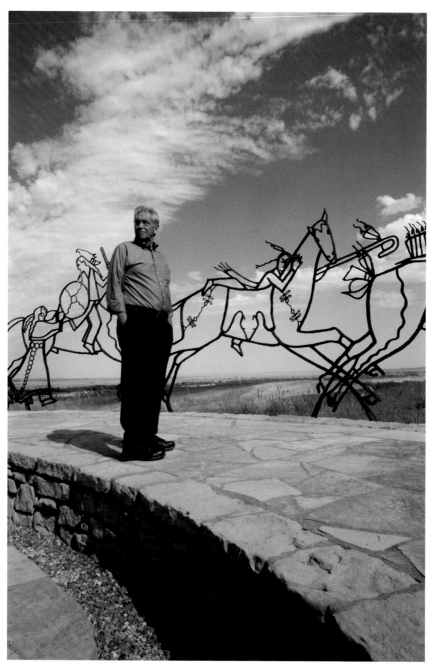

Kevin Gover, director of the Smithsonian's National Museum of the American Indian, at the Little Bighorn Battlefield National Monument, Crow Agency, Montana, 2016. NMAI

AFTERWORD

Kevin Gover

THERE IS NO ONE ANSWER as to why Native Americans have served at a higher rate than most communities. Surely it is some combination of the factors that lead others to serve in the military: opportunity, tradition, dutifulness, and of course patriotism. In speaking with Native veterans all over the United States, I was struck most by their commonness. And my use of that word is in no way disparaging. In almost every respect, they are like you and me, except for this one important thing: they chose to serve, to put themselves at risk, to leave home and family, and for this they deserve our most sincere and open respect and praise.

It occurs to me that while they were serving they spent little time pondering the paradox of serving the country that had for so long and in so many ways oppressed their people. In the aftermath of their service, they have become quite thoughtful about that. We hear them say, "It's still our country," or "This land is still ours." They are acknowledging the mistreatment their tribes have suffered at the hands of the United States, yet they still imagine a different and better tribal life in the future.

This reflects an optimism in tribal communities that many might find surprising. Most Native people I know believe that our best days lie ahead, that we can one day convince Americans to let these communities be different and still prosper. Put more concretely, we imagine a day when the government's many promises to the tribes will be fulfilled and the tribes' sovereign right to self-government will be fully honored. Perhaps that is why the cultural celebrations and official occasions of many tribes begin with the presentation of the American flag alongside those of the tribes. This is a deep patriotism, a belief that, despite all that has happened, the United States can be better, and we want to be a part of that.

Congress assigned to the National Museum of the American Indian the responsibility of building a memorial in the nation's capital to honor the Native Americans who have served in the military. We were both cowed by and grateful for that responsibility. We knew that Indian Country would support the effort, but how could we develop a memorial that would capture the breadth and depth of the remarkable story of Native military service?

We were enriched at hearing the stories of these good men and women who had served. Their humility and gentility belied the dangerous and brave lives they had led. They were candid about their service and themselves, often speaking freely about difficult subjects such as post-traumatic stress and its effects on their lives. They were funny, with the well-honed Native eye for the ironic and the absurd. They were generous in every possible way.

Before long, we realized that this memorial was not about war at all. It was, and should be, about the qualities of the men and women who served. From this realization, we were able to describe for artists from around the world what we hoped to convey through this memorial. The artists delivered amazing and beautiful ideas for the design of the memorial. In the end, one proposal stood out, the one submitted by Vietnam veteran, Cheyenne peace chief, and United States Marine Harvey Pratt. Fittingly, Harvey embodies the best qualities of Native veterans.

It is an honor for the NMAI to be the home of this memorial. To Native veterans, indeed to all veterans, we say welcome, thank you, bless you. This memorial is yours for all time.

CONTRIBUTORS

RAMONA DU HOUX is the executive director of *Maine Insights* news magazine, which she founded in 2005, as well as a writer, photographer, and illustrator. She is a cause-oriented organizer, a non-profit gallery director, president and owner of Insights public relations, and cofounder of the non-profit Solon Center for Research and Publishing. She has published a young adult novel, short stories, various news features and articles, as well as three books of children's poems. She continues to research Native American history with the goal of spreading awareness of Native cultural heritage as something every American needs to embrace. In 1991 she settled in central Maine, where she lives with her husband and three children.

ALEXANDRA N. HARRIS is a senior editor and writer at the Smithsonian's National Museum of the American Indian, where she has developed and edited scholarly books, exhibitions, strategic plans, and other museum communications since 2008. She is a graduate of the Smithsonian's Emerging Leaders Development Program and her editorial projects have earned awards for excellence in research from the Secretary of the Smithsonian. She edited and developed the exhibition catalogue *For a Love of His People: The Photography of Horace Poolaw*, chosen by the *New York Times* for their 2014 holiday gift guide, as well as the accompanying exhibition, which is currently traveling the nation. Prior to 2008, she was a curator at the Barona Cultural Center and Museum, tribal museum of the Barona Band of Mission Indians in San Diego. She holds an MA in American Indian studies from the University of California at Los Angeles (2001).

LAURENCE M. HAUPTMAN is SUNY Distinguished Professor Emeritus of History at SUNY New Paltz. He is the author of numerous books in Native American history, most recently *Coming Full Circle: The Seneca Nation of Indians, 1848 to 1934*, published by the University of Oklahoma Press in 2019. He is also a frequent contributor to *American Indian*, the magazine of the National Museum of the American Indian. In 2011, Hauptman was awarded the New York State Archives Lifetime Achievement Award for his research and publications. He has also testified as an expert witness before committees of both houses of Congress and in the federal courts and has served as a historical consultant for the Wisconsin Oneidas, the Cayugas, the Mashantucket Pequots, and the Senecas.

MARK G. HIRSCH has been a historian at the Smithsonian's National Museum of the American Indian since 2001. He was the lead researcher for the exhibition *Nation to Nation: Treaties Between the United States and American Indian Nations*, which opened in 2014. He is currently conducting research for an exhibition titled *Native New York*, which will open at the NMAI's George Gustav Heye Center in New York City. Mark earned a PhD in American history from Harvard University (1984) and an MA from the Centre for Social History, University of Warwick, England (1977).

RACHEL MENYUK is the processing archivist at the National Museum of the American Indian, Archive Center, where she has worked since 2010. She has a BA in anthropology and theater from the University of Maryland and an MA in humanities and social thought from New York University. At the NMAI, she has been instrumental in processing the records of the Museum of the American Indian / Heye Foundation as well as many additional photograph and manuscript collections, such as the Grace Thorpe collection. Rachel has been deeply involved in the museum's efforts to provide greater access to its archival collections, through description and online presentations, direct reference with researchers and artists, and collaborative projects with Native community members.

PAUL ONGTOOGUK (Iñupiaq) is the director of Alaska Native studies at the University of Alaska, Anchorage, where he has worked for more than twenty years. He has been a Gordon Russell Visiting Professor at Dartmouth University, a visiting lecturer at the University of Pennsylvania, and a professor at Illisagvik College for the North Slope of Alaska. He graduated from high school in Nome, Alaska, and received his BA in religion and philosophy at Northwest University and a BA in history from the University of Washington. He received an MEd in education from Michigan State University in 1991. His father, Tommy Ongtooguk (Iñupiaq), was born in Teller, Alaska, and his grandfather, also Iñupiaq, was born on Little Diomede Island. Both volunteered and served in the Alaska Territorial Guard.

HOLLY STEWART is an editor at the National Museum of the American Indian and has worked on books and other publications, exhibitions at the museum in Washington and New York and online, and social media. Her major credits include *Infinity of Nations: Art and History in the Collections of the National Museum of the American Indian*, *Spirit of a Native Place: Building the National Museum of the American Indian*, and *Creation's Journey: Native American Identity and Belief,* which won the Literary Marketplace Award for excellence in reference editing.

TY P. KĀWIKA TENGAN (Kanaka ʻŌiwi / Native Hawaiian) is an associate professor of ethnic studies and anthropology at the University of Hawaiʻi at Mānoa. He teaches courses in both precolonial and contemporary Hawaiian society, especially as it has been and continues to be transformed by Native Pacific and U.S. imperial histories. Tengan's research interests include Hawaiian masculinities, sovereignty, land, militarism, identity, museums, heritage, football, and Native Pacific culture and politics. He is researching the experiences of Native Hawaiian veterans. As a scholar committed to Hawaiian rights, he has served as a cultural expert on cases dealing with water rights on Maui, burial sites protection on Oʻahu and Hawaiʻi, and the protection of religious freedoms of Hawaiian prisoners on Oʻahu and in Arizona. He received his PhD in anthropology from the University of Hawaiʻi at Mānoa.

REBECCA HEAD TRAUTMANN is the project curator for the National Native American Veterans Memorial. She has worked as a researcher and curator of contemporary art at the Smithsonian's National Museum of the American Indian since 2003. Trautmann curated the NMAI exhibitions *Vantage Point: The Contemporary Native Art Collection* (2010) and *Making Marks: Prints from Crow's Shadow Press* (2013), and co-curated *Stretching the Canvas: Eight Decades of Native Painting* (2019). She worked previously at the Museum of Indian Arts and Culture in Santa Fe, New Mexico, and at the University of New Mexico's Maxwell Museum of Anthropology. Trautmann earned a BA in humanities at the University of Texas at Austin before doing graduate work in Native American art history at the University of New Mexico.

HERMAN J. VIOLA, curator emeritus at the Smithsonian's National Museum of Natural History, is a scholar of American Indian history and culture and the American West. Upon receiving his PhD in history in 1970 from Indiana University, he worked as an archivist at the National Archives, where he founded and edited its scholarly journal, *Prologue*, before joining the staff of the National Museum of Natural History. He curated two major exhibitions for NMNH: *Magnificent Voyagers* and *Seeds of Change*, in addition to serving as director of its National Anthropological Archives. Dr. Viola is a former member of the Citizens Coinage Advisory Committee for the U.S. Mint and senior advisor for the National Native American Veterans Memorial.

Co-Chairs

Senator Ben Nighthorse Campbell
(Northern Cheyenne)
United States Air Force

Lieutenant Governor Emeritus Jefferson Keel
(Chickasaw Nation)
United States Army

Advisory Committee Members

Mark Azure (Fort Belknap Assiniboine)
United States Army

Mitchelene BigMan (Apsáalooke [Crow] /
Hidatsa)
United States Army

Kurt V. BlueDog (Sisseton Wahpeton Oyate)
United States Army

Johancharles "Chuck" Van Boers
(Lipan Apache)
United States Army

Stephen D. Bowers (Seminole Tribe of Florida)
United States Army

Kevin P. Brown (Mohegan Tribe)
United States Army

James Chastain Sr. (Lumbee)
United States Army

Debora Coxe (Mackinac Tribe of Odawa
and Ojibwe Indians)
Gold Star Mother

S. Joe Crittenden (Cherokee Nation)
United States Navy

Gerald L. Danforth Sr. (Oneida Nation)
United States Navy

Colonel Wayne W. Don (Cup'ig / Yup'ik)
United States Army, Alaska Army
National Guard

John Emhoolah (Kiowa)
United States Army

Marshall Gover (Pawnee)
United States Marine Corps

Gary Hayes (Ute Mountain Ute Tribe)
United States Navy

Manaja Hill (Standing Rock Sioux Tribe)
United States Army

Allen K. Hoe (Native Hawaiian)
United States Army, Gold Star Father

Rear Admiral Michael L. Holmes, Retired
(Lumbee)
United States Navy

Judge Sharon House (Oneida Nation)
Military Family

Earl Howe III (Ponca Tribe of Oklahoma)
United States Army

Lee Gordon McLester III (Oneida Nation)
United States Marine Corps Reserves

Chairman Arlan D. Melendez (Reno-Sparks
Indian Colony)
United States Marine Corps

Debra Kay Mooney (Choctaw)
United States Army

Nancy Tsoodle Moser (Kiowa)
Military Family, United States Coast
Guard Civilian

Elaine Peters (Ak-Chin)
United States Marine Corps

Principal Chief Richard Sneed (Eastern Band
of Cherokee Indians)
United States Marine Corps

Jurors

Mr. Larry "Ulaaq" Ahvakana (Iñupiaq)
Artist

Ms. Stephanie Birdwell (Cherokee Nation)
Director, Veterans Affairs, Office of Tribal
Government Relations

Dr. Johnnetta Betsch Cole
Director Emerita, Smithsonian Institution

Mr. Edwin Fountain
General Counsel, American Battle
Monuments Commission

Mr. Mark Kawika McKeague (Native
Hawaiian)
Director of Cultural Planning, Group 70
International, Inc.

Mr. Brian McCormack (Nez Perce)
Principal Landscape Architect,
McCormack Landscape Architecture

Ms. Lillian Pitt (Wasco / Yakima / Warm
Springs)
Artist

Dr. Herman Viola
Curator Emeritus, Smithsonian Institution

Mr. Kevin Gover (Pawnee), Alternate Juror
Director of the National Museum of the
American Indian

ACKNOWLEDGMENTS

THIS BOOK COULD NEVER have been completed without the generous support of many people. First and foremost, we thank the American Indian, Alaska Native, and Native Hawaiian veterans who have served their Native nations and the United States. We are additionally grateful for the Indigenous veterans who attended the consultations for the National Native American Veterans Memorial and whose words informed the memorial and our narrative. We further thank our National Native American Veterans Memorial Advisory Committee and Jury members who spoke to us about their own or their relatives' service: Mitchelene BigMan, Kurt V. BlueDog, Johancharles "Chuck" Van Boers, Michael L. Holmes, and Kawika McKeague. We thank Congressional Committee Members Representative Deb A. Haaland and Representative Markwayne Mullin for sharing their family stories in support of the memorial and publication. To Harvey and Gina Pratt, we deeply appreciate your generosity in lending your photographs, stories, and extraordinary talent to both the memorial and book.

The histories of Native participation in the U.S. military cannot be told without the voices of veterans. For their part, we thank veterans Manuel Hernandez, Winonah Warren, Stanley Rodriguez, and Michelle Roberts, and family members Russell Hawkins, Linda Poolaw, Gabrielle Tayac, and Julie Tayac Yates for trusting us with your stories.

We are deeply grateful for the authors, scholars, knowledge keepers, and museum and archive professionals who shared their personal connections and knowledge to amplify this rarely shared history, including Dr. Laurence M. Hauptman, Dr. Tom Holm, Dr. William C. Meadows, Sid Mills, Paul Ongtooguk, and Dr. Ty P. Kāwika Tengan. We sincerely appreciate the assistance of Howard E. Halvorsen, Air Force Sustainment Center Historian at Tinker Air Force Base. Thank you to Allison Blakeslee, archivist at the Barona Cultural Center & Museum, for supporting our work with Major Hernandez. Thanks also goes to Smithsonian Institution colleagues Rajshree Solanki, chief registrar at the Hirshhorn Museum and Sculpture Garden, and Dawn Biddison, museum specialist at the Smithsonian Arctic Studies Center, for connecting us with military and community experts. We are grateful to Douglas Remley, rights and reproductions specialist at the National Museum of African American History and Culture, for his advice on language and style.

National Archives staff members Randy Thompson, senior archivist, the National Archives at Riverside, California, and Chris Killillay, archive specialist, Washington, DC, were of great assistance in sourcing the gems of the

historical record. We are especially grateful to Thomas Kaulukukui Jr. and Jerry Walker for sharing their perspectives on and photographs of lua, a tradition rarely discussed outside Hawai'i.

We deeply appreciate the enthusiasm shown by the United States Coast Guard to our book. Our sincere gratitude goes to William H. Thiesen, Atlantic Area Historian, for sharing his expertise, publications, and research with us. His passion for the coastguardsmen and women whose histories are seldom told is evident. Additional thanks are due to Dr. Dennis L. Noble; Lieutenant Emily Brockway, Office of External Outreach and Heritage; Beth Crumley, Assistant Historian; and Chief Warrant Officer Paul Roszkowski, U.S. Coast Guard Motion Picture, Television, and Author Liaison Office.

Finally, our utmost appreciation goes to our team at the National Museum of the American Indian: Julie Macander, who tirelessly pursued and organized the book's hundreds of images; Betsy Gordon, whose leadership on the memorial project is greatly valued; Rebecca Trautmann, the memorial's project curator, who lent wisdom gleaned from listening to hundreds of Native vets around the nation; Wendy Hurlock Baker, whose intellectual property knowledge is unparalleled; Dr. Bethany Montagano, whose research is always impeccable; Pat Jollie, for her generosity in sharing connections; Dennis Zotigh, whose writing and contacts for Native veterans helped inform our work; Elayne Silversmith, librarian of NMAI's Vine Deloria Jr. Library, for sharing her treasured collection and her research knowledge; Steve Bell and Julie Allred, whose design, as always, honors our content; our publication leadership, Tanya Thrasher and Ann Kawasaki, for their encouragement and support over the years we developed this book; Arwen Nuttall and Christine Gordon for their attention to editorial details; and Joanne Reams, who skillfully edited our volume. The authors are also indebted to three anonymous peer reviewers who offered generous and insightful comments and criticism of the text. This publication is far better for their commitment, skills, passion, and expertise.

NOTES

INTRODUCTION

1. Quoted in National Museum of the American Indian, *Native Words, Native Warriors* exhibition (2006), banner 15.

2. The legislation authorizing the National Native American Veterans Memorial and the National Museum of the American Indian combines Native Hawaiians and Alaska Natives with Native Americans under the category "Native Americans." In an effort to acknowledge the cultural, geographic, and legal distinctiveness of Native Hawaiians from Indigenous people of the mainland United States, the authors have included specific Native Hawaiian demographic, historical, and cultural information when possible. Native American Veterans' Memorial Establishment Act of 1994, Pub. L. No. 103-384, 108 Stat. 4067 (1994).

3. Native Americans have served in the U.S. military in enormous numbers, but there is little hard quantitative evidence to support and establish the claim. The problem of assessing American Indian participation in the armed forces is discussed in the essay titled "How Many Served?" in this volume's introduction.

4. Arguably, it has often been non-Indian scholars and writers who have pondered the seeming paradox of Native military service to a nation that has been implacably hostile to tribal rights.

5. Pamela Bennett and Tom Holm, "Indians in the Military," in *Indians in Contemporary Society*, ed. Garrick A. Bailey, vol. 2, *Handbook of North American Indians*, ed. William C. Sturtevant (Washington, DC: Smithsonian Institution, 2008), 17.

6. Arthur C. Parker, "The American Indian in the World War," *The Southern Workman* 47 (February 1918): 63.

7. Encouragement by Indian boarding schools and the Office of Indian Affairs also helps account for the high rate of Native enlistment in the armed forces in the early-to-mid-twentieth century. See Jill Doerfler and Erik Redix, "The Great Lakes," in *The Oxford Handbook of American Indian History,*

ed. Frederick Hoxie (New York: Oxford University Press, 2016), 187.

8. National Museum of the American Indian, National Native American Veterans Memorial Consultation, Agua Caliente, California, Consultation Transcript, November 14, 2016.

9. Unidentified Native American Special Forces veteran quoted in William C. Meadows, *Kiowa, Apache, and Comanche Military Societies: Enduring Veterans, 1800 to the Present* (Austin: University of Texas Press, 1999), 400.

10. Unidentified Native World War II veteran quoted in Meadows, *Kiowa, Apache, and Comanche Military Societies,* 399–400.

11. The organization, founded by Mitchelene BigMan in 2010, raises awareness about Native American women veterans and provides support services in health, employment, and education. Mitchelene BigMan quoted in National Museum of the American Indian, National Native American Veterans Memorial Consultation Report (2018), 7.

12. Thomas Kaulukukui, interview with Alexandra Harris, July 23, 2019.

13. David Kawika McKeague, email to Alexandra Harris, June 25, 2019.

14. Native American Veterans' Memorial Establishment Act of 1994, Pub. L. No. 103-384, 108 Stat. 4067 (1994).

How Many Served?

1. Thomas A. Britten, *American Indians in World War I: At Home and at War* (Albuquerque: University of New Mexico Press, 1997), 60.

2. Quoted in William C. Meadows, "Native American 'Warriors' in the US Armed Forces," in *Inclusion in the American Military: A Force for Diversity*, ed. David E. Rohall, Morten G. Ender, Michael D. Matthews (Lanham, MD: Lexington Books, 2017), 89.

3. Britten, 52.

4. Britten, 57.

5. Department of the Interior, Office of Indian Affairs, unaddressed letter [possibly a template]

from the Commissioner of Indian Affairs, Entry E998E, "Records Relating to Indians in World War I and World War II, 1920–1945," Box 1, Records of the Bureau of Indian Affairs, Record Group 75, National Archives Building, Washington, DC.

6. Meadows, "Native American 'Warriors' in the US Armed Forces," 91.

7. Grace Mary Gouveia, "'We Also Serve': American Indian Women's Role in World War II," *Michigan Historical Review* 20, no. 2 (Fall 1994): 159–60.

8. John Collier, "The Indian in a Wartime Nation," *The Annals of the American Academy of Political and Social Science* 223 (Sept. 1942): 29.

9. Gouveia, "'We Also Serve,'" 160.

10. Nese F. DeBruyne, *American War and Military Operations Casualties: Lists and Statistics* (Washington, DC: Library of Congress, Congressional Research Service, 2017), 6.

11. Meadows, "Native American 'Warriors' in the US Armed Forces," 94–95.

12. Tom Holm, *Strong Hearts, Wounded Souls: Native American Veterans of the Vietnam War* (Austin: University of Texas Press, 1996), 201n22.

13. Holm, *Strong Hearts, Wounded Souls,* 122–23.

14. Unidentified United States Army field officer, quoted in U.S. Congress, House Committee on Military Affairs, *Hearings on Army Reorganization,* 66th Cong., 2d. session, 2185 (1920), quoted in Barsh, "American Indians in the Great War," 282.

15. Department of Defense, *2017 Demographics: Profile of the Military Community* (Department of Defense (DoD), Office of the Deputy Assistant Secretary of Defense for Military Community and Family Policy (ODASD (MC&FP)), under contract with ICF, 2017), 7, accessed April 23, 2019, http://download.militaryonesource.mil/12038/MOS/Reports/2017-demographics-report.pdf; according to the Veterans Administration: "For the purposes of this analysis, only Veterans who reported a single race of AIAN are included in this group. Veterans who reported AIAN in combination with any other race are classified along with all other Veterans in the category 'All Other Races.' The single race of AIAN Veterans includes the Hispanic ethnicity." Department of Veterans Affairs, "American Indian and Alaska Native Veterans: 2015 American Community Survey" (August 2017), 4.

16. Letter from Miguel Aviles-Perez, Chief of the Office of Diversity and Inclusion, United States Coast Guard, to Alexandra Harris, June 21, 2019, in response to FOIA request 2019-CGFO-01532. The United States Coast Guard is under the Department of Homeland Security, as opposed to the Department of Defense, where the other four branches of the armed services are located.

17. Department of Defense, Defense Manpower Data Center, FOIA case #19-F-1068, May 24, 2019.

18. Holm, *Strong Hearts, Wounded Souls,* 15.

The Stereotype of the Indian Warrior

1. Tom Holm, *Strong Hearts, Wounded Souls: Native American Veterans of the Vietnam War* (Austin: University of Texas Press, 1996), 66–67.

2. Delaware and "Canasataugua" Indians originally took Smith prisoner. He was then taken to an "Indian town" inhabited by Delawares, Caughnewagos, and Mohicans. He was adopted forthwith into the "Caughnewago" Nation. Smith may be referring to the Conestoga (a tribe and village, first mentioned by Captain John Smith in 1608 as Susquehannock) and Conewago Indians of what is now Lancaster County, PA; the nearby creeks still bear their names. The "Indian Town" mentioned in Colonel James Smith's narrative may be the village of Conestoga, which was known as Indian Town. See George P. Donehoo, *A History of the Indian Villages and Place Names in Pennsylvania With Numerous Historical Notes and References* (Harrisburg, PA: Telegraph Press, 1928), 34–40. That there were so many different tribal people living at Indian Town could be a result of trade but also of the proliferation of refugee havens resulting from colonial expansion and dispossession of land. For more about refugee towns in the Upper Susquehanna and Iroquois territories, see Laurence M. Hauptman, "Refugee Havens: The Iroquois Villages of the Eighteenth Century," in *American Indian Environments: Ecological Issues in Native American History,* ed. Christopher Vecsey and Robert W. Venables. (Syracuse: Syracuse University Press, 1980), 128–39.

3. Archibald Loudon, *A Selection of Some of the Most Interesting Narratives, Or the Outrages Committed by the Indians In Their Wars With the White People: Also, an Account of Their Manners, Customs, Traditions, Religious Sentiments, Mode of Warfare, Military Tactics, Discipline And Encampments, Treatment of Prisoners, &c. Which Are Better*

Explained, And More Minutely Related, Than Has Been Heretofore Done, by Any Other Author On That Subject; Many of the Articles Have Never Appeared In Print; The Whole Compiled From the Best Authorities (Harrisburg: Harrisburg Publishing Company, 1888), 2:241.

4. Loudon, 244–45.

5. Loudon, 249–50.

6. Jere' Bishop Franco, *Crossing the Pond: The Native American Effort in World War II* (Denton, TX: University of North Texas Press, 1999), 120.

7. Laurence M. Hauptman, *Between Two Fires: American Indians in the Civil War* (New York: Free Press, 1995), 143.

8. Thomas W. Dunlay, *Wolves for the Blue Soldiers: Indian Scouts and Auxiliaries with the United States Army, 1860–90* (Lincoln: University of Nebraska Press, 1982), 66–67.

9. "Indians Win Fame on the Battle Front," *The Native American* 19 (March 1918): 81. Quoted in Thomas A. Britten, *American Indians in World War I: At Home and at War* (Albuquerque: University of New Mexico Press, 1997), 100.

10. Britten, 101.

11. Quoted in Mary Gouveia, "'We Also Serve': American Indian Women's Role in World War II," *Michigan Historical Review* 20, no. 2 (Fall 1994): 162; originally "Berthold Girl Is First Indian WAVE," *Bismark Tribune*, 2 November 1943, 3.

12. Holm, 89–90.

13. Holm, 150–51.

14. Cécile Ganteaume, *Officially Indian: Symbols That Define the United States* (Washington, DC: National Museum of the American Indian, 2017), 145–46.

15. Ganteaume, *Officially Indian*, 136–37.

CULTURES OF WAR

1. See Sonja John, "From Warrior to Soldier?," in *Warring Over Valor: How Race and Gender Shaped American Military Heroism in the Twentieth and Twenty-First Centuries*, ed. Samuel Wendt (New Brunswick, NJ: Rutgers University Press, 2019), 165–81, for a discussion of the complexity of the warrior stereotype versus the reality of being a warrior in Indigenous (specifically Lakota) culture.

2. The Hopi Foundation, accessed January 31, 2019, http://www.hopifoundation.org/the-hopi-way. Nevertheless, conflicts occur and are tended by Hopi warrior societies and related ceremonies:

Arlette Frigout, "Hopi Ceremonial Organization," in *Handbook of North American Indians*, ed. William Sturtevant, *Southwest*, ed. Alfonso Ortiz (Washington, DC: Smithsonian Institution, 1979), 9:575–76.

3. See Richard W. Hill Sr., "Linking Arms and Brightening the Chain: Building Relations through Treaties," in *Nation to Nation: Treaties Between the United States and Indian Nations,* ed. Suzan Shown Harjo (Washington, DC: Smithsonian National Museum of the American Indian, 2014), 37–58.

4. Jean Chaudhuri and Joyotpaul Chaudhuri, *A Sacred Path: The Way of the Muscogee Creeks* (Los Angeles: UCLA American Indian Studies Center, 2001), 29.

5. Angie Debo, *The Road to Disappearance: A History of the Creek Indians* (Norman: University of Oklahoma, 1941), 7.

6. Debo, 12–13.

7. Kamehameha Publishing, "Kumakahi: Living Hawaiian Culture," 2019, accessed April 5, 2019, http://www.kumukahi.org/units/na_kanaka/oihana/lua.

8. National Museum of the American Indian interview, "Native Words, Native Warriors" website, 2004, accessed October 28, 2019, https://americanindian.si.edu/static/education/codetalkers/html/chapter5.html.

9. Richard Kekumuikawaiokeola Paglinawan, Mitchell Eli, Moses Elwood Kalauokalani, and Jerry Walker, *Lua: Art of the Hawaiian Warrior* (Honolulu: Bishop Museum Press, 2006), 9, 32. A Hawaiian proverb states, *He niuhi ʻai holopapa o ka moku* (The niuhi [man-eating] shark that devours all on the island); if a chief or warrior captured this shark, they would acquire some of its nature. Mary Kawena Pukui, *ʻŌlelo noʻeau: Hawaiian Proverbs and Poetical Sayings* (Honolulu: Bishop Museum Press, 1983), 91–92.

10. Paglinawan, et al., 7.

11. Paglinawan, et al., 9.

12. James Adair, *Adair's History of the American Indians*, ed. Kathryn E. Holland Braund (Tuscaloosa: University of Alabama Press, 2005), 389.

13. Stephen M. Silver and John P. Wilson, "Native American Healing and Purification Rituals for War Stress," in *Human Adaptation to Extreme Stress: From the Holocaust to Vietnam,* ed. John P. Wilson, Zev Harel, and Boaz Kahana (New York: Plenum Press, 1988), 342.

14. National Museum of the American Indian interview, "Native Words, Native Warriors" website, 2004, accessed October 28, 2019, https://americanindian.si.edu/static/education/codetalkers/html/chapter4.html.

15. Pamela Bennett and Tom Holm, "Indians in the Military," in *Indians in Contemporary Society,* ed. Garrick A. Bailey, vol. 2, *Handbook of North American Indians,* ed. William C. Sturtevant (Washington, DC: Smithsonian Institution, 2008), 18.

16. Tom Holm, *Strong Hearts, Wounded Souls: Native American Veterans of the Vietnam War* (Austin: University of Texas, 1996), 35.

17. The archaeological record evidences some occurrences of large-scale violence, mostly on the northern Great Plains but also identified in the Southwest, Canadian Arctic, and possibly in the Southeast. For a survey on archaeology of North American warfare prior to European contact, see Patricia M. Lambert, "The Archaeology of War: A North American Perspective," *Journal of Archaeological Research* 10, no. 3 (September 2002): 207–41.

18. Holm, *Strong Hearts, Wounded Souls,* 41.

19. James Mooney, *History, Myths, and Sacred Formulas of the Cherokees: containing the full texts of* Myths of the Cherokee (1900) *and* The sacred formulas of the Cherokees (1891) *as published by the Bureau of American Ethnology* (Asheville, NC: Bright Mountain Books, 1992), 170.

20. Thomas Vennum Jr., *American Indian Lacrosse: Little Brother of War* (Washington, DC: Smithsonian Institution Press, 1994), 213–14.

21. Vennum, xii–xiv.

22. Vennum, 197, 216.

23. Though seen through an early non-Indian anthropologist's lens, Mooney's history is based on the testimony of William Holland Thomas (an adopted Cherokee who became principal chief and leader of the legion) and others present at the time. Mooney, 388–91.

24. Thomas A. Britten, *American Indians in World War I: At Home and at War* (Albuquerque: University of New Mexico, 1997), 149–50.

25. Julie Tayac Yates, interview with Alexandra Harris, July 11, 2019.

26. Holm, *Strong Hearts, Wounded Souls,* 107.

27. Bureau of Indian Affairs, *Indians at Work* 9, no. 8 (April 1942): 6.

28. Bureau of Indian Affairs, *Indians at Work* 10, no. 1 (Oct. 1943): 16–18.

29. Alison R. Bernstein, *American Indians and World War II: Toward a New Era in Indian Affairs* (Norman: University of Oklahoma, 1991), 58.

30. National Museum of the American Indian, "Native Words, Native Warriors," accessed March 8, 2019, https://americanindian.si.edu/education/codetalkers/html/chapter5.html.

31. Holm, *Strong Hearts, Wounded Souls,* 167.

32. Holm, 187.

33. Holm, 188.

34. National Museum of the American Indian, "Native Words, Native Warriors," accessed March 8, 2019, https://americanindian.si.edu/education/codetalkers/html/chapter5.html.

35. Tom Holm, "The National Survey of Vietnam Era American Indian Veterans: A Preliminary Reconnaissance," *Wicazo Sa Review* 1, no. 1 (Spring, 1985): 37.

36. "Celebration Planned for Returning Marine," *Billings Gazette,* August 21, 2006, accessed April 9, 2019, https://billingsgazette.com/news/state-and-regional/montana/celebration-planned-for-returning-marine/article_5bd57978-e87d-5032-87e1-b158bbb42d10.html.

37. "Tohono O'odham Tribe Honors Tribal Servicemembers," March 28, 2003, accessed August 8, 2019, https://www.kold.com/story/1203374/tohono-oodham-tribe-honors-tribal-servicemembers/.

38. Stan Rodriguez, phone interview with Alexandra Harris, April 18, 2019.

39. Sergeant Enrique S. Diaz, "U.S. Soldiers Celebrate Native American Heritage in Iraq," September 24, 2004, accessed April 9, 2019, https://www.1stmlg.marines.mil/News/News-Article-Display/Article/543174/us-soldiers-celebrate-native-american-heritage-in-iraq/.

40. Stephen Silver, "Lessons from Child of Water," *American Indian and Alaska Native Mental Health Research* 1, no. 6 (1994): 10.

41. Lawrence W. Gross, "Assisting American Indian Veterans of Iraq and Afghanistan Cope with Posttraumatic Stress Disorder: Lessons from Vietnam Veterans and the Writings of Jim Northrup," *American Indian Quarterly* 31, no. 3 (2007): 381. http://www.jstor.org/stable/30114250.

42. Silver, "Lessons from Child of Water," 15.

43. Mark Kawika McKeague, email to Alexandra Harris, June 25, 2019.

44. Mark Kawika McKeague, interview with Alexandra Harris, March 29, 2019.

45. Brooke Edwards, "Local group nominated for 'Nammy,'" *Victor Valley Daily Press,*

October 31, 2010, accessed March 11, 2019, https://
www.vvdailypress.com/article/20101031/NEWS
/310319997.

46. Other than noted, all references are from
the following source: Lance Corporal Dan-
iel Boothe, "Native American traditions uplift
wounded warriors," *Marines: The Official Website
of the United States Marine Corps*, March 8, 2010,
accessed March 11, 2019, https://www.pendleton
.marines.mil/News/News-Article-Display/Article
/537111/native-american-traditions-uplift-wounded
-warriors/.

47. Tom Kaulukukui, interview with Alexandra
Harris, July 23, 2019.

48. See Silver, "Lessons from Child of Water,"
4–17; Gross, "Assisting American Indian Veterans
of Iraq and Afghanistan Cope with Posttraumatic
Stress Disorder," 373–409.

49. Tom Kaulukukui, email to Alexandra Har-
ris, July 30, 2019.

Kiowa Warrior Societies

1. William C. Meadows, *Kiowa, Apache, and
Comanche Military Societies: Enduring Veterans,
1800 to the Present* (Austin: University of Texas
Press, 1999), 40.

2. Belt with drop, 2000–2006. Dyed tack
leather; German silver buckle, conchos, engraved
sheet-metal decoration, and jingles; hide thong;
coins. Moccasins, 2000–2006. Hide, sinew, green
and blue pigments, glass beads, metal rivets.
Dance staff, 2000–2006. Metal sword blade, wood
dowel, blue felted wool, yellow-dyed hide thongs,
brass bells. Necklace, 2000–2006. Bone beads,
plastic beads, commercial jewelry wire.

3. Meadows, email to the authors, July 14, 2019.

4. Meadows, *Kiowa, Apache, and Comanche
Military Societies*, 97.

5. William C. Meadows, *Kiowa Military Societ-
ies: Ethnohistory and Ritual* (Norman: University
of Oklahoma Press, 2010), 54, 188.

6. Meadows, *Kiowa, Apache, and Comanche
Military Societies*, 139; Meadows, *Kiowa Military
Societies*, 61.

7. Meadows, *Kiowa Military Societies*, 109.

8. Meadows, 307–30.

9. Meadows, 330–31.

THE PROMISE AND PERIL OF ALLIANCE: FROM CONTACT TO 1814

1. Daniel K. Richter, "Red Jacket," in Freder-
ick E. Hoxie, ed., *Encyclopedia of North American
Indians: Native American History, Culture, and Life
from Paleo-Indians to the Present* (Boston and New
York: Houghton Mifflin Company, 1996), 532;
Clifford E. Trafzer, ed., *American Indians/Ameri-
can Presidents: A History* (New York and Washing-
ton, DC: HarperCollins Publishers in Association
with the National Museum of the American
Indian, Smithsonian Institution, 2009), 65.

2. Colin G. Calloway, *New Worlds for All: Indi-
ans, Europeans, and the Remaking of Early America*
(Baltimore: Johns Hopkins University Press, 1997),
105.

3. Tribal battle lines during the Pequot War
were not hard and fast. For example, Indigenous
people, including the Sasqua of Fairfield, the
Quinnipiac of New Haven, the Western Niantic,
the Mohegan, the Narragansett, the Nipmuc, the
Wangunk, the Podunk, and the Mohawk of New
York fought both with and against the Europeans
and the Pequot. See "Battlefields of the Pequot
War," Mashantucket Pequot Museum website,
last modified October 23, 2009, http://pequotwar
.org/2009/10/welcome-to-pequot-war-battlefields/.

4. Calloway, *New Worlds for All*, 123.

5. Bernard Bailyn, "Shaping the Republic to
1763," in Bailyn, et al., *The Great Republic: A His-
tory of the American People*, (Boston: Little Brown,
1977), 141–43, 201–4.

6. Calloway, *New Worlds for All*, 104.

7. Calloway, 105.

8. Calloway, 105.

9. Louis Antoine de Bougainville, aide to
Louis-Joseph de Montcalm, commander of French
forces in North America during the French and
Indian War, quoted in Calloway, *New Worlds for
All*, 105.

10. Alejandra Smith, "Oneida," George Wash-
ington's Mount Vernon website, accessed Sep-
tember 26, 2019, https://www.mountvernon.org
/library/digitalhistory/digital-encyclopedia/article
/oneida/.

11. "The Polly Cooper Shawl: Testimony
to a Pact of the Revolutionary War," Oneida
Indian Nation website, accessed September 26,
2019, http://www.oneidaindiannation.com/the
-polly-cooper-shawl-testimony-to-a-pact-of-the
-revolutionary-war/.

12. Haudenosaunee and Abenaki leaders quoted in Calloway, *New Worlds for All,* 117.

13. Anonymous colonial observer, 1750, quoted in Calloway, *New Worlds for All,* 120.

14. Writes historian Laurence M. Hauptman, "The so-called 'French and Indian War, 1755–1763' was part of a world war fought on three continents. In my classes, I refer to it as 'the great war for empire between France and England, that lasted from 1689–1763, one in which Native Americans were forced to choose sides, much to their later regret.' I frequently refer to it by its proper name in European history, 'the Seven Years' War,' even though it lasted more than seven years." Laurence M. Hauptman, email to the authors, September 19, 2019.

15. Colin G. Calloway, *The Scratch of a Pen: 1763 and the Transformation of North America* (New York: Oxford University Press, 2006), 26–27, 48–49; Calloway, *White People, Indians, and Highlanders: Tribal Peoples and Colonial Encounters in Scotland and America* (New York: Oxford University Press, 2008), 95; Timothy J. Shannon, "Iroquoia," in *The Oxford Handbook of American Indian History,* ed. Frederick Hoxie (New York: Oxford University Press, 2016), 209.

16. Gordon S. Wood, *The Americanization of Benjamin Franklin* (New York: The Penguin Press, 2004), 105.

17. Gordon S. Wood, *The American Revolution: A History* (New York: Modern Library, 2003), 4–12; Richard White, *The Middle Ground: Indians, Empires, and Republics in the Great Lakes Region, 1650–1815* (New York: Cambridge University Press, 1991), 256–68.

18. Joseph Brant, quoted in Alan Taylor, *The Divided Ground: Indians, Settlers, and the Northern Borderland of the American Revolution* (New York: Vintage Books, 2007), 80.

19. Colin G. Calloway, *The American Revolution in Indian Country: Crisis and Diversity in Native American Communities* (New York: Cambridge University Press, 1995), 34, 45; Calloway, *New Worlds for All,* 110.

20. Calloway, *The American Revolution in Indian Country,* 28.

21. Louise Kellogg, ed., *Frontier Advance on the Upper Ohio, 1778–1779* (Madison: State Historical Society of Wisconsin, 1916), 138–45; White, *The Middle Ground,* 385; Hermann Wellenreuther, "White Eyes and the Delawares' Vision of an Indian State," *Pennsylvania History* 68, no. 2 (Spring 2001).

22. Robert W. Venables, "Native Nations and the New Nation, 1776–1820," in *American Indians/American Presidents: A History,* ed. Clifford Trafzer (New York: HarperCollins, 2009), 38–39; R. David. Edmunds, Frederick E. Hoxie, and Neal Salisbury, *The People: A History of Native America* (Boston: Houghton Mifflin, 2007), 148; "To George Washington from the Seneca Chiefs, 1 December 1790," *Founders Online,* National Archives, accessed April 11, 2019, https://founders.archives.gov/documents/Washington/05-07-02-0005. [Original source: *The Papers of George Washington*, Presidential Series, *1 December 1790–21 March 1791,* ed. Jack D. Warren, Jr. (Charlottesville: University Press of Virginia, 1998), 7:7–16.]

23. General Philip Schuyler, ca. 1784, quoted in Calloway, *The American Revolution in Indian Country,* 278.

24. J. David Lehman, "The End of the Iroquois Mystique: The Oneida Land Cession Treaties of the 1780s," *The William and Mary Quarterly* 47 (October 1990): 528.

25. Wood, *The American Revolution: A History,* 118.

26. See Barbara Graymont, *The Iroquois in the American Revolution* (Syracuse, NY: Syracuse University Press, 1972), 132, 188.

27. Laurence Hauptman, *Seven Generations of Iroquois Leadership: The Six Nations Since 1800* (Syracuse, NY: Syracuse University Press, 2008), 53.

28. Laurence Hauptman, "They Also Served: American Indian Women in the War of 1812," in *American Indian Magazine* (Fall 2015), 42.

29. Hauptman, *Seven Generations,* 59, 61.

30. Hauptman, *Seven Generations,* 61–62.

31. R. David Edmunds, "Pipe Tomahawk Presented to Chief Tecumseh," in *Infinity of Nations: Art and History in the Collections of the National Museum of the American Indian,* ed. Cécile R. Ganteaume (New York: HarperCollins Publishers in association with the National Museum of the American Indian, Smithsonian Institution, 2010), 192; Gerald McMaster and Clifford E. Trafzer, eds., *Native Universe: Voices of Indian America* (Washington, DC: Smithsonian National Museum of the American Indian in Association with National Geographic, 2004), 124.

32. Clifford E. Trafzer, *As Long as the Grass Shall Grow and the Rivers Flow: A History of Native*

Americans (Fort Worth: Harcourt College Publishers, 2000), 152–53; Fred Anderson and Andrew Cayton, *The Dominion of War: Empire and Liberty in North America, 1500–2000* (New York: Penguin Books, 2005), xvii.

33. Gregory Evans Dowd, *A Spirited Resistance: The North American Indian Struggle for Unity, 1745–1815* (Baltimore: Johns Hopkins University Press, 1992), 181.

34. Francis Paul Prucha, *The Great Father: The United States Government and the American Indians,* vols. 1 and 2 (Lincoln: University of Nebraska Press, 1984), 76–77; Gordon S. Wood, *Empire of Liberty: A History of the Early Republic, 1789–1815* (New York: Oxford University Press, 2009), 675; Reginald Horsman, *Expansion and American Indian Policy, 1783–1812* (Norman: University of Oklahoma Press, 1992), 169; Trafzer, *As Long as the Grass Shall Grow and the Rivers Flow,* 152–53, 157.

35. Philip F. Gura, "Son of the Forest: William Apess and the Fight for Indigenous Rights," *New England Review* 35, no. 4 (2015): 73–74; Margaret Bruchac, "Hill Town Touchstone: Reconsidering William Apess and Colrain, Massachusetts," *Early American Studies* 14, no. 4 (September 2016): 732; Jace Weaver, *The Red Atlantic: American Indigenes and the Making of the Modern World, 1000–1927* (Chapel Hill: The University of North Carolina Press, 2014), 30, 99.

36. *The Experience of William Apes, A Native of the Forest. Comprising a Notice of the Pequod Tribe of Indians. Written by Himself.* (New York: Published by the Author, 1829), 62, online at https://archive.org/details/sonofforestexper00inapes/page/n6.

37. Dowd, *A Spirited Resistance,* 182–83.

38. James P. Collins, "Native Americans in the Antebellum U.S. Military," *Prologue* 39, no. 4 (Winter 2007), accessed April 17, 2019, https://www.archives.gov/publications/prologue/2007/winter/indians-military.html#nt6.

39. Dowd, *A Spirited Resistance,* 185.

40. "Red Stick War," in *Encyclopedia of North American Indians: Native American History, Culture, and Life from Paleo-Indians to the Present,* ed. Frederick E. Hoxie (Boston: Houghton Mifflin, 1996), 533; Trafzer, *As Long as the Grass Shall Grow and the Rivers Flow,* 138.

41. Clara Sue Kidwell, *Choctaws and Missionaries in Mississippi, 1818–1918* (Norman and London: University of Oklahoma Press, 1995), 18, 23;

Herman J. Viola, *Diplomats in Buckskins: A History of Indian Delegations in Washington City* (Bluffton, SC: Rivilo Books, 1995), 165; Trafzer, *As Long as the Grass Shall Grow and the Rivers Flow,* 130, 144–45.

42. Dowd, *A Spirited Resistance,* 189–90.

Native Women Leaders and War

1. Since the late 1990s, scholars and activists have engaged in a contentious debate about invoking the word "squaw" and its derivatives in histories of Native America. The authors of *Why We Serve* agree that "squaw" is a disparaging term to be avoided when referencing contemporary Indigenous women. At the same time, research by Native American scholars and non-Native linguists (cited below) persuades us that the word "squaw," or *squa,* was originally a non-offensive, descriptive word that meant "woman" in the languages spoken by the Algonquian peoples of seventeenth-century New England. Likewise, derivatives of the word *squa,* such as *saunksqwa* and *squaw-sachem,* which meant "woman chief," were part of the *lingua franca* of European contact in eastern Massachusetts—expressions English colonists learned from their Indigenous neighbors. Far from a term of derision, *saunksqwa* was understood as an honorific by Natives and newcomers alike. It is in that spirit that we invoke *saunksqwa* in these pages. See Lisa Brooks, *Our Beloved Kin: A New History of King Philip's War* (New Haven, CT: Yale University Press, 2018), 2, 355n18; Marge Bruchac, "Reclaiming the Word 'Squaw' in the Name of the Ancestors," H-Net, Humanities and Social Sciences Online, November 1999, https://lists.h-net.org/cgi-bin/logbrowse.pl?trx=vx&list=h-amindian&month=9912&week=a&msg=//Wt4lIoJcFuIg%2BP975gmg&user=&pw=; Ives Goddard, "The True History of the Word Squaw," *News From Indian Country* (April 1997): 19a, Smithsonian Institution Libraries, Smithsonian Research Online, at https://repository.si.edu/handle/10088/94999.

2. Nathaniel Saltonstall, *The Present State of New-England With Respect to the Indian War* (London: Dorman Newman, 1675), 3.

3. Brooks, *Our Beloved Kin,* 27–29.

4. Brooks, 67, 131.

5. Brooks, 166–68.

6. Allan Forbes, ed., *Some Indian Events of New England* (Boston: Walton Advertising & Printing Co., 1941), 41–44.

7. Brooks, *Our Beloved Kin*, 158–59.

8. Brooks, 159.

9. Brooks, 240–41.

10. Brooks, 321.

11. Brooks, 321.

12. Increase Mather, *A Brief History of the War with the Indians in New-England* (Boston: Printed and sold by John Foster, 1676), 71; Forbes, *Some Indian Events of New England*, 23.

13. "Lockety Fight: Unraveling Centuries of Silence," Our Beloved Kin: Remapping a New History of King Philip's War website, updated January 23, 2018, accessed March 27, 2019, https://ourbelovedkin.com/awikhigan/lockety-fight?path=pocasset; Brooks, 321.

Daniel Nimham: Fighting for Two Nations

1. Tom Arne Mitrod, "Native American Land-holding in the Colonial Hudson Valley," *American Indian Culture and Research Journal* 37, no. 1 (2013): 79, 89.

2. Oscar Handlin and Irving Mark, eds., "Chief Daniel Nimham v. Roger Morris, Beverly Robinson, and Philip Philipse—An Indian Land Case in Colonial New York, 1765–1767," *Ethnohistory* 11, no. 3 (Summer 1964): 197.

3. Oscar Handlin, "The Eastern Frontier of New York," *New York History* 18, no. 1 (January 1937): 52n.

4. Captain Johann Von Ewald of the Schleswig Jäger Corps, quoted in *Diary of the American War: A Hessian Journal, by Captain Johann Von Ewald, Field Jager Corps*, trans. and ed. Joseph P. Tustin (New Haven, CT: Yale University Press, 1979), 145.

5. *Simcoe's Military Journal: A History of the Operations of a Partisan Corps, called the Queen's Rangers, Commanded by Lieut. Col. J.G. Simcoe, During the War of the American Revolution* (New York, 1844), 87 (or 89).

6. Irving Mark and Oscar Handlin, "Land Cases in Colonial New York, 1765–1767: The King v. William Prendergast," *New York University Law Quarterly Review* 19 (1942): 165–68; Laurence M. Hauptman, "The Road to Kingsbridge: Daniel Nimham and the Stockbridge Indian Company in the American Revolution," *American Indian* 18, no. 3 (Fall 2017).

7. Calloway, *The American Revolution in Indian Country: Crisis and Diversity in Native American Communities* (New York: Cambridge University Press, 1995), 88–89.

8. Hauptman, "The Road to Kingsbridge."

9. Calloway, *The American Revolution in Indian Country*, 97.

10. Lisa Foderaro, "Dotting the Parks, Monuments to the Famous or Forgotten," *New York Times*, January 9, 2014, https://www.nytimes.com/2014/01/12/nyregion/dotting-the-parks-monuments-to-the-famous-or-forgotten.html; Anthony Musso, "Fishkill Monument Pays Tribute to Chief Who Fought in Revolution," *Poughkeepsie Journal*, November 7, 2017, https://www.poughkeepsiejournal.com/story/news/2017/11/07/fishkill-monument-pays-tribute-chief-who-fought-revolution-daniel-nimham-dateline/837967001/.

THE INDIANS' CIVIL WAR: CHOOSING SIDES

1. Many sources estimate total Native American service in the Civil War at 20,000. This is difficult to establish accurately because most Confederate enlistment records were destroyed. "The Civil War: Facts," National Park Service, last modified May 6, 2015, www.nps.gov/civilwar/facts.htm.

2. "Facts," National Park Service, last modified May 6, 2015, www.nps.gov/civilwar/facts.htm.

3. See Laurence M. Hauptman, "Black Beaver: Delaware Hero of the Civil War," *American Indian Magazine* 16, no. 2 (Summer 2015).

4. Hauptman, 24; James P. Collins, "Native Americans in the Antebellum U.S. Military," *National Archives*, Winter 2007, 39, no. 4, accessed April 17, 2019, https://www.archives.gov/publications/prologue/2007/winter/indians-military.html#nt6; *Compiled Service Records of Volunteer Soldiers Who Served During the Mexican War in Organizations from the State of Texas* (National Archives Microfilm Publication M278, roll 16), RG 94.

5. Laurence M. Hauptman, "Introduction: American Indians and the Civil War" in *American Indians and the Civil War*, ed. Robert K. Sutton and John A. Latschar (Washington, DC: National Park Service, 2013), 15.

6. Laurence M. Hauptman, *Between Two Fires: American Indians and the Civil War* (New York: Free Press, 1995), 145.

7. Hauptman, *Between Two Fires*, 73–75.

8. Hauptman, 85.

9. Arthur C. Parker, *The Life of General Ely S. Parker, Last Grand Sachem of the Iroquois and General Grant's Military Secretary* (Buffalo, NY: Buffalo Historical Society, 1919), 133.

10. Mae Timbimboo Parry, "The Bear River

Massacre," in *American Indians and the Civil War*, ed. Robert K. Sutton and John A. Latschar (Washington, DC: National Park Service, 2013), 15.

11. Hauptman, *Between Two Fires*, 102.

12. Hauptman, 104–18.

The "Second Ruination of the Cherokee Nation"

1. Laurence M. Hauptman, *Between Two Fires: American Indians in the Civil War* (New York: Free Press, 1995), 42–43.

2. Hauptman, *Between Two Fires*, 48.

3. Hauptman, *Between Two Fires*, 47.

4. Hauptman, *Between Two Fires*, 42.

5. Jean Chaudhuri and Joyotpaul Chaudhuri, *A Sacred Path: The Way of the Muscogee Creeks* (Los Angeles: UCLA American Indian Studies Center, 2001), 149.

6. Quoted in Carolyn Ross Johnston, *Cherokee Women in Crisis: Trail of Tears, Civil War, and Allotment, 1838–1907* (Tuscaloosa: University of Alabama Press, 2003), 102.

7. Johnston, 86, 88.

Company K of the First Michigan Sharpshooters

1. Quoted in Laurence M. Hauptman, *Between Two Fires: American Indians in the Civil War* (New York: Free Press, 1995), 138.

2. Hauptman, *Between Two Fires*, 135.

3. Raymond J. Herek, *These Men Have Seen Hard Service: The First Michigan Sharpshooters in the Civil War* (Detroit: Wayne State University Press, 1998), 36, 387–90.

Native Hawaiians in the Civil War

1. Robert C. Schmidt, "Hawai'i's War Veterans and Battle Deaths," *Hawaiian Journal of History* 32 (Honolulu: Hawaiian Historical Society, 1998): 171–74.

2. Justin W. Vance and Anita Manning, "The Effects of the American Civil War on Hawai'i and the Pacific World," *World History Connected*, October 2012, http://worldhistoryconnected.press .uillinois.edu/9.3/vance.html, accessed July 31, 2018.

3. National Park Service, "Hawaiians in the Civil War," March 2015, accessed July 31, 2018, https://www.nps.gov/civilwar/upload/More-Info -on-Hawaiians-in-the-Civil-War-Alphabetically -by-Name.pdf.

4. Vance and Manning, "The Effects of the

American Civil War on Hawai'i and the Pacific World."

5. Justin Vance and Anita Manning, "Henry Ho'olulu (Timothy) Pitman," in *Asians and Pacific Islanders in the Civil War* (Washington, DC: National Park Service, 2015), 148.

6. Vance and Manning, "The Effects of the American Civil War on Hawai'i and the Pacific World."

7. Vance and Manning, "The Effects of the American Civil War on Hawai'i and the Pacific World."

8. Justin Vance and Anita Manning, "The CSS *Shenandoah*: A Confederate Raider in the Pacific," in *Asians and Pacific Islanders in the Civil War* (Washington, DC: National Park Service, 2015), 153.

INDIAN WARS, INDIAN SCOUTS

1. Keith H. Basso, *Western Apache Raiding and Warfare: From the Notes of Grenville Goodwin* (Tucson: University of Arizona Press, 1971), 154.

2. General George Crook, "Resume of Operations Against Apache Indians, 1882–1886," quoted in Peter Cozzens, ed., *Eyewitnesses to the Indian Wars, 1865–1890*, vol. 5, *The Army and the Indian* (Mechanicsburg, PA: Stackpole Books, 2005), 393.

3. Pekka Hämäläinen, "The Western Comanche Trade Center: Rethinking the Plains Indian Trade System," *Western Historical Quarterly* 29, no. 4 (Winter 1998): 491.

4. Thomas W. Dunlay, *Wolves for the Blue Soldiers: Indian Scouts and Auxiliaries with the United States Army, 1860–90* (Lincoln: University of Nebraska Press, 1982), 18; Laurence M. Hauptman, *Between Two Fires: American Indians in the Civil War* (New York: Free Press, 1995), 24.

5. Hauptman, *Between Two Fires*, 25.

6. Dunlay, *Wolves for the Blue Soldiers*, 25.

7. Though Utley's romantic-leaning prose may not hold up to contemporary examination, it does shed light on the sentiment of that time—and into the twentieth century. See Robert M. Utley, *Frontier Regulars: The United States Army and the Indian, 1866–1891* (New York: Macmillan Publishing, 1973), 8.

8. "Extract from report of the Secretary of Interior," in *Report of the Commissioner of Indian Affairs, The Year 1866* (Washington, DC: Government Printing Office, 1866).

9. Dunlay, *Wolves for the Blue Soldiers*, 62.

10. James Riding In, "The Betrayal of Civilization in United States–Native Nations Diplomacy: A Case Study of Pawnee Treaties and Cultural Genocide," in *Nation to Nation: Treaties Between the United States and American Indian Nations*, ed. Suzan Harjo (Washington, DC, and New York: National Museum of the American Indian in Association with Smithsonian Books, 2014), 162; Kevin Abourezk, "Civil War a Time for Tribal Conflict in Nebraska," *Lincoln Journal Star*, April 12, 2011, https://journalstar.com/special-section /civil-war/civil-war-a-time-for-tribal-conflict-in -nebraska/article_5838dd98-51ae-5244-a004 -9bdca47f31a4.html.

11. Dunlay, *Wolves for the Blue Soldiers*, 50.

12. Act to increase and fix the Military Peace Establishment of the United States, ch. 299, Thirty-Ninth Congress (1866); Dunlay, *Wolves for the Blue Soldiers,* 44. Anthropologist William C. Meadows attests that they were not, in fact, paid as much as regular soldiers. See William C. Meadows, *Through Indian Sign Language: The Fort Sill Ledgers of Hugh Lenox Scott and Iseeo 1889–1897* (Norman: University of Oklahoma Press, 2015), 57.

13. Dunlay, *Wolves for the Blue Soldiers,* 50.

14. Trevor K. Plante, "Lead the Way: Researching U.S. Army Indian Scouts, 1866–1914," *Prologue Magazine* 41, no. 2 (Summer 2009), accessed June 28, 2019, https://www.archives.gov/publications /prologue/2009 /summer/indian.html.

15. Tom Holm, *Strong Hearts, Wounded Souls: Native American Veterans of the Vietnam War* (Austin: University of Texas Press, 1996), 95.

16. Lorna Thackeray, "Scouts Play Part in Little Bighorn Battle," billingsgazette.com, June 24, 2012, https://billingsgazette.com/news/state -and-regional/montana/crow-scouts-play-part-in -little-bighorn-battle/article_6d406252-61c5-563b -8048-ef42546de5e6.html; Evan S. Connell, *Son of the Morning Star: Custer and the Little Bighorn* (New York: Perennial Library, 1985), 314–16.

17. Dunlay, *Wolves for the Blue Soldiers*, 55.

18. Dunlay, 52.

19. See Dunlay, *Wolves for the Blue Soldiers*.

20. Company I of Infantry Regiments (except for the 24th and 25th) and Company L of Cavalry Regiments (excluding the 9th and 10th), with a maximum of fifty-five Indians in each company.

21. Meadows, *Through Indian Sign Language*, 63.

22. Plante, "Lead the Way."

23. Meadows, *Through Indian Sign Language*, 58.

24. Meadows, 64.

25. Dunlay, *Wolves for the Blue Soldiers*, 5, 125, 129.

26. Basso, *Western Apache Raiding and Warfare*, 169.

27. Mark G. Hirsch, "American Indian Scouts," in *Nation to Nation: Treaties Between the United States and American Indian Nations*, ed. Suzan Shown Harjo (Washington, DC: National Museum of the American Indian, 2014), 174.

28. Native American Medal of Honor Recipients, online at https://history.army.mil/html/topics /natam/natam-moh.html; Ruth Quinn, "Native American Scouts," November 7, 2013, U.S. Army website, online at https://www.army.mil/article /114646/native_american_scouts; Robert M. Utley, *Geronimo* (New Haven, CT: Yale University Press, 2012), 184.

29. Eve Ball, *Indeh: An Apache Odyssey*, with Nora Henn and Lynda A. Sanchéz (Norman: University of Oklahoma Press, 1980), 109.

30. Dunlay, *Wolves for the Blue Soldiers*, 48.

31. In an interview with Eve Ball, Eugene Chihuahua (Chiricahua Apache) indicates that the Apaches called Crook Nantan Lupan, which translates into "Tan Wolf," because of the tan clothes Crook wore in Arizona. See Eve Ball, *Indeh: An Apache Odyssey*, 125. Also, this may be a syncretic name of Apache and Spanish. See "Native Languages of the Americas" blog, October 30, 2013, accessed June 28, 2019, http://native-languages .blogspot.com/2013/10 /nantan-lupan.html.

32. Dunlay, *Wolves for the Blue Soldiers*, 180.

33. Boyd Cothran, *Remembering the Modoc War: Redemptive Violence and the Making of American Innocence* (Chapel Hill: The University of North Carolina Press, 2014), 59; Robert Aquinas McNally, *The Modoc War: A Story of Genocide at the Dawn of America's Gilded Age* (Lincoln: University of Nebraska Press, 2017), 175–76, 226; Theodore Stern, "Klamath and Modoc," in *Handbook of North American Indians—Plateau*, vol. ed. Deward E. Walker Jr. (Washington: Smithsonian Institution, 1998), 12:460; Stephen Dow Beckham, "History Since 1846," in Walker Jr., 12:62.

34. Marshall Trimble, "Will C. Barnes: Soldier, Cowboy, Author and Storyteller," *True West Magazine*, April 11, 2018, accessed June 25, 2019, https://truewestmagazine.com/will-c-barnes -soldier-cowboy-author-and-storyteller/; John R. Welch, Chip Colwell-Chanthaphonh, and Mark Altaha, "Retracing the Battle of Cibecue: Western Apache, Documentary, and Archaeological

Interpretations," *Kiva* 71, no. 2 (2005): 135, http://www.jstor.org/stable/30246722.

35. Dan L. Thrapp, "Riley, Sinew L.," in *Encyclopedia of Frontier Biography* (Lincoln: University of Nebraska Press, 1988), 3:1222.

36. See Julie Irene Prieto, *The U.S. Army Campaigns of World War I: The Mexican Expedition, 1916–1917* (Washington, DC: Center of Military History, United States Army, 2016), https://history.army.mil/html/books/077/77-1/cmhPub_077-1.pdf.

37. See Russel Lawrence Barsh, "American Indians in the Great War," *Ethnohistory* 38, no. 3 (1991): 276–303, doi:10.2307/482356.

38. Roy Cook, "Special Forces Special Tribal Traditions," American Indian Warrior Association website, accessed June 25, 2019, http://aiwa.americanindiansource.com/specialforces/SpecialForces.html.

39. Ruth Quinn, "Native American Scouts," United States Army website, November 7, 2013, accessed June 25, 2019, https://www.army.mil/article/114646/native_american_scouts.

"Seminole Negro Indian Scouts"

1. In this essay, the author consulted the Smithsonian's National Museum of African American History and Culture (NMAAHC) for guidance regarding the appropriate language to describe the enslavement of peoples of African descent. Accordingly, we use their definition of maroon, included here: "Maroon/Cimarrón/Marron: The terms maroon in English and marron in French are derived from the Spanish word cimarrón. The word translates to mean wild or unruly. By the end of the 1500s cimarrón referred primarily to formerly enslaved men and women who escaped captivity." Office of Curatorial Affairs, "Language Usage and Communications Manual" (working document, Smithsonian National Museum of African American History and Culture, June 2019).

2. Kevin Mulroy, *Freedom on the Border: The Seminole Maroons in Florida, the Indian Territory, Coahuila, and Texas* (Lubbock: Texas Tech University Press, 1993), 10.

3. R. David Edmunds, Frederick E. Hoxie, and Neal Salisbury, *The People: A History of Native America* (New York: Houghton-Mifflin Company, 2007), 235.

4. Mulroy, *Freedom on the Border,* 11, 18.

5. Mulroy, 65.

6. Mulroy, 112.

THE SPANISH–AMERICAN WAR

1. "Soldiers, Sailors, and Marines of the Spanish American War," National Archives Records Administration, accessed August 24, 2018, https://www.archives.gov/publications/prologue/1998/spring/spanish-american-war-1.html.

2. United States Office of Indian Affairs. *Annual Report of the Commissioner of Indian Affairs.* Part of the *Annual Reports of the Department of the Interior for the Fiscal Year Ended June 30, 1898* (Washington, DC: Government Printing Office, 1898).

3. Theodore Roosevelt, *The Rough Riders*, ed. Marifeli Pérez-Stable (Chicago: R. R. Donnelley & Sons, 2003), 18–19.

4. Dale L. Walker, *The Boys of '98: Theodore Roosevelt and the Rough Riders* (New York: Tom Doherty Associates, 1998), 143.

5. Walker, *The Boys of '98*, 257–58.

6. Walker, 280.

7. Roosevelt, *The Rough Riders*, 24.

8. Roosevelt, 27.

9. Roosevelt, 130.

10. Roosevelt, 26.

William Pollock

1. Quoted in John Ault, "Native Americans in the Spanish American War," accessed August 24, 2018, http://www.spanamwar.com/NativeAmericans.htm. See also Carlisle Indian Industrial School, *Indian Helper*, July 15, 1898. Native Rough Riders spanned the spectrum of full- and mixed-blood.

2. Theodore Roosevelt, *The Rough Riders*, ed. Marifeli Pérez-Stable (Chicago: R. R. Donnelley & Sons, 2003), 24.

3. Roosevelt, *The Rough Riders*, 185.

4. Jacob A. Riis, *Theodore Roosevelt, the Citizen* (New York: Macmillan, 1918), 187.

5. Kristin M. Youngbull, *Brummett Echohawk: Pawnee Thunderbird and Artist* (Norman: University of Oklahoma Press, 2015), 20.

6. Laurence M. Hauptman, "William Pollock: Artist and Rough Rider," *American Indian Magazine* (Spring 2018): 29.

7. Youngbull, *Brummett Echohawk*, 20; Glenn Shirley, *Red Yesterdays* (Witchita Falls, TX: Nortex Press, 1977), 59–60.

8. Quoted in Shirley, *Red Yesterdays*, 60.

Native Nurses in Cuba

1. Thomas W. Foley, *Father Francis M. Craft: Missionary to the Sioux* (Lincoln: University of Nebraska Press, 2002), 2–5.

2. Quoted in Foley, *Father Francis M. Craft*, 120.

3. Foley, 128.

4. Quoted in Foley, 129.

5. Mercedes Graf, "Band of Angels, Part 2: Sister Nurses in the Spanish–American War" (Fall 2002, 34 no. 3), accessed June 6, 2018, https://www.archives.gov/publications/prologue/2002/fall/band-of-angels-2.html#nt78.

6. Foley, *Father Francis M. Craft*, 131.

7. Foley, 132.

8. Brenda Finnicum, "The First Indian Army Nurses," in *Indian Country Today* (January 3, 2001).

WORLD WAR I

1. R. David Edmunds, Frederick E. Hoxie, and Neal Salisbury, *The People: A History of Native America* (Boston: Houghton Mifflin, 2007), 365.

2. Frederick E. Hoxie, "The Reservation Period, 1880–1960," in Bruce G. Trigger and Wilcomb Washburn, eds., *The Cambridge History of the Native Peoples of the Americas*, vol. 1, North America, part 2 (New York: Cambridge University Press, 1996), 220–21.

3. Thomas A. Britten, *American Indians in World War I: At Home and at War* (Albuquerque: University of New Mexico Press, 1997), 59–60, 84.

4. The historian Thomas Britten has observed that Native responses to the war effort varied depending on "[c]ultural differences, the level of acculturation, geography and demographics, education, and the relationship of a particular Native American community with the federal government." See Britten, *American Indians in World War I*, 60.

5. Carlos Montezuma, "Drafting Indians and Justice," *Wassaja* 2, no. 7 (October 1917): 3, reprinted in Frederick E. Hoxie, ed., *Talking Back to Civilization: Indian Voices from the Progressive Era* (Boston: Bedford Books/St. Martin's, 2001), 125–27.

6. Hoxie, *Talking Back to Civilization*, 123.

7. President Woodrow Wilson, "Address of the President of the United States Delivered at a Joint Session of the Two Houses of Congress" (Apr. 2, 1917), S. Doc. No. 65-5, *U.S. Cong. Serial Set,* vol. 7264, https://lccn.loc.gov/92643101.

8. Department of the Interior, Office of Indian Affairs, "Indians in the World War," Entry E998E, "Records Relating to Indians in World War I and World War II, 1920–1945," box 1, Records of the Bureau of Indian Affairs, record group 75, National Archives Building, Washington, DC.

9. Edmunds, et al., *The People*, 364.

10. Entry 977B, "Card Files Relating to Indians in World War I," Records of the Bureau of Indian Affairs, record group 75, National Archives Building, Washington, DC.

11. Russel Lawrence Barsh, "American Indians in the Great War," *Ethnohistory* 38, no. 3 (Summer 1991): 279.

12. Britten, *American Indians in World War I,* 83, 205n38.

13. Barsh, "American Indians in the Great War," 278; "Indians in the World War," entry E998E, "Records Relating to Indians in World War I and World War II, 1920–1945," box 1, Department of the Interior, Office of Indian Affairs, record group 75, National Archives Building, Washington, DC.

14. Edmunds, et al., *The People*, 365.

15. Owen Hates Him (Cheyenne River Sioux), quoted in "In Their Own Words: Native Americans in World War I," online exhibition, Mathers Museum of World Cultures Digital Exhibit, http://dlib.indiana.edu/omeka/mathers/exhibits/show/in-their-own-words--native-ame/indian-identity/owen-hates-him.

16. Paul C. Rosier, *Serving Their Country: American Indian Politics and Patriotism in the Twentieth Century* (Cambridge: Harvard University Press, 2009), 49–51.

17. Hoxie, *Talking Back to Civilization*, 123.

18. Britten, *American Indians in World War I,* 136.

19. Susan Applegate Krouse, *North American Indians in the Great War* (Lincoln: University of Nebraska Press, 2007), 74–75.

20. Barsh, "American Indians in the Great War," 278.

21. William C. Meadows, Missouri State University, email to the authors, July 14, 2019.

22. Dr. Joseph K. Dixon, quoted in "Citizenship for Native Americans," online at www.nebraskastudies.org/1900-1924/native-american-citizenship/citizenship-for-native-veterans/.

23. Lora Whelan, "WWI Veterans from

Passamaquoddy Tribe Honored in Maine," The United States World War One Centennial Commission website, accessed September 20, 2018, https://www.worldwar1centennial.org/index.php/communicate/press-media/wwi-centennial-news/1264-passamaquoddy-tribe-wwl-veterans-honored.html.

24. Moses W. Neptune, "Maine, Military Index, 1917–1920," accessed through Ancestry.com, https://search.ancestrylibrary.com/cgi-bin/sse.dll?db=messm&h=20148&indiv= try&o_vc =Record:OtherRecord&rhSource=7884.

25. "What Do Native American Carvings in French WWI Quarries Mean?" *Smithsonian Magazine*, accessed September 14, 2018, https://www.smithsonianmag.com/videos/category/history/what-do-native-american-carvings-in-french-w/.

26. Joe High Elk (Cheyenne River Sioux), quoted in "In Their Own Words: Native Americans in World War I," online exhibition, Mathers Museum of World Cultures Digital Exhibits, http://dlib.indiana.edu/omeka/mathers/exhibits/show/in-their-own-words--native-ame/indian-identity/joe-high-elk.

27. Charles A. Eastman, "The Indian's Plea for Freedom," quoted in Hoxie, *Talking Back to Civilization,* 132.

28. Robert Yellowtail, quoted in Hoxie, *Talking Back to Civilization,* 124.

Code Talkers

1. William C. Meadows, "Honoring Native American Code Talkers: The Road to the Code Talkers Recognition Act of 2008 (Pub. L. No. 110-420)," *American Indian Culture and Research Journal*, 35, no. 3 (2011): 9. This number is under some contention, however, because of the lack of documentation of type two use of tribal languages during combat, and the difficulty of finding evidence after so much time. William C. Meadows, Missouri State University, email to the authors, September 10, 2019. Also see Code Talkers Recognition Act of 2008, Pub. L. No. 110-420, 110th Congress (October 15, 2008), Sec. 6 (3), *122 Stat. 4744*; R. David Edmunds, Frederick E. Hoxie, and Neal Salisbury, eds., *The People: A History of Native America* (Boston: Houghton Mifflin, 2007), 392; "Code Talkers," Native American Heritage, U.S. National Archives and Records Administration website, https://www.archives.gov/research/native-americans/military/code-talkers.html; Andrea M.

Page, *Sioux Code Talkers of World War II* (Gretna, LA: Pelican Publishing, 2017).

2. William C. Meadows, "'They Had a Chance to Talk to One Another . . .': The Role of Incidence in Native American Code Talking," *Ethnohistory* 56, no. 2 (Spring 2009): 269.

3. William C. Meadows, *The Comanche Code Talkers of World War II* (Austin: University of Texas Press, 2002), 15.

4. Quoted in National Museum of the American Indian, *Native Words, Native Warriors* exhibition (2006), banner 3.

5. William C. Meadows, "Native American Code Talkers of World War I," The United States World War One Centennial Commission website, accessed July 9, 2019, https://www.worldwar1centennial.org/index.php/american-indians-in-wwi-code-talkers.html.

6. Though the original news article references a "Captain Lawrence," no officer named Lawrence served in the 142nd; this is likely referring to their commanding officer, E. W. Horner. William C. Meadows, Missouri State University, email to the authors, August 19, 2019.

7. Meadows, *The Comanche Code Talkers of World War II*, 16–18; William C. Meadows, Missouri State University, email to the authors, July 14, 2019.

8. William C. Meadows, Missouri State University, email to the authors, July 14, 2019.

9. Meadows, *The Comanche Code Talkers of World War II*, 21.

10. A. W. Bloor, colonel, 142nd Infantry to Commanding General 36th Division, January 23, 1919, "World War I: Transmitting Messages in Choctaw," U.S. Army Center for Military History website, https://history.army.mil/html/topics/natam/wwi-choctaw.html.

11. Meadows, "'They Had a Chance to Talk to One Another . . .'," 271.

12. William C. Meadows, "An Honor Long Overdue: The 2013 Congressional Gold and Silver Medal Ceremonies in Honor of Native American Code Talkers," *American Indian Culture and Research Journal* 40, no. 2 (2016): 91–92; William C. Meadows, Missouri State University, email to the authors, July 14, 2019.

13. R. David Edmunds, et al., *The People*, 392; William C. Meadows, Missouri State University, email to the authors, July 14, 2019.

14. Mary Bennett, "Meskwaki Code Talkers,"

Iowa Heritage Illustrated 84, no. 4 (Winter 2003), 154–56.

15. Quoted in National Museum of the American Indian, *Native Words, Native Warriors* exhibition (2006), banner 3.

16. Tom Holm, *Code Talkers and Warriors: Native Americans and World War II*, ed. Paul C. Rosier (New York: Chelsea House, 2007), 76–77.

17. Holm, *Code Talkers and Warriors*, 53–54, 61.

18. Pamela Bennett and Tom Holm estimate that 375 to 420 Navajos served as code talkers. See "Indians in the Military," in *Indians in Contemporary Society,* ed. Garrick A. Bailey, vol. 2, *Handbook of North American Indians*, ed. William C. Sturtevant (Washington, DC: Smithsonian Institution, 2008), 17; William C. Meadows identifies 420 Navajo code talkers in his essays on the subject, including Meadows, "'They Had a Chance to Talk to One Another . . .,'" 271.

19. Holm, *Code Talkers and Warriors*, 100, 115, 118.

20. As related by Forrest Kassanavoid (Comanche), quoted in Meadows, *Comanche Code Talkers of World War II*, 141.

21. Meadows, "An Honor Long Overdue," 92.

22. Meadows, "'They Had a Chance to Talk to One Another . . .,'" 275.

23. Though the Navajo code talkers program was reportedly classified, news still got out. See Sergeant Murrey Marder, "Navajo Code Talkers," in *Indians in the War* (Chicago: Office of Indian Affairs, November 1945), 25–27 (*Indians in the War* was a special memorial edition of *Indians at Work,* published in 1945 "before the magazine was discontinued because of the paper shortage.") According to William C. Meadows, the only classified code was Navajo, though many leaks and more than forty publications referenced their code talking before it was declassified in 1968. Other codes were never classified. William C. Meadows, Missouri State University, email to the authors, July 14, 2019.

24. Code Talkers Recognition Act of 2008, Pub. L. No. 110-420, 110th Congress (October 15, 2008), Sec. 2 (1) and (2), *122 Stat. 4744*.

25. Quoted in National Museum of the American Indian, *Native Words, Native Warriors* exhibition (2006), banner 6.

WORLD WAR II

1. Pamela Bennett and Tom Holm, "Indians in the Military," in *Indians in Contemporary Society*, ed. Garrick A. Bailey, vol. 2, *Handbook of North American Indians*, ed. William C. Sturtevant (Washington, DC: Smithsonian Institution, 2008), 11. The United States Census Bureau in 1940 claimed a total American Indian population of 360,500. However, the Bureau of Indian Affairs estimated a total population of 394,280 "legal" Indians (living on or near reservations) in 1940, which ostensibly omits non-reservation Indians. Alison R. Bernstein, *American Indians and World War II: Toward a New Era in Indian Affairs* (Norman: University of Oklahoma, 1991), 11, 179n28.

2. John Collier, "The Indian in a Wartime Nation," *The Annals of the American Academy of Political and Social Science*, 223 (September 1942): 29.

3. Lindsay F. Holiday, Gabriel Bell, Robert E. Klein, and Michael R. Wells, "American Indian and Alaska Native Veterans: Lasting Contributions," U.S. Department of Veterans Affairs, Office of Policy, September 2006.

4. Bennett and Holm, 17–18.

5. Quoted in Paul C. Rosier, "Surviving the 20th Century, 1890–1960," in Frederick E. Hoxie, *Oxford Handbook of American Indian History* (New York: Oxford University Press, 2016): 120.

6. Bernstein, *American Indians and World War II*, 66.

7. Mary Gouveia, "'We Also Serve': American Indian Women's Role in World War II" *Michigan Historical Review* 20, no. 2 (Fall 1994): 168.

8. Forty-Fifth Infantry Division Museum, "History of the 45th Infantry," accessed September 13, 2018, http://45th.45wp.com/history.

9. Bernstein, *American Indians and World War II*, 55.

10. "Burial and Memorialization Statistics," American Battle Monuments Commission, online at https://www.abmc.gov/node/1975.

11. Ramona du Houx, "Medic at D-Day," *American Indian Magazine* (Summer 2018): 34.

12. William C. Meadows, Missouri State University, email to the author, February 28, 2020.

13. United States Army, "Charles Chibitty: Comanche Code Talker, October 31, 2012, https://www.army.mil/article/90294/charles_chibitty_comanche_code_talker.

14. National Museum of the American Indian, "Code Talking" in "Native Words/Native Warriors," 2007, http://nmai.si.edu/education/codetalkers/html/chapter4.html.

15. Until 2016, it was commonly understood that a Bitterroot Salish soldier, Private Louis C. Charlo, had been a participant of raising the first, smaller flag on Mount Suribachi, before the larger flag was raised later on that same day. After a panel organized by the Marine Corps reviewed a claim of a misidentified man in the Rosenthal photo (second raising), it was brought to their attention that there may be servicemen misidentified in a photograph of the first raising as well. The panel concluded that two people had been misidentified, and Charlo—while present during the battle—did not, in fact, raise the flag. See Lance M. Bacon, "Marines say men in first Iwo Jima flag-raising photo were also misidentified," *Marine Corps Times*, August 24, 2016, https://www.marinecorpstimes.com/2016/08/24/marines-say-men-in-first-iwo-jima-flag-raising-photo-were-also-misidentified/ and Thomas Gibbons-Neff, "There were two flags raised at Iwo Jima. The Marines now say they misidentified men at both." *Washington Post*, August 24, 2016, https://www.washingtonpost.com/news/checkpoint/wp/2016/08/24/there-were-two-flags-raised-at-iwo-jima-the-marine-corps-now-says-it-misidentified-men-at-both-of-them/?noredirect=on&utm_term=.2d9735c95b60.

16. William H. Thiesen, "The Long Blue Line: Joseph "White Eagle" Toahty—Pawnee Warrior of Guadalcanal," *Coast Guard Compass: The Long Blue Line* blog (unpublished, June 5, 2019).

17. "Simeon Peter Pletnikoff," obituary, Find A Grave website, accessed October 17, 2019, https://www.findagrave.com/memorial/1084456/simeon-peter-pletnikoff.

18. Quoted in Ray Hudson, "Aleuts in Defense of Their Homeland," in *Alaska at War, 1941–1945: The Forgotten War Remembered*, ed. Fern Chandonnet (Fairbanks: University of Alaska Press, 2008), 163.

19. Pamela Bennett and Tom Holm, "Indians in the Military," 12; Tom Holm, *Code Talkers and Warriors: Native Americans and World War II* (New York: Chelsea House Publishers, 2007), 51; National Park Service, "The Pearl Harbor Attack," https://www.nps.gov/articles/pearlattackww2.htm; Naval History and Heritage Command, "Battle of Midway: Army Air Forces" online at https://www.history.navy.mil/research/library/online-reading-room/title-list-alphabetically/b/battle-of-midway-army-air-forces.html; U.S. Army, "American Indians in the U.S. Army, Clarence L. Tinker,"

online at https://www.army.mil/americanindians/tinker.html; "Army Major General Clarence L. Tinker," online at https://archive.defense.gov/home/features/2014/1114_native-american/profiles/profile11.html; U.S. Air Force, "Major General Clarence Tinker," online at https://www.af.mil/About-Us/Biographies/Display/Article/1712834/major-general-clarence-l-tinker.

20. Wisconsin Historical Society, image description for Ruby Whiterabbit (64315), accessed October 2, 2019, https://www.wisconsinhistory.org/Records/Image/IM64315.

21. Program, "Presentation of the Army–Navy "E" Award to the Men and Women of Solar Aircraft Company," and *The Union News*, Wednesday, December 2, 1942, in box 270; folder Ortega, Elizabeth; Student Case Files, 1902–1981; Sherman Indian High School; Records of the Bureau of Indian Affairs, record group 75; National Archives at Riverside.

22. Bernstein, *American Indians and World War II*, 75.

23. Bernstein, 86.

24. Bernstein, 73.

25. Bernstein, 73.

26. Bernstein, 171.

27. Quoted in Paul C. Rosier, "Surviving the 20th Century," 120.

The Native Hawaiian Response to the Attack on Puʻuloa (Pearl Harbor)

1. Loring Gardner Hudson, *The History of the Kamehameha Schools: 1887–1950*, 2 vols. (Honolulu: Kamehameha Schools, 1953), 675–76.

2. Hudson, *The History of the Kamehameha Schools*, 679.

3. Dan Akaka with Jim Borg, *One Voice: My Life, Times and Hopes for Hawaiʻi* (Honolulu: Watermark Publishing, 2017), 40.

4. On the seventy-fifth anniversary of the December 7 attacks, students in an archival research class at KS Kapālama created an exhibit on KS experiences of the war that this essay draws from and expands upon with original research conducted by the author. Of particular note in the students' project is oral history research with the ladies of the class of 1944. See "Remembering Pearl Harbor," *I Mua News Room*, accessed May 13, 2019, https://www.ksbe.edu/imua/article/remembering-pearl-harbor/.

5. Louis "Buzzy" Agard, oral history interview by author, April 28, 2010.

The Alaska Territorial Guard

1. Historically, the term "Eskimo" referred to Alaska Native peoples who today call themselves Iñupiaq, Yup'ik, and Saint Lawrence Island Yup'ik. The term was given by outsiders and is considered derogatory by some, so its use is discouraged. Generally, Alaska Native peoples prefer the name they call themselves in their own languages. See "Inuit or Eskimo: Which name to use?" Alaska Native Language Center, July 1, 2011, accessed November 7, 2018, https://www.uaf.edu/anlc/resources/inuit_or_eskimo.php; Arctic Studies Center, personal communication with editor, November 7, 2018.

2. Charles Hendricks, "The Eskimos and the Defense of Alaska," *Pacific Historical Review* 54, no. 3 (August 1985): 277–78.

3. Melanie Arnis and Brendan Coyle, *Enemy Offshore: Japan's Secret War on North America's West Coast* (Vancouver: Heritage House, 2013), 71.

4. Ernest Gruening, "Introduction," in Marvin "Muktuk" Marston, *Men of the Tundra: Alaska Eskimos at War* (New York: October House, 1969), 5; Marston, 127–28.

5. Marston, *Men of the Tundra*, after 104 (image).

6. Hendricks, "The Eskimos and the Defense of Alaska," 281.

7. Marston, 130–40.

Grace Thorpe's Life and Legacy

1. "Medals received by Grace: WWII," ca. 1945, Grace Thorpe collection (NMAI.AC.085), box 11, items 1–5, National Museum of the American Indian Archive Center, Smithsonian Institution.

2. "Army Documents and Marriage Documents," 1945–47, Grace Thorpe collection (NMAI.AC.085), box 1, folder 4, National Museum of the American Indian Archive Center, Smithsonian Institution.

3. "National Congress of American Indians: Economic Development Conference Coordinator," 1968, Grace Thorpe Collection (NMAI.AC.085), box 1, folder 16, National Museum of the American Indian Archive Center, Smithsonian Institution.

4. "Business Resumes and Indian Activities," 1969–70, Grace Thorpe Collection (NMAI.AC.085), box 1, folder 20, National Museum of the American Indian Archive Center, Smithsonian Institution.

5. "Washington, DC: Working for Senator James Abourezk, American Indian Policy Review Commission," 1975, Grace Thorpe collection (NMAI.AC.085), box 2, folder 6, National Museum of the American Indian Archive Center, Smithsonian Institution.

6. "Newspaper Clippings: Jim Thorpe Legacy," 1971–72, Grace Thorpe collection (NMAI.AC.085), box 3, folder 1, National Museum of the American Indian Archive Center, Smithsonian Institution.

7. "Olympic Committee Medal Presentation," January 1983, Grace Thorpe Collection (NMAI.AC.085), photo folder 104–9, National Museum of the American Indian Archive Center, Smithsonian Institution.

8. See Grace Thorpe, "Our Homes are Not Dumps: Creating Nuclear-Free Zones," *Natural Resources Journal* 36, no. 4 (Fall 1996): 955–63; The Nuclear-Free Future Award, accessed November 20, 2018, https://www.nffa.de/laureates/.

Joe Medicine Crow: The Art of Capturing Horses

1. Adapted from George P. Horse Capture and Emil Her Many Horses, eds., *A Song for the Horse Nation* (Washington, DC: National Museum of the American Indian, 2006), 61–62.

KOREA, 1950–53

1. Video interview with Chester Nez, Chester Nez Collection, (AFC/2001/001/54891), Veterans History Project, American Folklife Center, Library of Congress, http://memory.loc.gov/diglib/vhp/story/loc.natlib.afc2001001.54891/.

2. Lindsay F. Holiday, Gabriel Bell, Robert E. Klein, and Michael R. Wells, "American Indian and Alaska Native Veterans: Lasting Contributions," Department of Veterans Affairs, Office of Policy (September 2006), 4; Liam Stack, "Korean War, a 'Forgotten' Conflict That Shaped the Modern World," *New York Times*, January 1, 2018, https://www.nytimes.com/2018/01/01/world/asia/korean-war-history.html.

3. The Veterans History Project of the American Folklife Center at the Library of Congress collects, preserves, and makes accessible the personal accounts of American war veterans, including audio and videotaped interviews, memoirs, letters, postcards, diaries, photographs, drawings, and scrapbooks. In addition to the Korean War, the project collects first-hand accounts of veterans from World War I, World War II, the Cold War, the Korean War, the Vietnam War, the American

invasion of Grenada (1983), the American invasion of Panama (1989), Operation Restore Hope (1992–93), the Persian Gulf War (1991), the U.N. Operation in Somalia, American intervention in Haiti (1994–95), Operation Allied Force (1999), peacekeeping forces in Bosnia and Herzegovina, Operation Joint Guardian (1999–), the War on Terrorism (2001–9), the Afghan War (2001–), and the Iraq War (2003–11). See https://www.loc.gov/vets/about.html. The Crow Indian Veterans Project, housed at the Little Big Horn College Archives, in Crow Agency, Montana, includes tapes and transcripts of interviews with Crow tribal veterans who served in World War I, World War II, the Korean War, the Vietnam War, and the first Gulf War. A duplicate of the collection resides at the Montana Historical Society in Helena. See http://lib.lbhc.edu/index.php?q=node/208.

4. President Harry Truman, "The President's News Conference," July 28, 1950, *The Public Papers of President Harry S. Truman, 1948–1953*, Harry S. Truman Presidential Library and Museum, Independence, Missouri, https://www.trumanlibrary.org/publicpapers/index.php?pid=806.

5. "How Many Americans Died in Korea?" *CBS News*, June 5, 2000, https://www.cbsnews.com/news/how-many-americans-died-in-korea/.

6. Video interview with Richard J. Moon, Richard J. Moon Collection (AFC/2001/001/96961), Veterans History Project, American Folklife Center, Library of Congress, https://memory.loc.gov/diglib/vhp/bib/loc.natlib.afc2001001.96961.

7. Video interview with Roy O. Hawthorne, Roy O. Hawthorne Collection (AFC/2001/001/52528), Veterans History Project, American Folklife Center, Library of Congress, https://memory.loc.gov/diglib/vhp/bib/loc.natlib.afc2001001.52528; "Code Talker Roy Hawthorne Sr. Passes," *Navajo Times*, April 26, 2018, https://navajotimes.com/reznews/code-talker-roy-hawthorne-sr-passes/.

8. Video interview with Andrew Campbell, Andrew Campbell Collection (AFC/2001/001/23826), Veterans History Project, American Folklife Center, Library of Congress, https://memory.loc.gov/diglib/vhp/story/loc.natlib.afc2001001.23826/mv0001001.stream.

9. Duane Champagne, "From Full Citizenship to Self Determination, 1930–75," in *American Indians/American Presidents: A History,* ed. Clifford E. Trafzer (New York and Washington, DC: HarperCollins Publishing in association with the National Museum of the American Indian,

Smithsonian Institution, 2009), 158; Senator Chuck Hagel, "Remembering Soldiers and Their Families," May 24, 2006, https://army.togetherweserved.com/army/servlet/tws.webapp.WebApp?cmd=ShadowBoxProfile&type=Person&ID=291040.

10. Kelly Agan, "George, Charles," *NCPEDIA*, State Library of North Carolina, https://www.ncpedia.org/george-charles; "The Quiet Warrior from Birdtown," Department of Veterans Affairs website, https://www.asheville.va.gov/about/The_Quiet_Warrior_from_Birdtown.asp; Congressional Medal of Honor Society website, http://www.cmohs.org/recipient-detail/3115/george-charles.php; Scott McKie, "Charles George Exhibit Opens at Museum of the Cherokee Indian," *Cherokee One Feather*, May 28, 2018, https://theonefeather.com/2018/05/pfc-charles-george-exhibit-opens-at-museum-of-the-cherokee-indian/.

11. Stack, "Korean War, a 'Forgotten' Conflict That Shaped the Modern World," https://www.nytimes.com/2018/01/01/world/asia/korean-war-history.html.

12. Video interview with Roy O. Hawthorne, Roy O. Hawthorne Collection (AFC/2001/001/52528), Veterans History Project, American Folklife Center, Library of Congress, online at https://memory.loc.gov/diglib/vhp/bib/loc.natlib.afc2001001.52528.

13. William C. Meadows, *Kiowa Military Societies: Ethnohistory and Ritual* (Norman: University of Oklahoma Press, 2010), 60–61.

14. Paul C. Rosier, *Serving Their Country: American Indian Politics and Patriotism in the Twentieth Century* (Cambridge, MA: Harvard University Press, 2009), 172.

The Medal of Honor

1. Among the resources used to formulate a list of Native American Medal of Honor recipients, see: Edward F. Murphy, *Korean War Heroes* (Novato, CA: Presido, 1997); Alison R. Bernstein, *American Indians and World War II: Toward a New Era in Indian Affairs* (Norman: University of Oklahoma Press, 1999); James H. Willbanks, *America's Heroes: Medal of Honor Recipients from the Civil War to Afghanistan* (Santa Barbara: ABC-CLIO, 2011); Department of Veterans Affairs, Office of Public and Intergovernmental Affairs, Office of Tribal Government Relations, "Native American Medal of Honor Recipients," https://www.va.gov/tribalgovernment/medal_of_honor_recipients.asp; Konnie LeMay, "A Brief History

of American Indian Military Service," *Indian Country Today*, May 28, 2012, https://newsmaven .io/indiancountrytoday/archive/a-brief-history -of-american-indian-military-service-X7hYOzqu EUin095S8QpVjw/; Center for Military History, United States Army, 2011, accessed July 2019, https://history.army.mil/html/topics/natam/natam -moh.html.

2. Referring to an extant list of Native Medal of Honor recipients, it is important to note that there have been calls to revoke Medals of Honor received by Seventh Cavalry soldiers who participated in the December 29, 1890, Wounded Knee Massacre, where an estimated three hundred Lakota, mostly women and children, died. Six of the fifty-one Lakota wounded also died. As such, the Native American Medal of Honor recipients who participated in the "Indian Wars" sparked new questions over the sensitive issue of Native Americans enlisted to and rewarded for fighting and killing other Native Americans. For more on this topic, see: Katharine Bjork, *Prairie Imperialist: The Indian Country Origins of the American Empire* (Philadelphia: University of Pennsylvania Press, 2018).

3. For information about the Black Seminole Scouts, see the chapter titled "Indian Wars, Indian Scouts" in this volume; Kevin Mulroy, *Freedom on the Border: The Seminole Maroons in Florida, the Indian Territory, Coahuila and Texas* (Lubbock: Texas Tech University Press, 1993); James F. Brooks, *Captives and Cousins: Slavery, Kinship, and Community in the Southwest Borderlands* (Chapel Hill: University of North Carolina Press, 2002); Kevin Mulroy, *The Seminole Freedmen: A History*, vol. 2, *Race and Culture in the American West series* (Norman: University of Oklahoma Press, 2007); Christina Snyder, *Slavery in Indian Country: The Changing Face of Captivity in Early America* (Cambridge: Harvard University Press, 2010).

4. Although Boyington claimed partial Sioux ancestry, his Native heritage has been called into question by recent historians, as the true identity of his biological father cannot be verified.

5. *Vietnam Magazine*, "James E. Williams Medal of Honor Recipient, 68,'" August 2017. Reprinted as "Willy Williams, the most decorated enlisted sailor in Navy history," *Navy Times*, November 8, 2018, accessed September 20, 2019, https://www.navytimes.com/military-honor/salute -veterans/2018/11/08/willy-williams-the-most -decorated-enlisted-sailor-in-navy-history/.

6. Richard Goldstein, "J. E. Williams, 68, Dies; Won the Medal of Honor," *New York Times*, October 19, 1999; Congressional Medal of Honor Society, "James E. Williams," www.cmohs.org/ recipient-detail/3447/williams-james-e.php; U.S. Navy, Chief of Information, Native Heritage, Navy Pride, Story Number: NNS151125-11, https:// www.navy.mil/submit/display.asp?story_id=92146.

7. Goldstein, "J. E. Williams, 68, Dies; Won the Medal of Honor," *New York Times,* October 19, 1999.

8. Murphy, *Korean War Heroes*, 78–80.

9. Willbanks, *America's Heroes*, 275–77.

10. Grant P. Arndt, "Something More than Patriotism: War, Veterans, and the Return of the Powwow," in *Ho-Chunk Powwows and the Politics of Tradition* (Lincoln: University of Nebraska Press, 2016).

11. Kim Gamel, "End of an Era: Camp Red Cloud is Finally Closing—For Real This Time," *Stars and Stripes*, October 24, 2018, accessed September 10, 2019, https://www.stripes.com/news /end-of-an-era-camp-red-cloud-is-finally-closing -for-real-this-time-1.553262.

12. Brummett Echohawk and Mark R. Ellenbarger, introduction to *Drawing Fire: A Pawnee, Artist and Thunderbird in World War II,* ed. Trent Riley and Ernest Childers (Lawrence: University Press of Kansas, 2018).

13. Kenneth William Townsend, *WWII and the American Indian* (Albuquerque: University of New Mexico Press, 2000), 129.

14. Dean Chavers, *Modern American Indian Leaders: Their Lives and Their Work* (Lewiston, NY: Edwin Mellen Press, 2007), 1:249.

15. Adam Bernstein, "Medal of Honor Recipient Ernest Childers Dies at 87," *Washington Post,* March 23, 2005, http://www.washingtonpost.com /wp-dyn/articles/A58550-2005Mar22.html.

Master Sergeant Woodrow Wilson Keeble

1. Russell Hawkins, interview with Mark G. Hirsch, July 24, 2019.

2. Kurt Bluedog, interview with Mark G. Hirsch, July 22, 2019.

3. Master Sergeant Woodrow Wilson Keeble, Medal of Honor Ceremony, *Program Schedule*, South Dakota State Legislature Joint Session, March 17, 2008, https://vetaffairs.sd.gov/resources /Medal%20of%20Honor/KEEBLE.pdf.

4. Hawkins, interview with Mark G. Hirsch, July 24, 2019.

5. James H. Willbanks, ed. *America's Heroes: Medal of Honor Recipients from the Civil War to Afghanistan* (Santa Barbara, CA: ABC-CLIO, 2011): 165-66.

6. Carrie McLeroy, "First Sioux to Receive Medal of Honor," February 22, 2008, United States Army, https://www.army.mil/article/7566 /first_sioux_to_receive_medal_of_honor.

7. "Biography of Master Sgt. Woodrow W. Keeble, Medal of Honor, Korean War," United States Army, https://www.army.mil/medalofhonor /keeble/profile/index.html.

8. McLeroy, "First Sioux to Receive Medal of Honor."

9. McLeroy, "First Sioux to Receive Medal of Honor."

10. Hawkins, quoted in McLeroy, "First Sioux to Receive Medal of Honor."

11. Hawkins, interview with Mark G. Hirsch, July 24, 2019.

12. Bluedog, interview with Mark G. Hirsch, July 22, 2019.

13. "Biography of Master Sgt. Woodrow W. Keeble, Medal of Honor, Korean War."

VIETNAM

1. Val Niehaus, "Native Americans in the Military, Vietnam War (1959–75)," *Potawatomi Traveling Times* 20, no. 20 (April 15, 2015): 1, 4, https:// www.fcpotawatomi.com/wp-content/uploads/2015 /04/web_Apr_15_21051.pdf.

2. Interview with Steven L. Bobb, April 23, 2003, "Experiencing the War: Stories from the Veterans History Project," Veterans History Project, American Folklife Center, Library of Congress, http://memory.loc.gov/diglib/vhp-stories /loc.natlib.afc2001001.09818 /transcript?ID =sr0001.

3. Christian G. Appy, *Patriots: The Vietnam War Remembered from All Sides* (New York: Penguin Books, 2003), xix.

4. Christian G. Appy, *Working-Class War: American Combat Soldiers and Vietnam* (Chapel Hill: University of North Carolina Press, 1993), 17.

5. Lindsay F. Holiday, Gabriel Bell, Robert E. Klein, and Michael R. Wells, "American Indian and Alaska Native Veterans: Lasting Contributions," Department of Veterans Affairs, Office of Policy (September 2006), 4; Herman Viola, *Warriors in Uniform: The Legacy of American Indian Heroism* (Washington, DC: National Geographic, 2008), 141.

6. An accurate enumeration of Native Americans who served in Vietnam cannot be compiled, partly because U.S. military enlistment and draft documents did not include the category "American Indian." See Tom Holm, "Forgotten Warriors: American Indian Servicemen in Vietnam," *Vietnam Generation* 1, no. 2, article 6 (1989), http:// digitalcommons.lasalle.edu/vietnamgeneration /vol1/iss2/6; Tom Holm, *Strong Hearts, Wounded Souls: Native American Veterans of the Vietnam War* (Austin: University of Texas Press, 1996), 123, 145; Profile of Prof. Tom Holm, American Indian Studies, University of Arizona website, https://ais .arizona.edu/users/tom-holm.

7. Holm, *Strong Hearts, Wounded Souls*, 118–19; Holm, "Forgotten Warriors," 61.

8. Carson Walks on Ice, quoted in Herman Viola, *Warriors in Uniform,* 152.

9. Leroy TeCube, *Year in Nam: A Native American Soldier's Story* (Lincoln: University of Nebraska Press, 1999), xviii.

10. Until 1965, college students, large numbers of white-collar professionals, fathers, married men without children, and those with various medical conditions could secure draft deferments that shielded them from induction into the U.S. military. As the war continued, selective service requirements, deferments, and exemptions changed, and on December 1, 1969, the United States instituted a draft lottery, which gave young men a random number corresponding to their birthdays. Men with lower numbers were called first and told to report to induction centers where they could be ordered into active duty. U.S. Selective Service System, "The Vietnam Lotteries," https://www.sss.gov/About/History-And-Records /lotter1; Amy Rutenberg, "What Trump's Draft Deferments Reveal," *The Atlantic*, January 2, 2019, https://www.theatlantic.com/ideas /archive/2019/01/trumps-military-draft-deferment -isnt-unusual/579265/.

11. One historian estimates that 55 percent of American forces in Vietnam were working class, 25 percent were poor, 20 percent were middle class, and a negligible number were wealthy. See Appy, *Working-Class War,* 27. A contrasting perspective can be found in Thomas Wilson, "Vietnam-Era

Military Service: A Test of the Class-Bias Thesis," *Armed Forces and Society* 21, no. 3 (1995): 461–71. "Project 100,000," a Defense Department program designed to "uplift" men otherwise deemed ineligible for military service, targeted poor, undereducated, and often minority men. See Lisa Hsiao, "Project 100,000: The Great Society's Answer to Military Manpower Needs in Vietnam," *Vietnam Generation* 1, no. 2 (1989): 14–37, http://digital commons.lasalle.edu /vietnamgeneration/vol1 /iss2/4.

12. Appy, *Working-Class War*, 155.

13. James Chastain, quoted in Herman Viola, *Warriors in Uniform*, 155.

14. Alan Brinkley, *The Unfinished Nation: A Concise History of the American People* (New York: McGraw-Hill, 1993), 825; Appy, *Working-Class War*, 155; Holm, *Strong Hearts, Wounded Souls*, 134–35, 145–47, 157.

15. TeCube, *Year in Nam*, xii.

16. Appy, *Patriots*, 201; Appy, *Working-Class War*, 227, 288–89.

17. Appy, *Working-Class War*, 289.

18. Appy, *Working-Class War*, 17.

19. Unidentified Native Vietnam War veteran, quoted in Tom Holm, *Strong Hearts*, 148–49.

20. Unidentified Native Vietnam War veteran, quoted in Tom Holm, *Strong Hearts*, 149.

21. Unidentified Native Vietnam War veteran, quoted in Tom Holm, *Strong Hearts*, 149.

22. Viola, *Warriors in Uniform*, 142, 147.

23. Viola, 155.

24. "President Jefferson Keel," National Congress of American Indians, accessed September 6, 2019, http://www.ncai.org/about-ncai/ncai -leadership/president-jefferson-keel.

25. Tom Holm, review of *Viet Cong at Wounded Knee: The Trail of a Blackfeet Activist*, in *Great Plains Quarterly* 26, no. 1 (Winter 2006), http:// digitalcommons.unl.edu/greatplainsquarterly/147.

26. Sid Mills, phone conversation with Mark Hirsch, December 20, 2018; Frank Hopper, "Fish War General: Native Hero's Belated Purple Heart Honors Lifetime of Activism," July 14, 2018, https://newsmaven.io/indiancountrytoday/news /fish-war-general-native-hero-s-belated-purple -heart-honors-lifetime-of-activism-Wz9OAu0y80 -drDASGjr5LA/.

27. Sid Mills, phone conversation with Mark Hirsch, December 20, 2018; Emily Chertoff, "Occupy Wounded Knee: A 71-Day Siege and a Forgotten Civil Rights Movement," *The Atlantic*, October 23, 2012, online at https://www .theatlantic.com/national/archive/2012/10/occupy -wounded-knee-a-71-day-siege-and-a-forgotten -civil-rights-movement/263998/.

28. The Matsunaga Vietnam Veterans Project, named for the late Senator Spark Matsunaga of Hawai'i, involved two parallel studies. One, the American Indian Vietnam Veterans Project, surveyed a sample of Vietnam combat veterans residing on or near two large tribal reservations in the Southwest and the Northern Plains. Among the study's conclusions: the prevalence of posttraumatic stress among American Indians was more than twice as high as for white or Japanese American Vietnam Veterans. See "Psychological Trauma for American Indians Who Served in Vietnam—The Matsunaga Vietnam Veterans Project," PTSD: National Center for PTSD, Department of Veterans Affairs, accessed September 6, 2019, https://www.ptsd.va.gov/professional/treat/type /vietnam_american_indians.asp; Lindsay F. Holiday et al., "American Indian and Alaska Native Veterans: Lasting Contributions," 4.

29. Unidentified Ho-Chunk elder, quoted in Lawrence William Gross, "Assisting American Indian Veterans of Iraq and Afghanistan Cope with Posttraumatic Stress Disorder: Lessons from Vietnam Veterans and the Writings of Jim Northrup," *American Indian Quarterly* 31, no. 3 (Summer 2007): 379.

Artist Veterans

1. Bill Anthes, *Native Moderns: American Indian Painting, 1940–1960* (Durham, NC: Duke University Press, 2006), 156–58.

2. Elizabeth Cunningham, "Eva Mirabal (Eah Ha Wa)," *Remarkable Women of Taos / Profiles: Legends*, 2011, accessed May 30, 2019, http:// womenoftaos.org/women/profiles-legends?/item /76/Eva-Mirabal-Eah-Ha-Wa.

3. Martha Hopkins Struever, with the assistance of Jonathan Batkin and Cheri Falkenstein-Doyle, *Loloma: Beauty Is His Name* (Santa Fe, NM: Wheelwright Museum of the American Indian, 2005), 8–9.

4. Karen Kramer, *T. C. Cannon: At the Edge of America* (Salem, MA: Peabody Essex Museum, 2018), 43–45.

5. Rebecca Dobkins, *Rick Bartow: My Eye* (Salem, OR: Hallie Ford Museum of Art, Willamette University; Seattle, WA: in association with

University of Washington Press, 2002), 17–18, and Charles Froelick, personal correspondence with Rebecca Trautmann, July 10, 2018.

6. *Michael A. Naranjo: Inner Vision* (Santa Fe, NM: Naranjo Studio, 2000), 1.

Pascal Cleatus Poolaw Sr.

1. Linda Poolaw, interview with Alexandra Harris, October 11, 2016.

2. "Pascal C. Poolaw Sr.," American Indians in the U.S. Army, United States Army, accessed October 12, 2018, https://www.army.mil/american indians/poolaw.html.

3. Fort Sill Tribune, "Kiowa Soldier Remembered during National Native American Heritage Month," United States Army website, December 6, 2018, accessed March 29, 2019, https://www.army .mil/article/214705/kiowa_soldier_remembered _during_national_native_american_heritage _month.

4. Linda Poolaw, interview with Alexandra Harris, March 28, 2019.

WAR AND PEACE

1. Contemporary U.S. military involvement in peacekeeping and related operations is discussed in a Congressional Research Service Report: Nina M. Serafino, "Peacekeeping and Related Stability Operations: Issues of U.S. Military Involvement," Foreign Affairs, Defense, and Trade Division, Naval History and Heritage Command, July 13, 2006, https://www.history.navy .mil/research/library/online-reading-room/title -list-alphabetically/p/peacekeeping-and-related -stability-operations.html.

2. Despite the moniker, "peacekeeping missions" can be dangerous, even lethal. Unexploded land mines, snipers, looters, warlords, and civil unrest—all put U.S. forces in harm's way.

3. Master Sergeant Chuck Boers, email to Alexandra Harris, April 11, 2019.

4. Major Manuel Hernandez, interview by phone with Alexandra Harris, April 10, 2019.

5. Karin Eagle, "Native Woman Warrior Honored at White House," *Native Sun News,* September 9, 2014, https://www.indianz.com/News/2014 /09/09/native-sun-news-native-woman-w.asp.

6. Mitchelene BigMan, interview by phone with Mark Hirsch, August 2, 2019.

7. BigMan interviewed by Janice Kaplan, November 2017, for National Museum of the American Indian National Native American Veterans Memorial Project.

8. BigMan interviewed by Janice Kaplan, November 2017, for National Museum of the American Indian National Native American Veterans Memorial Project.

9. BigMan, interview by phone with Mark Hirsch, August 2, 2019.

10. BigMan, interview by phone with Mark Hirsch, August 2, 2019.

11. Lisa De Bode, "Woman Warrior: Mitchelene BigMan Turns to Traditional Dance to Heal the Pains of Life and War," *Al Jazeera America*, August 24, 2014, http://projects.aljazeera.com/2014/native -veterans/woman-warrior/

12. "National Native American Veterans Memorial: Honoring the Military Service of Native Americans," Smithsonian National Museum of the American Indian website, https://americanindian .si.edu/nnavm/.

13. Derek Gean, "Female American Indian Veteran Brings Recognition to Fellow Warriors," November 26, 2014, U.S. Army website, https:// www.army.mil/article/139130/female_american _indian_veteran_brings_recognition_to_fellow _warriors.

14. National Native American Veterans Memorial Consultation Recordings, Cherokee Nation, Tulsa, Oklahoma Consultation, July 21, 2016, transcript, 77, lines 1882–1891.

Coast Guard

1. C. L. Willoughby to Hon. Summer Increase Kimball, 13 January 1882, box 13, Articles of Engagement for Surfmen, 1875–1914, Records of the United States Coast Guard, record group 26, National Archives Building, Washington, DC.

2. William H. Thiesen, "The Long Blue Line: Native Americans—One of the Longest Serving Minorities in the Coast Guard," *Coast Guard Compass*, November 1, 2018, accessed April 12, 2019, https://coastguard.dodlive.mil/2018/11/the -long-blue-line-native-americans-one-of-the -longest-serving-minorities-in-the-coast-guard/.

3. Albert T. Stream to Hon. Summer Increase Kimball, 9 January 1882, box 13, Articles of Engagement for Surfmen, 1875–1914, Records of the United States Coast Guard, record group 26, National Archives Building, Washington, DC.

4. Find A Grave, Chief "Lighthouse Charley" Ma-Tote, accessed April 12, 2019, https://www .findagrave.com /memorial/90166412/ma_tote.

5. Wreck Site, SV Lammerlaw (+1881), updated August 19, 2015, accessed April 12, 2019, https://www.wrecksite.eu/wreck.aspx?238469; the official report issued by the Naval Court in Portland, Oregon, can be found here: https://www.wrecksite.eu/docBrowser.aspx?4882?7?1.

6. Dennis L. Noble, *Lighthouses & Keepers: The U.S. Lighthouse Service and Its Legacy* (Annapolis, MD: Naval Institute Press, 1997), 106–7.

7. Mrs. Harold C. Dixon, ed., "A Page from The Journal," "From the Land of The Vikings," and "Chief Charley's Medal" in *The Sou'wester* 3, no. 2 (Summer 1968): 37–39.

8. Harland Plumb, "A Happy Summer on Peacock Spit," in *The Sou'wester* 13 no. 2–3 (Summer–Autumn 1978): 42, http://pacificcohistory.org/SouWester/1978%20Summer%20Autumn.pdf.

9. Jeremy D'Entremont, "History of Gay Head Light, Martha's Vineyard, Massachusetts," *New England Lighthouses: A Virtual Guide*, accessed April 15, 2019, http://www.newenglandlighthouses.net/gay-head-light-history.html.

10. "Charles W. Vanderhoop Jr.," obituary, June 2, 2001, accessed October 4, 2019, https://www.ccgfuneralhome.com/obit/charles-w.-vanderhoop-jr1.

11. William H. Thiesen, "The Long Blue Line: The Wampanoags at Gay Head Light," *Coast Guard Compass*, November 10, 2016, https://coastguard.dodlive.mil/2016/11/the-long-blue-line-the-wampanoags-at-gay-head-light/.

12. Thiesen, "The Long Blue Line," *Coast Guard Compass*, November 10, 2016, accessed April 15, 2019.

13. William H. Thiesen, "The Long Blue Line: The Pacific Islands—Coast Guard Connection," *Coast Guard Compass*, May 3, 2018, accessed April 15, 2019, https://coastguard.dodlive.mil/2018/05/the-long-blue-line-the-pacific-islands-coast-guard-connection/.

14. William H. Thiesen, "The Long Blue Line: Native Americans and their Service in the U.S. Coast Guard," *Coast Guard Compass*, November 3, 2016, accessed April 15, 2019, https://coastguard.dodlive.mil/2016/11/the-long-blue-line-native-americans-and-their-service-in-the-coast-guard/.

15. William H. Thiesen, email to Alexandra Harris, April 3, 2019.

16. Sealaska, *Sealaska Shareholder* Q4 (Juneau, AK: Sealaska, 2015), 6. https://docplayer.net/120892911-A-quarterly-newsletter-from-sealaska
-celebrating-the-life-of-robert-loescher-youth-advisor-update-from-barbara-dude.html.

17. Michelle Roberts, interview with Alexandra Harris, May 26, 2019.

18. William H. Thiesen, "The Long Blue Line: Master Chief Petty Officer Melvin Kealoha Bell—Minority Pioneer, Pacific War Hero," *Coast Guard Compass* blog, September 27, 2018, accessed October 18, 2019, https://coastguard.dodlive.mil/2018/09/tlbl-etcm-melvin-bell/.

Rear Admiral Michael Holmes: A Lifetime of Service

1. Rear Admiral Michael L. Holmes, Retired, United States Navy Biography, July 16, 2013, https://www.navy.mil/navydata/bios/bio.asp?bioID=147.

2. All quotations from Rear Admiral Michael L. Holmes are cited from his PowerPoint presentation, "History of Native Americans in the U.S. Armed Forces," given at U.S. Bank, November 14, 2018. The authors wish to thank Admiral Holmes for sharing this document.

CONFLICTS IN THE MIDDLE EAST: 1991–2018

1. See James P. Pfiffner, "Did President Bush Mislead the Country in His Arguments for War with Iraq?" *Presidential Studies Quarterly* 34, no. 1, Going to War (March 2004): 25–46.

2. Nese F. DeBruyne, *"American War and Military Operations Casualties: List and Statistics,"* Congressional Research Service, accessed April 26, 2019, https://fas.org/sgp/crs/natsec/RL32492.pdf.

3. Oklahoma State Department of Health, "Oklahoma Violent Death Reporting System," accessed December 12, 2018, https://www.ok.gov/health/Protective_Health/Injury_Prevention_Service/Oklahoma_Violent_Death_Reporting_System/index.html.

4. Sergeant Enrique S. Diaz, "U.S. Soldiers Celebrate Native American Heritage in Iraq," United States Marine Corps, September 24, 2004, https://lists.rootsweb.com/hyperkitty/list/amerind-us-se.rootsweb.com/thread/27774558/.

5. Rob McIlvaine, "Native American Soldiers Beat Drum of Warrior Spirit," December 6, 2011, United States Army website, https://www.army.mil/article/70360/native_american_soldiers_beat_drum_of_warrior_spirit.

6. Honoring Native Veterans, at the Museum and with the Muscogee (Creek) Nation in Oklahoma," National Museum of the American Indian blog, November 2011, https://blog.nmai.si.edu/main/2011/11/honoring-native-veterans.html.

7. "Powwow for Renewal in Iraq," *Citizen-Soldier*, October 26, 2017, https://citizen-soldier magazine.com/powwow-renewal-iraq/.

8. "Powwow for Renewal in Iraq."

Lori Ann Piestewa, 1979–2003

1. Osha Gray Davidson, "A Wrong Turn in the Desert," *Rolling Stone*, May 27, 2004, https://www.rollingstone.com/culture/culture-news/a-wrong-turn-in-the-desert-234692/.

2. Rudi Williams, "Army Spc. Lori Piestewa: Honoring a Fallen Hero," *Defend America: U.S. Department of Defense News About the War on Terrorism*, Department of Defense, May 27, 2003, https://web.archive.org/web/20070808195738/http://defendamerica.mil/profiles/june2003/pro60203b.html.

3. Upon learning that Lori hadn't fired a shot, that she was instead attempting to drive her Humvee to safety, her father, Terry, said, "We're very satisfied she went the Hopi way. She didn't inflict any harm on anybody." Osha Gray Davidson, "A Wrong Turn in the Desert."

4. "Army Pfc. Lori Ann Piestewa," *Military Times*, https://thefallen.militarytimes.com/army-pfc-lori-ann-piestewa/256538.

Don't Call Me Chief

1. See Stephen W. Silliman, "The 'Old West' in the Middle East: U.S. Military Metaphors in Real and Imagined Indian Country," *American Anthropologist* 110, no. 2 (June 2008): 237–47.

2. Jake Tapper, Huma Khan, Martha Raddatz, and Lauren Effron, "Osama Bin Laden Operation Ended with Coded Message 'Geronimo-E KIA'," ABC-NEWS, May 2, 2011, https://abcnews.go.com/Politics/osama-bin-laden-operation-code-geronimo/story?id=13507836.

3. "Calling on the U.S. Government and Department of Defense Cease from Designating Enemy Held Territory as Indian Country and to Cease Designation Enemy Combatants with Native American Leaders Names," National Congress of American Indians, Resolution #MKE-17-064 (2017), http://www.ncai.org/resources/resolutions/calling-on-the-u-s-government-and-department-of-defense-cease-from-designating-enemy-held-territory-as-indian-country-and-to-cease-designation-enemy-combatants-with-native-american-leaders-names.

HONORING THE LEGACY OF SERVICE: THE NATIONAL NATIVE AMERICAN VETERANS MEMORIAL

1. National Native American Veterans Memorial consultation hosted by the Southern Ute Indian Tribe, Ignacio, Colorado, April 28, 2017.

2. Nelson N. Angapak Sr., written statement submitted at National Native American Veterans Memorial consultation, Anchorage, AK, June 14, 2017.

3. National Museum of the American Indian, "National Native American Veterans Memorial Design Competition: Stage II Jury Report" (Unpublished), 2.

INDEX